Turner *and the Masters*

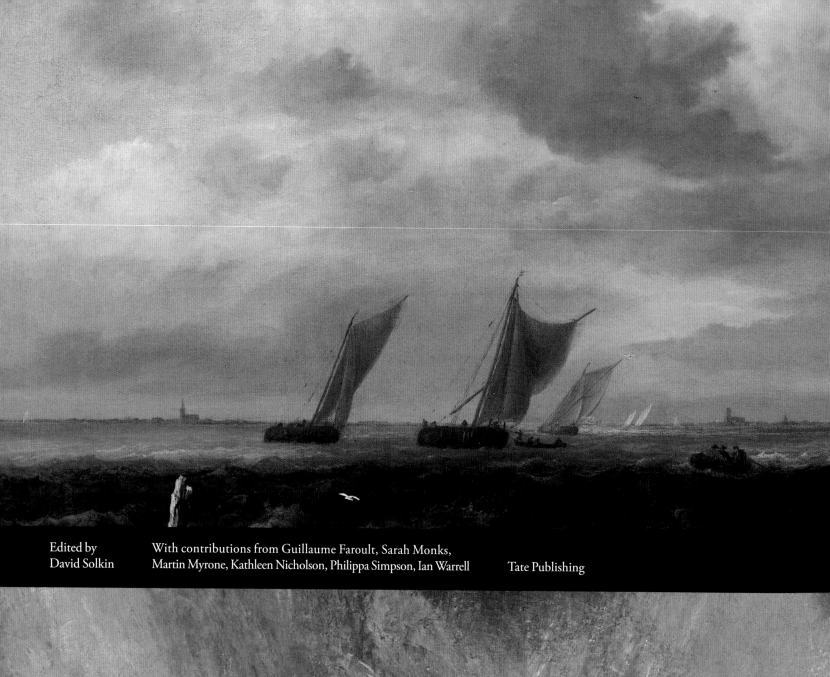

Edited by
David Solkin

With contributions from Guillaume Faroult, Sarah Monks,
Martin Myrone, Kathleen Nicholson, Philippa Simpson, Ian Warrell

Tate Publishing

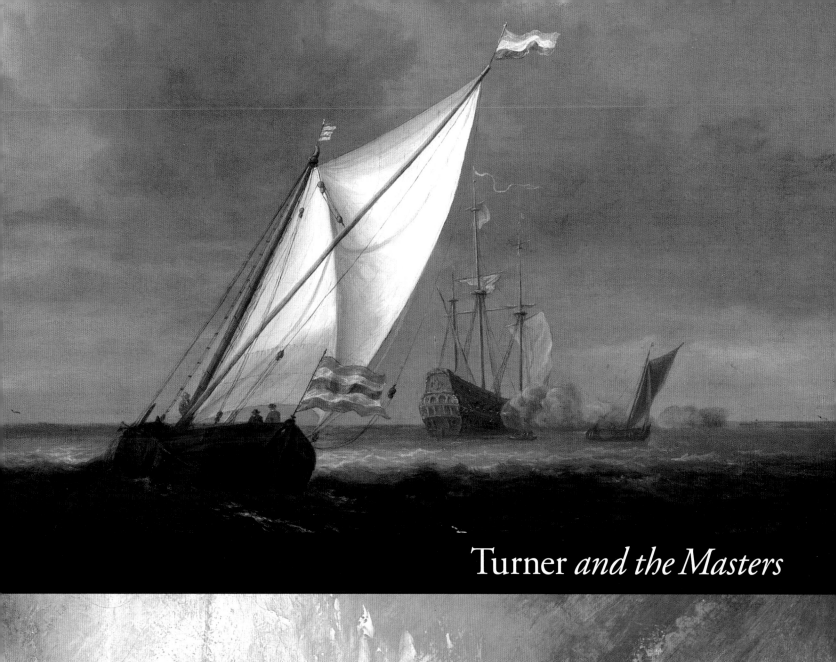

Turner *and the Masters*

Supported by McKinsey & Company

First published 2009 by order of the Tate
Trustees by Tate Publishing, a division of Tate
Enterprises Ltd, Millbank, London SW1P 4RG
www.tate.org.uk/publishing

on the occasion of the exhibition
Turner and the Masters

Tate Britain, London
23 September 2009 – 31 January 2010

Galeries nationales (Grand Palais,
Champs-Elysées), Paris
22 February – 24 May 2010

Museo Nacional del Prado, Madrid
22 June –19 September 2010

British Library Cataloguing in Publication Data
A catalogue record for this book is available
from the British Library

ISBN 978 1 85437 798 2 (pbk)
ISBN 978 1 85437 865 1 (hbk)

Distributed in the United States and
Canada by Harry N. Abrams, Inc., New York

Library of Congress Cataloging
in Publication Data
Library of Congress Control Number:
2009923146

Designed by Rose
Colour reproduction by
DL Interactive Ltd, London
Printed in Italy by Conti Tipocolor, Florence

Front cover: J.M.W. Turner,
*Snow Storm – Steam Boat off
a Harbour's Mouth* exh.
RA 1842 (detail, no.101)
Back cover: Jacob van Ruisdael,
Rough Sea c.1670 (detail, no.98)

Pages 10–11
Top: Canaletto, *The Bacino di San Marco
on Ascension Day* c.1733–4 (no.66, detail)
Bottom: J.M.W. Turner, *Bridge of Sighs,
Ducal Palace and Custom House* exh.RA 1833
(detail, no.67)

Pages 96–7
Top: Thomas Girtin, *The White
House at Chelsea* 1800 (detail, no.86)
Bottom: J.M.W. Turner, *The Lauerzersee
with the Mythens* 1848 (detail, no.87)

Measurements of artworks are given
in centimetres, height before width

Contents

Directors' Foreword

Though this exhibition begins and ends with J.M.W. Turner and his own precoccupations as a painter, its purpose is also to engage with some wider art historical questions of a particular kind and currency. In exploring how a nineteenth-century painter forged a new and distinctly modern form of landscape painting rooted in an understanding of and critical independence from past art, the exhibition seeks to broaden our understanding of the concept of artistic originality and reveal how a sense of history can shape artistic production. It also places British art, still too often seen as parochially isolated from – or at best an eccentric off-shoot of – European art, squarely in relationship with the great traditions of Western painting. In engaging so powerfully with the art of Claude and Poussin, Rembrandt and Teniers, Watteau and Rubens, as well as the greatest of his contemporaries and immediate predecessors, such as Girtin, Gainsborough, Constable and Wilson, Turner insisted that his paintings needed to be understood in the context of a trans-historical artistic enterprise, one that was not limited in any simple sense by national borders.

In that respect, this partnership between Tate Britain and colleagues from the Musée du Louvre, the Réunion des Musées Nationaux and the Museo Nacional del Prado, and the tour of the exhibition from London to Paris and Madrid, is especially significant. Following recent exhibitions which have brought the art of Turner to new audiences in Russia, America and China, *Turner and the Masters* will further consolidate a sense of Turner's international significance as an artist, and help ensure that British art is understood and appreciated in global contexts. The chance to see these paintings together, often for the first time – sometimes for the first time in centuries – gives a unique opportunity to assess, with fresh eyes, Turner's place in the history of art.

The present exhibition has a long genesis, and is rooted in the best traditions of scholarship and curatorial work around Turner. As the home of the Turner Bequest – the remarkable group of nearly 300 oil paintings and around 30,000 sketches and watercolours that Turner left to the nation, thus helping to ensure that his achievements would be long remembered – Tate has had a leading role in researching the artist's work and promoting the understanding and appreciation of his art. Turner's art has been subject to a quite uniquely

intensive, focused and searching body of scholarship, much of it generated by the Tate's own curators and conservators. But if this scholarship has long recognised the central roles played by the art of the past in Turner's own ambitions, never before has an exhibition been mounted which explores this theme so comprehensively, by bringing Turner's works in direct physical juxtaposition with the full range of the masters of past art that he emulated, rivalled, and sought to out-do.

That we have been able to do so now is the result, on one hand, of the decision to form a close collaborative relationship between our three institutions and, on the other, of the singular clarity of vision and scholarship of the exhibition's curator, David Solkin, Professor of the Social History of Art at the Courtauld Institute of Art in London, where he has been a leading presence in the study of British art for almost twenty-five years. His groundbreaking Tate exhibition of 1982, *Richard Wilson*, was to prove one of the great milestones of 'new' British art historical scholarship of the day, all the more so for the controversy it engendered. Since then, his *Painting for Money: The Visual Arts and the Public Sphere in Eighteenth-Century England* (1993) has become a standard text for the teaching and understanding of eighteenth-century British art history. And his spectacular exhibition *Art on the Line: The Royal Academy Exhibitions at Somerset House* (2001) at Somerset House, and the book which accompanied it, was acclaimed for forging new approaches to British art and introducing questions about the social context and significance of the visual arts which have now become central to the discipline.

David proposed and conceived the present exhibition, led on the selection of exhibits, and has been rigorous in pursuing his duties as editor and lead author of the present catalogue. In all these tasks, he has worked in close partnership with his co-curators from Tate: Martin Myrone, whose wise judgement in helping shape the show has been fundamental; Ian Warrell, an outstanding scholar of Turner's art who has worked tirelessly on this exhibition alongside an array of other commitments; and Philippa Simpson, whose energetic presence as assistant curator throughout the life of the project has been essential to its success. Philippa's new research on the early nineteenth-century art market, undertaken as a Tate-Courtauld PhD fellow from 2005 to 2008, has added significantly to our sense of the wider context of

Turner's artistic enterprise. The important input of Guillaume Faroult of the Musée du Louvre has been greatly appreciated, as has the support of Vincent Pomarède of the Louvre and Catherine Chagneau of the RMN; the exhibition would have been impossible to realise in its present form without their commitment. Javier Barón Thaidigsmann and Gabriele Finaldi have led the Prado's important curatorial contribution to the project. It has been an extremely productive and harmonious collaboration for us all.

Every major loan exhibition is dependent, of course, on the generosity of lenders. With this exhibition, our debt is all the greater, as our principles of selection have been unusually unforgiving: we have sought to include works which, by dint of their provenance, display history, and very precise visual qualities, make particularly telling partners to specific works by Turner. This scrupulous method of selection has meant that we have had to pursue individual works for which no effective alternative exists. With that in mind, I would like to thank all our lenders, institutional and individual, for their kindness in making the works included in this exhibition available. For their generosity and help in this regard, we are indebted to, among others, Brian and Judy Schindler, the Trustees of the Hoare Family, Don Bacigalupi and Larry Nichols of Toledo Museum of Art, Sir Jack Baer, Amy Meyers of the Yale Center for British Art, Duncan Robinson, Brian Allen, Alastair Laing of the National Trust, Lord Egremont, The Marquis of Lansdowne, Ian Dejardin of Dulwich Picture Gallery, Desmond Shawe-Taylor of the Royal Collections Trust, The Earl and Countess of Mansfield and Mansfield, Nicholas Penny, Susan Foister and Chris Riopelle of National Gallery, London, Earl A. Powell and Franklin Kelly of the National Gallery of Art, Washington, Paul Tucker, and Tom Venditti.

Finally, our thanks are due to McKinsey & Company for so generously supporting the exhibition in London, as well as enabling the conservation of four Tate works in the show.

Stephen Deuchar, Director, Tate Britain
Thomas Grenon, General Administrator, Réunion des Musées Nationaux
Henri Loyrette, President and Director, Musée du Louvre
Miguel Zugaza, Director, Museo Nacional del Prado

Acknowledgements

The organisation and successful installation of the exhibition at Tate Britain has rested upon the expert talents and commitment of many people within Tate and beyond. The curatorial team at Tate Britain would like to thank the many individuals who provided help, support and advice during the organisation of loans for this exhibition, including Christopher Baker, Emily Blanshard, Julius Bryant, Richard Burns, Dai Evans, Mark Evans, Oliver Fairclough, Kate Fielden, Timothy Goodhue, Constance McPhee, Jill McNaught-Davis, Jan Piggott, Janice Reading, Xavier Salomon, Luisa Sampaio, Dr Andreas Schumacher, George Shackleford, Eric Shanes, Greg Smith, MaryAnn Stevens, Hiroya Sugimura, Katrina Thomson, Angus Trumbull, Rosalind Mallord Turner, Ernst Vegelin, Arthur K. Wheelock, Humphrey Wine, Andrew Wyld, and, of course, our colleagues at the Louvre, RMN and the Prado including Isabella Reusa and Lucía Villareal.

 The exhibition design, a model of restrained elegance, was provided by Paul Williams and Juliet Phillips from Stanton Williams, with exhibition graphics designed by Philip Miles. The installation was overseen by Andy Shiel, Art Installation manager, working with Hattie Spires and Juleigh Gordon-Orr, and undertaken by the art handling team, led by Geoff Hoskins. The exhibition's registrar was Kiko Noda, while Bronwyn Gardner, Catherine Clement and her team managed the complex movements of works from the Tate Collection. The extensive preparation and conservation of the Tate works in the exhibition was undertaken by Rebecca Hellen, Amelia Jackson, Gerry Alabone, Piers Townshend and their colleagues. Nicola Bion, Roanne Marner and Deborah Metherell at Tate Publishing have been responsible for the exhibition catalogue, which has been designed by Simon Elliott and Rupert Gowar-Cliffe at Rose.

Editor's acknowledgements

This catalogue and the exhibition it accompanies build on the achievements of a generation of scholars who, over the past forty years and more, have shaped modern understandings of J.M.W. Turner's art. All of the contributors to *Turner and the Masters* have found a constant and immeasurably helpful companion in the exemplary catalogue raisonné of Turner's paintings by Martin Butlin and the late Evelyn Joll, while over and over again we have drawn upon the publications of Gerald Finley, John Gage, Cecilia Powell, Eric Shanes, Barry Venning, Selby Whittingham, Andrew Wilton, and Jerrold Ziff, among others. My first serious introduction to Turner came courtesy of the late Michael Kitson, when I had the privilege of studying under him in the early 1970s, and Michael's elegant and insightful writings on the artist continue to guide me to this day.

David Solkin

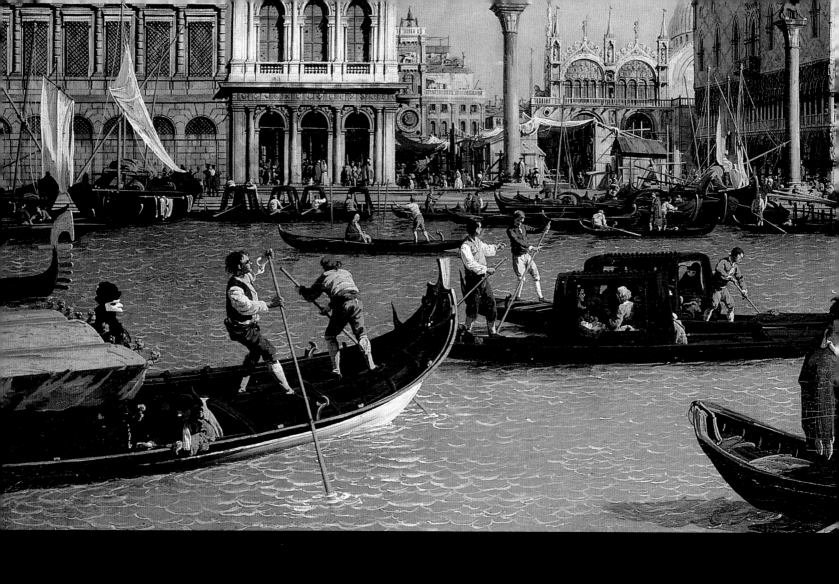

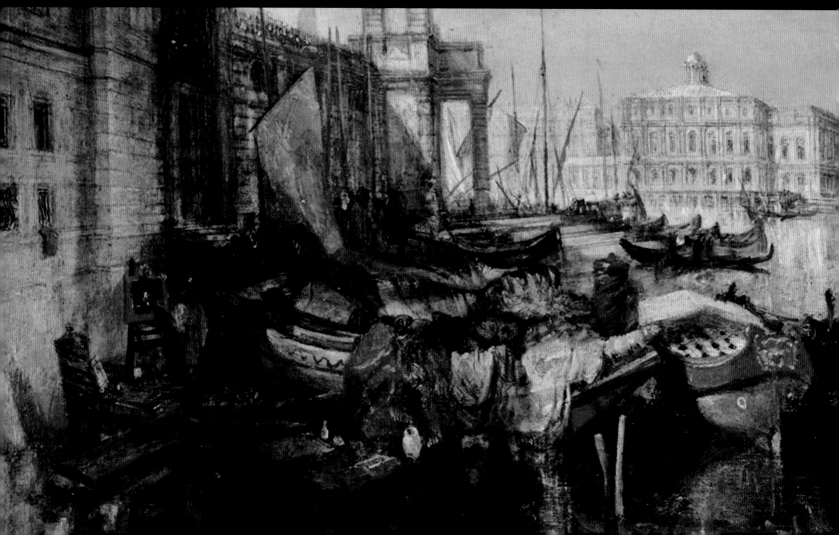

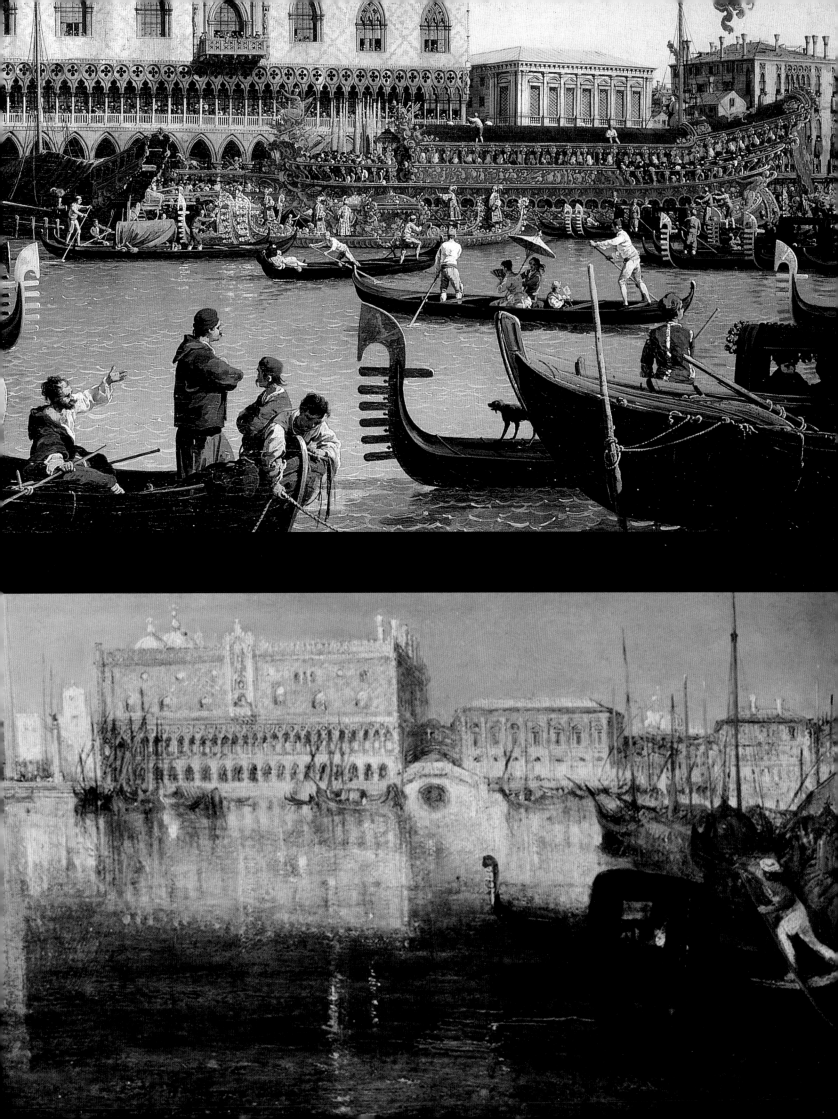

Turner and the Masters: Gleaning to Excel
David Solkin

No artist can practise as an artist without engaging with the art of the past; but in the case of J.M.W. Turner (1775–1851) that engagement was unusually public, complicated and prolonged. Throughout his career Turner never tired of matching his talents against those forerunners whom he most admired, and of openly dramatising his attempts to do so, even as he devoted more and more of his energies to devising his own, defiantly innovative forms of modern pictorial imagery. In the process he fashioned a type of landscape painting that not only strove to be true to the appearances of nature, but also self-consciously explored the making of art itself.

Because our own aesthetic attitudes have been so deeply coloured by the Romantic period, and because Turner tends to be most fervently admired for what has often been taken to be the forward-looking nature of his work, his lifelong preoccupation with a select group of precursors nowadays tends to be regarded with a certain degree of ambivalence: as a sign of his own high ambitions, certainly, but also as a bit of a holdover from an earlier epoch. As Sam Smiles justly notes in his recent introduction to the artist, 'If Turner's respect for the old masters seems at first unlikely for an artist whose reputation today is wedded to some notion of his premonition of modern art, we need to remember that his attitude to tradition was formed from eighteenth-century precepts.'[1]

Those precepts, however, were neither static nor monolithic (nor perhaps as *retardataire* as we might tend to imagine) – and 'respect' was far from being the only attitude that they engendered. There can be no doubt that Turner's artistic education helped shape in his mind an exceptionally keen awareness of tradition as a rich and absolutely indispensable resource for his own practice as a painter, and as an equally necessary frame of reference for his own artistic aspirations; but the cultural debates of his youth and early adulthood also taught him to place the highest value on his own creative autonomy – an autonomy that he could only hope to secure precisely by throwing off the shackles of the past. From an early stage Turner made it his business to pursue both these commitments simultaneously, and to revel in the contradictory demands that they imposed upon his art.

An abiding reverence for the traditions of European painting was one of the principal lessons taught at England's recently founded Royal Academy, where Turner was admitted as a pupil at the age of fourteen, at the end of an era dominated

J.M.W. Turner
Regulus exh. Rome 1828,
reworked, exh. BI 1837
(detail, no.91)

by the institution's first president, Sir Joshua Reynolds (1723–1792). In the *Discourses* he delivered at the prize-giving ceremonies held between 1769 and 1790, Reynolds urged the Academy's students to nourish themselves on the 'great works of [their] predecessors' – an entirely conventional piece of advice.[2] In 1774 he went even further, when he prescribed this nourishment as the sustenance for a lifetime:

> Study therefore the works of the great masters, for ever. Study as nearly as you can, in the manner, and on the principles, on which they studied. Study nature attentively, but always with those masters in your company; consider them as models which you are to imitate, and at the same time as rivals with whom you are to contend.[3]

Turner would go on to follow Sir Joshua's advice to the letter and beyond. Alone among his contemporaries, he persisted in cultivating a wide array of rivalries with the artistic giants of previous times (and with a few living competitors as well). In part because he proclaimed these engagements in so overt a manner, their central importance to his art has long been recognised by scholars; but only by placing his 'imitations' and their 'models' side by side – as this exhibition does for the very first time – can we begin to grasp the full implications of what he was trying to do. The fact that some of these juxtapositions may seem to work in Turner's favour, whereas others may not, underlines the fact that he pursued this project despite or because of the knowledge that he did so at considerable risk to his own reputation – which indeed on more than one occasion suffered when critics judged his imitations as inferior to his models. So why, it seems perfectly fair to ask, did he invest so much in such a perilous enterprise?

To answer by referring to Turner's exceptional ambition is simply to pose the same question in a different way: for it still leaves us needing to try and identify the factors that drove his ambition to such elevated heights, and along the particular paths that it followed. Here one might begin this admittedly difficult task by acknowledging the significance of Turner's relatively humble social origins: how as the perfunctorily educated son of a Covent Garden barber – whose shop lay so near and yet so far from the Royal Academy's grandiose premises at Somerset House – he embarked on his chosen career with few of the accomplishments and even fewer of the social graces that had come to be expected of the professional artist. From his unprepossessing physical appearance (fig.1) and his strong cockney accent,[4] even in his youth Turner must have realised that he was never going to pass muster as a gentleman; nor – what with looking after his father at home, fathering two illegitimate daughters, and (from 1820) owning the Ship and Bladebone pub in the East End of London – did his adult lifestyle prove to be any more compatible with the norms of polite society. Thus to earn the respect of the well-to-do upon whose patronage he depended, Turner had to compensate for his lack of breeding by amassing other forms of symbolic capital. Here the Academy had a crucial role to play. Notwithstanding its associations with royalty, the Royal Academy operated largely (if not entirely) along meritocratic lines: it was an institution that openly valued labour as the principal means of professional and social advancement, and had in its power to award those who worked to the terms of its agenda with the trappings of genteel status, in the form of honorific titles (A.R.A., Associate of the Royal Academy, R.A., Royal Academician, etcetera) and offices (like that of Professor of Perspective, or P.P., which Turner assumed in 1807, five years after

being elected a Royal Academician). A further source of prestige – probably of greater importance still – lay in the heritage of art in the Grand Style (see pp.123–41), which academic theory was dedicated to promote, as the bedrock on which modern painters and sculptors might base their claims to being equals in dignity with even their most high-ranking patrons and admirers.

Turner was quick to take advantage of this cultural resource, but to do so in such a way as to avoid the economic pitfalls that had so often attended British artists (notably history painters), whose dreams of grandeur had led them to overlook the realities of the marketplace. While he may never have said so in so many words, he saw little or no point in acquiring cultural capital unless it furthered his assiduous and at times brazen pursuit of its material counterpart; or as his early biographer P.G. Hamerton put it, 'He had the passion for art … and he had the far commoner passion for accumulating money'[5] – again, not a desire which any true gentleman was supposed openly to espouse. The key to Turner's economic success lay in his

Fig.1
Charles West Cope
J.M.W. Turner Painting at the British Institution 1837
Oil on card, 15.9 x 13
National Portrait Gallery,
London

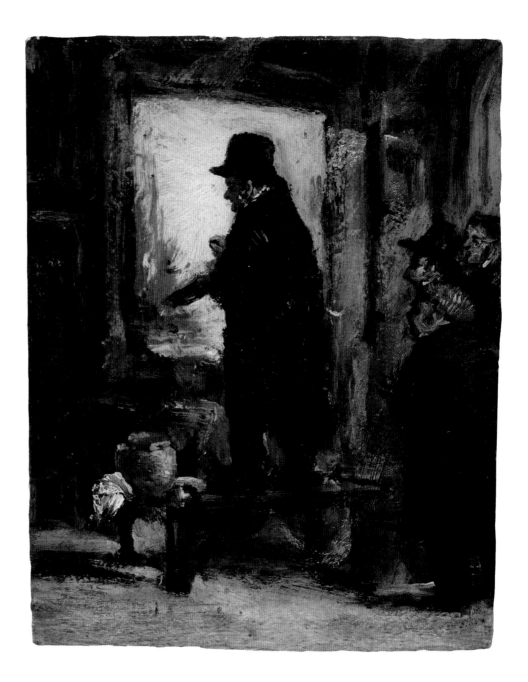

willingness and ability to produce a strikingly broad range of high-quality artistic commodities, from fairly straightforward topographical views intended for sale and/or engraving, to virtuoso watercolours for specialist collectors, to large-scale oil paintings designed for public or private display; these were executed in a variety of manners, and represented a veritable panoply of scenes, both actual and imagined. In the market for landscape imagery, where specialist producers predominated, Turner would virtually operate as a one-man conglomerate, taking on a host of comers at their particular games, and thriving on the competition. There was good money to be earned, he soon discovered, by emulating those Old European Masters whose works fetched such high prices in the sale-rooms of London dealers and auctioneers – but especially for someone with so few assets apart from his talent, there was also a reputation to be made.

Throughout most of the eighteenth century, in literature as well as the visual arts, the dominant critical orthodoxy in Britain and elsewhere held that the moderns should model themselves on the very best of the ancients, and build on their achievements, if they wished to claim their place amidst the same exalted company. This is not to say that copying – in other words mere reproduction – was held in high esteem (for under most circumstances it was not), but neither was novelty to be pursued for its own sake; rather, the value of a work of art was judged to consist first and foremost in the quality of its sources, and the manner in which they had been reworked. If an imitation was truly inspired, then it breathed new, authentic life into the fragments appropriated from the illustrious dead.

It was this animating power that a long succession of classical aesthetic theorists, stretching from Reynolds as far back as Quintilian and Longinus, had in mind when they spoke of 'genius', and that the English 'Augustan' poets – John Dryden and Alexander Pope are probably the best-known examples – sought to demonstrate in the verses they produced in imitation of Horace, Virgil and other celebrated writers of Roman antiquity. The rationale for this widespread literary practice was often described in terms of landownership. In an essay of 1752, for example, the dramatist Arthur Murphy asked his readers to imagine Mount Parnassus, the home of Apollo and the Muses, as a tract of land divided into private portions, each owned by a different poet and signifying his writing. Although most of this territory is taken up by the ancients, there is always room available for additional occupants, who are free to borrow from those who have come before them: as a follower 'you may take in an open manner, what slips you please to graft upon your own stock, and you may transplant at pleasure, provided it be seen that you remove to a proper soil, and have skill to encourage the growth'. 'Game-laws', Murphy elaborates, 'are not known in Parnassus. You may go upon what lands you please, and what you start, you may hunt down, without being deemed a trespasser; but it is expected of every sportsman that he shall fairly acknowledge the person, to whom he is under an obligation.'[6] Three years earlier the novelist Henry Fielding had said much the same in the introduction to *Tom Jones*, where he more pithily comments that 'The Antients may be considered as a rich Common, where every Person who hath the smallest Tenement in Parnassus hath a free Right to fatten his Muse.'[7] That a fundamentally identical code of conduct applied to contemporary practitioners of the visual arts can be clearly appreciated by considering the works of Richard Wilson (1713?–1782), who would later come to be regarded, by Turner among others, as the founder of the British landscape school. Wilson established his reputation by openly modelling himself on the seventeenth-century painters

Claude Lorrain (c.1604/5–1682) and Gaspard Dughet (1615–1675), two of the most celebrated masters of classical landscape art (see pp.110–13). When asked to recommend the antecedents from whom he had learned the most, Wilson is reported to have replied, 'Why, sir, Claude for air and Gaspard for composition and sentiment; you may walk in Claude's pictures and count the miles.'[8] These are not the sentiments of someone who doubted the generosity of the landlords of the pictorial acres he wished to till, or who felt at all constrained by or in their presence. Wilson's paintings speak no less eloquently of the ease with which he assumed his place in the classical tradition, and of his confident belief that its precepts gave him the freedom to express himself as fully as he might have wished.

But Turner was unable to take either of these assumptions for granted. As impressed as he may have been by Reynolds's *Discourses*, by the closing decades of the eighteenth century neither he nor any other young British artist could have failed to recognise that the proponents of imitation were fighting a desperate rearguard action against a growing phalanx of spokesmen for a fundamentally antithetical aesthetic ideology, of radical creative originality. This development left its most obvious imprint on trends in English literary production, as during the second half of the 1700s poets almost entirely abandoned the hitherto prevalent practice of writing verses 'in imitation of' classical authors; simultaneously, beginning with Edward Young's *Conjectures on Original Composition* of 1759, a succession of influential critics championed originality as the cultural value of supreme importance – a value that was defined chiefly in terms of a resistance to influence by others. As Young himself put it:

> An *Imitator* shares his crown, if he has one, with the chosen object of his imitation; an *Original* enjoys an undivided applause. An *Original* may be said to be of a *vegetable* nature; it rises spontaneously from the vital root of genius; it *grows*, it is not *made*. *Imitations* are often a sort of *manufacture* wrought up by those *mechanics, art* and *labour*, out of pre-existent materials not their own.[9]

It is entirely apropos that Young's treatise was addressed to and published by Samuel Richardson, a best-selling novelist who was also a printer: for underlying the ostensibly high-minded notion of original genius was a new understanding of private property dictated by the requirements of a modern commercial society, in which cultural artefacts circulated as purchasable commodities alongside an ever-expanding variety of other luxury goods. Under these circumstances, the products of authors' mental labours came to be regarded as their 'works', and theirs alone – a right that soon came to be recognised in law.

Over the first three quarters of the eighteenth century, the foundations of modern copyright legislation were hammered out in the British courts, through a succession of hard-fought battles between competing publishers that culminated in two landmark decisions in 1774, the year prior to Turner's birth. By happy coincidence both judgements concerned James Thomson's *The Seasons* – arguably our painter's favourite poem – and they turned on a question of central relevance to the practice of landscape art: whether an author who took his materials directly from nature, and then coloured them with his own ideas and feelings, could then be said to have created an entity that could be called his personal property.[10] The answer, as provided by the rulings on Thomson's *Seasons*, was a resounding yes.

These decisions effectively codified what was already well on its way to becoming the characteristically modern definition of authorship – that is, as a particular form of unequivocally private ownership; but because this understanding also extended to the authors (and artists) of the past, it soon became clear to their counterparts in the present that their relationship to tradition had to be rethought, and in a number of fundamental ways.

Under the new dispensation that defined a work of art as the exclusive property of its creator, imitation of a prior model came to look less like a means of striving to equal the very best, or of borrowing freely from an open public repository, than a transgressive act of forgery, trespass, or even theft. Yet what space could be found for achieving genuine originality, given the overwhelming presence of those monumental achievements of earlier times and the necessity of using them as a starting-point? It was this 'anxiety of influence' that prompted Young to attack the legions of great writers past as the enemies of creative genius: for 'They *engross* our attention, and so prevent a due inspection of ourselves; they *prejudice* our judgment in favour of their abilities, and so lessen the sense of our own; and they *intimidate* us with this splendour of their renown.'[11] Even Reynolds was ready to admit that imitation might be taken to regrettable extremes: 'We may suffer ourselves to be too much led away by great names', he warned, 'and to be too much subdued by overbearing authority', to the point where 'We find ourselves, perhaps, too much overshadowed' and thus incapable of achieving greatness ourselves.[12] Turner paraphrased this passage almost word for word in the notes he compiled for one of his own lectures to the students of the Royal Academy[13] – and one imagines that in his case Sir Joshua's warning shot struck particularly close to home.

The problem Turner faced took the form of a potentially debilitating awareness that as a painter he was entering a territory that so many supreme masters had occupied before he'd been given the chance to make his personal mark on history. This acute sense of his own belatedness was a feeling he shared with the most innovative English poets of his era: witness John Keats's paralysing fear that 'there was nothing original to be written in poetry; that its riches were already exhausted – and all its beauties forestalled'.[14] Such anxieties were an inevitable by-product of a cultural economy which demanded of writers and artists that they be truly and completely original: for the stronger the insistence that an author should (in the words of William Wordsworth) 'owe nothing but to nature and his own genius',[15] the more obvious it became that strict obedience to this imperative would make art or literature impossible. 'A painter must not only be of necessity an imitator of the works of Nature', observed the writer for a popular art magazine of the early 1830s, '… but he must be as necessarily an imitator of the works of other painters. This appears more humiliating, but is equally true; and no man can be an artist, whatever he supposes, upon any other terms.'[16] Some twenty-five years earlier the same point had been reluctantly conceded by John Opie (1761–1807), in one of his lectures to the Royal Academy (lectures that we know Turner attended to with great care): 'whether we wish it or no, nine hundred and ninety-nine out of a thousand of our thoughts, are necessarily suggested by the works of others'.[17] This was hardly a comforting reminder – except, perhaps, for the most pedestrian and least imaginative of students. Previously embraced as an empowering resource which generously supported the high ambitions of each successive generation, the legacy of past art now imposed itself as an altogether more weighty and daunting presence.

Fig.2
Claude Lorrain
Landscape with the Father of Psyche Sacrificing at the Temple of Apollo 1663
Oil on canvas, 174 x 220
Anglesey Abbey, The Fairhaven Collection
(The National Trust)

Thus where Richard Wilson may have found ample space to walk the miles of Claude Lorrain's masterpieces, when faced with the French artist's works Turner initially felt cramped, even stifled. According to his friend George Jones, as a young man he burst into tears in front of the *Seaport with the Embarkation of the Queen of Sheba* (no.93), while in 1799 one of the celebrated Claudes from the Altieri collection (either fig.2 or fig.32) made Turner 'both pleased and unhappy while He viewed it, – it seemed to be beyond the power of imitation'.[18] It is well worth noting that Turner came across these two pictures in London, whereas Wilson would almost certainly have first encountered them in Rome – since this is symptomatic of a broader development which further helps us understand why the modern British artist's relationship to his most illustrious Continental precursors had begun to change so fundamentally as the eighteenth century drew to a close. Here the factor I have in mind is the dramatic expansion of the London art market that took place from the 1790s onwards, making large numbers of

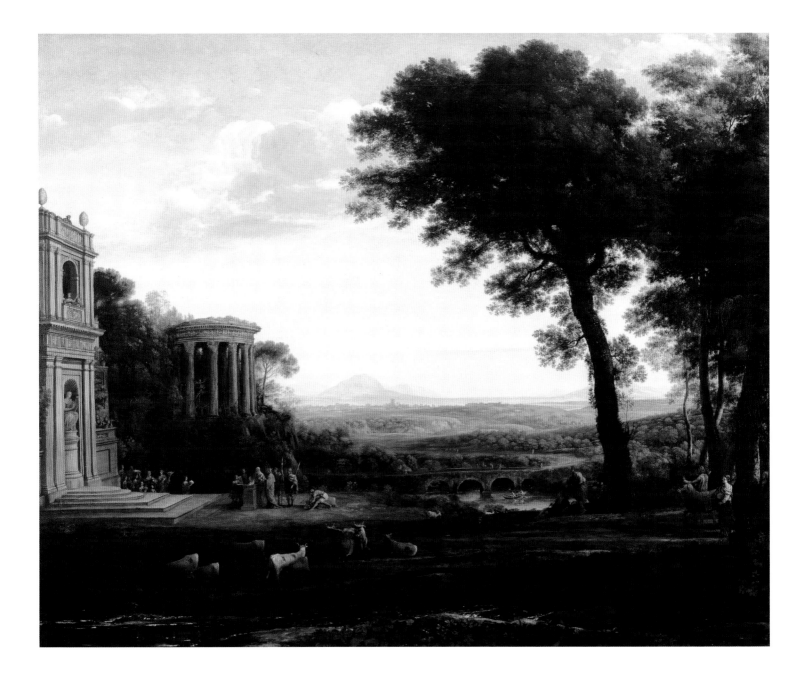

high-quality European masterpieces available for viewing (and purchase) in the English capital for the very first time. Because Philippa Simpson's essay explores this phenomenon in depth, here I wish only to discuss a few of its implications, starting with the terribly obvious point that the sudden influx of pictures by the Old Masters simply made them far more *physically* present in London than had been the case before. In addition, they assumed a more potent *economic* presence; one imagines that Turner became even unhappier with *The Temple of Apollo* (or its pendant) when William Beckford subsequently offered him only £150 for the Poussinesque *Fifth Plague of Egypt* (fig.3), after having paid the dealer Robert Fagan £6,825 for the two Altieri Claudes. As John Gage has usefully observed, the emerging trend among collectors of Old Masters to make occasional high-profile purchases of contemporary art – for example, the 3rd Duke of Bridgewater commissioning from Turner a pendant to his sea-piece by Willem van de Velde the Younger (1633–1707; nos.19 and 20) – further made it clear that living British painters and their foreign predecessors were competing for something far more substantial than fame.[19]

I wonder whether this complex dynamic of rivalry and dependence may not have been complicated further still by the fact that as works by European masters became relatively easy to see at home, they became virtually impossible for British artists to see abroad, throughout almost the entire period of the French wars (1792–1815). Whereas eighteenth-century painters like Reynolds and Wilson had familiarised themselves with the classical tradition by spending years studying in Italy – at a distance from England, in time (actual and symbolic) as well as space – Turner initially confronted the masterpieces of different centuries and nations in one country (his own, or two, if we count his visit to the Louvre in 1802), as 'a vast array of varied achievement, existing in and constantly multiplying in an "eternal present"'.[20] Never before had British artists enjoyed more immediate access to such a plethora of pictorial resources, potentially ripe for exploiting to their own material and aesthetic benefit; but the same circumstances also gave a whole new impetus to that most pressing and worrying of questions: '*What is there left to do?*'[21]

Turner spent an entire career addressing this dilemma. He had no desire, he told the students of the Academy, 'to depreciate the ancients to whom we are very much indebted for the valuable remains that have come to our hands'. 'But', he went on to reassure them, 'let us not stop in our pursuit after Perfection & think there is no excellence in Nature left for us to glean: we ought to endeavour to excell'.[22] This curious passage points in two conflicting directions: while implying that we must aspire not simply to equal but to surpass the 'ancients', Turner also acknowledges that they have almost entirely deprived us of the resources needed to achieve this goal. By stark contrast with the claims that certain British cultural theorists were prepared to advance just a generation or two earlier, Turner falls far short of implying that the modern artist can freely take what he chooses from the stock cultivated by past masters, or that their performances constitute a common land on which he may confidently 'fatten his muse'. Instead he must accept the fact that he can aspire to be nothing more than a gleaner – a degraded figure who, lacking any property of his own, is condemned to toil on someone else's fields, which he is permitted to enter only after the crop has already been gathered in. So what chance does a nineteenth-century painter have of excelling his precursors, if all he can do is to stoop down to pick the odd stalks of grain accidentally left behind by the master harvesters of previous times?

From the outset Turner was determined to show that great art could be built even on such unpromising foundations. Initially, however, he pursued this goal with a certain degree of caution – understandable for so young a painter, especially in one so desperate to build up his stock of symbolic capital. Taking Reynolds's counsel very much to heart, in the late 1790s he began to study nature in the 'company' of the great masters, and to exhibit a series of pictures explicitly modelled on their works (see nos.4–15). One of the earliest objects of his sustained attention was Richard Wilson, who was never far from Turner's thoughts during the two sketching trips he undertook in Wales in 1798 and 1799; this was the region that Wilson (himself a Welshman) had been the first to exploit as the subject-matter for landscape painting of the most elevated – that is to say, classical – sort. When confronted by paintings like Turner's *Harlech Castle* (no.15), contemporary critics immediately recognised that the artist was positioning himself as the ambitious inheritor of a grand pictorial tradition, but that he was also bringing something new to the table, above all in his rendering of light and atmosphere. 'This Landscape', claimed the reviewer for the *True Briton*, 'though it combines the style of CLAUDE and of our excellent WILSON, yet wears an aspect of originality, that shows the painter looks at Nature with his own eyes.'[23]

By the late eighteenth century the notion that the key to originality lay in the direct study of nature had become a critical commonplace, whether in discussions of modern poetry – here again Thomson's *Seasons* offers the most pertinent example – or of the visual arts. Absolutely convinced that this was the only way for an artist to 'form a language of his own',[24] Turner later fully endorsed John Opie's recommendation that:

> observation must precede invention, and a mass of materials must be collected before we can combine them. He therefore, who wishes to be a painter or a poet, must … enlarge his sphere of attention, keep his fancy ever on the wing, and *overlook no kind of knowledge*. He must range deserts and mountains for images, picture upon his mind every tree of the forest and flower of the valley, observe the crags of the rock, and the pinnacles of the palace, following the windings of the rivulet, and watch the changes of the clouds; in short, all nature, savage or civilized, animate or inanimate, the plants of the garden, the animals of the wood, the minerals of the earth, and the meteors of the sky, must *undergo his examination*. To a painter or poet nothing can be useless: whatever is great, whatever is beautiful, whatever is interesting, and whatever is dreadful, must be familiar to his imagination, and concur to store his mind with an inexhaustible variety of ideas, ready for association on every possible occasion, to embellish sentiment, and give effect to truth.[25]

By 1807, when Opie first publicly laid out these principles of study, Turner had been taking them as his guide for well over a decade, furnishing his mind with ideas drawn not only from nature but also from literature and a broad spectrum of past art. In this initial phase of his career as a painter in oils, however, he aspired only to achieve a certain '*aspect* of originality', disciplined by an obvious loyalty to the most authoritative exponents of landscape art in the Grand Style – not just Wilson and Claude but also Nicolas Poussin (1594–1665) and Salvator Rosa (1615–1673; see nos.28 and 23). Turner would subsequently urge the next

Fig.3
J.M.W. Turner
The Fifth Plague of Egypt exh. RA 1800
Oil on canvas, 121.9 x 182.9
Indianapolis Museum of Art.
Gift in memory of Evan F. Lilly

generation of artists to do as he had done: to follow in the 'footsteps of value' left by 'all that have toiled up the steep ascent' to artistic greatness, and 'to mark them as positions or beacons in [a] course' dedicated to 'the further advancement of the profession'.[26] Joshua Reynolds could hardly have said it better himself. No wonder that Turner was made an Associate of the Royal Academy (A.R.A.) when aged just twenty-four (the youngest permissible age), nor that he was elected to full membership less than four years later, on 12 February 1802.

Yet as wedded as the youthful Turner may have been to the dictates of academic art theory, even prior to the turn of the century he had begun to strike out in directions that diverged significantly from the prescriptions enshrined in Reynolds's *Discourses*. One of the first indications of this difference comes from Turner's choice of models – both from the range of different styles that he was seeking to emulate, and from the deep seriousness of his involvement with seventeenth-century Dutch art (notably the works of Rembrandt van Rijn [1606–1669] and of van de Velde), a national school that Sir Joshua broadly judged as unworthy of emulation. As Sarah Monks explains elsewhere in this volume, his main objection to Netherlandish art was to its focus on the particular in nature, and its concomitant refusal to distil the material details of the external world into idealised central forms. In Reynolds's thinking this criticism went hand in hand with his promotion of a liberal artistic personality whose ability to abstract general truths from particular appearances also entailed a responsibility to try (as much as possible) to eschew a distinctly personal style in favour of aspiring to embrace the universal language of the classical tradition. But by the early 1800s it was already clear that Turner had other aims in mind.

Following his first tour of the Continent, to France and Switzerland during the summer and autumn of 1802, Turner painted his first major canvas in full-blown emulation of Claude Lorrain, *The Festival upon the Opening of the Vintage of Macon* (see fig.28), for exhibition at the Academy in the year following. Although the picture was hailed by one critic as a work of 'incomparable' quality, and in parts even superior to anything created by the famed seventeenth-century master, another reviewer dismissed it as an oversized performance of '*bastard grandeur*', and complained about the crude rendering of the foreground details.[27] The older landscape painter Joseph Farington (1747–1821) – a former pupil of Richard Wilson's – made much the same point about all five of Turner's RA exhibits, which he felt had been much over-rated, especially by the younger generation of artists. 'On duly considering them', Farington wrote in his diary, 'I found the pictures of Turner much *below* the pretension & the value set upon them.– with a great deal of *aim* in them, they are crude,– ill-regulated, – & unequal. The *novelty of the manner* imposes beyond what their real merit wd. Claim – compared as they are & rather preferred to the fine works of the greatest masters'.[28]

For Farington – and here he is essentially following Reynolds – 'manner' and 'novelty' go hand in hand as joint terms of moral and aesthetic corruption, since both are symptomatic of the imaginative excesses of private individuals who embrace the fluctuating vagaries of fashion over the immutable truths of nature, and who reject the universal principles of an idealising aesthetic in favour of parading their own singularities for commercial gain.[29] But what certain early nineteenth-century commentators regarded as meretricious attempts by contemporary artists to draw as much attention as possible to themselves in a highly competitive marketplace, others praised as the bold manifestations of

original genius. It was along this fault-line that critical opinions of Turner's work divided, and with mounting ferocity over the years.

Among the early sources of concerted opposition to Turner's art, none played a more prominent role than the British Institution, a private body founded in London in 1805 to promote the advancement of the fine arts. Membership in the BI was limited to wealthy collectors and connoisseurs, who felt that they – as opposed to the professional artists who ran the Royal Academy – were best equipped to shape the development of the British School. The Institution's Directors – among them the amateur landscape painter and influential arbiter of taste, Sir George Beaumont – promoted the Old Masters as the only valid yardstick against which to measure contemporary art, and gave material rewards to artists who produced pictures in line with this aesthetic agenda. One would have thought that the Directors would have lent their unqualified support to Turner, given his own ostensibly similar commitments, but such proved to be anything but the case. Himself a great admirer and collector of Claude, Beaumont began complaining about the liberties that Turner was taking with the seventeenth-century artist's work as early as 1803, specifically in the *Opening of the Vintage of Macon*; and by the middle of the next decade, by which time Turner had started colouring his Claudean compositions in a distinctly personal and defiantly non-Claudean fashion, the connoisseur was almost incandescent with rage. When in 1815 other commentators hailed *Dido Building Carthage: or the Rise of the Carthaginian Empire* (no.94) as a 'transcendent' work of 'sublime' character surpassing anything ever done by Claude,[30] Beaumont objected that 'the picture is painted in a false taste, not true to nature; the colouring discordant, out of harmony, resembling those French Painters who attempted imitations of Claude, but substituted for His purity & just harmony, violent mannered oppositions of Brown and hot colours to Cold tints, blues & greys'.[31] The year before, Turner had come up with an elaborate ruse to dramatise the contempt in which he held the British Institution by submitting to one of its annual competitions (albeit after the deadline had passed) a full-scale copy of Claude's *Landscape with Jacob, Laban and his Daughters* (nos.24 and 25) – the only significant departure from the original being the inclusion of an entirely different cast of characters, from Ovid's *Metamorphoses* instead of the Bible. Featuring a shepherd who was punished by the gods for clumsily mimicking a group of nymphs, the story of Turner's *Appulia in Search of Appulus*, together with the picture itself, was clearly intended as an attack on what he regarded as the Institution's policy of urging young British artists to paint servile imitations of earlier (mainly seventeenth-century) art. And yet one cannot help but wonder whether Turner was also implicitly raising the same questions about himself: for even if *Appulia* aimed to highlight the fine line that separated sterile copying from creative emulation, at the same time the picture could not help but dramatise how difficult its own author found it to disentangle himself from those forerunners (Claude above all) whom he so deeply admired. It was one thing to say that 'imitation at best is but a secondary merit',[32] as the artist had noted privately to himself a few years earlier – but quite another to refrain from the practice altogether.

By the mid-1810s, however, as we have already noted, Turner had begun to rework his Old Master sources in a far more aggressively personal fashion than had been the case ten or fifteen years previously. George Beaumont may have had a particular axe to grind, but he was far from unobservant: when placed beside a Claude like the *Seaport, with the Embarkation of the Queen of Sheba*, *Dido Building Carthage* does indeed appear to be painted in an emphatically different 'manner'.

Where the pale sunlight that suffuses Claude's scene bathes all its forms and local colours in a remarkably even unifying glow, Turner presents a dramatic contrast of hot and cool tints, which pointedly refuse to resolve themselves into a calm, harmonious whole; likewise his *Dido* pointedly eschews Claude's extraordinary delicacy of touch, relying instead on a palpably physical handling that sometimes borders on the crude, and that never allows us to forget the material presence of the richly painted surface. Later variations by Turner on Claude's seaport theme would see him taking greater and greater liberties with this format – by 1837 the 'glare, turbulence, and uneasiness' of his *Regulus* (no.91) would prompt the famous remark that he had become 'just the reverse of Claude'[33] – but never to the extent of altogether masking his initial source of inspiration.

Likewise Turner painted his *Dort, or Dordrecht, the Dort Packet-Boat from Rotterdam becalmed* of 1818 (no.60) as a blatant assimilation of the artistic property (as well as the native scenery) of the seventeenth-century Dutchman Aelbert Cuyp (1620–1691; no.62); but on this occasion there was a nod as well in the direction of the no less overtly Cuyp-like *Pool of London* that Augustus Wall Callcott (1779–1844) had displayed at the Royal Academy two years before (no.61). *The Dort* seems to be saying that Callcott's neat, descriptive precision exposed his failure properly to appreciate Cuyp's ability (in Turner's own words) 'to blend minutiae in all the golden colour of ambient vapour'[34]; though at the same time Turner may also be using his own dazzling luminosity and emphatically liquid handling to imply that even Cuyp himself had remained too beholden to the ordinary appearances of nature. This may be a suitable moment to remind ourselves that if we are dealing with a case of 'influence', then we are doing so in the complex sense proposed by the literary critic Harold Bloom, when he speaks of poetic influence as something that 'always proceeds by a misreading of the prior poet, an act of creative correction that is actually and necessarily a misinterpretation'. Such a misreading, adds Bloom (at least 'when it involves two strong, authentic poets'), is 'likely to be idiosyncratic, and it is almost certain to be ambivalent, though its ambivalence may be veiled'.[35] Bloom's language, of course, is implicitly gendered; in other words, when he says 'strong' he also means 'masculine'.

The same might no less justly be said of 'strong' painters, and of Turner as one of the prime examples of an artist who time and time again produced creative misreadings of past masters – misreadings that were simultaneously celebratory and critical, acts of homage yet also profoundly ambivalent challenges to authority. If his were productive misinterpretations, which aimed to confirm his own imaginative vitality while seeking to revitalise the inert forms of older art (and we may judge certain of his attempts as more productive than others), then this achievement was due above all to Turner's assiduity as a gleaner. Although he may only have been able to look at the world through the mediating filter of art, a laborious regime of drawing (and occasionally painting) from nature did yield discoveries that encouraged him to push and prod his models in unexpected directions; as for instance when his direct experience of the light of the Roman Campagna emboldened him to redo Claude in a much higher colour key than the original. Yet any lessons that Turner may have learned from nature could only have been given form in the language of painting – that is to say, with the materials he gleaned from the Old Masters themselves (and a few modern ones). Many formidable talents may have colonised the realm of landscape prior to his time; but by crossing back and forth among their different properties, and exploiting the

cracks and fissures between them, Turner found ample space to operate. Trespassing on either side of the gulf that divided the classical and Netherlandish schools, he played each tradition off against the other (and both against his own position in the middle); he introduced a Claudean sunset, for instance, into his *Sun Rising through Vapour* (no.103), an exercise in the manner of Jan van de Cappelle, or he treated a classical scene (such as *Mercury Sent to Admonish Aeneas*, no.92) with a colouristic brilliance and a textural vigour learned in part from studying the works of Rembrandt (e.g. fig.39). To some degree it must have been Turner's desire to maximise his opportunities to express himself, and not to be enslaved by the system of any single Old Master, that motivated his painterly engagement with such an extensive range of canonical figures, as well as a much smaller number of contemporaries whom he held in high regard. Whereas we have seen that Reynolds had advocated the study of a wide variety of works for the purpose of trying to grasp the 'great general rules'[36] of the Grand Style, Turner's resolution to take up arms on so many different fronts spoke of his unwavering commitment to the irreducibly *individual* essence of original genius – both that of his models (dead and living) and his own. This is something that the dual character of his inventive re-creations never allows us to forget – provided only that we are willing to look closely enough.

By 1813 the watercolourist and art critic William Henry Pyne had already recognised that Turner represented 'a rare instance of a modern determining to rival the fame of the greatest landscape-painters of any age or country'.[37] This ambition was one that he would doggedly pursue until the very end of his life, by which time he'd even begun to produce 'creative corrections' of compositions done earlier in his career (for example, no.96) – thus in effect placing his younger self among the ranks of his hallowed precursors. This message was one that Turner reinforced in his will, where he left instructions that *Sun Rising through Vapour* (RA 1807; no.103) and *Dido Building Carthage* (RA 1815; no.94) were to be bequeathed to the National Gallery, to hang between two of his favourite works by Claude, the *Queen of Sheba* (no.93) and the *Marriage of Isaac and Rebecca* (fig.30). We know that he deliberated long and hard over the choice of his own pictures, at first intending to select two Claudean seaport scenes before eventually rejecting one in favour of a Netherlandish coastal view. I believe that Turner's final selection was meant to convey at least three important points: first of all, that posterity should come to regard him as a painter who had mastered both the Italian and Northern landscape traditions; secondly, that he wished to be esteemed as much for his naturalism (the defining hallmark of the Dutch School) as for his imaginative idealism (the bedrock of classical aesthetics); and finally, that he wished to leave behind an example for other artists to follow, if they wished to build successfully on the past – the example of a painter who had 'endeavoured to excell' by gleaning what others before him had overlooked, throughout all the various regions of nature and of art.

Did any of these messages achieve the effect he had intended? The first two may have done so, perhaps, but probably not the last, or at least not for a considerable while. For even as Turner staked his claim to be worthy of a place among the immortals, and even to have surpassed his most highly revered predecessors, his bequest to the nation could not help but accelerate a process which has been provocatively described as 'the single greatest problem that modern art … has had to face': that is to say, 'the remorseless deepening of self-consciousness, before the rich and intimidating legacy of the past'.[38]

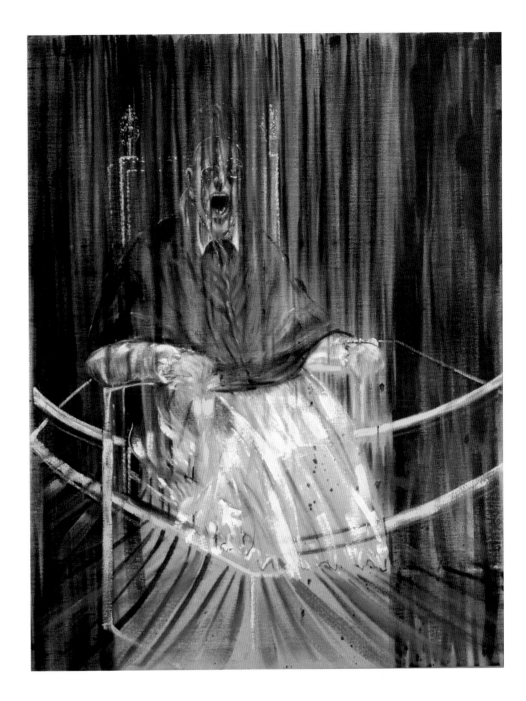

Fig.4
Francis Bacon
*Study after Velázquez's Portrait
of Pope Innocent X* 1953
Oil on canvas, 153 x 118
Purchased with funds from the
Coffin Fine Arts Trust; Nathan
Emory Coffin Collection of the
Des Moines Art Center, 1980

Few painters have shown more awareness of this problem than did Turner,
and it is hard to think of any who have been less intimidated by its potentially
incapacitating implications. Yet in the end the spectacular scope and scale of his
own achievements could only dramatise how inescapable the 'anxiety of influence'
had become for artists by the mid-nineteenth century – and how difficult an act
Turner was himself to follow. For the genuine successors of so radically traditional
and original a painter, we need to look further afield than Victorian Britain: to
Edouard Manet, for instance, to Henri Matisse and Pablo Picasso, or to Francis
Bacon's redoings of Diego de Velázquez 'in reverse', in the form of his screaming
Popes (fig.4). It would be entirely in keeping with the contradictory nature of
Turner's hugely ambitious enterprise if, in the end, we were to reach the
paradoxical conclusion that it is precisely the most 'old-fashioned' dimension
of his artistic project that ultimately confirms its indisputable modernity.

Facing up to the Past: The Old Masters and the British School in Turner's London

Philippa Simpson

When the fourteen-year-old William Turner entered the Royal Academy Schools in 1789 – the year of far more momentous events taking place across the Channel – London had no national gallery, no exhibition spaces dedicated to the Old Masters and only a very few auction houses and sale-rooms, described at the time as a 'common cloaca [sewer] and sink, through which all the refuse and filth of Europe is emptied'.[1] By the time Turner reached the age of fifty, in 1825, the capital had witnessed a vast proliferation of Old Master sales and exhibitions, the establishment of a major new institution for loan displays and the opening of not one but two public art galleries. Underlying this transformation was a boom in the market for works by the Old Masters that took place during the period of the French revolutionary and Napoleonic wars (1792–1815), when private houses, aristocratic picture galleries and churches throughout Europe had consigned their treasures for sale to England, in order to keep them from falling into the hands of revolutionaries or wave upon wave of marauding armies. If British picture dealers profited from these developments, so, too, did British artists, and Turner in particular.

Turner and his colleagues may have felt frustrated because the state of almost continual conflict prevented travel to the Continent, but the expanding network of gallery spaces in the English capital offered a compensation of sorts for the loss of opportunities to study great works of art abroad. Moreover, while artists enjoyed unprecedented access to high-quality paintings by the Old Masters without having to leave London, audiences galvanised by the metropolis's burgeoning exhibition culture were able to develop an increasingly sophisticated understanding of the art of the past. This soon became a source of patriotic pride. As a leading dealer later recalled, the large sums spent by early nineteenth-century British collectors gave the lie to 'the assertion which foreigners had made till then that we were a nation possessing no love for the fine arts, or any knowledge of them'.[2]

That knowledge extended to a growing awareness of the close relationship between contemporary British art and its Continental precursors, which in turn informed a succession of efforts by writers and critics to situate the nascent British School – widely thought to be flourishing under the patronage of George III – within a broader European art-historical context. Paradoxically though, while home-grown painters and sculptors found their work taken more seriously as a

result, they also worried about being overshadowed by the Old Masters, and about losing out to them where it mattered most: in the marketplace. Sensitive to charges that their activities damaged the national interest, numerous dealers and collectors made a show of their patriotic support for 'native talent' by offering privileged terms of access to artists, whose ambitions, it was argued, would rise to new heights when they were exposed to major accumulations of privately owned masterpieces.

For Turner, the opportunities thus afforded could hardly have been more propitious. As an eighteen-year-old art student in 1793, he must have eagerly awaited the arrival of the Dutch and Flemish paintings that had until recently belonged to Louis XVI's cousin, the Duc d'Orléans – works which had, until the French Revolution, been housed at the Palais Royal in Paris. Also home to a plethora of famous Italian works that would come to London five years later, the duke's collection – described by *The Times* as 'the finest in the Universe'[3] – had been avidly visited by a host of British travellers on the Grand Tour from the 1720s onwards, and widely disseminated in the form of engravings. Hence the display and sale of the first tranche of the Orleans pictures served as an especially potent harbinger of London's emerging status as the new capital of the pan-European market for fine art. This development was welcomed in the highest social echelons: rumour even had it that George III, 'conscious of the want of proper models of imitation for the students of his academy', was keen to augment its holdings by purchasing several of the Orleans masterpieces.[4] Although this expectation was soon disappointed, there can be no doubt of the huge public interest that attended the first extended display of Old Masters ever to have taken place in London; in premises that had once played host to the Royal Academy, crowds virtually trod the carpets bare, and sales at times amounted to values as high as £6,000 a day.[5] Among the 259 works on view were Rembrandt's *The Mill* (no.58) and *The Cradle* (no.41), which Turner would address (in different ways) later on in his career. Audiences marvelled at the vast sums spent on these and other celebrated pictures like Peter Paul Rubens's (1577–1640) *Judgement of Paris* (National Gallery, London), which were avidly discussed in the press.[6]

Another blockbuster show opened the following year, when Charles-Alexandre de Calonne, the former French prime minister, mortgaged his huge collection and found himself unable to pay off the debt. After his pictures had been sent to the auction rooms, rumours of a blanket purchase by the Empress of Russia, Catherine the Great, put a halt to the sale. Rather than disappoint expectant audiences, all the works that had already been unpacked were orchestrated into an impromptu display in rooms at Spring Gardens. At first, 'notwithstanding many applications' from other interested parties, access was allowed only to professional artists.[7] 'If they look at this collection as a school', wrote the *Morning Chronicle*, 'it will convince them that they are but scholars, but if they study it with care they may become masters.'[8]

Eventually, the nobility and gentry were invited to a private view of the pictures, which drew a 'constant flow of fashion' so heavy as to limit visibility.[9] Among the highlights of Calonne's collection were no fewer than nine works by Nicolas Poussin, of which the most highly praised was the *Bacchanalian Revel before a Term* (fig.5). Other paintings such as Bartolomé Esteban Murillo's (c.1618–1682) *Flower Girl* (Dulwich Picture Gallery, London) were to prove star attractions when they were shown in various London venues over the next few decades. A number of British works also appeared at this exhibition, including Thomas Gainsborough's (1727–1788) *Girl With Pigs* (Castle Howard, North Yorkshire), one of his

best-known fancy pictures, and Joshua Reynolds's *Mrs Siddons as the Tragic Muse*
(Huntington Library and Art Gallery, San Marino, California), shown between
two full-length portraits by Anthony van Dyck (1599–1641).[10]

In March 1795, once rumours of Catherine the Great's purchase had
proved unfounded, Calonne's pictures went to auction and the vast majority
disappeared from public view. Their dispersal prompted one reviewer to lament
the damage done to the public interest, since 'Together they would have formed
a collection that would have done honour to the nation that possessed them.'[11]
Although calls for the creation of a national art gallery had been made in Britain
throughout the eighteenth century, the influx and sale of so many important
Old Masters made it seem all the more regrettable that they were 'bought by the
affluent, and hid in their mansions from the study of artists'.[12] But the visibility
of such paintings had its problems. Despite being frustrated by the limits placed
on their access to the Old Masters, painters fretted that the presence of so many
imports might stimulate collecting at the expense of patronage, diverting money
that would otherwise have been spent on contemporary British art into the
pockets of those who dealt in the works of their dead European rivals.

In 1798, when the Italian pictures from the Orleans collection finally
arrived in London, artists were torn between intense curiosity and the fear that
such a stunning array of grand-style history paintings would put their own efforts
to shame. Nearly three hundred canvases, including such major works as Titian's
(c.1490–1576) *Diana and Actaeon* (National Gallery, London, and National Galleries
of Scotland, Edinburgh), Raphael's (1483–1520) *Procession to Calvary* and Sebastiano
del Piombo's (c.1485–1547) *Raising of Lazarus* (both National Gallery, London), had
been imported with the backing of a syndicate of noblemen, who in return for their
investment retained a number of the very best examples, eventually absorbing them
into their own private cabinets. Before this, the pictures were shown for seven
months across two venues, in Pall Mall and the Strand, in a bid to raise additional
capital for the investors. Hoping that the rarity of the chance to see so many

canonical Old Masters would lure in hordes of visitors, the organisers decided to levy a relatively high admission charge of half a crown; but audience figures never rose above disappointing levels, and sales were painfully slow.

Reactions from the Royal Academicians – who, spurred by the example of the Calonne sale, insisted on receiving free tickets – were mixed in the extreme.[13] James Barry lingered in the rooms, criticising the pictures 'in the loudest manner and without reserve',[14] but he then attempted to persuade the Academy to buy a number of works, by way of promoting 'the advancement of the Arts'.[15] The portraitist John Hoppner (1758–1810) also took a negative line, saying that, 'on looking over the Orleans collection, so far from being dispirited, he thought more respectably of himself, and so might his fellow artists if they would do themselves justice'.[16] Nonetheless the Academy's president, Benjamin West (1738–1820), attempted to raise £40,000 to purchase the 'cream' of the collection, only to find it had been sold from practically under his nose.[17]

Although collectors had struggled to find the funds or the room for the Orleans Italian paintings, which included many gigantic works, at an auction in 1800 every picture (apart from those already claimed by the syndicate's members) reached its reserve,[18] and the repercussions of the collection's arrival were still reverberating many years later. In 1820 the critic William Hazlitt (who had begun his career as a painter) recalled how the experience had changed his life:

> I was staggered by when I saw the works there collected, and looked at them with wondering and with longing eyes. A mist passed away from my sight; the scales fell off. A new sense came upon me, a new heaven and a new earth stood before me … we had heard of the names of Titian, Raphael, Guido, Domenichino, the Carracci – but to see them face to face, to be in the same room as their deathless productions, was like breaking some mighty spell – was almost an effect of necromancy![19]

Five years later the lawyer-turned-dealer William Buchanan far more prosaically claimed that the importation of the Orleans masterpieces had given a 'new turn … to the taste for collecting in this country'.[20] While this may have been something of an exaggeration, the Italian sale in particular was to have an enormous impact on the formation of Britain's first public galleries for European art.

In the meantime, there continued to be debates about how such pictures were to be presented, and how access to them should best be organised. While it was generally agreed that artists had a special right to view displays of important Old Masters, there was no consensus as to how exhibitions should meet the needs of education or improvement – or indeed if they had any responsibility to do so. These issues took on added urgency in 1802, when the sudden outbreak of peace following the signing of the Treaty of Amiens made it possible once again for Britons to travel to the Continent. In particular, the peace allowed collectors, amateurs and connoisseurs to visit Paris, and its astonishing new museum, the Musée Central des Arts (in the Palais du Louvre), which contained the remarkable collection of art treasures that revolutionary and Napoleonic armies had seized from all over Europe. 'To those who were warmed by a love . . . of the liberal arts', as one writer later put it, 'the spoils of vanquished Italy which adorned the gallery of the Louvre, presented a resistless temptation to cross the Channel'.[21] Joining a host of artists, including Henry Fuseli (1741–1825), John Opie, Benjamin West

and Joseph Farington, Turner made the journey, and spent a week scrutinising paintings of international fame, as well as some less well-known works, now gathered in the majestic quarter-mile expanse of the Grande Galerie.

Even with their houses and mansions adorned with many of the recent imports, few British tourists could have been even remotely prepared for the spectacle of riches that they saw upon arriving at the Louvre. 'It would be no easy task to express the various sentiments which take possession of the mind of the lover of the arts, when, for the first time, he enters this splendid repository', exclaimed one journalist.[22] What the Louvre presented was a 'wonderful', 'overpowering' and 'immense' *coup d'oeil*; a dazzling view, in other words, across the entire 'terrain' of art history, defined by such supreme monuments as the *Apollo Belvedere*, Raphael's *Transfiguration*, Titian's *St Peter Martyr* (see no.35) and his *Entombment of Christ* (fig.6).[23] Here was 'a sort of dictionary, in which may be traced every degree of improvement or decline that the art of painting has successively experienced', wrote one amazed English visitor.[24] For Turner, the experience must have been both exhilarating and challenging; never before had he been in a better position to assess the true extent of the task facing any modern painter who wished to join the ranks of the greatest masters of past times.

Universal entry to the museum was widely praised as 'a policy … by which ignorance becomes enlightened'.[25] Even one staunch Francophobe writer professed his wish that he could 'say the same of our excellent establishments at home'.[26] In practice, different viewers were invited on specific days of the new French ten-day week. Three days were termed 'public', when anyone was able to attend, but overseas visitors were especially welcome on the six days reserved for artists for the purposes of study, when other French nationals were excluded.[27] As a result, British travellers were particularly exposed to the function of the museum as a site of learning, and to the role it played in directing the course of contemporary art.[28]

Some commentators questioned the efficacy of such a resource, and the ability of artists to rise to the challenge. In the opinion of the *Morning Chronicle,* 'The collection in one spot of so many *chef d'oeuvres*' would:

> not be very favourable to the Arts … it will be visited too mechanically. It will excite no enthusiasm; pictures are separated from their history, statues from their connection, everything from its propriety. The student … is made an artist by force of imitation, not by reflection, of cautious comparison, of comparison in various stages of improvement … It will produce imitators, not artists.[29]

The Royal Academician Joseph Farington agreed that 'the great purposes which the Art of Painting is calculated to answer are certainly defeated by what the French government has done'. Patriotic posturing aside, however, he was still willing to concede that any painter who seized the opportunity offered here to 'learn the principles upon which the Great Masters of his art worked', would:

> learn to think soberly and rationally on the nature of his Art. – He will find that it has as little to do with the visionary as any other labour of the mind. That the greatest painters were not inspired Men who produced their works spontaneously, that he must not deceive himself by thinking

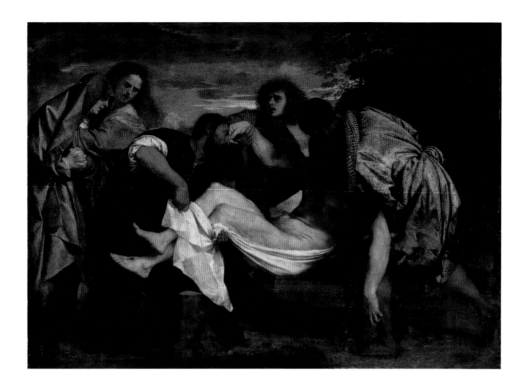

that he is particularly gifted and that the Art will come to him. He will
see that it was by the most diligent perseverance that Raphael advanced
by slow degrees from making tame and puerile attempts to the power
of producing the Transfiguration.[30]

Fig.6
Titian
Entombment of Christ
c.1520
Oil on canvas, 148 x 212
Musée du Louvre, Paris

The model of artistic improvement that Farington saw embodied at the Louvre was
closely in line with conventional academic dogma, which championed industry as the
means by which gradual improvement, and eventual perfection, might be achieved.
These tenets had been laid down by the Royal Academy's first president, Joshua
Reynolds, but by the early nineteenth century there were many who were ready and
willing to make a contradictory case, for the primacy of artistic inspiration.

 At this early stage of his career, having just been elected to full membership
of the Academy, Turner would have been broadly in sympathy with Farington's point
of view. Indeed his 'Studies in the Louvre' sketchbook demonstrates precisely how he
set about 'learning the principles upon which the Great Masters … worked', as Ian
Warrell demonstrates in the following essay. Moreover, the amount of attention
Turner devoted to history painting – according to academic theory, the most elevated
form of pictorial imagery – gives some measure of the height of his ambitions for his
chosen genre of landscape art.

 The free nature of Turner's copies (for example, fig.7) coupled with the
often critical tone of his written comments, however, shows how far his investigative
process was from servile adulation. In the case of Poussin's celebrated *Deluge*, for
instance, he wrote of its 'absurdity as to forms', and granted the quality of sublimity
only to its colour.[31] Three years later he produced a tour-de-force response, designed
to outdo the original (nos.29 and 30), and drawing on his experience of another Old
Master, Titian, whose works he had studied extensively in Paris. Choosing his
models with great care, Turner also turned to the *St Peter Martyr* – widely hailed as
Titian's greatest masterpiece[32] – and soon after his return to London produced a
highly inventive pastiche, *Venus and Adonis* (no.36). A strategic, specific reference of

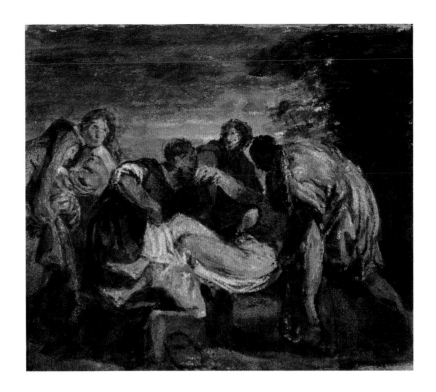

this type presumed the existence of an equally knowing audience, formed in part by those hordes of Britons who had visited the Louvre.

Only fourteen months after the suspension of hostilities, the war with France resumed, making travel to the Continent again impossible for the next dozen years. British tourists hurried home, where they were greeted by another significant accumulation of Old Masters, which had been imported during the temporary outbreak of peace. In the summer and autumn of 1802, an Austrian count by the name of Joseph Truchsess tried to capitalise on the current fascination with the Louvre by embarking on a public campaign aimed at persuading the 'British nation' to purchase his vast private collection. What London needed, he insisted, was 'a regular Gallery of paintings … affording to the artist and amateur, the means of making themselves acquainted with all the Schools of Painting, by a complete a series as possible of the works of their successive masters'.[33] The count invited artists to attend a private view at the Truchsessian Gallery[34] (Turner's visit was delayed until August 1803), but apart from William Blake – who felt spiritually refreshed by the early Northern pictures on display[35] – most found the collection to be of such indifferent quality as to be hardly worthy of comment. Whether it was for this reason, or because the count failed to persuade enough members of the general public to subscribe funds to a scheme so little to their own direct personal advantage, his appeal for support never got off the ground. Four years after first opening its doors, the Truchsessian Gallery was broken up at auction; instead it was a British nobleman's collection, housed in a private townhouse, that was now being hailed as the '*Louvre* of London'.[36]

The aristocrat in question was the Marquis of Stafford, who in 1806 opened a specially designed gallery at Cleveland House, his West End residence, to a limited public of family, friends, Royal Academicians and specially recommended amateurs. Access was permitted on Wednesday afternoons during the three-month London season in order to give this select group of visitors an opportunity to inspect the pictures bequeathed to the marquis three years previously by his uncle,

the 3rd Duke of Bridgewater.[37] The latter had been a leading member of the investment syndicate behind the sale of the Orleans collection, which provided the Stafford Gallery with more than half of its Italian paintings. Many of the other significant works, such as Rubens's *Peace and War* (National Gallery, London), had been bought from English dealers making the most of the market surge in the years just prior to Bridgewater's death. The collection may not have been the first of its type to open in this semi-public manner, but it was 'universally allowed to exceed any other in this country',[38] while its careful arrangement by school had transformed it from an assemblage of riches into a well-ordered didactic gallery, like the Louvre though on a much smaller scale.

For Turner, the Stafford collection was not only a rich resource for study; it had also been the stage for his first major challenge to the Old Masters, which had taken place in 1800 when Bridgewater had commissioned him to paint a companion-piece to the Duke's celebrated marine by Willem van de Velde the Younger (nos.19 and 20; see Sarah Monks's essay in this volume). At first the two pendants were displayed together, in a room containing masterpieces by Aelbert Cuyp, Poussin, Titian and Claude Lorrain; by 1806, however, the collection had been divided into Italian and Northern schools, each housed in its own large gallery, while the Turner had been moved to a room in between the two, together with a small number of other British paintings.

Here Turner's *Dutch Boats in a Gale* (or the *Bridgewater Sea-Piece*) was 'placed as if intended for companions' with Richard Wilson's *The Destruction of the Children of Niobe* (fig.8), a resolutely classical and historical composition by the founding father of the modern British School of landscape art.[39] Although Turner had emulated Wilson's classicism in a number of pictures from just before 1800 (for example, see nos.12 and 13), on this occasion their works represented two distinct traditions – one rooted in the Dutch heritage of van de Velde, the other in the Italianate grand manner of Poussin and Gaspard Dughet. Together, however, Turner and Wilson set the example for a national style that drew upon both northern and southern European precedents without being beholden to either. As a writer for the

Fig.8
Richard Wilson
The Destruction of the Children of Niobe c.1760
Oil on canvas, 123.8 x 173
Private Collection

Cabinet of the Arts had said in 1805, the object of the British School should be to 'unite in itself … the various excellencies which lie dispersed among all the other classes of painters'.[40] Yet artists struggled to achieve this act of synthesis, as restrictions continued to hamper access to high-quality works by their European rivals.

By way of addressing this widely acknowledged problem, in 1806 Stafford joined with a number of other collectors and connoisseurs in establishing the British Institution. This organisation held annual exhibitions of modern works, but was also dedicated to ensuring that British artists should have 'no difficulty in referring to the old masters'.[41] To this end the Directors put a small number of pictures, lent from various English collections, on temporary view each year in the Institution's exhibition rooms in Pall Mall, for artists to study at times when the galleries were closed to the general public. Supporters of this public-spirited initiative were quick to claim that it would, 'in all probability … soon lead to the perfection of the Fine Arts in this country'.[42] Although no formal tuition was offered, at the Institution's so-called 'schools' young pupils and seasoned professionals alike were meant to 'complete their studies in the admirable lessons of composition, light and shade and colour, contained in the best works of the Old Masters'.[43] Initially straightforward copying was permitted, if not actually encouraged; but a few years later the practice was banned, and the student was urged 'to catch the spirit, rather than to trace the lines, and to set his mind, rather than his hands, to work upon this occasion'.[44]

Turner probably first encountered Rembrandt's *Girl at a Window* (no.43) at the British Institution's schools, and it was here (in 1806) that he must have seen the Dutch master's *The Mill* (no.59) for the first time since its appearance at the first Orleans sale more than a decade earlier. In subsequent years, the same schools featured works by Claude, Raphael, Poussin, Rubens and numerous others, pictures that were exposed to the close scrutiny of up to one hundred enthusiastic students in any given season. Although Turner was among the many established painters to exploit this facility, he had a difficult relationship with the Directors of the BI, and especially with George Beaumont, who felt that the artist took unacceptable liberties with the Old Masters he chose as his models. For his part, Turner believed that the Institution's policies would damage the emerging British School, by stifling its creativity; the story of how he used his art to state his opposition is told elsewhere in this volume (see p.24).

For its own part, however, the BI saw itself as a great champion of the nation's artists, of both the present and the past. It hosted annual exhibitions of contemporary art, purchased important pictures by Benjamin West and David Wilkie (1785–1841), among others, and included works by several eighteenth-century British painters for study in its annual schools. Moreover, when in 1813 the Institution launched a high-profile series of Old Master shows, it chose to start with a huge retrospective of the works of Joshua Reynolds, the founding president of the Royal Academy. Although Turner may have felt that this event was 'invidious towards the Artists of the present day' because it clashed with the Academy's own annual exhibition, this didn't stop him from attending the inaugural dinner, along with most of his fellow academicians.[45] Two years later artists were allowed special access to the Institution's spectacular survey of seventeenth-century Dutch and Flemish art, drawn almost entirely from London private collections, now among the richest in the world. On view were pictures by all the most renowned Netherlandish masters, including Rubens, Rembrandt, Anthony van Dyck and David Teniers. Certain commentators voiced their unease that the Institution was fostering unfair comparisons between '*all*

the first Painters of Europe, with the ANNUAL exhibition of the Metropolis [the Royal Academy]', but apart from the complaints of a few disgruntled painters, the response of the artistic community seems to have been overwhelmingly positive.[46]

After the show closed, a number of its works were retained for artists to study, among them Rembrandt's *Girl at a Window* (again), Rubens's *Watering Place* (fig.9) and Cuyp's *View of the Maas at Dordrecht*, which first Callcott and then Turner were soon to try and emulate (see nos.60–2) in two hugely ambitious canvases that would have been unimaginable prior to the emergence of the Old Masters onto the stage of British public life. The following year (1816) an exhibition of Italian and Spanish works was to prove equally successful, and landscapes by Claude and Poussin, along with a number of religious works, were held back for use at the 'school'.

At almost exactly the same moment as these 'highly gratifying' temporary exhibitions were being lauded in the press, plans were underway on the outskirts of London to establish Britain's first permanent public art gallery.[47] This was to be formed by a collection of pictures bought by the dealer Noel Desenfans, who in 1790, at the start of the market boom, had been commissioned to purchase works in London on behalf of King Stanislas of Poland.[48] When the king abdicated in 1795, the paintings devolved to Desenfans, who on his death left them to his great friend, the artist Francis Bourgeois (1756–1811). Bourgeois in turn bequeathed the works (as well as a substantial number of his own, inferior efforts) to Dulwich College in 1811, stipulating that they were to be placed on permanent display.

At first, only recommended artists were granted access to this new gallery, but from 1817 tickets were issued to interested members of the public at large. The governors of Dulwich College further agreed to lend six works a year to the Royal Academy, to form a 'school of painting' along the lines already established at the British Institution; pictures by Rembrandt, Cuyp and Poussin featured among the most regular loans. Thanks to the variety and quality of its Old Master holdings, Dulwich was soon being praised as 'a fine addition to the schools of study for our young artists'.[49] Although works here were broadly divided into national schools, the very few British paintings were scattered amongst them, with a view to highlighting links with the different Continental traditions. Thus an early work by Philip James de Loutherbourg (1740–1812) in the Dutch Italianate manner hung beside a broadly comparable picture by Jan Both (c.1615–1652), while a classical landscape by Richard Wilson was given the honour of being shown in the company of several works by Claude. Upon his death decades later in 1851, Turner would seize the same accolade himself, but by means of a grander gesture on a more prestigious public stage in the very heart of the metropolis.

In 1823 the British Government made the landmark decision to buy the collection belonging to John Julius Angerstein – 'the choicest in the capital'[50] – as the nucleus of what was from that point onward termed the National Gallery. Initially situated in Angerstein's former 'parlour … and two drawing rooms', the new museum's opening was decidedly low-key; but after three years over 100,000 people were visiting annually, and by 1836 the gallery had moved to grand new buildings in Trafalgar Square.[51] Although the collection was still quite small, no one questioned its quality, containing as it did Sebastiano del Piombo's enormous *Raising of Lazarus*; Raphael's *Pope Julius II*; two paintings by Rembrandt, including his *Christ and the Woman Taken in Adultery* (no.39); Claude's *Marriage of Isaac and Rebecca* (see fig.30) and the *Seaport, with the Embarkation of the Queen of Sheba* (no.93); as well as

Reynolds's *Lord Heathfield* and the series of *Marriage à-la-Mode* by William Hogarth (1697–1764). Contemporary artists must have been struck in particular by the further inclusion of a work by one of their own number, in the form of David Wilkie's *Village Holiday* (Tate). Two years later George Beaumont's bequest introduced a second Wilkie into the Gallery – the same *Blind Fiddler* that Turner had tried but failed to outshine at the Royal Academy exhibition in 1807 (see nos.49 and 51).

Starting in 1837, when the Royal Academy moved its shows from Somerset House to Trafalgar Square, Britain's leading painters and sculptors enjoyed the honour of exhibiting under the same roof with all the great Old Masters, albeit only for three months in every year. Another significant feature of the hang in the new building was a section specifically dedicated to the painters of the British School, where the Hogarths, Reynolds's *Lord Heathfield* and the Wilkie from the founding collection were joined by such notable works as Richard Wilson's 'Beaumont' *Niobe* (now destroyed), Thomas Gainsborough's *Watering Place* and John Constable's (1775–1837) *Cornfield*.

Having lived, however, in an era that had seen the most famous painters of the European past become the shining stars of Britain's flourishing exhibition culture, Turner wanted subsequent generations of visitors to the National to remember him not merely as a great English artist, but as a great master – full stop. With this goal in mind he asked his executors to carry out two important tasks: to oversee the construction of a Turner Gallery, attached to the National Gallery, for the display of all the finished pictures still in the artist's possession at the time of his death, and to separate out two landscapes (nos.94 and 103) of which he felt especially proud, and to ensure that these were hung between two of the Angerstein Claudes. Both these gestures underlined Turner's ultimate determination to stand apart from his fellow-countrymen – even from figures as illustrious as Hogarth, Gainsborough, Wilson and Joshua Reynolds. As much as he may have championed the British School, Turner wanted posterity to judge his achievements on their own merits, or to measure him against the very best.

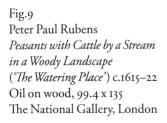

Fig.9
Peter Paul Rubens
*Peasants with Cattle by a Stream
in a Woody Landscape
('The Watering Place')* c.1615–22
Oil on wood, 99.4 x 135
The National Gallery, London

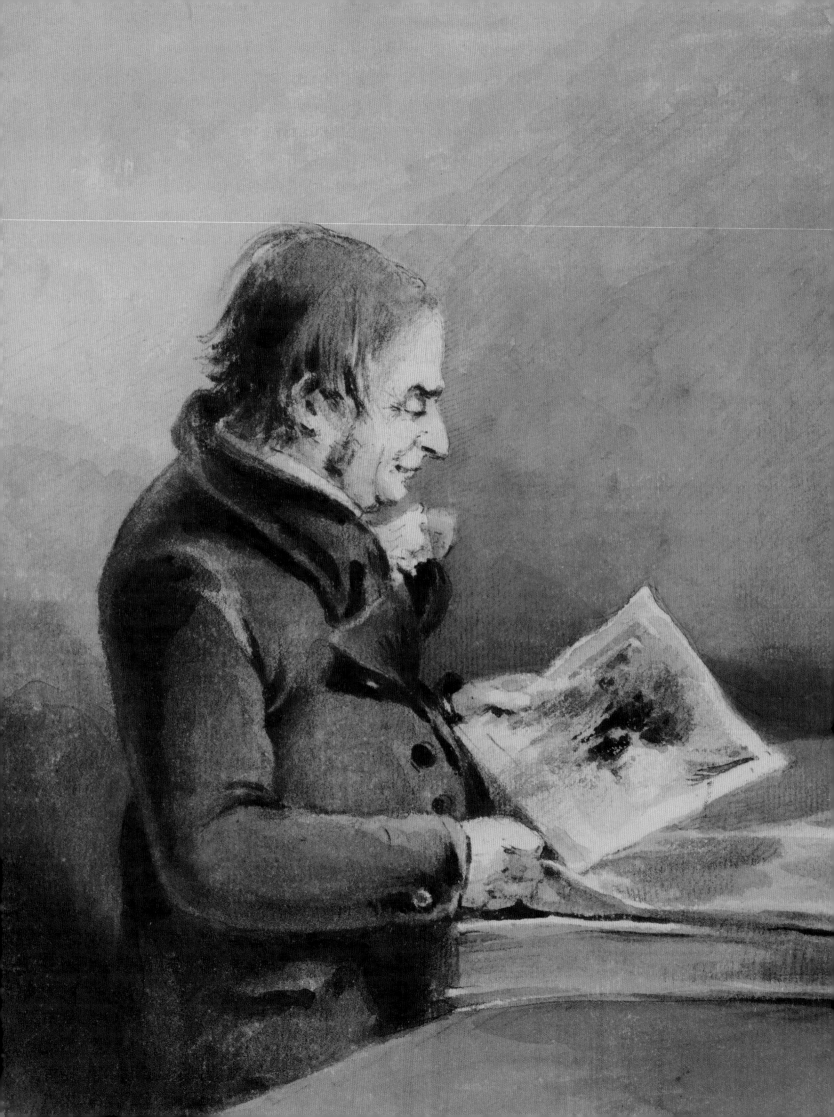

'Stolen hints from celebrated Pictures'[1]: Turner as Copyist, Collector and Consumer of Old Master Paintings

Ian Warrell

Perhaps the most endearing portrait of J.M.W. Turner is that made in the mid-1820s by John Thomas Smith (1766–1833), then Keeper of the Print Room at the British Museum. He shows Turner standing in that setting, utterly absorbed in the process of studying a batch of prints or drawings (fig.10). With the corners of his mouth rising towards a smile, he fondly contemplates the image before him, even as his impatient fingers tug at the next sheet, suggesting his unquenchable appetite for fresh visual stimuli.[2] Turner's greatcoat pocket bulges, presumably because it contains one of the hundreds of sketchbooks that he carried with him throughout his life. On this occasion, his *vade mecum* is primed, ready to preserve any inspiration that the British Museum will offer. For although Turner's sketchbooks were mainly filled with topographical material, from time to time his studies from nature were interrupted by extensive or rudimentary memoranda of the paintings, sculptures and prints that particularly impressed or intrigued him. These seemingly random transcripts are in fact a vital resource in helping to document exactly when and where Turner saw the works they reproduce, pinpointing the catalytic moment of engagement in a way that is so much harder to locate for artists of our own age, where images can be instantly and endlessly reproduced mechanically around the planet.[3] This essay will examine the traces of Turner's first-hand confrontations with works by the Old Masters, identifying the character and extent of the visual reference materials he accumulated, and showing how the information he gleaned from these encounters was subsequently put to use.

Any British painter of Turner's generation who aspired to gain even a basic understanding of the traditions of Western art quite naturally assumed that the only way to achieve this goal was by travelling to Europe, with Italy the preferred destination. But apart from a brief interlude in 1802–3, the wars with France made Continental tourism largely impossible throughout the entire period from 1792 to 1815. During these years, as the portraitist Thomas Phillips (1770–1845) later recalled, British artists had to subsist on 'the knowledge to be gathered from copies, prints, and drawings, and the admirable lectures of Joshua Reynolds and Mr Fuseli'.[4] Reynolds's *Discourses* to the students of the Royal Academy – including the

Fig.10
John Thomas Smith
Turner in the British Museum Print Room
c.1825–30
Watercolour over graphite,
22.2 x 18.2
The British Museum,
London

Fig.11
Nicolas Poussin
*The Exposition
of Moses* 1654
Oil on canvas,
149.5 x 204.5
Ashmolean Museum,
University of Oxford

young Turner, from 1789 and into the early 1790s – stressed the importance of a
proper reverence for the greatest masters of the past as both models and rivals, as
David Solkin observes elsewhere in this volume (see p.14). Implicit in such
teaching was a belief in the value of making copies of acclaimed compositions, as
a means principally of understanding how to structure a picture, but also, just as
importantly, of enabling students to appreciate the techniques of their chosen
models. Turner's years of apprenticeship probably resulted in many exercises of this
sort, though all that survive are a group of relatively straightforward copies or
variants, derived from Michelangelo, de Loutherbourg, Gainsborough, Wilson,
Claude-Joseph Vernet (1714–1789) and a few lesser figures (for instance, see figs.53–6,
nos.14–15).[5] His sources for these works would have been engravings, and such
paintings as were readily available to an, as yet, undistinguished student.

 Turner's opportunities to see high-quality Old Masters increased
incrementally as his own art attracted praise and patronage, and in the process
gained him entrées to some of Britain's greatest picture collections. But possibly the
most important formative influence on his development was the work he undertook
for Dr Thomas Monro (1759–1833), from around 1793, when he was still only
eighteen. In essence, he and his colleague Thomas Girtin (1775–1802) were employed
to copy drawings in the doctor's collection, which included examples by Canaletto
(1697–1768) and other masters, but most notably the Swiss and Italian travel
sketches of the watercolourist John Robert Cozens (1752–1797; see no.16). When
describing the process by which they created their versions of Cozens's landscapes,
the two young artists explained that 'Girtin drew in outlines and Turner washed in
the effects'.[6] It is significant that even at this stage Turner was not given, or perhaps
did not accept, the servile role of simply transcribing Cozens's scenes; instead he
took on the transformative act of ornamenting and amplifying the originals with
appropriate atmospheric effects. It may have been with a sense of pride in his
precocious achievement, mingled with regret for the premature loss of Girtin's
comparable talent, that he acquired many of these works from the sale of Dr
Monro's collection some forty years later, in 1833.[7] The process of closely studying
and recreating Cozens's work contributed substantially to Turner's lifelong ability to
infuse life into those topographical studies by other artists (some of very indifferent

Fig.12
J.M.W. Turner
after Nicolas Poussin
The Exposition of Moses c.1798
from the 'Dolbadarn' sketchbook
Pencil, watercolour, pen and ink,
7.8 x 13.1
Tate

quality) that he was required to transform into finished landscapes without ever having seen the places they depicted.[8] But more fundamentally, what he took from the Monro years was a belief in his own power to reproduce and surpass even the greatest of previous masters.

Although Turner's travels in the 1790s gave him valued opportunities to study the collections at Petworth, Stourhead and Harewood House (as well as those in London), it was not until the very end of the decade that he regularly began to transcribe Old Master landscapes with the aim of making their creators' achievements his own. These copies may be primarily academic exercises, but they also attest to a youthful artist's desire to appropriate only the most highly prized of models: above all, those provided by the classical landscape tradition founded in seventeenth-century Rome, and subsequently brought home to Britain by the Welshman Richard Wilson.[9] Inevitably for Turner there was an underlying pragmatism in the direction he took. Turning from the still undervalued Wilson, he reached back to Poussin and Claude, whose status and market value seemed unassailable. Turner's sketchbooks of the late 1790s contain copies of two landscapes by Poussin, as well as a partial watercolour rendering of one of the most celebrated pictures by Claude in a British collection.[10] Remarkably, none of these transcriptions can be said to be a literal, or even a close copy, each revealing something of Turner's motives for making them. For example, the colours in his versions are not exact matches for the originals; he compresses one of Poussin's compositions to exaggerate its architectonics (figs.11 and 12); and his version of the Claude excludes its narrative content, preserving only the verdant landscape. By copying works by both masters at this time, as well as images by their contemporary Gaspard just a few years later,[11] Turner sought to identify those principles of classical landscape that could have a wider application, and quickly integrated these elements into his own work (for instance, see nos.28, 30 and fig.28).

Around the turn of the century Turner also made his earliest documented acquisitions of works by other artists. At an auction in 1798 he bought several lots of figure studies by the minor history painter and illustrator Charles Reuben Ryley (1752–1798); three years later, at the studio sale of the watercolourist Michael Angelo Rooker (1747–1801), he acquired various topographical drawings, as well as some detailed studies of barges by the marine painter Samuel Scott (c.1702–1772).[12] As in

the case of his contemporaneous studies from Old Master pictures, it was Turner's desire to equip himself as a professional artist (rather than any wish to become a collector) that motivated him to make these purchases. They also testify to the importance of the London sale-rooms at this time as a kind of informal academy, where British artists could gain access to some of the most celebrated examples of European art (as Philippa Simpson describes at length elsewhere in this volume, pp.29–39). Many of the paintings Turner saw at the famous Orleans sale in 1798, for example, such as Titian's *Diana and Actaeon* (National Gallery, London, and National Galleries of Scotland, Edinburgh) and Paolo Veronese's (1528–1588) *Mercury and Herse* (Fitzwilliam Museum, Cambridge), became established in his mind as incomparable achievements, which he continued to refer to well over a decade later.[13]

A glimpse of Turner's developing connoisseurship can be found in the observations he made during his stay in Paris in 1802. His notes on the Louvre collection, then considerably swollen with the great altarpieces and other canvases that Napoleon's agents had exacted as tributes from the subdued cities of Italy, occur in two sketchbooks: the first, used as he paused briefly before racing southwards to the Alps, has just a copy of Pier Francesco Mola's (1612–1666) *Vision of St Bruno* (no.38); but the second, filled on Turner's return to Paris towards the end of his Continental travels, records a more extended and systematic engagement with what he found in the French museum.[14] Most of the pages of the 'Studies in the Louvre' sketchbook are prepared with earthy washes, presumably in an attempt to replicate the warm tone conventionally used as the underlying ground for oil painting. Several sheets contain fully coloured copies of paintings, mostly by Titian (see, for example, fig.7) or Giovanni Francesco Barbieri, Il Guercino (1591–1666), though Turner misattributed the latter's works to Domenichino (1581–1641).[15] But the vast majority of his copies after pictures in the Louvre are highly summary pencil transcriptions with only the occasional touch of colour. Finally, a third category of notemaking, which probably evolved in order to save time, resulted in schematic notations that preserve a terse approximation of a composition based only on the colours used; appropriately, Turner adopted this challenging and austere approach chiefly for several works by Poussin. Running through the images are some thirty-five pages of analytical written commentaries, intended to supplement the adjacent pictorial *aide-mémoires*. Although there was no need for these private jottings to be fully considered or resolved, Turner clearly attempted to pursue a disciplined process in recording his observations. For the most part he had a propensity to focus on general visual impressions, but where an aspect of a picture particularly engaged him, as in the case of the works by Titian and Jacob van Ruisdael (1628/9–1682), he made more detailed comments on how it was built up. Yet for all the effectiveness of their reductive economy, one wonders just how useful Turner's notes and drawings would have been for recalling nuances of tone and colour. Surely conventional copies in oils, which demanded much more time and labour to produce, would have yielded far more information; but presumably, as in Turner's topographical sketches, he knew he could rely upon his phenomenal visual memory to supplement his summary notes.

Given what is known about the discussions that took place amongst the numerous other British artists who were in Paris at the time (mainly from Joseph Farington's diary), it seems likely that the enthusiasms of the throng steered Turner towards certain of the works that he copied. Yet more often than not he set his own independent priorities. Turner did not, for example, devote time or paper to Raphael's 'extraordinary'[16] *Transfiguration*, perhaps because it was already well known

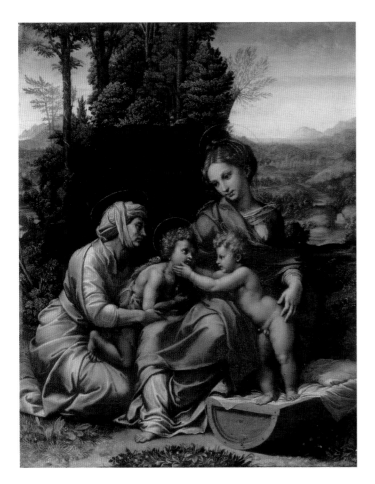

Fig.13
Giulio Romano
The Little Holy Family
Oil on wood, 29.5 x 38.6
Musée du Louvre, Paris

Fig.14
J.M.W. Turner
after Giulio Romano
The Small Holy Family 1802
from the 'Studies in the Louvre'
sketchbook
Pencil and chalk on paper,
12.9 x 11.4
Tate

through engravings. A Raphaelesque work he did study, however, was the so-called *Little Holy Family* (figs.13 and 14), now attributed to Giulio Romano (c.1499–1546); together with Lorenzo Lotto's (c.1480–1556) *Adoration of the Infant Jesus* (Paris, Louvre), which he also copied, the *Little Holy Family* may have been a picture Turner had in mind when he set about painting his own *sacra conversazione* in the months after his return to London (no.32). Elsewhere, his concentration on landscapes by Domenichino and Mola may seem surprising, but both men were believed to have followed Titian's lead in blurring the distinction between pure history painting and landscape[17] – a direction that Turner had already begun to explore, and which he afterwards developed further. The same interest drew him to Titian's *St. Peter Martyr* (see no.35), and to Poussin's historical landscapes, of which there were a number of key examples on view (including no.29); but it is curious that Turner addressed figurative works in so many of his studies at the Louvre. Even more strikingly, perhaps, there is no evidence to suggest that he devoted any part of his Parisian sojourn to examining whatever landscapes were available by Claude. He may have felt – with some patriotic pride – that there were better examples in British collections, though other factors may have been responsible for this apparent neglect.[18]

On the whole Turner's notes reveal a fascination with the methods used by earlier painters; in the expressive brushwork of Ruisdael and more especially of Titian, for instance, he located affinities with, as well as differences from, his own application of paint to canvas. A sense of what this kinship meant to Turner can be found in a private note written a few years later, where he grumbled about the injustice of so many works by the great Venetian colourists ending up in Paris,

Fig.15
J.M.W. Turner
The Artist's Studio c.1808
Pen and ink with watercolour
and scratching out, 18.5 x 30.2
Tate

home to Jacques-Louis David's (1748–1825) coolly linear approach to painting;
Turner believed they would have been much more appreciated in London where
purely painterly qualities were actively encouraged.[19]

Revealing judgements of this kind, coupled with the range of references
Turner made to works in major British aristocratic collections, indicate that he had
acquired the habit of continually assessing and absorbing the pictures that came his
way, compiling a kind of mental database of visual sources. Like John Opie, a fellow
Royal Academican, he clearly believed that 'To the *study* of nature' the artist 'must
also join that of art, and enrich his mind by the contemplation of all the treasures
produced by it in ancient and modern times.'[20] This sense that art progresses by
begetting more art largely went without saying in the early nineteenth century – far
more so than in recent times. But Turner worried that the past might weigh so heavily
on the present as to undermine any attempts at innovation. His sweeping criticism of
contemporary French painting rested precisely on what he regarded as its derivative
nature – that it was 'all made *up of Art*', as he succinctly put it.[21] The implications of
this dismissive comment are explored elsewhere in this catalogue (see pp.87–95), but
they require additional consideration here, on account of the fundamental questions
that they raise about Turner's own activities. For how could this artist – having already
made such obvious references in his own work to Wilson, Willem van de Velde,
Poussin, Claude and numerous other precursors – imply that there was a clear
distinction between his use of such sources and the comparable practices of his
French contemporaries? Was he thinking essentially of stylistic factors, or more
broadly of the construction and content of the images themselves? Did it not matter
that he referenced an Old Master if the resulting picture was agreed to have surpassed
its model? These questions remained at the forefront of Turner's mind and practice
over the next thirty years and more. Throughout this period he struggled to devise a
type of landscape that would be capable of satisfying the prevailing desire amongst
conservative arbiters of taste for modern works that they deemed to be worthy of
comparison with the greatest masterpieces of the past. At the same time, Turner
pressed relentlessly forward, as he strove to produce a more personal form of
landscape imagery based on direct observation of nature, but which remained
suffused with allusions to the longer landscape tradition.

The dependence of British artists on Old Master models became an issue of burning significance for Turner from 1806, prompted by two directly relevant factors. The first of these was the launch of the British Institution, a rival exhibiting body to the Royal Academy, whose aims were circumscribed by a group of conservative connoisseurs who believed no modern artist came near the achievements of a pantheon of earlier 'greats'. Compounding the issues raised by the establishment of the BI was the appearance of a powerful new rival at the Royal Academy exhibitions: the painter in question was David Wilkie (see nos.48, 49, and 51), a precocious Scottish upstart whose genre subjects, conceived in the manner of David Teniers the Younger, were being championed by a group of wealthy collectors and connoisseurs.

The most prominent of these was Sir George Howland Beaumont (1753–1827), himself an amateur (if pedestrian) artist, and the owner of many great paintings, including several notable Claudes. Furthermore, for some years Beaumont had been acting as the most vocal representative of a strident critical faction whose members publicly condemned Turner for what they regarded as his arrogant betrayal of Old Master principles. Angered by these comments, and by what he viewed as the connoisseurs' attempts to stifle artistic innovation, by 1808 Turner began to consider a means of counter-attacking Beaumont; the principal idea that he had in mind was to follow the example of William Hogarth, who in the previous century had fought similar battles through a fusion of satirical word and image. In Turner's case his campaign went no further than a sepia study for an unexecuted painting, known as *The Artist's Studio* (fig.15), depicting a modern Master poring over one of his own canvases, while a guileless assistant toasts buttered rolls before the fire.[22] The intended target can only have been Beaumont, with his fondness for basking in the glory of promising protégés.[23] Turner also penned some verses to supplement the image, describing the blinkered self-satisfaction of the Master:

> Pleased with his work he views it o'er and oer
> And finds fresh beauties never seen before.

From Turner's other inscriptions on the sketch, which accumulate in Hogarthian fashion to amplify its meaning and to sharpen its sardonic humour, we learn that the conceited painter was to be surrounded with 'Old Masters scattered over ye floor', highlighting how his art was literally founded on 'Stolen hints from celebrated pictures'.

Fig.16
J.M.W. Turner
Study for a Claudean Embarkation or Landing Scene, from the 'Studies for pictures: Isleworth' sketchbook 1805
Watercolour, pencil and ink, 15 x 25.8
Tate

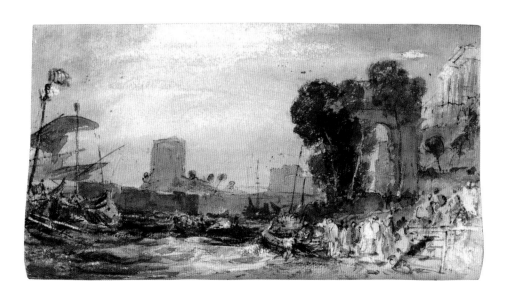

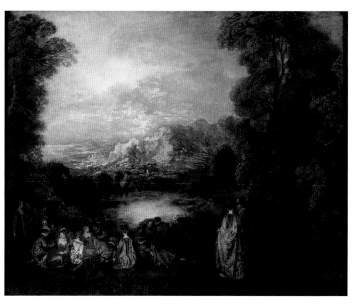

Fig.17
J.M.W. Turner after Jean Antoine Watteau
The Enchanted Isle c.1818
from the 'Hints River' sketchbook
Pencil, 8.8 x 11.4
Tate

Fig.18
Jean Antoine Watteau
The Enchanted Isle c.1716–18
Oil on canvas, 47.5 x 56.3
Private collection, Switzerland

Ultimately Turner chose not to work his design up into a public statement, perhaps recognising that it would merely further antagonise a powerful adversary. But this private criticism of an influential connoisseur, and by association those artists who were prepared to cannibalise (that is to say, plagiarise) earlier images, strikes a discordant note coming from Turner. After all, this was the period when, year after year, he summoned up the ghost of one Old Master after another in the pictures he sent to the Academy exhibitions, and in the mezzotints of his *Liber Studiorum*. Yet there are few indications that this consistent engagement with earlier art emanated from the study of specific paintings – Rembrandt's *The Mill* being a singular exception (see p.78 and nos.58 and 59) – and Turner left almost no trace of his sources among his personal sketches.[24] Evidently these provide only an incomplete record of his taste and his process of learning. For example, in the first decade of the nineteenth century he made a close study of the group of *Seaports* by Claude that belonged to John Julius Angerstein (including no.93), an experience that left a palpable imprint on pictures like *Sun Rising through Vapour* (RA 1807; no.103) – essentially a Northern seaport scene. But in Turner's contemporary sketchbooks, the only evidence for this engagement consists in a series of free variations on the same landscape theme (fig.16). This kind of imaginative response to Claude, or any other artist, encapsulated the point Turner was making in *The Artist's Studio*, where he displayed his contempt for painters who simply regurgitated their sources undigested. By contrast, Turner's underlying argument was that the achievements of earlier masters were to be used to stimulate innovation, and not to generate soulless repetitions of what had already been done.

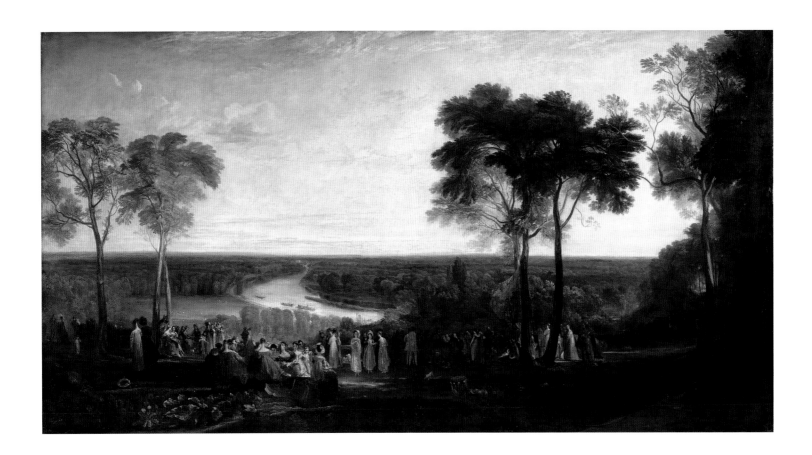

Fig.19
J.M.W Turner
England: Richmond Hill,
on the Prince Regent's Birthday
exh.RA 1819
Oil on canvas, 180 x 334.6
Tate

This belief soon emerged as one of the central themes in the lectures that Turner gave intermittently at the Royal Academy as Professor of Perspective from 1811 onwards. One of the elementary ideas he sought to convey to his students was the need for an artist to pursue an independent direction, informed by studies both of the world and of the ways in which it had been represented. Rejecting the notion that landscape was simply a matter of recording the visual facts, Turner prescribed a more imaginative response, stressing that 'To select, combine and concentrate that which is beautiful in nature and admirable in art is as much the business of the landscape painter in his line as in the other departments of art'.[25] Turner's series of lectures, especially the lecture on landscape, or 'Backgrounds', tell us more about the range of paintings with which he had become familiar by the 1810s. These included works he had seen but not copied in Paris, like Veronese's *Marriage at Cana*, and new interests, such as the portraits by Hans Holbein (c.1497–1543) at Petworth, or landscapes by Paul Brill (1554–1626) and Hans Rottenhammer (1564–1626). As well as Turner's own striking diagrams, his presentations evidently included a range of visual material, including Old Master prints, which on at least one occasion he had to apologise for mislaying.[26] The frequently revised texts of the lectures reveal that Turner occasionally pitched his comments to suit his audience's expectations;[27] but he did not shrink from expressing more personal opinions, such as his distaste for the 'meretricious Zuccarelli' and his contrasting preference for the tasteful elegance of Watteau.[28] This comment may be contemporaneous with a pencil copy of Watteau's *The Enchanted Isle* (figs.17 and 18), which Turner probably executed around 1818.[29] Despite reducing the

shifting sinuous patterns of the picture to a frieze-like outline, the jotting signals quite a sophisticated interest in Watteau, at a time when the French painter's charms were gaining a deeper appreciation in England (see nos.52–3). Soon afterwards Turner painted his first Watteauesque *fête galante*, and on an enormous scale, with his principal Royal Academy exhibit of 1819, entitled *England*, marking the Prince Regent's birthday celebrations above the Thames on Richmond Hill (fig.19).[30]

 While the picture was still at the Academy, Turner set off for Italy on a six-month journey during which he used his sketchbooks more systematically than ever before as a repository for his observations on paintings and sculpture; together the tour and its resulting material were conceived as, and afterwards constituted, a crucial reference point for his later paintings. However, aside from his diligently exhaustive survey of the Vatican sculpture collection, to which he devoted almost an entire volume, Turner's Italian sketchbooks contain nothing comparable with the efforts he had made some seventeen years before to record the Old Masters in the Louvre.[31] Where he did commit the compositions of other artists to paper, this was invariably done in a hasty and cursory fashion, as if his hand were barely an adjunct to the richer pleasures enjoyed by his eyes. Curiously, it is known that on this tour, and again in the 1830s, he was asked

Fig.20
Abraham Storck
Ships on the River Ij in Front of the Tollhouse near Amsterdam c.1690
Oil on canvas, 109.9 x 150.7
(as Turner would have known it, before 19th-century additions were removed in conservation)
National Maritime Museum, London

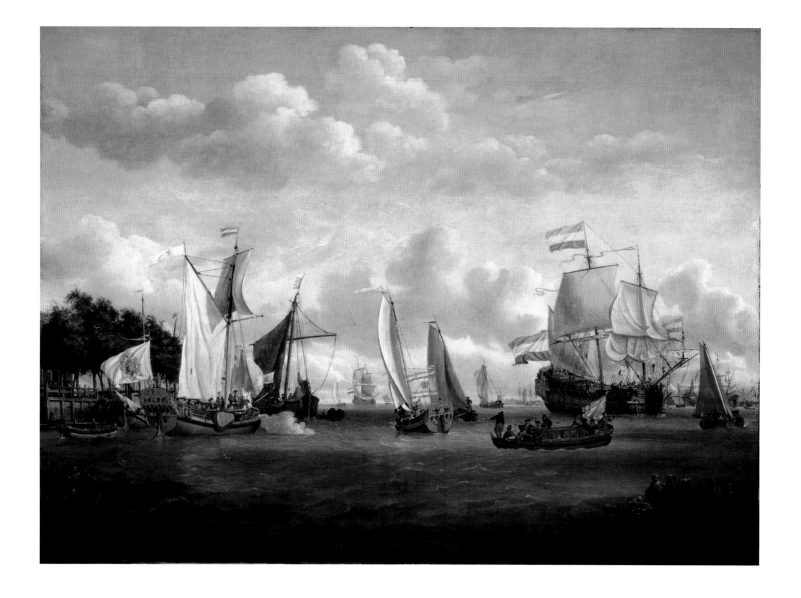

 'Stolen hints from celebrated Pictures': Turner as Copyist, Collector and Consumer of Old Master Paintings

to copy specific pictures by associates in London, either to satisfy their interest in famous works, or to serve as models to be engraved.[32] But if he did make any such transcriptions, none of them has survived. Turner very probably regarded slavish copying as a waste of his valuable time, which doubtless explains why he seems to have resorted to purchasing reproductive prints whenever possible.

Many of the pictures Turner recorded during his travels in Italy between August 1819 and February 1820 were by the same range of canonical Old Masters he had previously favoured in Paris, or discussed in his lectures. But if his studies sometimes appear to have been directed by recommendations in his guidebooks, his insatiable curiosity ensured his eyes remained open to other works that would hardly have attracted a second glance from even the most assiduous of contemporary art tourists. Thus in Venice, for example, Turner not only sought out the notable paintings by Titian and Veronese, but also discovered the 'stormy brush' of the relatively unfashionable Tintoretto (1518–1594), whose works he greatly admired (see p.170).[33] In Florence, at the Uffizi Gallery, he predictably and reverently transcribed the famous *Seaport* by Claude (fig.31); far more surprising, however, is the interest he demonstrated in Albrecht Dürer (1471–1528), Piero di Cosimo (1462–1521), Alesso Baldovinetti (1427–1499), Simone Martini (c.1284–1344) and Lippo Memmi (c.1290–1356); and in the frescoes by Andrea del Sarto (1486–c.1530), Jacopo Pontormo (1494–1557), Matteo Rosselli (1578–1650) and Bernardino Poccetti (1548–1612) in the church of SS. Annunziata.[34] Once he arrived in Rome his sketches reveal that he tracked down every canvas he could find by Claude, in the Doria-Pamphili, Pallavicini, Barberini and other Roman palaces.[35] A parallel interest, as manifest in his sketches, centred on Raphael, perhaps indicating that Turner had already conceived the idea of a picture to mark the forthcoming three-hundredth anniversary of the Renaissance artist's death (see no.63).[36]

Despite working alongside colleagues – both British and Italian – the contents of Turner's notebooks suggest that he took little or no interest in the works of contemporary artists. One notable exception is an outline memorandum of Pietro Benvenuti's picture of *The Oath of the Saxons to Napoleon after the Battle of Jena* (1812; Palazzo Pitti, Florence), which Turner saw during his stay in Florence.[37] Benvenuti (1769–1844) owed his position as Director of the Accademia to his initial adherence to the neo-classical style of David (the leader of the modern French School), but had increasingly absorbed the broader manner of the next generation. Although Turner had previously scorned the Davidian linear style,[38] he may have been persuaded to rethink its Italian manifestation by Benvenuti's close friend, the celebrated sculptor Antonio Canova (1757–1822). Furthermore, during his time in Naples Turner quite probably met another follower of David, the Savoyard Giacomo Berger (1754–1822), who taught history painting at the Academy. Then, or at some point later, Turner acquired a *Death of Abel* painted by Berger.[39]

It is frustrating that Turner's activities as a collector can be only partly reconstructed from the inventory of the oil paintings found in his house at the end of his life, though some additional details are provided by the catalogue compiled when the residue of the collection was sold in 1874 (see pp.231).[40] The house inventory mentions a number of intriguingly unidentified pictures. Some of these may have been bought from colleagues to support their endeavours, such as the items by Callcott sold by 'Turner' at Christie's on 23 November 1827.[41] But Turner appears to have made other acquisitions primarily with a view to assisting the

development of certain aspects of his own work – like the studies by Ryley, Scott and van de Velde, as well as the drawings attributed to Rembrandt he bought from Monro's collection.[42] One painting he bought that certainly did have a direct impact on his art was a seventeenth-century Dutch shipping scene (fig.20) by Abraham Storck (1644–1708), which has recently been identified as the source for the main vessel in *Admiral Van Tromp's Barge at the Entrance of the Texel, 1645*, one of Turner's Royal Academy exhibits in 1831 (fig.59, p.144).[43]

As already implied, Turner's allusions to the prints he intended to use in his lectures suggests that he must also have accumulated a substantial number of engravings based on Old Master paintings. In addition to the Richard Earlom edition of Claude's *Liber Veritatis*, Turner is known, for example, to have bought prints after Titian, and he clearly had access to a copy of the *Recueil Julienne*, the multi-volume set of engraved reproductions of Watteau's paintings and drawings (see no.64).[44] He may also have owned an impression of William Woollett's (1735–1785) classic rendering of Richard Wilson's *Destruction of the Children of Niobe* (1761), for he instructed one of his own engravers to try to imitate some of its details.[45] But, regrettably, no account survives of the scale or scope of this potentially vital store of visual raw materials, presumably stored haphazardly, and therefore deemed worthless by the assessors of Turner's estate.

The inventory also reveals that, aside from a few canvases by Wilson, and various portraits by Reynolds, Thomas Lawrence (1769–1830) and John Jackson (1778–1831; another British artist who was with Turner in Rome in 1819), Turner owned no paintings of any real consequence – and certainly nothing to compare with the two landscapes by Claude (e.g. fig.22) bought in or around 1812 by John Glover (1767–1849, the other contender for the title 'The English Claude').[46] The best Turner could manage was a pair of small round landscapes (one is fig.21) attributed to Claude's teacher Goffredo Wals (c.1595–1638) that were bequeathed to him by the artist-playwright Prince Hoare (1755–1834).[47] Set against Turner's wide-ranging connoisseurship, this may strike us as an odd deficiency. Yet given the artist's notorious rapacity in his business dealings, the decision not to lavish money on choice acquisitions must have been a deliberate one. Turner spent much of his social life in the company of collectors, but the competitive qualities that distinguished so many other aspects of his character do not seem to have driven him to contend in this sphere (except when it came to hoarding his own art; see no.103). Perhaps the establishment of public collections of paintings, such as Dulwich Picture Gallery in 1811 and the National Gallery in 1824, impinged on Turner's sense of what he felt to be necessary or useful for him to possess. Evidently a great believer in the value of national art collections, he was among those who (unsuccessfully) petitioned the government in the early 1830s to buy the late Thomas Lawrence's unrivalled holdings of Old Master drawings. Turner was also a devoted supporter of the Royal Academy's mission to provide suitable examples for its students to learn from, advocating the Academy's acquisition of a copy of Leonardo's *Last Supper*, believed to be by either Marco d'Oggiono (1475–c.1530) or Giampietrino (1493–1540).[48]

Where an original work of art could not be purchased but was highly esteemed, as in the case of the Leonardo fresco, it had long been standard practice for collectors to seek out, or commission, painted reproductions instead. These were obviously of less financial worth, but still regarded as valuable sources of knowledge about the images they replicated.[49] Turner's

Fig.21
Attributed to Goffredo Wals
Italianate Landscape c.1615–30
Oil on wood, 26.7 diameter
Tate. Presented by Miss M.H.
Turner 1944

initial understanding of a number of canonical works would certainly have been
shaped by second-hand versions in the collections he visited, and he gave his
lectures at the Royal Academy surrounded by James Thornhill's (1675–1734)
copies of Raphael's Tapestry Cartoons. Furthermore, Turner's long-term
perception of other celebrated pictures rested on a group of copies in his own
collection, which apparently included facsimiles of Titian's *Sacred and Profane
Love* in Rome's Galleria Borghese, and the *Bacchus and Ariadne* (National
Gallery, London), which he whimsically parodied in one of his Royal Academy
exhibits of 1840.[50] Other likely reproductions listed in the posthumous
inventory of Turner's effects are a picture described as Rubens's *Rape of Phoebe
and Hilaria* (presumably based on the Flemish master's *Rape of the Daughters of
Leucippus* in the Alte Pinakothek, Munich), as well as copies of a supposed
Giorgione (c.1477–1510) and of an unattributed painting of *Jupiter and Semele*.
The last two were probably acquired at the dispersal of Thomas Lawrence's
collection, where the first was identified as 'A Bacchanalian Festival; an
extensive composition with fine landscape background, coloured with great
vigour', and the second as a copy of 'The Io of Correggio by Thomson [Henry
Thomson, R.A. (1773–1843)], after the original in the Imperial Collection at
Vienna'.[51] Although Turner, as has already been noted, was loath to devote much
of his precious time to copying the Old Masters, it is conceivable that on rare
occasions he may have executed a large-scale reproduction of a work he
especially admired. It is tempting to think that this was what Turner did in the
case of Titian's *Sacred and Profane Love*, which fascinated him during his stay
in Rome in 1819–20 – but the version he acquired might well have been by an
Italian artist.[52] Nevertheless, Turner's ownership of works of this type
strengthens the impression that his home and studio contained a well-used
body of visual reference material.

By the time Turner was in his mid-forties, he held quite firmly established ideas about which of his predecessors were of particular significance to his own art. Even though he continued to travel, the concentrated burst of copying from Old Master paintings in the sketchbooks of 1802 and 1819 was not to be repeated in the second half of his career. When he made further notations of this kind, the process was more sporadic, as if Turner were serendipitously rounding out gaps in his knowledge,[53] or confirming his abiding interest in artists with whom he had long been preoccupied. The most important of such figures was Claude, whose pictures in Paris Turner at last scrutinised properly in 1821 (fig.27). If Turner's transcriptions of the pair of Claude's paintings at Dresden in 1835 seem somewhat cursory in comparison, he was nevertheless singular in seeking them out, revealing the exceptional nature of his devotion.[54] His scrappy copies were made during a journey he had expressly undertaken to assess the collections and new art galleries in Germany, with a view to how this could inform the National Gallery's forthcoming move to Trafalgar Square. But, given this objective, it is surprising not to find the artist's sketchbooks filled with plans and illustrated commentaries, appraising the architecture and its relationship with the picture hang. The rudimentary notes Turner made of compositions by Correggio, Raphael, Ruisdael, Watteau and two followers of Rembrandt are no more than idle doodles that can have served little purpose, other than fixing these images in his retentive mind.[55]

Although he was steadfast in favouring a core group of Old Masters, Turner did not neglect artists he found problematic. Prominent among these was Rubens, whose technique Turner obviously admired, even as he disdained his lack of naturalism – a point he made about Rubens's landscapes in both the Louvre sketchbook notes and the 'Backgrounds' lecture (see nos.54–6). This was a position Turner maintained, and vigorously defended against strong opposition, during his second stay in Rome in 1828.[56] And yet he was clearly enchanted by the Flemish painter's sensual portraits of young women: he made a sketch of the famous *Chapeau de Paille* (*The Straw Hat*, depicting Susanna Fourment; National Gallery, London) when it appeared on the art market in 1823, and likewise of the more overtly erotic *Helena Fourment in a Fur Wrap* (Kunsthistorisches Museum, Vienna) ten years later in Vienna.[57] Turner's libidinous preference for this aspect of Rubens's work would also account for his ownership of a version of the *Rape of the Daughters of Leucippus*, as has been noted above. The same taste for highly sensual imagery may also have prompted Turner to copy a Titian-inspired *Venus* by Lambert Sustris (1515–1568) during his second stay in Italy; apparently the English painter's appreciation of art occasionally strayed from dry connoisseurship into something rather more full blooded.[58] But such preoccupations aside, evidence in the sketchbooks of an ongoing interest in earlier paintings becomes much less tangible after the later 1830s, though the nature of his exhibited paintings continued to indicate their undiminished relevance to Turner's idea of himself as an artist (in contrast, for example, with Picasso, who most often turned to the Old Masters at times of stylistic transition or crisis). By 1837 the Royal Academy was housed in the same building as the National Gallery, and for Turner the dialogue proposed by this conjunction may have been a sufficient and more immediate stimulus in itself.

A fundamental question remains: how different was Turner from his peers in his contemplation of, and devotion to, the art of earlier centuries? In his adherence to academic principles, he was part of a generation whose gods were

'Stolen hints from celebrated Pictures': Turner as Copyist, Collector and Consumer of Old Master Paintings

initially the Venetian colourists (and above all Titian) coupled with the classical landscape school. Over the first half of the nineteenth century, however, Britain witnessed a shift of taste that admitted the more highly particularised achievements of Dutch and Flemish art, and the subtle appeal of Watteau's flickering effects. While the nature and application of Turner's response is unique, a broadly similar pattern of interest and involvement can be found in the work of contemporary artists as diverse as David Wilkie, William Etty (1787–1849), Thomas Phillips, William Hilton (1786–1839), Andrew Geddes (1783–1844), John Scarlett Davis (1804–1845), David Cox (1783–1859), R.P. Bonington (1802–1828) and John Constable.[59] Admittedly, many of these men were much more diligent than Turner, in the sense that they produced the precise copies that academic discipline conventionally required – but when it came to his engagements with the art of the past, Turner cannot be said to stand alone.

Indeed his art was far more firmly rooted in the aspirations and practices of his own age than has sometimes been assumed. In particular, the attempts over the last century to claim Turner too exclusively as a progressive figure, liberated from the past, have denuded him of his own insistence on the value of renewing earlier prototypes, and his sense of empathy with his predecessors. Throughout his career, he invariably found new directions for his art without the need to destroy or flood the museums (as proposed by the early twentieth-century Italian Futurists), leading some commentators to make extravagant claims for Turner's genius. Ruskin's father, for example, enthused that Turner 'copied every man, was every man first, [and yet he] took up his own style, casting all other away'.[60] But, in fact, what is remarkable about Turner's trajectory as an artist is that he insisted on keeping his sources visibly in play throughout his working life. His exhibited tributes to Rembrandt, Titian and Claude all arise from the same kind of personal meditations on Old Master images found in his sketchbooks. Yet like Bottom (in Shakespeare's *A Midsummer Night's Dream*), Turner's desire to take on so many roles sometimes defeats him, threatening to make him seem at best a virtuoso show-off and at worst ridiculous. Nevertheless, even as we smile at the impudent extent of his ambitions, we recognise and admire his exuberant desire to be accepted among the Greats – a status very few are privileged to approach, and even fewer to attain.

Turner, Claude and the Essence of Landscape
Kathleen Nicholson

In 1707 the art theorist Gérard de Lairesse offered a charming definition of landscape for painters and patrons alike:

> A Landscape is the most delightful object in the Art, and has very powerful qualities, with respect to sight, when by a sweet harmony of colours and elegant management, it diverts and pleases the Eye. What can be more satisfactory than to travel the world without going out of doors; and in a moment to journey … even into the Elysian Fields, to view all the wonders, without danger or inconvenience from sun or frost? What is more acceptable than shady groves, open parks, clear waters, rocks, fountains, high mountains and deep misty valleys? All these we can see at once; and how relieving must the sight be to the most melancholy temper?[1]

Nature in this formulation refreshes and uplifts the human spirit – especially so when enjoyed through its representation in painted landscapes because they please by appealing to the eye rather than the intellect, and demand no physical exertion. A skilful artist 'manages' the unruliness of nature by imparting an orderly design to the scene as a whole, and by producing a harmonious display of colour as an additional source of delight. De Lairesse, a painter who turned to writing when he became blind towards the end of his life, celebrated the ability of landscape to transport us to places we might not yet have visited, or be able otherwise to see, when they belonged to the past or existed only in the realms of the imagination. Later in his treatise he encouraged landscape artists to enrich their scenes with themes taken from the Scriptures or Ovid's *Metamorphoses*, though he conceded that this would require 'the time to spare' and a 'love of reading' which he felt very few painters possessed.[2]

Surely Turner shared de Lairesse's encompassing view of the art of landscape, as well as an abiding commitment to deepen the significance and narrative potential of his chosen genre. Among painters his key predecessor in this regard, as well as his most cherished source of inspiration among the Old Masters, was the French-born Claude Gellée, commonly known as Claude Lorrain, or more

Claude Lorrain
Landscape with the Marriage of Isaac and Rebecca (The Mill)
1648 (detail, fig.30)

simply as Claude. Not only had Claude pioneered landscape as a form of imagery worthy of being appreciated on its own terms and for its appeal to the senses, but decades before de Lairesse he had introduced pastoral, Biblical, or mythological themes into natural settings to create an integrated imagery that addressed both the eye *and* the mind. This became one of Turner's central aims as well: throughout his long career he made a point of demonstrating that he shared Claude's inspired understanding of the role that light, atmosphere and colour might play in bringing nature and human narrative to life, both visually and affectively.

By the early nineteenth century, British art critics and connoisseurs had long been accustomed to using 'Claude' as a shorthand metaphor for a set of pictorial qualities and features (both natural and man-made) that conveyed an orderly, accessible and enticing idea of the outside world. As the discerning writer and occasional painter William Hazlitt explained in the 1820s:

> The name of Claude has alone something in it that softens and harmonizes the mind. It touches a magic chord. Oh! matchless scenes, oh! orient skies, bright with purple and gold; ye opening glades and distant sunny vales, glittering with fleecy flocks, pour all your enchantment into my soul; let it reflect your chastened image, and forget all meaner things![3]

For Hazlitt it was as if de Lairesse's definition of landscape art belonged to Claude alone.

Although Claude's own contemporaries might not have spoken in such hyperbolic terms, they gave ample evidence of their approbation. Based in Rome, the artist served a sophisticated and powerful clientele that included popes, kings, princes, noblemen and diplomats – men steeped in classical learning, and nostalgic for the pleasures of pastoral peace and harmony associated above all with the poetry of Virgil. To them Claude offered images that presented the natural world as a tactfully perfected place of repose and retreat from the pressures of modern life, whether that retreat be at a verdant forest's edge or in the sunlit open countryside. For more discerning patrons who desired symbolic or narrative complications, he willingly developed thought-provoking themes appropriate to a given setting (for example, fig.2). Most of his admirers, however, had less demanding pleasures in mind.

The fundamental and enduring appeal of Claude's landscapes lay in his idealising approach to the representation of nature – though idealisation is a slippery term when applied to the depiction of the outdoors. Whereas the ideal proportions of a classical Venus or Apollo can literally be measured, we are less able or equipped to agree upon the qualities or proportions of a perfect tree, or dale, or brook, let alone of a scene combining all three. Eighteenth-century aesthetic theorists argued at length about possible systems for evaluating the sublime, the beautiful, or the picturesque – and although Claude's pictures were usually equated with the beautiful, their effect corresponded to no specific formula.

William Hazlitt, whose admiration for the artist easily matched Turner's, grappled with the equation of beauty, the ideal and Claude in an essay that allows us to savour the impact that contemplation of his imagery had, and still has – and to appreciate the difficulty of fully analysing the visual components which prompt that enjoyment. Although the critic had no specific painting in mind or before his eyes, we might find a match for his description in a quiet scene with a piping

shepherd from the latter part of Claude's career (fig.22). Hazlitt's account begins (and ends) with a Romantic's subjective definition of the ideal as 'that which answers to the preconceived imagination and appetite in the mind for love and beauty'. The ideal, he explains, 'depends on harmony and continuity of effect', and is determined 'by a concentration of feeling'. Claude exemplifies the ideal in his landscapes because he:

> balances and harmonises different forms and masses with laboured delicacy, so that nothing falls short, no one thing overpowers another … There are neither rainbows, nor showers, nor sudden bursts of sunshine, nor glittering moon-beams in Claude. He is all softness and proportion … The two sides (for example) of one of Claude's landscapes balance one another, as in a scale of beauty … The ideal has its source in the interest excited by a subject, in its power of drawing the affections after it linked in a golden chain, and in the desire of the mind to dwell on it for ever. The ideal, in a word, is the height of pleasing, that which satisfies and accords with the innermost longing of the soul.[4]

But whereas Hazlitt could use his writing to indulge the unspecified longing occasioned by contemplating a fine landscape painting, Turner needed to comprehend Claude's mental and artistic procedures so that he could not just replicate them in formal terms, but also assimilate and modernise the classical ideal. His great precursor's own source of inspiration, Turner proposed, had been nature itself. 'As beauty is not beauty until defin'd or science science until reveal'd', Turner wrote of Claude, 'we must consider how he could have attained such powers but by continual study of parts of nature.'[5]

Fig.22
Claude Lorrain
Landscape with a Piping Shepherd 1667
Oil on canvas, 52.1 x 69.3
Nelson-Atkins Museum of Art,
Kansas City, Missouri. Purchase:
William Rockhill Nelson Trust

Fig.23
Claude Lorrain
View with Trees c.1638
Graphite, 31.5 x 21.9
The British Museum,
London

From Claude's earliest biographers onwards, it had become a commonplace in art criticism that his glorious achievements had rested first and foremost on his first-hand discovery of, and submission to, nature as he found it. For Turner, Claude's example offered no more important lesson than this. Perhaps the best indication of their fundamental affinity can be discovered in the fact that both artists found drawing from the motif an indispensable part of their artistic practice, each responding to nature's vibrancy with equal detail as well as breadth (for example, figs.23 and 24). Claude's studies *en plein air* (of which there are many) seem to have been little known in early nineteenth-century England, and Turner's first significant encounter with them appears to have been delayed until 1824 – too late in his career to have had much of an impact on his style.[6] But in any event what mattered to Turner was the *knowledge* that Claude's art was anchored in the master's acute powers of observation of the natural world.

Yet such powers do not immediately translate into an ability to paint landscapes that can elicit longing. To achieve this, Claude had expanded what had previously been a narrow repertory of landscape themes to include open sunlit prospects, more densely forested views and classicised harbours. For each of these types he developed a set of visually and conceptually satisfying patterns and motifs that allow a viewer both to command the scene as a whole and to explore its particularities. In the aforementioned *Landscape with Piping Shepherd* for instance – an example of the first category – Claude invites us to enjoy a viewing position well back and slightly above the encompassing prospect that unfolds before us. A broad foreground provides a stable point of departure and contains the figural activity in a stage-like manner. Graceful silhouetted trees and architecture act as framing elements for the panoramic scene beyond, whilst a body of water flows past a scale-marking bridge and a hill town in the middle distance, and winds through a series of gently overlapping hills and valleys. Furthest away from us,

Fig.24
J.M.W. Turner,
A Woodland Road from
'Swans' sketchbook 1798–9
Pencil and watercolour, 17.4 x 25
(both pages)
Tate

at the horizon, a mountain beckons as the terminal point or anchor for the eye's journey. Claude's vaulting sky helps give the scene its breadth and seeming airiness, yet maintains a pleasing ratio to the earth below. These patterns and structuring devices impart a reassuring predictability to what would otherwise be inchoate nature. Claude avoided lapsing into mere convention by attending to variations that one observes in nature itself: the orientation of a water element to the left or right, tracing shallow or deep curves; the time of day depicted; or the silhouette of a group of trees.

To enhance the sense of nature as inviting, Claude developed a hallmark visual fluidity, which was responsible for creating 'all the aerial qualities of distance, aerial lights, aerial colour'[7] that Turner so much admired. Earlier Venetian painters like Giorgione and Titian might have portrayed the subtleties of a morning sky or the softening shades of approaching dusk, but Claude made the representation of light his principal means of uniting object to object, and area to area, within a harmonious, all-embracing atmosphere. Standing before one of his landscapes, a viewer is readily caught up in the almost alchemical transformation of paint into coloured air. There are no telltale marks of the brush and one hue disappears delicately and seamlessly into the next. Hazlitt rhapsodised about just this effect, explaining how in a Claudean sky 'one imperceptible gradation is as it were the scale to another, where the broad arch of heaven is piled up of endlessly intermediate gold and azure tints, and where an infinite number of minute, scarce noticed particulars blend and melt into universal harmony'.[8] In this way Claude succeeded in grounding the appeal of nature in art's remove where, to recall de Lairesse's encomium on landscape painting, the variety of the outside world could be savoured in perfect comfort.

Distilled from his intense study of nature, Claude's art of idealisation deftly confounded 'place' with 'landscape'. As Joshua Reynolds put it in one of his *Discourses* to the Royal Academy, Claude 'was convinced that taking nature as he

found it seldom produced beauty. His pictures are a combination of the various draughts which he had previously made from the various beautiful scenes and prospects.'⁹ In fact more of Claude's settings were imaginary than not, if often dotted with identifiable monuments from the Italian countryside. The desire one has to enter their spaces gains in poignancy precisely because the scenes involve mental projection by both the artist and the viewer. Meaningfulness deepens with the ideas one brings to the scenes, whether a scholarly interpretation of Virgilian pastoral, the more general notion of a golden age favoured in the eighteenth century, or a Romantic longing for transcendence. Even Claude's later subject paintings that treat elaborate narratives from the *Aeneid* remain pleasantly allusive until or unless one delves into the text of the epic (see fig.32). In his landscapes, suggestion prevails over didacticism.

For many early nineteenth-century commentators the ineffable magic of a work by Claude rested first and foremost in the luxuriance of his palette. Hazlitt, we recall, spoke of skies 'bright with purple and gold'; likewise when Turner thought about Claude his mind's eye saw the 'golden orient or the amber-coloured ether … campagnas rich with all the cheerful blush of fertilization, trees possessing every hue and tone of summer's evident heat, rich, harmonious, true and clear'.¹⁰ Both Hazlitt and Turner engaged in these verbal 'repaintings' less in an attempt at description than as exercises in imaginative projection arising from a modern, revised notion of 'Claude'.

Encouragement to evoke Claude in this poetic fashion came from no less an authority than Reynolds. In his thirteenth *Discourse*, originally delivered to the Academy in 1786, a discussion of the power of imagination had led to an appreciation of the merits of landscape painting; it is here that Sir Joshua famously speaks of Claude as someone who 'conducts us to the tranquillity of Arcadian scenes and fairy land'. While numerous eighteenth-century critics had linked Claude to pastoral Arcadia, 'fairy land' as a destination was novel, and paved the way for a broader comparison that followed. Warming to his subject, Reynolds proceeded to equate a landscape painter's ability to affect the viewer with the poet's power to move his readers, provided that the artist 'makes the elements sympathise with his subject', as for example when Claude 'gild[s his] clouds … with the setting sun'. A picture composed in such a spirit would be immeasurably superior to any 'cold prosaick narrative or description', and 'would make a more forcible impression on the mind' than even nature herself.¹¹

If there was a central reason why Turner engaged in constant artistic dialogue with Claude, it was to help him raise the affective power of landscape painting – to give the portrayal of nature the same power to move the heart and mind expected of the depiction of significant human actions in history painting. The difficulty of that imperative explains why no single term correctly describes Turner's relationship to Claude, whether indebtedness, emulation, homage, or pastiche, although one or more might apply in particular cases. One wonders whether Turner shared the opinion of the twentieth-century artist and writer Lawrence Gowing, who insightfully declared Claude to be a 'painter's painter'.¹² This rather unexpected compliment acknowledges both a master's exceptional craft and the high level of accomplishment it allows – accomplishment that Turner had initially feared was 'beyond the powers of imitation'.¹³ Such trepidations notwithstanding, he set about to incorporate the Claudean ideal into his pictorial repertory, translating it into an idiom all his own in the expectation that it would lead him to the essence of landscape.

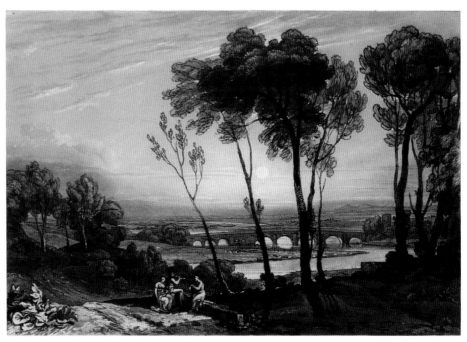

With other artists, whether Old Masters or contemporaries, Turner's approach fell
somewhere between trying out and taking on their styles and/or reputations at
appropriate moments in his career. His engagement with Claude was something
quite different, and not least because it spanned close to fifty years with almost
unabated intensity.[14] Rather than requiring a period of apprenticeship, Turner
mastered the Frenchman's artistic conventions almost immediately, rehearsing them
in the privacy of his sketchbooks and working through their possibilities as he
assembled a stock of ideas for the future (for example, fig.25). Then, beginning in
1807, in the didactic graphic project on landscape that he entitled the *Liber Studiorum*
– to invoke its affiliation with the *Liber Veritatis*, Claude's celebrated book of
composition studies – Turner offered a sustained demonstration of the character of
Claudean landscape relative to other types (fig.26).[15]

 Between 1811 and 1817 Turner further affirmed Claude's central importance
to his own artistic project with a series of major paintings that included his first
classical seaports in Dido buildings. That Turner would subsequently (in 1821) fill
three pages with careful sketches and notes after Claude's paintings in the Louvre

with the diligence of a beginning student testifies to the profound connection he felt to his predecessor, even from the standpoint of a successful forty-six-year-old artist at mid-career (fig.27). Turner's affection hardly diminished over the next two decades, as he revisited Claudean compositional formats and glowing light effects in any number of watercolour studies, unfinished oils and exhibited works, including his very last (no.92).

If we now examine a chronological trajectory of selected works, we can track Turner's understanding of, as well as revisions to, Claude – revisions that helped him in his own pursuit of the essence of landscape. In his first exhibited painting in a Claudean vein, the *Festival upon the Opening of the Vintage of Macon* of 1803 (fig.28), he set out to provide an ambitious and elegant demonstration of how Claude might have responded to 'northern climes', had he chosen to live there.[16] At first glance this enormous prospect of the River Saône seems to be a conventional exercise in the manner of a Claude river view composition like *Landscape with Jacob, Laban and his Daughters* (no.24), which he had probably seen in the mid-1790s. But if we look more closely, we realise that Turner has in effect refocused or concentrated the Claudean repertoire of elements to underscore the *experience*, rather than simply the *idea*, of nature. In part this different end has been achieved by introducing a cluster of dancing figures into the right-hand foreground that provides an enlivening cadence to the curve of the expansive river beyond. The eye then moves over the water's

Fig.27
J.M.W. Turner
Copies of three paintings by Claude Lorrain in the Louvre
from 'Dieppe, Rouen, Paris'
sketchbook 1821
Pencil, 23.1 x 11.8
Tate

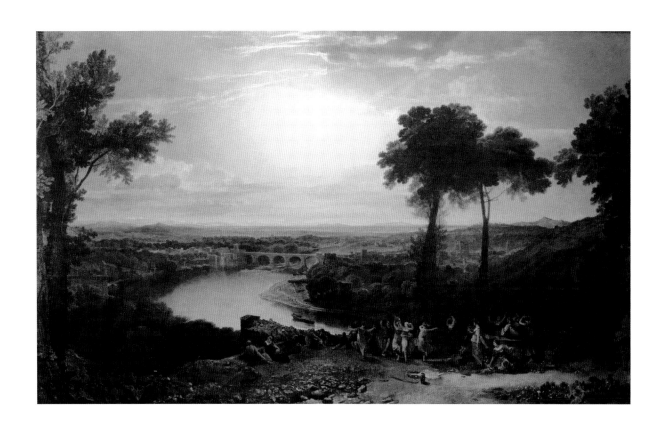

Fig.28
J.M.W. Turner
*The Festival upon the
Opening of the Vintage
of Macon* exh. RA 1803
Oil on canvas, 146 x 237.5
Sheffield Galleries and
Museums Trust

mirror-like surface into an equally deep, delicately receding space, but one in which the contemporary moment asserts itself, as suggestions of Macon replace Claude's Italian monuments in the miniaturised architectural display. Rather than just taking in the stately scene from a privileged position outside the prospect, the viewer is more actively drawn into it through the allure of its broad, luminous sky. The emphatic presence in the *Opening of the Vintage* of the orb of the sun, an innovation of Claude's that soon became Turner's hallmark,[17] directs one's thoughts to weather, to the hour and to an anticipation of the particular pleasures of destinations in the French countryside.

In *Crossing the Brook* of 1815 (no.34) Turner went a step further by clarifying how a modern artist might *find* Claudean harmony in local scenery – on his own doorstep, if you like. His unusual choice of a vertically oriented canvas directly invoked Claude's own practice, as one can appreciate by seeing this magisterial composition in the context of his precursor's equally impressive *Landscape with Moses Saved from the Waters* (no.33). Differences rather than similarities underscore the basic affinity between the two painters who appreciated nature on its own terms, but who were dedicated to making that 'more forcible impression on the mind' which is the province of art. Turner's denser, wooded foreground obstructs the expected motif of a river bend, leaving just a glimpse of its flow in the middle ground. In place of a grassy proscenium with figures enacting a Biblical or mythological scene that one observes in passing as the eye tracks to the distant view, *Crossing the Brook* offers a novel foreground that fixes the attention. To enter into the scene the viewer must cross the limpid stream punctuated by a wading girl and her friendly dog. The brook

Fig.29
J.M.W. Turner
Palestrina – Composition 1828
(detail, no.26)
Oil on canvas, 140.3 x 248.9
Tate

itself holds back from becoming an idealised component of a larger, eternal unity; instead it is a familiar obstacle for a traveller that calls forth the senses of touch and sound. Meanwhile the deeply tracked roadbed on the right both leads to the brook and away from it – thus distracting, if only in a minor way, from the primary projection leftward into scenery recognisable as the valley of the Tamar in Devon. Turner offered the modern viewer everyday choices – to linger, to seek shade in a deep wood, or to continue the journey into the sunlit countryside. So deftly had he domesticated Claude in *Crossing the Brook* that one critic claimed to 'perceive no affinity to any style or any school [in it] … we think his manner and his execution are as purely original as the poetic forms which create his compositions'.[18]

Only the year before, in 1814, Turner had forced the issue of sacred models and slavish imitation by sending *Appulia in Search of Appulus … Vide Ovid* (no.25) to the British Institution's annual competition for aspiring artists. As David Solkin recounts elsewhere in this volume, Turner offered this 'copier's copy' of *Jacob, Laban and his Daughters* (owned by Lord Egremont, his patron) to challenge the prejudices of his most strident critics. But perhaps Turner also had a more subtle lesson in mind about the enduring value of idealised landscape within modern art. Hazlitt begrudgingly acknowledged as much, characterising *Appulia in Search of Appulus* as a 'grand landscape' in which 'the beautiful arrangement is Claude's; the powerful execution is [Turner's] own. From this specimen of parody … we could almost wish that this gentleman would always work in the trammels of Claude … All the taste and all the imagination being borrowed, his powers of eye, hand, and memory are equal to any thing'.[19]

Turner henceforth demonstrated the degree to which he shared Claude's taste and imagination rather than borrowed from them. The magnificent *Palestrina – Composition* from 1828 is a case in point (no.26). This has traditionally been identified as the work Turner was referring to when, in a letter written whilst

en route to Rome for his second visit, he spoke of his eagerness to get to work 'con amore [on] a companion picture for [Lord Egremont's] beautiful Claude' (no.24).[20] But the compliment was being paid to Claude, rather than to Turner's patron, who neither commissioned nor purchased the resultant painting. Although the two pictures match in size, their compositions do not balance each other as in a conventional pair of pendants like Turner's *Bridgewater Sea-Piece* and Willem van de Velde's *A Rising Gale* (nos.20 and 19). Instead Turner may have had a different sort of 'companionship' in mind, one designed to offer the patient viewer a way to analyse and conceptualise one key aspect of landscape's essence: its capacity to transport us to places we can only visit by virtue of the power of art, as both de Lairesse and Reynolds had posited.

In *Palestrina – Composition* Turner conveys a traveller's sense of delight in and discovery of a new locale by once again emphasising the foreground and now, as well, the middle ground (fig.29). Here he has turned the Claudean motif of an elegantly arching bridge perpendicular to its normal placement, and marked the change with foaming, rushing water flowing beneath it from left to right. Having rendered the bridge's initial parapet in startling projection towards the viewer, Turner then asks us to follow its more angular contours to an extravagant hill town, and to plunging cascades that momentarily arrest Claude's normally harmonious passage into the distance. The effect of so much to see is dazzling. Meanwhile the right half of the foreground offers a more traditional pastoral scene, where goats feed among ancient sculptural fragments and where one might like to rest or stroll. But here Turner has accelerated Claude's graceful tempo by challenging the eye to follow the rapid recession of his *allée* of trees to the hazy point on the far horizon, and then back again to the sandy foreground, as if to suggest that the pastoral realm is basically only ever a state of mind. At the centre of the canvas, beyond the smaller waterfall, the distant, sunlit valley unfolds at a properly metred Claudean pace towards a pale blue Claudean mountain – a homage, of sorts, to the seventeenth-century master's role in the history of landscape painting.

In the will he drew up in 1829, Turner stipulated for the first time that he wished his artistic relationship with Claude to be placed on public display for posterity. Initially he had in mind to bequeath two of his Claudean seaport scenes, both on Carthaginian subjects, to the fledgling National Gallery. A few years later, however, he settled instead on one of these, *Dido Building Carthage; or the Rise of the Carthaginian Empire* (no.94), and a coastal view entitled *Sun Rising through Vapour: Fishermen Cleaning and Selling Fish* (no.103); he specified that these were to hang between Claude's *Seaport with the Embarkation of the Queen of Sheba* (no.93) and his *Landscape with the Marriage of Isaac and Rebecca* (known at the time as *The Mill*, fig.30). The affinity between the two grand seaport paintings is obvious; so close is their resemblance at first glance that Turner risked appearing to future audiences as a 'follower' of Claude, whose rights to 'ownership' of this distinctive format have never been in doubt. But this risk evaporates once we examine the visual evidence more carefully, and recognise that the theme and setting of *Dido Building Carthage* – the picture that Turner cherished above all his other works – encourage a reading of both it and its seventeenth-century counterpart as metaphors for landscape painting's capacity to transport the viewer back in time or into the furthest reaches of the imagination.

By pairing *Dido Building Carthage* with Claude's *Embarkation of the Queen of Sheba*, Turner underscored or thematised the idea of departure. In Claude's painting an imminent voyage is promised by the morning sun that illuminates the open sea beyond the harbour. We can trace an elegantly sinuous path from the reclining figure in the left foreground who gazes out through the sequence of boats to the ship anchored in the centre distance. Because the Queen of Sheba has been relegated to the group of small figures descending the staircase at the right, the viewer 'stands' in her place, free to anticipate the departure – or to indulge in a longing for one's own passage away from the everyday. Turner's port scene, in contrast, is enclosed by a bridge in the middle distance. Bathing the scene in tones warmer than those in Claude's painting, the sun rides higher in the sky; here it and the evident surrounding brushwork arrest the eye and vie for attention with the harbour's banks, busy with details of new beginnings in a rising empire. But at the same time the motif of the children's toy boat setting sail in the foreground is subtly emblematic of a later episode in Dido's story – her love for and tragic abandonment by Aeneas. This boat elicits an additional modality of imaginative departure, and states in a most understated yet characteristic way the thematic and programmatic connections between Turner's seaport and Claude's.

The other half of Turner's gift to the National Gallery addresses a different but related avenue of accomplishment in the painting of nature. When Claude originally sold the *Embarkation of the Queen of Sheba* he, or its buyer, paired it with *The Mill*. Turner chose not to match this idealised inland prospect with a similar composition of his own, but to offer a handsome visual counterpoint of sea to land with *Sun Rising through Vapour*. Since the latter testifies to his engagement with seventeenth-century Dutch landscape painting and masters such as Jan van de Cappelle (1624/6–1679) or Aelbert Cuyp (nos.102 and 46), the choice might seem surprising. But rather than underscoring the contrast between the classical and northern schools of landscape – a standard trope of art criticism – Turner's pairing instead celebrates the naturalism that can be discovered in both. Claude's *The Mill* was a particularly good candidate because of its numerous details of rural life: the scattered herd in the foreground, the working mill in the left centre, the detailed weir spanning a river that flows from the distance toward the viewer, and not the other way round. Even the unusually asymmetrical profile of the faraway mountain suggests the kind of first-hand observation that Claude recorded in his drawings but then usually submitted to generalisation in his paintings.

Turner's quiet early morning coastal scene with fisherfolk and boats poised for the day's work seems almost like the first installment in a 'times of day' series, as a complement to Claude's portrayal of late afternoon. In *Sun Rising through Vapour* the suffused light and offshore bank of misty grey clouds are almost palpable, as is the promise of heat from the rising sun – a sun that is nonetheless more materially paint on canvas than Claude's in the *Embarkation of the Queen of Sheba*. In a letter that Turner wrote about *Sun Rising through Vapour* in 1818, he suggested that an alternative title might be 'Dispelling the Morning Haze or Mist'.[21] For Turner, natural effects in his paintings should be read as transient or ongoing; but he surely did not mean for Claude's more static representations to be judged in a negative light. Rather, by placing their two paintings side by side, he sought to display his precursor's as well as his own abilities to treat nature as its own kind of poetry. One can only wonder whether he had read in de Lairesse the advice that

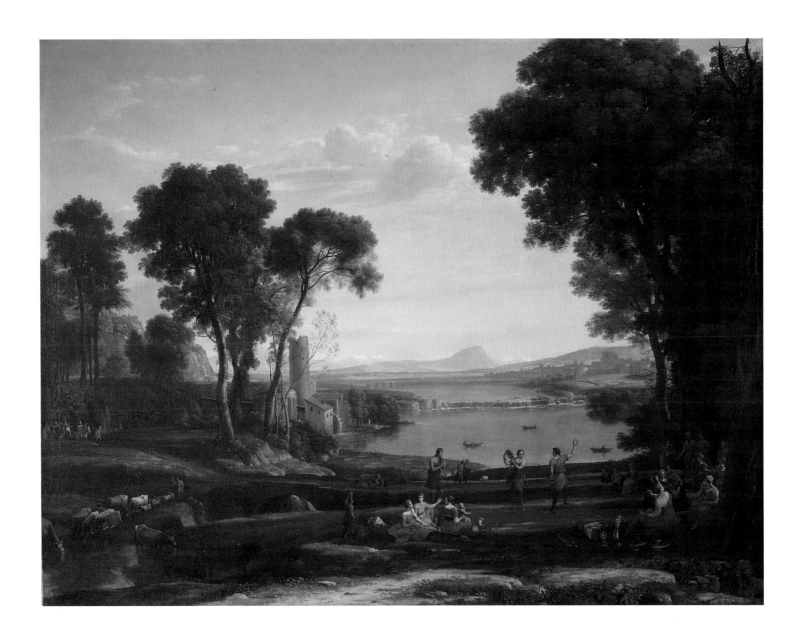

Fig.30
Claude Lorrain
Landscape with the Marriage of
Isaac and Rebecca (The Mill) 1648
Oil on canvas, 152.3 x 200.6
The National Gallery, London

landscape painters should either recreate the 'ancient world' because it was perfect, or paint the world around them because 'Nature is modern, that is, imperfect'.[22] Turner's bequest to the National Gallery allowed the public to appreciate that both he and Claude – and implicitly, perhaps they alone among painters – had fully mastered the two basic categories of landscape.

Over the closing decades of his career Turner engaged in a painter-to-painter dialogue with Claude about the question of landscape's essence and how best to express it. Nowhere can we better follow that exchange than in *Regulus* (no.91), a work that Turner first exhibited in Rome in 1828 and then publicly repainted in 1837. In a curious departure from his mature practice, his initial idea seems to have been to produce a free reworking of Claude's *Seaport with the Villa Medici* (fig.31), which he had sketched and annotated in Florence in 1819. Apart from *Appulia in Search of Appulus*, no picture by Turner so closely echoes a composition by Claude, although *Regulus* also dramatises the lengths he went to distance himself from his model: first through Turner's historical subject-matter and its narration, and then formally, when he revisited his canvas on varnishing days at the British Institution, in an open display of his astonishing technique.

The Roman general Regulus's tragic story entailed a complicated series
of comings and goings. Having failed at a forced mission in Rome to win the
release of Carthaginian prisoners of war, Regulus, on his return to Carthage, was
sentenced to a terrible punishment. His captors first cut off his eyelids, forcing
him to stare into the sun, then sealed him in a spiked barrel, a fate to which
Turner refers in the lower left of his painting. The general himself may or may
not be one of the infinitely tiny figures somewhere on the right. Even more
emphatically than Claude had done in his *Embarkation of the Queen of Sheba*,
Turner puts the viewer in Regulus's place – since it is we, finally, who look
directly into the brilliant spectacle of light that fills the sky.[23] Hence, at the level
of narrative, we relive the torment of Regulus and can imagine his longing to
be free from his bodily plight.

At the formal level Turner's emphatically worked surface, full of the
mark-making that Claude had so tactfully avoided in his skies, creates a visual
web that elicits its own kind of longing from the viewer to mesh with (or recoil
from) the light it represents. From Turner's facture we learn that in essence a
landscape painting must engage the senses as nature does, leading to a heightened
state of awareness that facilitates our transport to the realms it depicts – just as
Claude's images do, if in a much quieter register, by 'conducting' viewers to more
tranquil, calmer settings. Turner challenged his contemporaries, and posterity,
with a heat and turbulence befitting the modern era. He also took the example of
Claude's magical formal transformation of paint into atmosphere to its logical
conclusion by demonstrating – commandingly – that the essence of a painter's
re-creation of the physical world does not consist of rote, mimetic transcription
of nature's details. As Turner's scumbled surface attests, an effect like glowing
sunlight is equally convincing when it has been painted with evident craft and
honesty to the materials of art.

Fig.31
Claude Lorrain
Seaport with the Villa Medici 1637
Oil on canvas, 102 x 133
Florence, Galleria degli Uffizi

Fig.32
Claude Lorrain
*The Arrival of Aeneas before the City
of Pallanteum in Latium* 1675
Oil on canvas, 175.5 x 225
Anglesey Abbey, The National Trust

In a final, poignant gesture, Turner bid Claude farewell by dedicating his last four
exhibited works to Aeneas's quest to found a new empire, a theme also treated by
Claude in one of the most famous of his own late paintings, *The Arrival of Aeneas
at Pallanteum* (fig.32). In Turner's *Mercury Sent to Admonish Aeneas* (no.92), as in
Claude's *Pallanteum*, we can see how each artist in his own way has adjusted the
landscape to the particular story, and the story to its landscape. Each painter draws us
into the scene before us, Claude with decorum and measure, Turner with fervour and
wonderful excess. Both are exemplary landscapes in the way they transport us out of
our own reality. Claude's art takes us back to a crystalline moment locked in a distant
past, albeit a past and a moment refreshed by the image of the natural world into
which it has been set. Turner, on the other hand, summons up that past from the
recesses of his and our collective memory, and then leaves us in a very present state
of awareness – of nature, of art and of our encounter with the essence of both.

Turner Goes Dutch
Sarah Monks

Let us begin, as Turner invites us to, with a Dutch painting that he looked at a great deal: Willem van de Velde the Younger's *A Rising Gale* (no.19). Against a billowing cream-coloured sail appears a figure who grasps the boat's rigging as if to steady himself while he points the way ahead. Having recently turned, it would seem, in order to avoid too-close contact with the oncoming boat beyond (the mainsail's loosened status is indicated by the curves of the shadow across it), this foreground boat thuds against a new swell where the breaking spray glistens in a shaft of sunlight. Above, dark clouds look to be gathering, defined weakly by the remaining daylight which elsewhere breaks through to illuminate a rural coastline. Silhouetted against this distant patch of brightness, we see a three-masted ship whose sails have been slackened and furled up in preparation, perhaps, to anchor and ride out the coming weather. In the distance other vessels appear to come and go independently. Little else would seem to be happening here. Deduction or knowledge might lead us to the fact that these vessels fly the flags of the Dutch Republic, and to the supposition that this is therefore a view across Dutch waters secured by the presence of Dutch naval shipping. Otherwise, there are no proper nouns to employ, and even if we imagine that seventeenth-century viewers knew where these boats are meant to be going, or why, we surely do not. After just two hundred words, my narrative reconstruction of this image has begun to run its course, while van de Velde's work – almost two metres wide and painted with splendid attention to the articulation of wood, waves, sails and clouds – remains emphatically and materially present. This survival of seventeenth-century Dutch painting, long after the fleeting moments it seemed (to modern minds) to depict, together with its persistent emphasis upon the material character of both paint and world, 'art' and 'nature', offered Turner and his contemporaries the means to consider the meanings and possibilities of painting itself. And in a string of some sixty finished canvases, which ran from the first to the last decades of his working life and which turned upon the forms of seventeenth-century Dutch painting, Turner would launch, contest and ultimately define his artistic career.

 Dutch painting had long been a source of deep ambivalence for art theorists. Its apparently unmediated transcription of the world, seeming distance from moral content, sheer abundance and continued popularity across a broad

Willem van de Velde
the Younger (1633–1707)
A Rising Gale c.1672
(detail, no.19)

spectrum of picture buyers, meant that Dutch painting represented a conjunction of artlessness, mindlessness and populism to most writers who considered it, or at least to those seeking to promote the contemporary artist's claims to social and intellectual prestige. Netherlandish painting appeared in these accounts as a form of primitive artistry, its main source of value seeming to lie in the skilful application of paint. The contrast between the mere craftsmanship of Dutch art and the poetic intelligence of its Italian counterpart was one of many in which these two artistic traditions were presented as polar opposites. Whereas Italian art was described in terms of sophisticated narrative revelation, its Dutch counterpart was made out to be a plotless art enumerating the fleeting and unexceptional (even disagreeable) moments of common life through an indiscriminate and excessively materialistic attention to the mere surfaces of objects and of paint. Its lack of significant depicted action meant that Dutch art seemed to have been painted for its own sake, describing appearances on their own terms rather than in any attempt to communicate higher truths. In academic theory, Dutch art therefore served as the necessary negative ground against which to cast the glories of the classical/Italianate tradition.

By the end of the eighteenth century, however, the clear desirability of seventeenth-century Dutch pictures among élite British collectors meant that academic orthodoxy could no longer pass unchallenged. The high-profile exhibition and sale in 1793–4 of the Netherlandish pictures from the celebrated Orleans collection (discussed by Philippa Simpson, p.30) was just one of many London auctions during this period in which the appearance of works imported from the Continent helped to mitigate the hitherto benighted status of Dutch and Flemish art. This trend found important support among contemporary developments in theories of the picturesque, which encouraged the notion that an appreciation of the world's visual appearance, its status as received (and, in art, executed) patterns of light and shade, was more significant than a reading of its narrative or moral implications.[1] Hence the ability to divine the 'unity of colour' in a painting by Aelbert Cuyp, say, carried far greater cachet than the ability to identify either the breed of its cows or the economic connection between their milk and the townscape before which they grazed.[2] The properly 'sensitive' eye received pictures as patterns whose formal qualities (colour, mass, light and shade) resonated with or revolted the viewer's refined sensibilities. Such visual abstraction, informed and facilitated by seventeenth-century Dutch paintings, endowed art with a new and unique agency over the sensual and mental state of its viewers, and supplied the ground upon which Turner's claims to artistic power would stand – or fall.

For until the mid-nineteenth century at least, the proper character of that abstraction was narrowly defined by dominant critical opinion: good art necessarily combined both 'harmony' and 'nature', coexisting interdependently in a relationship that Old Master painting was called upon to verify. A significant instance here was the work of van de Velde, the exemplary quality of whose art resided in its apparent revelation of nature's aesthetic and social harmoniousness. In 1799, the portraitist James Northcote therefore praised van de Velde as 'the Vandyke of Ship painters, on acct. of his flowing happy pencil [brush]', an artist able to tailor his painterly style to the description of both natural and man-made elements in a manner that was deemed 'graceful', 'just' and 'true'.[3] Such comparisons of van de Velde's merits with those of other artists were common

during this period, as the recent influx of so much Old Master painting onto the London art market allowed new critical hierarchies to be envisaged. In particular, judgements focused on van de Velde's relative ranking behind Claude Lorrain, whose 'truth & beauty' were conventionally considered 'manifestly superior', but whose throne the younger Willem and Cuyp apparently jostled with each other to contest.[4]

Turner stepped onto this terrain of comparative assessment, trans-historical competition and potential upheaval when his *Dutch Boats in a Gale: Fishermen Endeavouring to Put their Fish on Board* (the *Bridgewater Sea-Piece*; no.20) – commissioned as a pendant to van de Velde's *Rising Gale* – made its public debut at the Royal Academy in 1801.[5] Here contemporary critics found the fullest realisation thus far of the enormous promise that they had seen manifest in Turner's oil paintings since their first appearance at the annual exhibitions five years earlier – but there were aspects of the young artist's triumph that gave rise to concern. On the one hand, *Dutch Boats* seemed proof that his was an art of grand intelligence, the product of an imagination capable of forming 'a comprehensive view of Nature', and hence of that 'free touch' which enabled him to transcend the superficial appearances of the world. On the other hand, the sheer popularity of *Dutch Boats* ('a peculiar favourite of the spectators') threatened Turner's 'good sense', the giddying 'effects of public favour' seeming to tempt him into a '*liberal stile of painting*' which was characterised above all by the radical openness of its technique. In what would prove a recurrent critical response to Turner's work, one reviewer wrote that this was a picture by an artist so enamoured with '*carelessness* and *obscurity*' that he had allowed the act of painting to exceed the boundaries of depiction. Until Turner could confine paint within 'a firm determined outline', and hence address himself to the 'sober' observation of nature, his 'pre-eminent claims' to greatness seemed likely to remain unfounded.[6]

The broader implications of such criticism – voiced within a society where the boundaries of political representation were repeatedly reinstated – can only be left to resonate here, but shortly afterwards they gained added strength when Turner's painting and its seventeenth-century companion-piece were hung alongside each other. One foot larger in both dimensions than the Dutchman's canvas, and with a sweeping facture which draws emphatic attention to the labour of its own production, *Dutch Boats* reiterates van de Velde's painting at greater volume. In so doing it reveals the radical disconnection between the earlier artist's subject-matter (the momentary passing of vessels), and the temporal and spatial qualities of his creative process (the work of reconstructing in paint, upon a large canvas, the world as seen in a far-reaching view). At the same time, Turner both highlights and calls into question the pictorial naturalism for which his model was justly renowned, apparent, for instance, in van de Velde's juxtaposition of a wooden boom's shining tip against the roseate suffusion of the clouds beyond. In Turner's painting that same juxtaposition verges on a conflict between painting-as-mimesis and painting-as-matter, the jutting boom remaining convincingly present to us while the cloudscape appears as both ethereal insubstantiality and applied pigmented substance. Our abrupt encounter with the picture's surface finds a parallel in the distribution of the foreground vessels, which, unlike those in van de Velde's painting, seem about to collide with one another. Before us, fishermen focus on hauling up their catch from the deep, set upon a sea that is emphatically presented as a gravitational body. Great vortices

appear to have been created here by natural and artistic forces, heavy brushstrokes encouraging us to recognise water and painting as both surface and mass alike. *Dutch Boats* establishes Turner as *painter* and its viewers as painting's witnesses. In his dialogue with van de Velde's painting, Turner found a means of holding art apart, exposing the gap between the world and its representation through the exploration of a pictorial genre in which 'art' and 'nature' were expected to be congruent. Turner's picture represents a refusal to subordinate painting to depiction, liberating 'art' from its culturally ordained obligations to both 'nature' (depiction) and 'harmony' (idealism). As his work's earliest critics suggested, this represented a substantial break with artistic decorum, one that (to some) was uncomfortably redolent of personal claims to public attention.

Competition, with 'nature' and with precedent, hung in the air around Turner's picture. It was commissioned by the third Duke of Bridgewater, the builder of an extensive canal network and one of a trio of aristocrats who bought and resold the 297 Italian and French Old Master paintings formerly in the Orleans collection, a venture from which he came away with huge profits and fifty-two of the most acclaimed examples of Renaissance and Baroque art.[7] From at least 1802, van de Velde's painting and its Turnerian translation were hung with eighteen other works – by such luminaries as Nicolas Poussin, Titian, Claude and Raphael – in Bridgewater's private London picture gallery. Genuflecting to seventeenth-century art but emphatically individualist in its outlook and means, *Dutch Boats in a Gale* – painted by a twenty-five-year-old Englishman – here gatecrashed a room populated by a constellation of canonical European masterpieces.[8] If his earliest biographer was right, and Turner later became 'fully conscious that he had outshone Cuyp, distanced Vandervelde, beaten Ruysdale, rivalled Canaletti, and transcended even Claude', then Bridgewater's gallery was the stage on which those competitions had begun.[9]

Fig.34
J.M.W. Turner
*Spithead: Two Captured Ships
entering Portsmouth Harbour*
(also known as *Spithead:
Boat's Crew recovering an
Anchor*) exh. Turner's gallery
1808 and RA 1809
Oil on canvas, 171.5 x 235
Tate

Over the following decade, Turner continued to explore the pictorial and
metaphorical possibilities of van de Velde's painting in some twelve exhibited
canvases, eight of them painted between 1807 and 1809. All, including *The Junction of
the Thames and the Medway* (fig.33), are variations on van de Velde's theme, playing
upon the social contrast between a plebeian incident in the foreground – fishermen
reeling in their catch or fixing a rudder – and the distant forms of naval authority,
as also upon the material differences between deep tidal waters, scudding coastal
traffic and the anchored bulk of men-of-war. Throughout these works, the adopted
Dutch imagery of differential forces and weights, together with their effects and
their resistance (in the forms of pitching vessels, straining sails and human bodies
that lean against the wind and the tilt), is turned over and over again in Turner's
hands. The result is a series of paintings in which the dynamic relation between one
rolling element (water) and another (sky) appears to condition human experience
and possibility, thus implicitly dramatising the artist's concern with the extent of
his own material and aesthetic powers. No wonder that the bold drama of their
handling prompted Benjamin West's disgust at these 'crude blotches' than which
'nothing could be more vicious' precisely because they represented both the artist's
continued and (it seemed to West) conceited disloyalty to nature and his refusal
to live up to his representational obligations.[10] Yet Turner could elsewhere seem
capable of compliance. His *Spithead: Boat's Crew recovering an Anchor* (fig.34)
offered a patriotic (if actually rather ambivalent) commentary on the monumentality
of contemporary warfare's visual, material and human effects, a commentary that
only Turner's fluency in the forms and meanings of Dutch marine painting enabled
him to make. It was this fluency that was most striking when the painting was
exhibited at the Royal Academy's annual exhibition in 1809. If the image seemed to
represent the 'bulwarks of Britain "towering in their strength"' and a renunciation
of Turner's earlier 'bold eccentricities', the artist at last deciding to 'fall back, like a

true soldier, into the ranks of reason', it also displayed 'the superiority of this man's mind' and of 'the production of his hands' such that 'not only all the painters of the present-day but all the boasted names to which collectors bow sink into nothing'.[11] This was, in other words, a painting to surpass 'the BACKHUYSENS and VANDERVELDES of former days', a world-beating work born of an attentive yet competitive dialogue with his Dutch predecessors.[12] By 1810 (when this picture was exhibited once more) that dialogue – and its artistic possibilities – had begun to take on an additional dimension, in the form of a renewed engagement with the art of Rembrandt van Rijn.

 Turner's first attempts to emulate this most famous of Dutch masters had taken place in the mid-1790s, after his encounter with Rembrandt's nocturnal *Rest on the Flight into Egypt* (see nos.7–9). During this period, Turner is also likely to have seen Rembrandt's *The Mill* (no.58) which, as part of the Orleans collection, had been on view in London for over a year prior to its sale in the summer of 1794. Turner certainly seized the next available chance to view the picture, when it was loaned to the British Institution in 1806 for artists and art students to study. His considered pictorial response was *Grand Junction Canal at Southall Mill* (fig.35), his most direct imitation of a specific Dutch prototype since the *Bridgewater Sea-Piece* nine years earlier.[13] Ever since its arrival in London, Rembrandt's *Mill* had been celebrated for the dramatic chiaroscuro which alone seemed to endow its humble subject-matter with poetic solemnity, even sublimity. Academic art theory ruled that light and shade were to be distributed within an image not only according to the grandeur and 'nobility' of its subject-matter (the more dignified the theme, the more strong shadow and sublime obscurity could be admitted), but also in order to elucidate the picture's meaning; light was always to be shown falling on the main feature of the composition in order to make its narrative significance clear 'at the first glance'.[14] *The Mill* therefore fuelled Turner's conviction that, instead of being restricted to a supportive role, chiaroscuro on its

Fig.35
J.M.W. Turner
Grand Junction Canal at Southall Mill exh.
Turner's gallery 1810
Oil on canvas, 92 x 122
Present location
unknown

own might be powerful enough to constitute the very significance of an image – no matter what academic theory had to say on the matter. For Turner, Rembrandt's painting presented a model of obfuscation and extremes in which the forceful contrast of light and shade seemed to challenge the limits of visual knowledge. As the English artist would note to himself, only 'the sails of the mill are touched with the incalculable [i.e., inexplicable] ray, while all below is lost in inestimable gloom'. Hence the basic economy of Rembrandt's image seemed to Turner to defy pictorial logic, its forms (apart from those of the sails) determined only vaguely by an indirect glow, yet its sky so dramatically lit as to be 'reduced to black and white'.[15]

That perverse economy carries over into *Grand Junction Canal*, whose central foreground zone consists of the shade cast by that most undramatic of elements, a brick wall. Beneath and beyond this shadow, the slope of the earth is rendered so illegible that the picnicking figure above seems alternately to be seated at a roadside and on a clifftop; here one of landscape painting's major challenges – the representation in two dimensions of a three-dimensional gradient – is blithely undercut by Turner in a move that returns us, as before, to the matter of painting itself. A search for significance might lead us to the area below, where a barge appears to pull through the lock. Yet even here we see form only obscurely, the strenuous and confused labours of those opening the gates serving to reveal all the drama of a puny chimney. Moreover, just as in Rembrandt's painting, the towering windmill's relation to the scene before us is as spatially uncertain (its shadow contradicting the general fall of light, its form so backlit that only its sails prevent it from appearing two-dimensional) as it is unclear in meaning. The painting's central subject might therefore be read as the contrast between one form of propulsion (wind) and another (coal), or indeed as a pictorial response to the Grand Junction Canal itself, 'a great National Work' which had cut through the heart of England to both profit and growing concern.[16]

Such a contextual sense of this painting might help us to understand its title and central theme but would leave us guessing at its substantial moments of awkwardness, of formlessness, obscurity and disconnection which (if we believed in the tenet of naturalism, that the most successful image is that which seems most true to its subject-matter) we could only explain as aberrations on Turner's part. Yet the striking character of this picture – that impressive play of dark against light and vice versa – would suggest that Turner intended most of all to make an *aesthetic* impact, one whose force required some inelegance. For as he would mumble to his students, Rembrandt 'depended upon his chiaroscuro, his bursts of light and darkness to be felt'. Content to let the work of 'art' evoke his paintings' meanings, Rembrandt seemed ready to throw 'a mysterious doubt over the meanest piece of Common'. All things – even when they are 'the most objectionable that could be chosen, namely … The Mill' – here become the valid focus of an alchemical hand which can transform them into pictorial artistry thanks to an ability to suspend us in 'matchless colour'. Indeed, to look at Rembrandt's image is (Turner argues) to be drawn into a highly conducive, deeply pleasurable captivity, in which our eye 'dwells so completely enthrall'd' that 'it seeks not for its liberty but as it were, thinks it a sacrilege to pierce the mystic shell of colour in search of form'.[17] A 'shell' or sheer field of colour from which form might only secondarily (perhaps regrettably) emerge, the painting in such a proto-aestheticist account requires little fidelity to the world of appearances (that 'piece of Common'), and owes much to the artist's vision and judgement.

These personal qualities, and their apparent absence, would prove central to Turner's
public reputation, no more so perhaps than when he next turned to engage seriously
with Rembrandt's work some seventeen years later. In the interim, Turner had
occasionally revisited Dutch ground, taking on the manners of both Cuyp *and* his
early nineteenth-century British imitators in at least three large exhibited paintings
(see nos. 60–2).[18] Yet his return to Dutch styles and precedents in 1827 is strikingly
concerted, yielding more than twelve paintings over the following six years. One
likely impetus was the founding of the National Gallery, which by 1827
contained six major oil paintings by seventeenth-century Dutch artists (four of them
by Rembrandt). Another probable impetus was the British Institution's mixed
exhibition of Old Master paintings in 1824, featuring three works by Rembrandt
whose distinct effects Turner would subsequently seek to emulate: *Joseph and
Potiphar's Wife* (fig.36), *The Flight into Egypt* (no.8) and *Portrait of a Man* (fig.38).
Feted as 'a very brilliant specimen of colouring', the first of these had famously been
discovered several years earlier among the detritus of a minor auction-house by the
president of the Royal Academy, Thomas Lawrence. 'Immediately struck by the
picture, even in its dirty and mutilated condition', Lawrence had (newspapers
claimed) bought the work, now 'said to be the finest ever painted by Rembrandt'.[19]
On its exhibition in 1824, however, critics were puzzled by the quiet domesticity of
Joseph and Potiphar's Wife, given its theme of sexual seduction and deceit.[20] Turner's
response to this work – *Rembrandt's Daughter* (fig.37 – amplifies the effect of
chiaroscuro presented by its Dutch referent, while retaining its thematic concern
with the lurking presence of female desire within the home. Exhibited at the Royal
Academy that year, the painting nevertheless drew criticism less for its subject-matter
(the discovery of a daughter's furtive love life) than for its handling: it was 'a
confusion … like nothing we can imagine in nature', a 'parody' of Rembrandt's
painting in an image that seemed to depict 'a great dish of gooseberries and cream'.[21]

Such comments would become most shrill, and Rembrandt's influence
most clear, with Turner's Royal Academy exhibits of 1830, which included *Pilate
washing his Hands, Jessica* and, to his critics' bafflement, *Palestrina – Composition*

(nos. 40, 44 and 26). The last of these seemed to have come from a different painter, one capable of constructing 'gorgeous' and 'dazzling' Italianate aerial transparency beside which the clotted paintwork of *Pilate washing his Hands* and *Jessica* appeared incomprehensible.[22] Together these exhibits tested his contemporaries' tolerance of the aesthetic, rather than the real, as the space within which an artist might operate, in a manner that tied him not to the world of appearances but to that of the picture surface as a site of 'composition'. As a 'conundrum' whose human and architectural forms seem to merge indecipherably into one another – Turner clearly having read works such as Rembrandt's *The Woman Taken in Adultery* (no.39) and *The Flight into Egypt* (no.8) as models of dissolution – *Pilate washing his Hands* sorely tested its viewers' willingness to grant artistic licence.[23] Displaying blithe disregard both for the central pillars of meaning within European art (Christ here is rendered 'a something – alive, we suppose, but whether with a head or without a head, or whether going out, or coming in, to the scene, nobody but Mr. TURNER himself can explain') and – by dint of its ostensible subject-matter – for the consequences of one's own actions, *Pilate washing his Hands* was nevertheless 'lovely, compared with a thing called "Jessica"'.[24]

That 'thing' represented a flagrant transgression of art's accepted boundaries, in part due to the 'smeared and daubed' field of 'King's yellow' at its centre.[25] Consisting of sulphur and pure arsenic, this poisonous, foul-smelling and highly reactive pigment had only occasionally been used in painting, despite the common view among artists that it produced 'the most beautiful colour we have'.[26] Nevertheless, the extent of this colour's dramatic use by Rembrandt had recently been made apparent at both the 1824 exhibition – where his *Portrait of a Man* had appeared '"all gold"; the hair is bright yellow, the beard, the mustachios, the face, all daubed with yellow' – and the public sale four years later of his *The Jewish Bride* (fig.39).[27] And just as Rembrandt here deployed yellow to alchemical effect, turning a simple gesture of intimacy into a rich experience of sensory

Fig.39
Rembrandt van Rijn
Portrait of a Couple dressed as Figures from the Old Testament
known as *The Jewish Bride* c.1665–9
Oil on canvas, 121.5 x 166.5
Rijksmuseum, Amsterdam

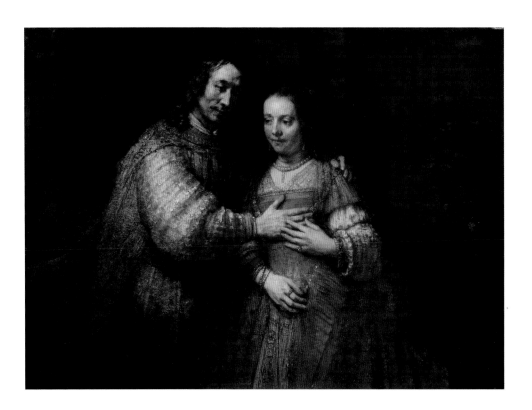

Fig.40
Jacob van Ruisdael
Rough Sea at a Jetty
c.1670
Oil on canvas, 110 x 160
Musée du Louvre,
Paris

warmth and weight, so Turner's *Jessica* directs this golden hue to both narrative and
aesthetic ends. Exhibited with a mock quotation from Shakespeare's *Merchant of
Venice*, Turner's painting depicts the moment at which Jessica obeys her father
and shuts herself off from the world of masque, music and art beyond his
window, while realising that she will soon open it again in order to see (and elope
with) her lover. *Jessica* therefore is concerned with the relationship between art,
vision and love, the golden backdrop signifying both Jessica's state of heightened
visual desire and the preciousness with which she is endowed by lover and father
alike.[28] For Turner's critics, however, the artist seemed to have done little more
than shove this colour down their throats, its blazing effect comparable for many
to that of mustard powder. Deriding their rough music and blindness to sheer
aesthetic delight, *Jessica* suggested that Turner was willing to sacrifice his own
'taste, and talent, and genius' in a revolt against art's regulation by nature. As one
critic wrote, 'Let Mr. Turner stick to landscape, and tint it from nature's pure
tints, not from his own imagination'.[29] A return to order is here commanded
in which 'nature' and the obligation of its depiction might be reasserted at the
expense of those realms that defy regulation: imagination, eccentricity and
individual abstraction.

These realms had all come to be located at the forefront of Turner's
practice, as is amply evident from *Port Ruysdael* (no.70), a painting exhibited three
years earlier and one that seems to herald his subsequent exploration of the seascape
as a site for pictorial abstraction. Paradoxically it does so by looking back in time, on
this occasion to the work of another seventeenth-century Dutch painter, Jacob van
Ruisdael. At least four of Ruisdael's many views of rough seas with sailing boats are
likely to have been known by Turner (nos.69 and 98).[30] All set white water against
dark, and dark clouds against white, to produce images in which the drama of
stormy elements is heightened and aestheticised by the minimalism of the palette
with which they are painted. In 1802 Turner's notes on one of these paintings (fig.40)
had emphasised this dynamic, somewhat antagonistic relation between nature and

Fig.41
J.M.W. Turner
Three Seascapes c.1827
Oil on canvas, 90.8 x 60.3
Tate

artistry: admirably, Ruisdael had allowed tones of brown underpaint to pervade much of his sea 'so as to check the idea of it being liquid', but in choosing to combine this with a starkly lit zone of improbable white-water waves, the Dutch artist seemed to have overplayed his hand, ensuring that the whole was too 'artificial', 'glaring' and full of 'inattention' to natural forms.[31] Twenty-five years later, Turner would return to this antagonism between art and nature, this balance of opposing spheres, finding its perpetuation (at which Ruisdael had previously seemed to fail) a means of depicting natural forces and hence of endowing his images with poetic meaning. His concern with the expressive effect of reducing space to pattern can therefore be seen in his remarkable *Three Seascapes* (fig.41), a canvas of oil sketches in which the bare bones of the genre – the natural forms of sea and sky – are alternated, turned upside-down and recycled over and again like a litany. In *Port Ruysdael*, the intense visual drama produced by this banding effect, of dark and light, near and far, water and cloud, is turned to sensory effect by the wind, which seems not only to fill the sails of a boat as it crashes its way through opposing waves but also to whip against a precarious beacon on the painting's far left-hand side. The implications of this striking forcefulness – of aesthetic and thematic means alike – come home in the foreground, where we see the weatherbeaten form of an old pier, buffeted by a surging tide which threatens to invade our space. There, in front of us, lie the upset contents of the fisherman's basket to which the scudding boat will return, an emblem of futility set within a bleak and steely environment. The quiet horror of this scene and the pathetic fallacies it invites were noted by the critic Robert Hunt, for whom the painting offered 'an ocean of maritime and sentimental pleasure', conjuring both nature (the sea's 'freshening influence') and the imagination ('gleams of hope amidst surrounding glooms of fate').[32] It is therefore significant that there is no such place as 'Port Ruysdael', this openly fictional title suggesting not only that Turner has been to Ruisdael for inspiration but also that the painting's redolence of the sea is as much due to the artist's imaginative engagement with art as to any studied contact with nature. But if Turner had absorbed Ruisdael in order to present his painting as a site of pictorial invention, he had contemporary competition. Hanging nearby in the same Royal Academy exhibition was Augustus Wall Callcott's *Heavy Weather coming on, with Vessels running to Port* (fig.42), a 'very extraordinarily-felt and executed picture' which Hunt considered equal to *Port Ruysdael*.[33] Commissioned as a pendant to Turner's *Ships bearing up for Anchorage* (exh. RA 1802; Petworth, allocated to Tate 1984) by the latter's longtime patron, the third Earl of Egremont, Callcott's work draws on an Old Master painting in the same way that Turner had with van de Velde some twenty-six years earlier. For Callcott, however, that Old Master painting was none other than Turner's *Dutch Boats in a Gale*, which was now effectively assigned to the past – just as three decades earlier Turner's picture had signalled his own supercession of van de Velde.[34]

For by 1827 Turner had two rivals – Callcott and more recently Clarkson Stanfield – whose success with public and patrons alike was largely due to their ability to provide finely-wrought, less challenging versions of quintessentially Turnerian subjects (in particular Dutch-influenced seascapes), while Turner's most ambitious canvases remained in his studio, unsold.[35] Partly in an elaborate pictorial dialogue with these competitors through which he asserted claims to pictorial territory and authority, and partly in a self-conscious meditation on the past, present and future of his painting, Turner began to return (from the early 1830s and repeatedly during the final decades of his

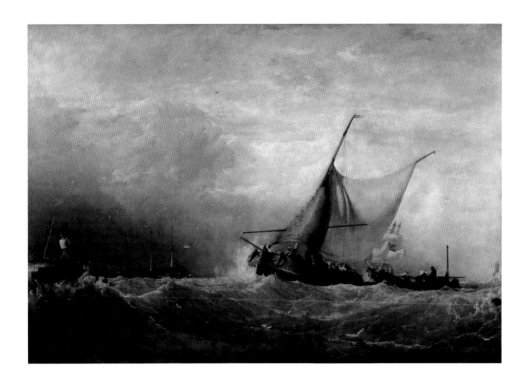

Fig.42
Augustus Wall Callcott
*Heavy Weather coming
on, with Vessels running
to Port* exh. RA 1827
Oil on canvas, 115.5 x 169
Petworth House, The
Egremont Collection.
Acquired in lieu of tax
by HM Treasury in 1957
and subsequently
transferred to the
National Trust

career) to the scene of some of his earliest victories: that imagery of expansive
maritime space and its loose painterly evocation developed through his
encounter with van de Velde in 1801.[36] And when *Dutch Boats in a Gale* (no.20),
the original outcome of that encounter, appeared alongside its van de Velde
pendant (no.19) in the British Institution's Old Master exhibition of 1837,
Turner's response was *Fishing Boats with Hucksters bargaining for Fish* (fig.43),
a work that follows the composition, subject-matter and large size of his own
earlier painting. Turner painting Turner painting van de Velde, *Fishing Boats
with Hucksters* is both a return to the primal scene of his own emergence as a
distinct 'genius' and a proclamation of his readiness to become – while still alive –
an Old Master painter. Yet it represents more than a rehearsal of Turner's past
glories, for like *The Fighting 'Temeraire'* (1839, National Gallery, London) it also
comes laden with regret about the social changes that had occurred in the
interim: where *Dutch Boats in a Gale* foregrounds fishermen absorbed almost
heroically in landing their catch, *Fishing Boats with Hucksters* depicts the
onboard squabbles of petty hawkers who barter over trivial sums.[37] This is a
world where competition has lost its frame of reference, and in which creativity
and achievement – signified by a small empty fishing boat, golden in reflection –
lies neglected yet tethered to the vessel it must serve. The boat's closest visual
affiliation is rather with the distant and glowing horizon, towards which it seems
to swing. A meditation on the tensions between duty and desire, and between
the realities of Turner's old age and the shining possibility represented by his
youthful work, *Fishing Boats with Hucksters* reflects on the passage of the artist's
career since 1801, when Bridgewater had 'launched my Boat at once with the
Vandevelde'. Asked to name his price for it in 1844, Turner was open to any offer
as long as it came from the second Duke of Sutherland, who had inherited both
'the Vandevelde' and *Dutch Boats in a Gale*: the new painting had to 'work up
against the reputation of' its two predecessors, beside which Turner wished it
could be displayed.[38]

Tested by his own spectre, the artist was now concerned to compete not only with Old Master tradition and contemporary rivals but also with himself, in a painting that demonstrates his continued abilities to set the world in motion by manipulating paint on canvas. Crowned by a flag inscribed 'J M W Turner', *Fishing Boats with Hucksters* was a fitting confirmation of the present tense in one critic's comment on seeing *Dutch Boats in a Gale* in 1837: 'at least, in one department of the fine arts, there is in this country living merit, as high as that which is attached to the greatest name [van de Velde], in that department, of former days'.[39] Yet Turner's painting was also about more than persistence, for what is most striking in the comparison with his early work is the transformation in his oil painting practice. Its palette dominated by paper-white tones, and the whole produced with soft, fluid strokes and dry scumbling over what appear to be muted washes of colour, *Fishing Boats with Hucksters* has been painted in the style (perhaps even with the aid) of watercolours. This was a manner that Turner had recently begun to apply systematically to his oils, and one which facilitated both the thorough dissolution of natural forms and the imaginative expression of natural forces which would henceforth characterise his work.[40] As before, Turner had found in Dutch painting – and its imitation – the grounds for rethinking painting itself.

Fig.43
J.M.W. Turner
Fishing Boats with Hucksters bargaining for Fish exh. BI 1838
Oil on canvas, 174.5 x 224.9
The Art Institute of Chicago.
Mr and Mrs W.W. Kimball
Collection, 1922

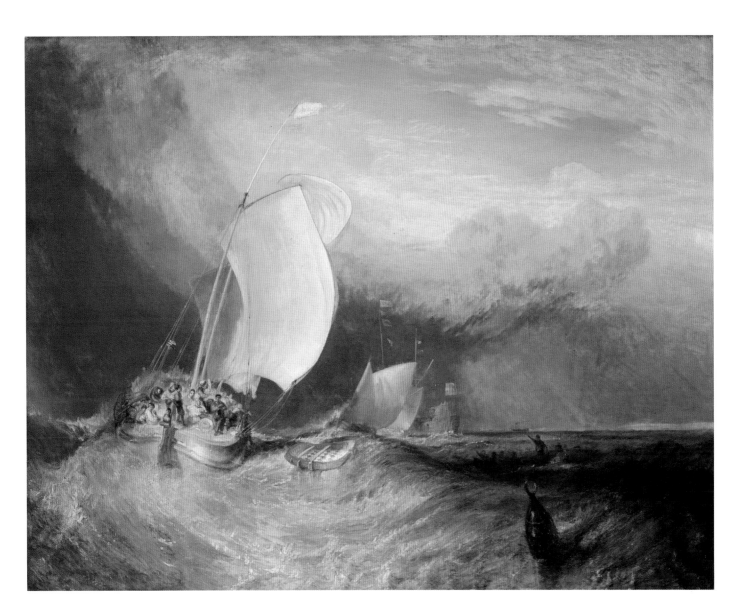

'*He said he held it very low*':[1] Turner and Contemporary French Landscape Painting in 1802

Guillaume Faroult and David Solkin

FOR ANNE-LISE DESMAS

Turner's tour of France and Switzerland in the summer and autumn of 1802 (roughly between 15 July and 20 October) marked a defining moment in his career: this was the first excursion outside the United Kingdom for an artist who would undertake many more, and for whom travel was a central source of creative inspiration and renewal. After nearly ten years of war between Britain and France had come to an end (temporarily, as events turned out) with the signing of the Treaty of Amiens on 25 March, Continental tourism had once again become possible, and Turner seized his opportunity with enthusiasm. Although he spent the greater part of his time abroad travelling and sketching in the Alps,[2] like many other British artists (and art lovers), he was also anxious to go to Paris; for it was here, in the Musée central des Arts located in the Louvre, that the Napoleonic regime had assembled the greatest collection of art treasures that modern Europe had ever seen, taken from Italy and Flanders as well as the French provinces; this at a time when no other country – least of all England – enjoyed the luxury of a comparable 'universal museum'.[3]

But the French capital possessed at least one other important attraction for artists from across the Channel. Paris around 1800 was a brilliant and alluring creative centre for internationally renowned painters and sculptors, where the activities of the press and specialist publishers maintained an intellectual climate especially favourable to reflection and debate. The Salons – public displays of contemporary works of art, which began to be held regularly in 1737, and the direct inspiration for the annual exhibitions held in London from 1760 – were art events that had long attracted the interest of visiting British painters, and after their prolonged period of isolation on the other side of the Channel, perhaps especially in 1802.

Thanks to Joseph Farington, we know that Turner went to the Salon at least once, towards the end of his longest stay in Paris, which lasted from around 27 September to 5 October. His recorded comments on the contemporary artistic scene were as unkind as they were laconic: 'I looked generally over the French Exhibition with Turner', Farington tells us, 'He said he held it very low – all made

Jean-Victor Bertin
Mountainous Landscape with a Procession c.1802 (detail, fig.51)

up of art: but He thought Madame Gerards little pictures very ingenious.'[4]
Presumably, 'very low' refers to the parlous current state of the French School, rather
than to any imputation of vulgarity, while the accusation of artifice – of a concern for
art to the exclusion of nature – had been a commonplace in British criticism of
modern French art going back at least as far as the 1780s. Furthermore, to single out
some small-scale scenes by a female artist (including fig.44), and to describe them as
'ingenious', was of course to damn with faint praise, whilst implicitly reinforcing the
clichéd association between Frenchness, femininity, triviality and affectation.[5] Yet
nonetheless it seems fair to ask whether such dismissive comments do full justice to
Turner's response to the Salon, and to all of the contemporary art he encountered
while in Paris. Given the general climate of hostility between Britain and France,
less than six months after nearly a decade of bloody warfare, it would have been
surprising if any members of the phalanx of visiting British artists had publicly
extolled the achievements of their French counterparts, at least as a collective body.
When Farington, for example, returned from his first visit to the Salon, he confided
to his diary that the exhibition had 'not given me a very high impression of French
painting. I would scarcely have imagined there could be so much uniformity in the
Art practised in any Nation'.[6] Although such opinions were far from unexceptional,
there is evidence that the important London artists who went to Paris – including
the president of the Royal Academy, Benjamin West, and his fellow academicians
Farington, Henry Fuseli, John Flaxman (1755–1826), John Opie and Turner –
engaged in animated discussion about everything the Parisian art scene could then
offer in abundance: not just the Louvre, private collections and monuments, but
also France's most celebrated contemporary masters.

Although Turner neither spoke nor read French, during his brief stay in
Paris he frequented a coterie of British artists who had made it their business to
familiarise themselves with all the latest trends. A few, notably West, enjoyed an
extremely active social life, and made the acquaintance of a number of outstanding
French artists – not just Jacques-Louis David, the acknowledged leader of the
French School, but also François-André Vincent (1746–1816), François Gérard
(1770–1837) and Pierre-Narcisse Guérin (1774–1833).[7] By 2 September, Joseph
Farington was reporting an opinion that must have been extensively shared by the
British visitors: 'Philips [the painter Thomas Phillips, 1770–1845] has been in Paris
10 weeks and has seen a great deal of what is going forward in Art. He said the
following were the best Artists David, Vincent, Gerard, Arode [i.e. Hérold] …
History, Tawney [Nicolas-Antoine Taunay, 1755–1830], Valenciennes [Pierre-Henri
de Valenciennes, 1750–1819] … Landscape'.[8]

Thus the small band of British artists with whom Turner associated while
in Paris were well informed about the latest fashions in French painting. They
knew the names and debated the merits of the leading historical artists, with most
agreeing that David was inferior to Guérin, whose *Return of Marcus Sextus* (fig.45)
they particularly admired. Turner expressed his approval (or at least his curiosity)
by seizing the chance afforded by a visit to Guérin's studio to make an evocative
drawing of this famous composition (fig.46). Even so, however, his dislike for the
linear bias of modern French figurative art remained undiminished. Some years
later, in a note inscribed in the margins of his copy of John Opie's *Lectures on Art*
(1809), Turner condescendingly referred to 'the work of David and the French
school, where draughtsmanship is everything'[9] – of far greater import, in other
words, than he felt it ought to have been.

Fig.44
Marguerite Gérard
*Regrets, or Girl in a Landscape,
Weeping on Seeing Her Lover's
Mark Inscribed on a Tree Trunk*
exh. Salon 1802
Oil on wood, 44 x 36
Present location unknown

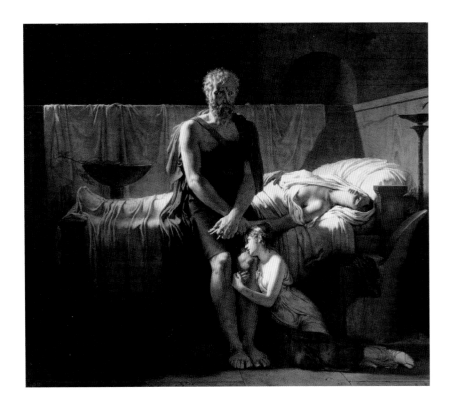

Fig.45
Pierre-Narcisse Guérin
The Return of Marcus Sextus
exh. Salon 1799
Oil on canvas, 217 x 243
Musée du Louvre, Paris

Fig.46
J.M.W. Turner
*Copy after Guerin's
'The Return of Marcus
Sextus'* 1802 from 'Studies
in the Louvre' sketchbook
Pencil and chalk, 12.9 x 11.4
Tate

One would like to know more about Turner's views on contemporary French landscape art, which at the opening of the nineteenth century was undergoing something of a renaissance. Not only were more artists practising the genre than ever before but also the field had considerably diversified and become the subject of deeper study. Just two years prior to Turner's visit Pierre-Henri de Valenciennes had published his *Elements of Practical Perspective for the Use of Artists, Followed by Reflections and Advice to a Student of Painting, and of Landscape Painting in Particular*,[10] the first French analytical treatise dedicated to landscape. The work is of considerable importance for its re-evaluation of landscape theory, formerly considered a more or less minor discipline, and the book immediately enjoyed a resounding success. A German translation rapidly followed, but the work never appeared in English. Yet even though Turner could not have read Valenciennes' book, he may have heard about it through intermediaries, and in any case would have seen several of its key principles put into practice on the Salon walls.

Here our arguments must necessarily enter the realm of informed speculation, albeit based on the secure knowledge that Turner on the one hand, and Valenciennes and his circle on the other, had an important common interest: historical landscape painting and, more specifically, historical landscapes done in the classicising manner of Nicolas Poussin. The first concrete signs of Turner's interest in Poussin date from around 1798, when he produced his earliest known copies of the seventeenth-century master's work (e.g. fig.12);[11] two years later he painted and exhibited the *Fifth Plague of Egypt* (see fig.3), an ambitious exercise in the Poussinesque sublime. It was with this selfsame work, fusing a storm scene with a Biblical story, that Turner began to essay the creation of a particularly elevated form of landscape regarded as 'historical'.[12] Here Turner may have been following the example of West, who at the Royal Academy in 1797 had shown a work entitled

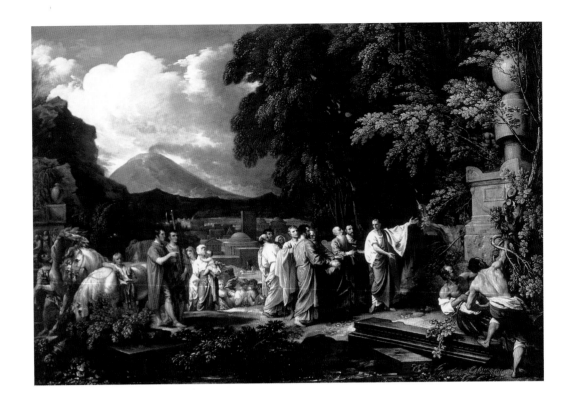

Fig.47
Benjamin West
*Cicero Discovering the
Tomb of Archimedes* exh.
RA 1797
Oil on canvas, 125 x 180
Collection of Mr and
Mrs Michael D. Eisner

Cicero Discovering the Tomb of Archimedes (fig.47); this was described in the exhibition catalogue as an 'historical landscape', and according to the connoisseur George Beaumont was 'superior . . . even to the Landscapes of N. Poussin'.[13] Turner's *Fifth Plague* must have been designed to provoke similar comparisons, as was his *Tenth Plague* of two years later, (fig.58) which seems to have been modelled on Poussin's *Landscape with Pyramus and Thisbe* (fig.48), then in the collection of Lord Ashburnham. Thus when Turner left for Paris in the summer of 1802, he had already claimed the historical landscape tradition that had originated with Poussin as a prestigious legacy of his own.

No wonder, then, that Turner devoted so much time to studying Poussin's paintings in the Grande Galerie of the Louvre. Of the nineteen examples that were then on view, Turner made notes on no fewer than fourteen; only Titian and Rembrandt stimulated his interest to anything like a comparable degree.[14] By contrast, he seems to have paid little or no attention to the works of Claude Lorrain, who amongst all the great landscape masters was the one who normally preoccupied him the most. The hypothesis that the seven Claudes in the Louvre were too poorly lit to permit close examination is not entirely convincing;[15] so it may well be that as far as the classical landscape tradition was concerned, Turner's allegiances at this particular moment had swung in the direction of Poussin. Thus knowingly or otherwise, he would have found himself occupying much the same position that Valenciennes had advocated in his *Elements of Practical Perspective*. The publication of this treatise in 1800 marked the theoretical culmination of a regeneration of Poussinesque landscape art that had been under way in France for the better part of two decades. Valenciennes' principal aim was to promote the cause of historical landscape, which he defined as the domain of artists who 'stirred the imagination ... and moved the soul with sentiments other than

admiration', aspiring to the '*beau idéal*'.[16] The unrivalled master of this art was not Claude, but Poussin, whom the *Elements* presents as an heroic figure, and not just as a skilful imitator of nature but a true creator in his own right.[17] 'Claude', writes Valenciennes, 'portrayed the morning dew as it really was. You can see its freshness imprinted on the earth and the foliage. Poussin however depicts Aurora preceding the Sun's chariot, scattering pearls and flowers upon Nature. One gives us the rising Sun, the other makes it rise.'[18]

It was Poussin's example that Valenciennes set out to emulate in his finished landscapes from the late 1780s onward (as opposed to the oil sketches from nature for which he is most admired today), and that he urged his fellow countrymen to follow. Of the 385 entries listed as paintings in the catalogue of the Salon of 1802, 115 are explicitly classified as landscapes, with the small number of historical compositions receiving the lion's share of critical attention. Few of the exhibits, in any genre, attracted more attention than the *Act of Bravery* (fig.49), an historical landscape by Nicolas-Antoine Taunay (1755–1830) – the same 'Tawney' whom Thomas Phillips had singled out, alongside Valenciennes, as the 'best' of the French landscape specialists.[19] Valenciennes exhibited several works under the same catalogue number (perhaps an indication that they were not pictures of major importance, or that some or all had appeared in previous Salons), and unfortunately

Fig.48
Nicolas Poussin
*Landscape with Pyramus
and Thisbe* 1652
Oil on canvas, 193 x 273
Städel Museum, Frankfurt
am Main

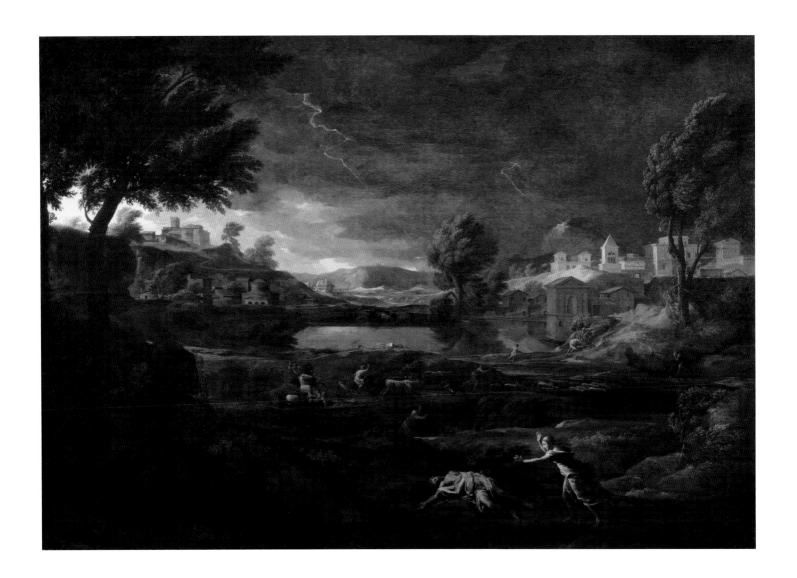

Fig.49
Nicolas-Antoine Taunay
Act of Bravery exh. Salon
1802
Oil on canvas, 197 x 293
Musée de L'Echevinage,
Saintes

none can be identified today; an austere composition shown in 1798 may give a
broad indication of their appearance (fig.50). But of all the landscapes in the Salon of
1802, it may have been those by Valenciennes' pupil Jean-Victor Bertin (1767–1842)
that most comprehensively met the criteria of excellence prescribed by his teacher.
The titles of Bertin's most ambitious submissions exude an aura of solemn or
meditative antiquity: *Callimachus Inventing the Corinthian Capital* or *Entrance to a
Wood; in the Foreground a Shepherd Playing the Flute*. The most ambitious of these
compositions (no.702 in the Salon catalogue) was called *A Site in the Alps in the
Setting Sun: The Subject of the Figures is a Feast of Flora* – presumably a work very like
(and possibly even identical to) the *Mountainous Landscape with a Procession* that
appeared on the New York art market about a dozen years ago (fig.51).[20] Although
also indebted to the vertical compositions of Gaspard Dughet, Bertin's image reveals
a remarkable lucidity in its chiaroscuro and a quasi-geometric order in its planar
structure that follow closely on the heels of both Poussin and Valenciennes. A more
unusual feature is the insertion into the upper centre of the composition of a
grandiose but tranquil mountain view, presumably an idealised prospect of the Alps.
Of course Turner had just come back from his first tour of this region, and he may
already have been considering the idea of painting an alpine landscape in the manner
of Poussin; but whether or not he paused to examine Bertin's *A Site in the Alps in the
Setting Sun*, or any similar works by Valenciennes, his own way of addressing the
same pictorial challenge would turn out to be diametrically opposed to theirs.
Prior to his first journey to the Continent, Turner had sought to emulate Poussin

Fig.50
Pierre-Henri de
Valenciennes
*The Idalian Woods with
Cephisa and Cupid* 1797;
exh. Salon 1798
Oil on wood, 42 x 76
National Gallery of
Canada, Ottawa

first and foremost as a painter of sublime imaginary landscapes – a task he resumed after returning to London, when he produced his own radical reworking of the master's *The Deluge* (nos.29 and 30), together with *The Destruction of Sodom* (fig.52). Like Taunay's *Act of Bravery*, the *Sodom* refers back to Poussin's highly ordered prospects of human drama in extremis (for example, fig.48); but where his French contemporary accentuated the element of order, Turner took precisely the opposite course by opting for dramatic disorder, almost to the extent of narrative and painterly chaos. But after visiting Paris he also for the first time turned his attention to Poussin's calmer, more purely classical scenes. It was to this type of work that Turner paid homage with the *Châteaux de St. Michael, Bonneville, Savoy* (no.28), which he exhibited at the Royal Academy in 1803. On this occasion, perhaps somewhat surprisingly, the specific painting by Poussin that he had in mind was not one of the nineteen works he had seen in Paris, but instead the *Roman Road* (no.27) belonging to the London dealer Noel Desenfans, who in 1802 had put his entire collection on public view. If Turner had Bertin or Valenciennes even remotely in his mind when he set to work on the *Châteaux de St. Michael* (as with Taunay, in the case of *The Destruction of Sodom*), they could only have represented examples that he wished to surpass, or indeed at all costs to avoid. Whereas modern French painting was all 'made *up of art*', Turner was determined to show that he had looked closely at nature, and that he could transfer the fruits of that study onto a finished canvas; that in place of a smooth finish and precise outline drawing, he believed in rich colours and painterly textures; and that instead of mere ingenuity, he could offer the breadth

and boldness of creative genius. Finally, implicit in this enterprise was Turner's claim to a superior understanding of Poussin's art – an understanding that he doubtless felt surpassed that of West, never mind that of their French contemporaries. When compared with works like the *Sodom* or the *Bonneville*, the landscapes of Valenciennes and his followers may look more calculated and correct, especially as far as their spatial order is concerned; but the viewer takes away the impression of structure for its own sake, and that is devoid of any sense of genuine engagement with an observed place in the outside world. For Turner art on its own – including the art of Poussin himself – was simply not enough.

Does this mean that Turner learned nothing at all from his visit to the Salon in 1802? Given his highly competitive personality, and the immediacy with which he responded to any potential rivals, he is unlikely to have ignored the modern French landscape school altogether – especially since its central preoccupations (with historical subject-matter, and with Poussin) were also

Fig.51
Jean-Victor Bertin
Mountainous Landscape with a Procession c.1802
Oil on canvas, 83 x 61.9
Present location unknown. Sold Christie's 21 October 1997, lot 341

very much his own. Although the case is impossible to prove, it seems entirely conceivable that the encounter with Valenciennes and the painters in his coterie helped the young Turner to define his own identity at a crucial moment in his career, when his exposure to the glories of the Louvre threw the issue of his relationship to the Old Masters into question perhaps as never before. Judging from the works he produced in the years following his trip to Paris, Turner seems to have returned home with a strengthened sense of commitment to two discrete, even contradictory objectives: to immerse himself still further in the classical landscape tradition (of Claude as well as Poussin), and to pursue the study of nature (even to the point of painting directly from the motif) with even more vigour than he had hitherto displayed. The landscapes that he saw – and on the whole disliked – on that October day in the Salon may have been only one of several factors that assisted Turner in clarifying his artistic priorities; but there are times when even a negative example can help a painter find his way.

Fig.52
J.M.W. Turner
The Destruction of Sodom
exh. Turner's gallery 1805 (?)
Oil on canvas, 146 x 237.5
Tate

Education
and Emulation

David Solkin

William Turner (as he styled himself until he became J.M.W. Turner, R.A., in 1802) embarked on his formal artistic training at the age of fourteen, in 1789, when he spent a short time working in the drawing office of the architect Thomas Hardwick (1752–1829) before entering the studio of the architectural draughtsman Thomas Malton (1748–1804), whom he later described as his 'real master'. Here he learned the rules of perspective and a highly disciplined use of line, in the usual way of young eighteenth-century artists: that is to say, mainly by studying and copying works by his teacher and other established masters, and by producing his own pictures in their manner. By December of that year, when Turner gained admission to the Royal Academy Schools after one term's probation, he would already have absorbed the all-important lesson that artists were meant to learn their craft by emulating those who had come before them – and it was this principle, together with a commitment to drawing industriously from nature, that guided him during the first decade of his career proper and beyond.

According to the watercolourist Edward Dayes (1763–1804), writing in the opening years of the nineteenth century, Turner 'acquired his professional powers … by borrowing, where he could, a drawing or picture to copy from; or by making a sketch of any one in the Exhibition early in the morning, and

J.M.W. Turner
Harlech Castle, from Twgwyn Ferry, Summer's Evening Twilight exh. RA 1799 (detail, no.15)

finishing it at home'.[1] Only a very small proportion of such works survive, among them a copy of part of a print after the Italian artist Pietro Fabris (c.1740–1792) (nos.1 and 2), as well as several drawings after the topographical draughtsmen Thomas Hearne (1744–1806) and Michael Angelo Rooker (1743–1801). In addition there are the numerous close paraphrases of the watercolours of John Robert Cozens which Turner manufactured in collaboration with his exact contemporary Thomas Girtin during the mid- to later 1790s (for example, no.16), for which they were paid small salaries by the physician-cum-amateur artist, Dr Thomas Monro; at the latter's informal evening art school, Turner also copied a number of views by Dayes, and produced some of his first tentative essays in the calligraphic manner of Canaletto. A few years previously he had also briefly turned his attention to the work of the Alsace-born Royal Academician Philip James de Loutherbourg, whose characteristic compositions he closely imitated on a number of occasions (figs.53 and 54) – rather surprisingly, perhaps, considering that in the early 1790s Turner was principally engaged in making fairly pedestrian watercolours of architectural subjects, whereas de Loutherbourg was best known as a painter of highly theatrical sublime landscapes (for example, fig.68).

But this was the direction in which the younger man was heading. By 1795 or thereabouts, on his first visit to Richard Colt Hoare (1758–1838) at Stourhead, Turner encountered a set of unusually large and visually forceful watercolours of classical ruins by the Swiss Abraham-Louis-Rodolphe Ducros (1748–1810). It was these works (for example, no.5), together with the dramatic etchings of Giovanni Battista Piranesi (1720–1778), that Turner then assimilated in the

Fig.53
J.M.W. Turner
*A Rocky Shore, with Men
Attempting to Rescue a Storm-tossed
Boat* c.1792–3
Pencil and watercolour,16.1 x 23.2
Tate

Fig.54
Philip James de Loutherbourg
Smugglers Landing in a Storm 1791
Oil on canvas, 106.7 x 160
Victoria Art Gallery, Bath

series of monumental watercolour views of Gothic church interiors (such as nos.4 and 6) that he went on to execute (and often to exhibit) in the following five years. Stourhead also gave him his first prolonged exposure to a significant collection of Old Master landscape paintings, with consequences that were both immediate and profound.

In particular, Colt Hoare's treasured Rembrandt of *The Rest on the Flight into Egypt* (no.8) appears to have struck Turner with the force of a potent revelation. In a lecture given around fifteen years later, he was still speaking with reverence of the picture's 'aerial perspective enwrapt in gloom'[2] and of its contrasting light effects – features that he'd appropriated for use in some of his first attempts at oil painting (see nos.7 and 9). Turner was evidently fascinated at first sight – as indeed were many of his contemporaries – by Rembrandt's magical ability to endow the most mundane scenery with an aura of poetic mystery. There were few lessons of greater importance that the British painter would ever learn.

But if Stourhead exposed Turner to the famous Dutchman's mastery of common nature, it also contributed to his ongoing education in what the Royal Academy took to be the most elevated form of landscape – the classical tradition identified above all with a trio of seventeenth-century Franco-Roman painters, Claude Gellée (known as Claude Lorrain), Nicolas Poussin and Gaspard Dughet. As befitted a neo-Palladian villa

perched above an extensive garden dotted with temples, sculptures and inscriptions evocative of Roman antiquity, the picture collections at Stourhead also included works by or after (in the case of Claude) all three of these masters, as well as a mythological scene by their leading eighteenth-century British follower, in the form of Richard Wilson's Gaspard-like *Lake of Nemi, or Speculum Dianae* (no.12). Possibly on his own initiative, or more likely at the request of Colt Hoare, in around 1798 Turner painted what surely must have been intended as a pendant to Wilson, featuring another famous Italian lake, Lake Avernus (no.13), at dusk (instead of broad daylight), and with figures from Virgil's *Aeneid* rather than Ovid's *Metamorphoses*. Here, according to the dictates of academic pedagogy, was a textbook example of how emulation was meant to work, resulting in a picture that was (as Wilson's *Nemi* had been in its turn) both like and unlike its highly respected precursor. But Colt Hoare may have found the Turner too derivative, and there is no evidence that it ever entered his collection.

Aeneas and the Sibyl, Lake Avernus dates from a time in Turner's early career when he was particularly preoccupied with Wilson, who since dying in drunken penury in his native Wales had come to be regarded as the main founder of the British landscape school, and as a successor truly worthy of Gaspard and of Claude. In 1796–7 Turner copied several of Wilson's compositions into a sketchbook which he inscribed with the latter's name, and during each of the following two

years he undertook sketching trips in Wales, the region that his hero had made famous through his art. At one point the young draughtsman even broke off from his sketching to make a brief pilgrimage to the Welshman's final resting-place, in an out-of-the-way Clwyd churchyard – but the best evidence of the extent to which he was haunted by Wilson's presence comes from the drawings and paintings of Welsh scenery that resulted from these tours. Amongst other works, the *Kilgaran Castle* that he showed at the Royal Academy in 1799 demonstrated to contemporary viewers that Turner had done his Wilson homework speedily and well (figs.55 and 56), and bode fair to surpass his model in the foreseeable future (nos.14 and 15). To attain this goal he was by now starting to look even further back in time, to the seventeenth-century masters whom Wilson had tried to emulate – and at original works by Claude and Poussin in particular. Turner's loyalty to the classical grand style would shortly earn him the approval of the Royal Academicians, who elected him an Associate Member at the earliest possible opportunity, before he'd reached the age of twenty-five.

However, not all the artists whom Turner chose as models would have met with the Academy's unqualified endorsement. By the late 1790s, his reputation as a prodigy in the medium of watercolour was beginning to be eclipsed by the rising star of his good friend Thomas Girtin, who in the eyes of more than one influential observer was felt to have more 'genius', in contrast to Turner's 'industry'.[3] The latter's characteristic response was to try and outdo Girtin at his own game, by introducing bolder atmospheric effects and designs with a more immediate visual gestalt into his watercolour renderings of British topography (see nos.17 and 18). Unfortunately, his rival's premature death in 1802 brought this productive competition to an end almost before it had fully begun – prompting Turner's alleged remark that 'Had Tom Girtin lived, I should have starved'.[4] But the extreme unlikelihood of Turner ever succumbing to so miserable a fate was already clear by 1800, when he received his most prestigious commission to date – for a pendant sea-piece to a major work by Willem van de Velde the Younger, owned by the 3rd Duke of Bridgewater (nos.19 and 20). After being shown to great acclaim at the Royal Academy in 1801, Turner's *Dutch Boats in a Gale* was hung in the gallery at Cleveland House containing many of the Duke's most prestigious pictures; apart from the van de Velde, there were landscapes by Claude and Aelbert Cuyp, as well as five of Poussin's *Seven Sacraments*, a *Virgin and Child* by Raphael, and Titian's *Diana and Actaeon* and *Diana and Callisto*. By dint of laborious emulation, Turner had precociously assumed his place among the company of the great.

Fig.55
Richard Wilson
Kilgarran Castle c.1765
Oil on canvas, 51 x 74
The President and Fellows of
Magdalen College, Oxford

Fig.56
J.M.W. Turner
Kilgaran Castle on the Twyvey, Hazy Sunrise, previous to a Sultry Day exh. RA 1799
Oil on canvas, 92 x 122
Wordsworth House (The National Trust)

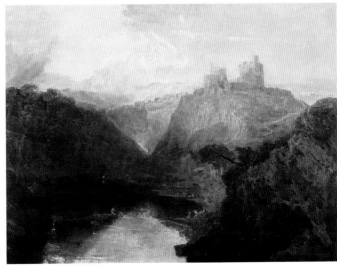

1

1
Paul Sandby (1725–1809) after
Pietro Fabris (fl. c.1740–1784)
Part of Naples, with the Ruined Tower of St. Vincent published 1778
Etching and aquatint, 35.3 x 53.8
The British Museum, London

2
J.M.W. Turner, after Sandby after Fabris
The Ruined Tower of St. Vincent c.1792
Bodycolour, pencil and watercolour, 20.2 x 25.3
Tate

As was typical for art students of the period, copying played a central role in Turner's early education. The models to which he enjoyed easiest access in his youth came in the form of prints, which he could take home and study at his leisure. In this instance the object of his attention was one of a series of aquatint *Views in and near Naples* after the Italian artist Pietro Fabris that Paul Sandby and Archibald Robertson had published between 1778 and 1782; presumably Turner's interest in this work stemmed in part from the fact that in addition to being a printmaker and occasional publisher, Sandby was a founder member of the Royal Academy, and the nation's leading producer of

2

topographical landscapes. Nonetheless Turner felt perfectly free to take considerable liberties with his prototype: aside from transforming Fabris's horizontal vista into an oval vignette, he introduced a host of changes into the background and the foreground, while substantially reducing the amount of human and commercial incident. Coupled with the use of colour to invoke a roseate and golden sunset sky, the cumulative effect of these various alterations is to produce a more tranquil and elegiac scene with overtones of pastoral melancholy. At the age of seventeen or eighteen, Turner was already attempting to chart his own path.

3
Giovanni Battista
Piranesi (1720–1778)
Interior View of the Villa of Maecenas at Tivoli 1764
Etching, 47.5 x 62.1
The British Museum, London

4
J.M.W. Turner
The Transept of Ewenny Priory,
Glamorganshire exh. RA 1797
Watercolour, scraping out and pencil, 40 x 55.9
National Museum of Wales, Cardiff

5
Abraham-Louis-Rodolphe Ducros (1748–1810)
The Stables of the Villa of Maecenas at Tivoli c.1786–7
Watercolour and gouache, 74.9 x 107.9
Stourhead, The Hoare Collection (The National Trust)

6
J.M.W. Turner
The Interior of Durham Cathedral,
Looking East along the South Aisle c.1798
Pencil, watercolour and gouache, 75.8 x 58
Tate

Turner's adolescent training as an architectural draughtsman may have taught him how to use line and tinted washes with disciplined precision, but by the time he reached his early twenties he was clearly aiming at artistic goals far above and beyond the prosaic transcription of buildings. Sensitive to the demands of the public exhibition, and to the need to create eye-catching images capable of commanding attention in this highly competitive arena, Turner began producing watercolours on a monumental scale, and to imbue them with an element of sheer visual drama almost without precedent for his chosen medium. To guide him on his way he looked principally to the works of two eighteenth-century European artists, the Italian Giovanni Battista Piranesi and the Swiss Abraham-Louis-Rodolphe Ducros.

In Piranesi's famous etchings of Roman ruins, and his fantastic imagined prison interiors, Turner discovered a form of architectural drawing where all the tricks of exaggerated perspective combined with an exceptionally bold use of chiaroscuro to create a sense of overwhelming atmosphere and scale, and in so doing to invoke the experience of the Sublime. Piranesi's large prints may have made it clear that size did indeed matter; but from his example Turner absorbed a far more important lesson, to the effect that an imagery without action in any conventional sense, and where the human figure played a minor role or was absent altogether, could nonetheless achieve a visual impact of startling immediacy and power.

That watercolour was capable of achieving contrasts of such tonal richness, together with their attendant theatrical effects, may not have occurred to Turner until his first encounter with the works of Ducros, which almost certainly took place when the young British artist first visited Stourhead, in 1795 or thereabouts. This Wiltshire estate was the property of Sir Richard Colt Hoare, who while on the Grand Tour between 1786 and 1793 had bought no fewer than thirteen of Ducros's large views of Roman ruins as souvenirs of his time in Italy. In design, as well as in their manipulation of light and shadow, these

3

Veduta interna della Villa di Mecenate...

4

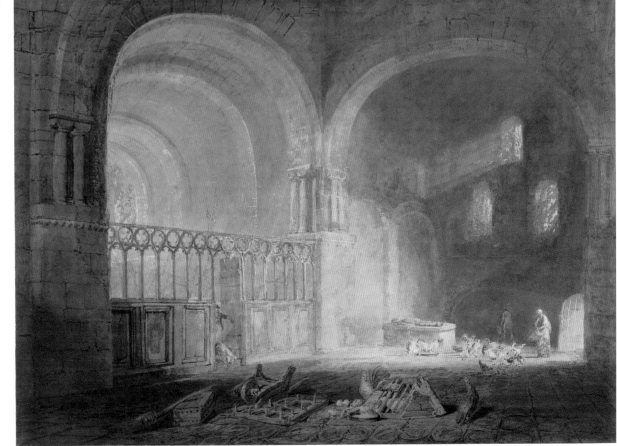

works obviously owe a great deal to Piranesi; but above all it must have been Ducros's handling of his medium that caught the young Turner's eye. Ducros built up his watercolours in a far more elaborate manner than did any of his British contemporaries, by applying free and broad washes that he then modified in a variety of ways. These included the introduction of bodycolour and gum, which gave his pictures a sumptuousness that made them look less like tinted drawings and more like quite sizeable glazed paintings in oil.

Although Turner had begun moving in this general direction even prior to his visit to Stourhead, Ducros's example probably helped alert him to the possibilities of exploiting Piranesi's compositional devices, and of deploying these in sublimely dark watercolours of considerable size. He may also have been emboldened by the Swiss artist's works to take more liberties with the watercolour medium in the interests

of enhancing its sheer visual punch. But in the series of views of Gothic church interiors that Turner drew in the later 1790s, he never tried to emulate the showy hues that are such a prominent feature of Ducros's work, preferring instead to deploy a more subtle and restrained palette reminiscent of the brownish appearance of Old Master paintings. When his *Transept of Ewenny Priory, Glamorganshire* was shown at the Royal Academy in 1797, a reviewer was moved to comment that: 'In point of colour and effect, this is one of the grandest Drawings we have ever seen; and equal to the best Pictures of REMBRANDT.'[1] The comparison was justly made: for even if Turner's immediate points of departure may have been Piranesi and Ducros, ultimately his ambition was to rival Rembrandt's mastery of atmospheric chiaroscuro. Whether his subject was a modestly-sized Welsh Benedictine priory, or as grand a structure as Durham Cathedral, Turner's aim was to invest British medieval architecture with the awe-inspiring character of the Sublime.

5

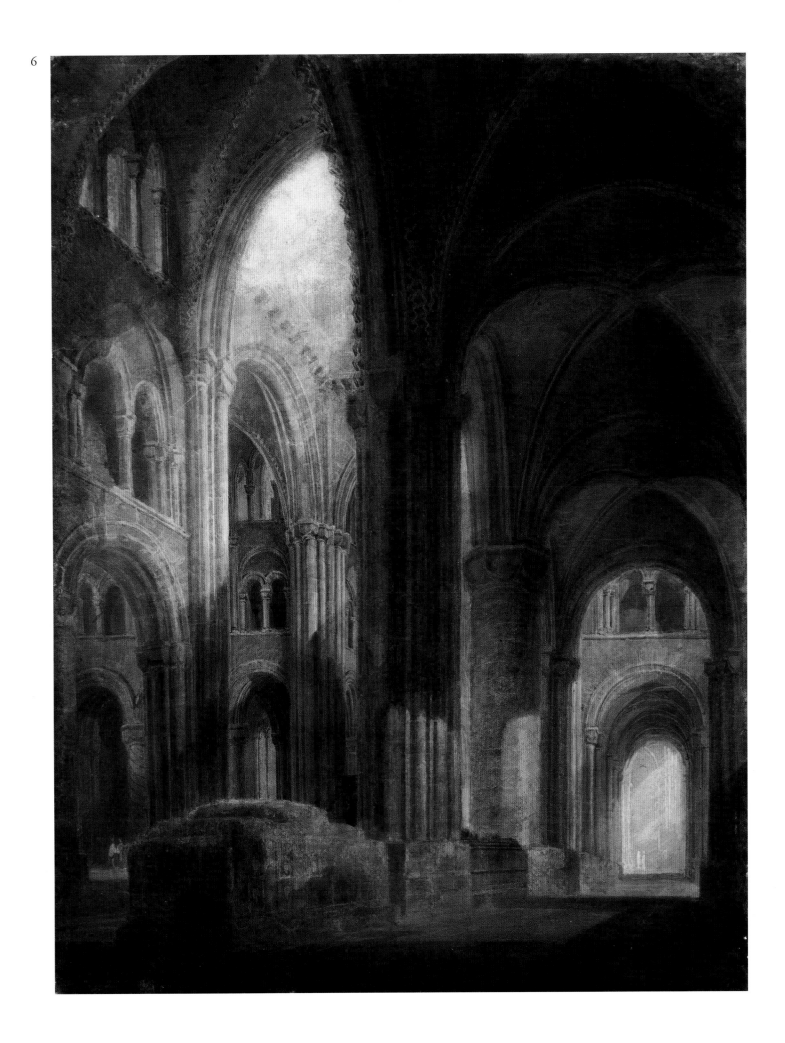

7
J.M.W. Turner
Moonlight, a Study at Millbank exh. RA 1797
Oil on panel, 31.5 x 40.5
Tate

8
Rembrandt Harmensz. van Rijn (1606–1669)
Landscape with the Rest on the Flight into Egypt 1647
Oil on panel, 38 x 48
National Gallery of Ireland, Dublin

9
J.M.W. Turner
Limekiln at Coalbrookdale c.1797
Oil on panel, 28.9 x 40.3
Yale Center for British Art,
Paul Mellon Collection

The *Rest on the Flight into Egypt* may have been the first landscape painting by Rembrandt that Turner ever encountered, when he visited its owner and his patron Richard Colt Hoare at his Stourhead estate in the mid-1790s. Judging by the comments he made some fifteen years later, he was particularly impressed by the light effects that Rembrandt had managed to create in this nocturnal scene – effects that the young British artist sought to emulate in some of his earliest essays in the medium of oils.

In *Moonlight, a Study at Millbank*, which appeared at the Royal Academy in 1797 (where it seems to have attracted very little attention), Turner replaced Rembrandt's fire with a bright full moon that casts its reflection across the broad expanse of the River Thames, the moon's illuminating power gradually reducing in intensity as it penetrates the further reaches of the prospect. The *Limekiln at Coalbrookdale* addresses a similar problem of representation, albeit in a different and somewhat more complicated way, by denying us direct visual access to the hot glow of the kiln, and instead describing how its yellow brilliance plays itself out on the nearby figures and the surrounding landscape. The cool twilight sky in the furthest distance introduces an additional element of difficulty which Turner had appreciated in the *Rest on the Flight*; here, as he

would subsequently observe, 'Rembrandt has introduced two lights, one of the fire and the other from a window, to contrast the grey, glimmering dawn from gloom'.[1]

A passage from a lecture that Henry Fuseli delivered at the Royal Academy in 1801 offers us a pertinent insight into the qualities in Rembrandt's art that Turner and his contemporaries particularly prized. 'He possessed', according to Fuseli:

> the full empire of light and shade, and of all the tints that float between them: he tinged his pencil with equal success in the cool of dawn, in the noon-day ray, in the livid flash, in evanescent twilight, and rendered darkness visible. Though made to bend a steadfast eye on the bolder phenomena of Nature, yet he knew how to follow her into her calmest abodes, gave interest to insipidity or baldness, and plucked a flower in every desert. None ever like Rembrandt knew to improve an accident into a beauty, or give importance to a trifle.[2]

This was part of the challenge that Turner set himself in *Moonlight, a Study at Millbank* and the *Limekiln at Coalbrookdale* – to 'give importance to a trifle', to landscapes signally lacking in features of conventional pictorial interest. Even at the age of twenty-two, he had already begun trying to put Rembrandt's programme into practice.

7

8

9

10
Gaspard Dughet (1615–1675)
Ideal Landscape c.1658–60
Oil on canvas, 93.6 x 133
Lent by Culture and Sport Glasgow on
behalf of Glasgow City Council. Bequeathed
by Mrs John Graham-Gilbert 1877

11
Richard Colt Hoare (1758–1838)
The Lake of Avernus, & Temple on its Banks.
The Promontory of Misenum & the Castle of Baiae.
Part of the Monte Nuovo 1790
Pen and wash, 37.8 x 53.1
Stourhead, The Hoare Collection
(The National Trust)

12
Richard Wilson (1713?–1782)
Lake of Nemi, or Speculum Dianae Probably 1758
Oil on canvas, 75.6 x 97.2
Trustees of the Hoare Family,
on loan to The National Trust, Stourhead

13
J.M.W. Turner
Aeneas and the Sibyl, Lake Avernus c.1798
Oil on canvas, 76.5 x 98.4
Tate

Aeneas and the Sibyl, Lake Avernus is Turner's earliest known painting of a classical landscape with mythological figures. It represents the hero of Virgil's *Aeneid* asking the Cumaean Sibyl to guide him to the Underworld, which the ancient Romans believed could be entered through the sulphurous waters of Lake Avernus.

In both form and content, Turner's picture closely follows the example of Richard Wilson, whom in the late 1790s he looked up to as the greatest of all previous British landscape artists. Turner was far from alone in holding this opinion of a painter who had died in poverty and obscurity less than twenty years before, and who (although he was in fact Welsh) had since come to be referred to as the 'English Claude'. In the supplement to his *Dictionary of Painters*, published in 1798, Matthew Pilkington even went so far as to say that the comparison with Claude did the British master a grave injustice: 'the Frenchman', claimed Pilkington, 'enters too far into the minutiae of nature, – he painted her littlenesses. Wilson, on the contrary, gives a breadth to nature, and adopts only those features that more eminently attract attention. … Claude was rather the plain and minute historian of LANDSCAPE; Wilson was the POET'.[1] Though surely Turner would have taken strong issue with any attempt to denigrate Claude, he shared the same view of the elevated character of Wilson's art, and made it an object of sustained and close study.

The specific model for *Aeneas and the Sibyl* was a Wilson belonging to Sir Richard Colt Hoare of Stourhead, entitled the *Lake of Nemi, or Speculum Dianae*, which was in turn based on a seventeenth-century composition, by another founding master of the classical landscape tradition, Gaspard Dughet . A less subtle painter than Claude, Gaspard had devised a range of easily imitable compositional formulae that were put to frequent use by subsequent generations of European artists; his standard arrangement of unbalanced framing trees flanking a centralised progression of distinct foreground, middle-ground and background planes had been particularly popular in eighteenth-century Britain. The *Lake of Nemi* was only one of several works that Wilson overtly modelled on this familiar Gaspard type.[2]

Although in Wilson's case the story – of the goddess Diana chastising her errant nymph Callisto – comes from Ovid's *Metamorphoses*, and we see a lake near Rome instead of one close to Naples, the similarities between his work and Turner's far outweigh their differences. The fact that both pictures are virtually identical in size and composition (albeit with the

12

main framing elements arranged in reverse) further introduces the likelihood that Turner conceived of his *Avernus* as a pendant to Wilson's *Nemi* (and possibly as an 'evening' to its 'morning'). Having never visited Italy, however, he required more in the way of topographical information, which Colt Hoare provided in the form of a highly finished (and obviously Gaspardesque/Wilsonesque) drawing of Avernus that he himself had executed less than ten years earlier on the Grand Tour. Whether all this was done at the artist's own initiative, or whether he was working at his patron's bidding, there can be no denying the curious character of the end product: in effect, this is Turner's imitation of Colt Hoare's imitation of Wilson's imitation of an original by Gaspard, which itself may have been roughly based on the scenery around Lake Nemi. Thus multiply removed from the site it represents, Turner's *Aeneas and the*

Sibyl has – not unexpectedly – less the look of Italian nature than the rather stodgy appearance of a student's self-conscious effort to produce an ersatz Old Master. That this impression is reinforced by the fresher colours and livelier brushwork of Wilson's *Nemi* may help to explain either why Colt Hoare didn't buy the proposed companion-piece – or, if he did, why some seventeen years later he would commission Turner to paint a replacement version that looked less Wilsonesque, more Claudean, but above all more characteristically Turnerian in its colour and facture (fig.57).

13

Fig.57
J.M.W. Turner
*Lake Avernus: Aeneas
and the Cumaean Sibyl* 1814–15
Oil on canvas, 72 x 97
Yale Center for British Art.
Paul Mellon Collection

14

14
Richard Wilson (1713?–1782)
Pembroke Town and Castle c.1765–6
Oil on canvas, 101.6 x 127
National Museum of Wales, Cardiff

15
J.M.W. Turner
Harlech Castle, from Twgwyn Ferry,
Summer's Evening Twilight exh. RA 1799
Oil on canvas, 87 x 119.4
Yale Center for British Art, Paul Mellon Collection

When Turner undertook his first sketching tour of Wales during the summer of 1798, his Welsh forebear Richard Wilson was never far from his mind. Some forty years earlier, on his return home after seven years spent studying in Italy (1750–6/7), Wilson had taken it upon himself to apply the elevated precepts of classical landscape art to the portrayal of British scenes, concentrating on sites of historic and/or cultural importance. No pictures were more central to this enterprise than the series of six Welsh views from the mid-1760s (all subsequently engraved), in which Wilson idealised his native principality as a tranquil Arcadian realm, redolent of British antiquity. This achievement was one on which Turner was determined to build. Using the composition of Wilson's *Pembroke Town and Castle* as one of his principal points of departure, he removed his portrayal of *Harlech Castle* that much further away from straightforward topography, and

15

that much closer to elegiac poetry, by submerging all the details of his landscape in a golden evening light derived from Claude Lorrain, while reducing the ostensible focus of his attention – that is to say, Harlech itself – to an evocative silhouette on the distant horizon. The results make (and were probably intended to make) even Wilson look prosaic. Reversing the priorities suggested by its title, Turner's painting offers itself less as the portrayal of a medieval fortress than as the evocation of a 'Summer's Evening Twilight' – an emphasis reinforced in the Royal Academy catalogue for 1799, which asked viewers to compare *Harlech* with the following lines (slightly paraphrased) from Milton's *Paradise Lost* (book iv, ll.598–608):

> Now came still evening on, and twilight grey
> Had in her sober livery all things clad.

> … Hesperus that led
> The starry host rode brightest 'till the moon
> Rising in clouded majesty unveiled the peerless light.

Not content to try and invoke parallels with Milton, Turner also used his painting to allude to highly topical modern realities. For if the castle on the far-off promontory offers eloquent testimony to remote and ancient conflicts, the ships being built on the right-hand shore would surely have reminded the artist's contemporaries of the current war with France – bringing to mind the British navy's 'walls of oak', and how they protected the nation's peace-loving citizens (like the family in the foreground) from their enemies abroad. It was by bringing new dimensions of meaning to bear on familiar landscape themes that Turner helped consolidate his reputation for originality.

16
Thomas Girtin and J.M.W. Turner
after John Robert Cozens (1752–1797)
Angera, Lake Maggiore c.1796
Watercolour, 15.6 x 25.5
Tate

17
Thomas Girtin (1775–1802)
Lindisfarne Castle, Holy Island, Northumberland c.1797
Watercolour on rough cartridge paper, 38.1 x 52
Metropolitan Museum of Art, New York, Rogers Fund, 1906

18
J.M.W. Turner
Warkworth Castle, Northumberland –
Thunder Storm Approaching at Sunset exh. RA 1799
Watercolour, 50.8 x 75
Victoria and Albert Museum, London. Ellison Gift

Turner began his exhibiting career at the Royal Academy in 1790, embarking on a path to be followed four years later by his friend Thomas Girtin. Contemporary observers quickly became aware that two exceptionally talented young watercolourists had arrived on the London art scene, but that each had something different to offer. According to an unidentified reviewer of the annual exhibition in 1797, 'Turner's drawings are wonderfully laborious, Girtin's are bolder'.[1] This comparison soon became something of a critical commonplace. Two years later, the portraitist John Hoppner told the painter and diarist Joseph Farington how Edwin Lascelles and the Countess of Sutherland – both of whom not only collected landscape watercolours but also produced their own examples of the genre – were 'disposed to set up Girtin against Turner – who they say effects his purpose by industry – the former more genius – Turner finishes too much'.[2]

The juxtaposition of Girtin's *Lindisfarne* with Turner's *Warkworth Castle* demonstrates that such comparisons were far from being unfounded. Whereas Girtin describes forms with a remarkable simplicity of means, employing broad sweeps of wash that eschew detail wherever possible, Turner treats his buildings with the linear precision of an architectural draughtsman, and offers a far more intricate rendering of the appearances of earth, water and sky. As a result his watercolour yields an impressive amount of specific visual information

about the various components of the scene – by contrast with the Girtin, which seems less committed to the business of naturalistic description than to the task of expressing its creator's own distinctive sensibilities. Hence whereas Turner varies his handling to suit the different forms he portrays, Girtin deploys much the same calligraphic brushwork throughout, its blottings and blurrings made all the more prominent for having been applied to a rough piece of cartridge paper was then hung on a rope to dry. This was a way of dramatising the artist's virtuosity in manipulating his raw materials – a goal that Turner would never try to achieve in quite the same way. But the monumental forms and atmospheric drama of his exhibition watercolours from the late 1790s suggest that he was happy to emulate other aspects of Girtin's achievements in order to promote his own claims to the 'boldness' of genius.

The compositional similarities between the *Lindisfarne* and the *Warkworth* watercolours may reflect Turner's prior knowledge of Girtin's Northumberland views – Girtin having toured the north of England in 1796, a year before his friend's first visit to the region. It is more likely, however, that both artists were looking back independently to the same common source, in the works of John Robert Cozens. Over a period of at least three years starting in 1794, Girtin and Turner together attended the informal academy run by Dr Thomas Monro, who employed them to produce numerous copies of Cozens's watercolours (for example, no.16); Girtin was charged with drawing the outlines in pencil, while Turner's job was to colour these in. But by the end of the decade their private collaboration had given way to public competition, which abruptly came to a premature end when Girtin died, possibly of asthma, in 1802.

16

19
Willem van de Velde
the Younger (1633–1707)
A Rising Gale c.1672
Oil on canvas, 132.2 x 191.9
Lent by the Toledo Museum of Art: purchased with funds
from the Libbey endowment, gift of Edward Drummond Libbey

20
J.M.W. Turner
*Dutch Boats in a Gale: Fishermen Endeavouring to Put their
Fish on Board* (the *Bridgewater Sea-Piece*) exh RA 1801
Oil on canvas, 162.5 x 222
Private collection, on loan to the National Gallery, London

21
J.M.W. Turner
The Wreck of a Transport Ship c.1805–10
Oil on canvas, 172.7 x 241.2
The Fundaçao Calouste Gulbenkian, Lisbon
Madrid only

'Ah! That made me a painter', Turner is reputed to have
said in later life on catching sight of a print after Willem
van de Velde the Younger, the undisputed master of the
Dutch (and British) marine painting tradition.[1] In 1800 he
was given the opportunity to show whether he could match
or even surpass the artist who had first inspired him, when
Francis Egerton, 3rd Duke of Bridgewater, commissioned
him to paint a companion-piece to the major van de Velde,
A Rising Gale, which he had bought a few years earlier,
shortly after its arrival from Amsterdam.

Although held in low esteem by academic theorists like
Joshua Reynolds, who felt that Netherlandish painters were
only capable of imitating the particular appearances of
common nature, by the late eighteenth century van de
Velde's works had come to be prized by the leading British
collectors, of whom none was more prominent than
Bridgewater. Presumably he, like other connoisseurs of the
period, admired van de Velde for his technical mastery, and
in particular for his ability to harmonise the natural and

19

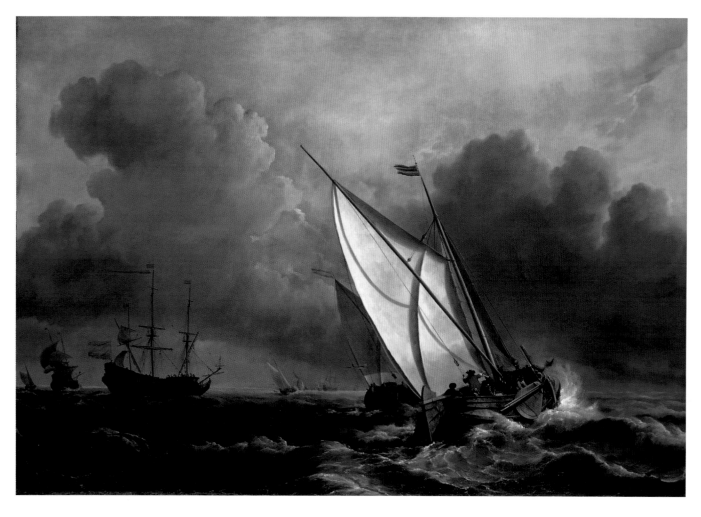

20

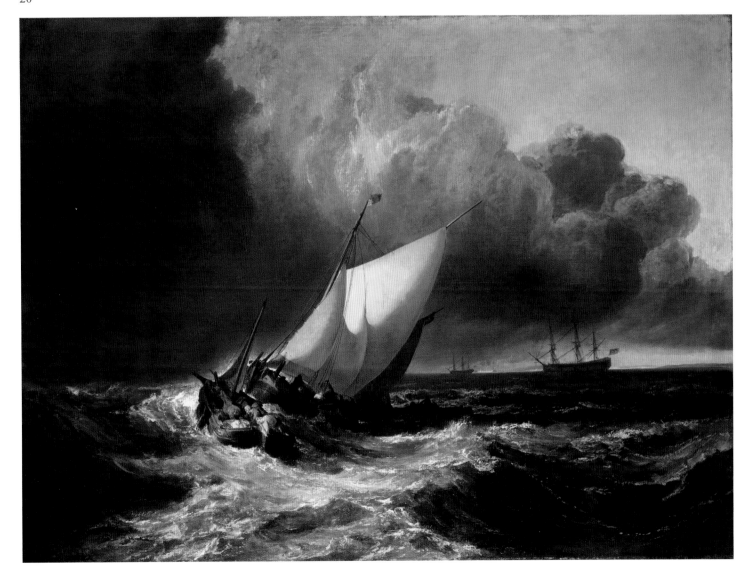

man-made elements of his chosen subject-matter, and to do so in a way that seemed both graceful and true to life. These were qualities that Turner must have valued, too, though he had no wish to remain subservient to his model. Not only did he make his pendant considerably larger, but by reversing van de Velde's composition and introducing more contrasts between light and shade he gave his own design a greater sense of movement, thus heightening the drama arising from the fact that his ships look to be set on a collision course. In addition Turner's broader facture lends his paintwork a more emphatically material presence than van de Velde ever strove to produce. This serves to remind us that the *Bridgewater Sea-Piece* is as much about art as it is about nature, and that, for Turner, never the twain shall meet.

Dutch Boats in a Gale became the picture of the year at the annual Royal Academy exhibition in 1801, even if its popularity prompted certain critics to wonder whether Turner might have gone overboard with his painterly bravura, in a bold attempt to catch the viewer's eye. Although the reviewer for the *Porcupine* conceded that 'Nothing little appears from his hand, and his mind seems to take a comprehensive view of Nature … It must be confessed, however, that his desire of giving a *free touch* to the objects he represents betrays him into *carelessness* and *obscurity* so that we hardly see a firm determined outline in anything he does'.[2] Turner's fellow artists were more effusive in their praise. Both Henry Fuseli and Benjamin West compared the picture to Rembrandt, West even going so far as to say that it was 'what Rembrandt thought of but could not do' – possibly referring to the Dutch master's only known sea-piece, *Christ in the Storm on the Sea of Galilee* of 1633 (Isabella Stewart Gardner Museum, Boston), though the compliment may have been more generally meant. In 1804, when West saw the Turner and the van de Velde hanging side by side in the Bridgewater Gallery, he commented that the juxtaposition made the earlier picture look '*brittle*' – prompting George Beaumont (no great fan of Turner's) to respond that the van de Velde 'made Turner's *Sea* appear like pease soup'.[3]

Dutch Boats in a Gale was the first in a series of grand sea-pieces, including no fewer than ten publicly exhibited works, which Turner produced during the first decade of the nineteenth century; the series comes to a climax with *The Wreck of a Transport Ship*, which in the violence of both its subject-matter and its brushwork leaves the *Bridgewater Sea-Piece* trailing in its wake. And unlike its predecessor, the shipwreck scene features a modern British vessel. Amongst those shown struggling for survival are two red-coated soldiers, whose presence underlines the patriotic role played by sea and shipwreck imagery in the era of Nelson and Trafalgar.

21

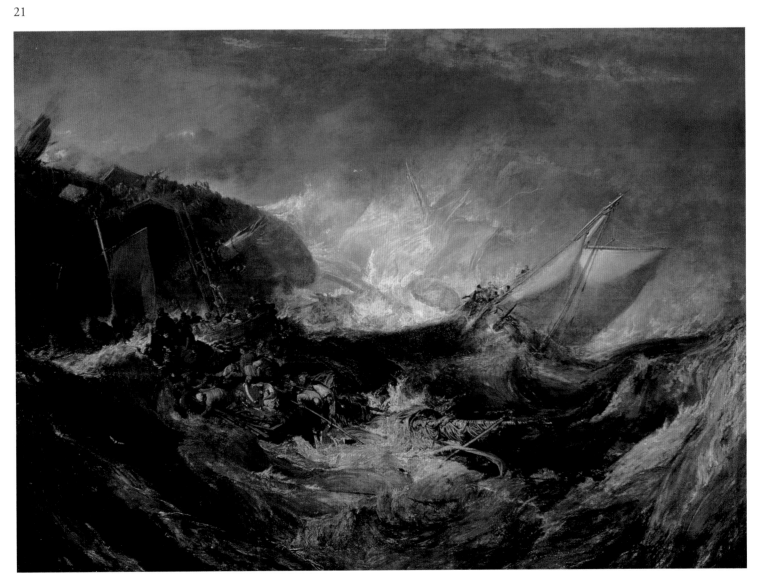

The Academy and the Grand Style

Philippa Simpson and Martin Myrone

From an early age Turner looked to London's pre-eminent artistic institution, the Royal Academy, as a means of securing professional recognition as a painter and a degree of prestige and social acceptance as an individual. Although as the son of a barber he came from relatively modest circumstances, his father's shop was fortuitously located near the Strand, and so even as a boy he must have been aware of the RA, situated as it was within the architectural splendour of Somerset House facing onto that busy thoroughfare. From the end of 1789, concurrent with his training in Thomas Malton's studio, he attended the Academy's drawing schools, where its members taught their young pupils to draw from plaster copies of ancient sculptures and to make studies from the life model. In the following year, when he was just fifteen, Turner showed a picture at the Academy's annual exhibition for the first time; over 250 more were to follow in his long working life. Securing election as an Associate Member in 1799 effectively gained him entry into a highly exclusive art establishment, which three years later became more exclusive still, when Turner joined the elite of Royal Academicians (of whom there were then only forty at a time). Later he went on to become Professor of Perspective (1807–37) and a tireless supporter of the Academy's bureaucratic activities and exhibitions, serving on the council, in the drawing schools, sitting on committees and even, briefly, acting as president in 1845–6.

J.M.W. Turner
The Deluge exh. Turner's
gallery 1805 (?)
(detail, no.30)

This lifelong affiliation brought with it an allegiance to a set of hierarchical principles about the nature and value of art. For the training provided at the schools, geared toward life drawing as the foundational skill and directing close attention to the art of the past, particularly of ancient Greece and Rome, was meant to provide the basis for the pursuit of the most elevated artistic genre: what Joshua Reynolds had called the 'great' or the 'grand' style.[1]

Deriving from ancient and Renaissance critical writing, and given its most authoritative theoretical form by spokesmen for the seventeenth-century French *Académie Royale*, the Grand Style was meant to represent the highest possible achievement within the pictorial arts, which were ranked according to subject-matter and manner of representation. At the bottom of the academic hierarchy of genres was still-life painting, which supposedly demanded nothing more than 'mechanic' (manual) skills in the visual description of inanimate objects. Above this came landscape, which likewise dealt with material nature unenlightened by thought, and especially when concerned with the portrayal of identifiable views, was bound to focus on particulars; on the rung above stood portraiture, which was still concerned with specific appearances rather than abstract ideas, but at least demanded some understanding of human character. At the top was history painting, or the Grand Style, which presented noble human actions taken from distinguished historical or literary sources (including the Bible), and which described its actors in the universal language of classical idealism. These thematic and formal commitments raised the artist of the Grand Style to the level of the high-minded historian or epic poet, and merited an equivalent degree of respect.

The doctrine of the hierarchy of genres was still well entrenched in early nineteenth-century Britain. From Reynolds onwards, the presidents and professors of the Royal Academy restated the authority of the Grand Style as the highest form of the visual arts; the only way for British painters and sculptors to achieve greatness, they insisted, was by following the revered tradition that had originated in classical antiquity, and which had been revived in modern times by the Roman, Florentine and Bolognese Schools. But there was general acknowledgement that the Grand Style in its pure form could not thrive in modern Britain. Whereas the leading artists of the ancient world, or of Renaissance and Baroque Europe, had been able to rely on the patronage of the state, great princes, or religious establishments, the arts in Britain were supported only more modestly by private individuals or by commercial enterprise. Contemporary viewers, furthermore, were in the main understood to have little taste for the intellectual character of ancient or more recent classical art, with its heroic themes, restrained colours and generalised forms; instead they wanted something more accessible and pleasurable, with the sensory appeal often associated with the rich colours and painterly textures of Venetian painting. As art critics and Academy professors chronically complained, the preference among patrons and collectors for such artists as Titian and Veronese – or for the naturalistic verisimilitude of Dutch and Flemish painting – constituted, at best, a guilty pleasure, and, at worst, an indictment of the corrupt nature of taste in modern Britain.

The same circumstances also helped to explain why the late eighteenth- and early nineteenth-century English market for landscape painting tended to be dominated by visually pleasing but intellectually undemanding views of rustic scenery or well-known sites on the picturesque tour. Less popular but more prestigious were landscapes in the Grand Style: works that distilled the particulars of nature into a set of generalised, ideal forms, arranged to express a sense of perfect order, and which were populated with figures taken from ancient history, classical mythology, or literature (usually pastoral poetry). Grand Style landscape art was associated above all with the names of three French painters who had made their careers in seventeenth-century Rome – Claude Lorrain (nos.24 and 33), Nicolas Poussin (nos.27 and 29) and Gaspard Dughet (no.10). Characteristically, compositions by these artists are carefully balanced, with prominent foreground *repoussoirs* (usually trees or buildings) on one or both sides, framing a succession of planes that construct a central avenue of space which invites us to explore the prospect at our leisure; in so doing we are asked to appreciate how every element of the scene relates to all the others, and contributes to the harmony of the whole.

The eighteenth-century British painter most closely identified with the practice of Grand Style landscape art was Richard Wilson. As we have already seen (in section I, see pp.111-115), Turner's youthful adherence to his Welsh predecessor's example offers an object lesson in the principles of 'emulation', by which the conventions of the classical tradition were handed down, reproduced and improved from one generation to the next. Wilson had based his approach on the aforementioned trio of seventeenth-century masters – and it was their works that Turner chose as his models, starting around 1800. His Royal Academy exhibits for that year included the *Fifth Plague of Egypt* (fig.3), a sublime historical landscape in the manner of Nicolas Poussin, against whom he also asked to be measured with the *The Tenth Plague of Egypt* (RA 1802; fig.58)and the *Châteaux de St. Michael, Bonneville, Savoy* (RA 1803; no.28). In 1803 he exhibited his first major oil in the manner of Claude, the *Festival upon the Opening of the Vintage at Macon* (fig.28), while a year later he focused his sights on Gaspard Dughet, when he produced his *Landscape with Narcissus and Echo* (B&J no.53). Turner's visit to the Louvre in 1802 also prompted him to try and see whether he could rival the supreme Venetian colourist Titian, with a *Holy Family* (RA 1803; no.32) and a *Venus and Adonis* (no.36). It was with these figurative works – the *Holy Family* most obviously – that Turner publicly assumed the role most highly esteemed by the Royal Academy – that of an historical artist in the Grand Style. In taking Titian as his model, however, he was also striking out on his own path, since academic theory recommended the *disegno* of the Roman and Florentine Schools over the 'ornamental' *colore* of the Venetians. Earlier Turner had displayed another hint of rebelliousness when, to mark his election as an Academician proper, he presented the RA with *Dolbadern Castle* (no.23), an exercise in the manner of Salvator Rosa – an artist widely admired for the sublime wildness of his scenes, but also for expressing an imaginative freedom in defiance of all rules.

But of all the landscape painters in the Grand Style, as Kathleen Nicholson explains elsewhere in this volume, it was Claude whom Turner most admired and with whose art he remained engaged for the longest time – indeed up to the very end of his career (and beyond). With *Crossing the*

Brook (RA 1815; no.34) he painted the sort of image that (he imagined) Claude himself might have produced, had he ever visited England, and then two years later he exhibited *Dido Building Carthage* (no.94), the first in what would turn out to be a long sequence of Claudean seaport scenes. Seeing Italy for the first time in 1819 encouraged Turner to brighten his palette, and henceforth he began to take more liberties with Claude, as in *Palestrina – Composition* (no.26) which he initially conceived as a companion-piece of sorts to the Old Master's *Landscape with Jacob, Laban and his Daughters* (no.24), belonging to his friend and patron Lord Egremont. But if *Palestrina* is an act of homage, it is – in colouring above all – no less obviously a declaration of Turner's independent vision.

Fig.58
J.M.W. Turner
The Tenth Plague of Egypt
exh. RA 1802
Oil on canvas, 143.5 x 236.2
Tate

22
Salvator Rosa (1615–1673)

Landscape with Hermit c.1662
Oil on canvas, 75.8 x 75.5
Walker Art Gallery, National Museums, Liverpool

23
J.M.W. Turner

Dolbadern Castle, North Wales exh. RA 1800
Oil on canvas, 119.4 x 90.2
Royal Academy of Arts, London

Over the course of the eighteenth century in Britain, the name of the Neapolitan painter Salvator Rosa had come to be synonymous with pictures of sublimely rugged and hostile mountain scenery. Hugely popular with artists and collectors alike, Rosa's landscapes generally represented imagined views, peopled with appropriately fierce 'romantic' figures such as soldiers or banditti. Indeed the artist was often himself

characterised as a 'savage' who delighted in 'representing scenes of desolation, solitude and danger'. It was in order to bring such meanings into play that Turner invoked a typically dramatic composition by Salvator Rosa – the *Landscape with Hermit* being an excellent example – as the prototype for his image of Dolbadern Castle, a ruined fortress in the wilds of north Wales.

When the picture was exhibited at the Royal Academy, Turner inserted the following lines of poetry (possibly written by himself) into the catalogue:

> How awful is the silence of the waste,
> Where nature lifts her mountains to the sky,
> Majestic solitude, behold the tower
> Where hopeless OWEN, long imprison'd, pined
> And wrung his hands for liberty, in vain.[1]

The OWEN referred to here is Owain Goch ap Gruffydd, who was confined in this lonely castle for more than twenty years, as punishment for having joined a rebellion against

22

his brother Llewellyn, the last Prince of Wales. A further and more general historical allusion is to the final conquest of the Principality by the English under Edward I, who brought centuries of Welsh liberty to an end. But the verses in the catalogue were only designed to reinforce a message that Turner was trying first and foremost to communicate by visual means – and not just by depicting Dolbadern, and a manacled figure guarded by soldiers in the foreground beneath the tower. His aim was to maximise the expressive possibilities of his chosen motif, and of landscape art as his chosen genre. This was where his appropriation of 'savage' Salvator came into play.

From the Italian master Turner borrowed more than a strikingly sombre palette, and a familiar iconography of rugged mountains and armed figures, whose relatively diminutive size makes their vertiginous surroundings look massive by comparison. More importantly, perhaps, pictures like the Walker Art Gallery's *Landscape with Hermit* also taught him how to arrest the viewer's eye within a claustrophobically confined foreground space from which

we seek to escape by moving rapidly upwards, towards the bright light of the sky. In so doing the composition invites us to experience the feeling of imprisonment, and the attendant longing to be free – to put ourselves in Owen's place, in other words, but at a distance that also allows us to identify with the power of the sublime. Turner's relationship to Salvator Rosa partakes of a similar dynamic, in that he both pays tribute to a renowned precursor and asserts his own distinctive originality, as a poetic British painter of historical landscape art.

The ambitions apparent in *Dolbadern Castle* are consistent with its production at a crucial moment in the young Turner's career, just a few months after he had been elected an associate member of the Royal Academy. His other exhibits in 1800 were *Dutch Boats in a Gale* (no.20) and *The Fifth Plague of Egypt* (fig.3), in the manners of Willem van de Velde the Younger and Nicolas Poussin respectively – so he was publicly taking on not just one but three Old Masters at a time. Two years later, when he became a full member, he presented *Dolbadern* to the Academy as his diploma work.

23

24
Claude Gellée,
known as Claude Lorrain (c.1604/5–1682)

Landscape with Jacob, Laban and his Daughters 1654
Oil on canvas, 143.5 x 251.5
Petworth House, The Egremont Collection (The National Trust).
Acquired in lieu of tax by HM Treasury in 1957 and subsequently
transferred to The National Trust

25
J.M.W. Turner

*Appulia in Search of Appulus Learns from the Swain
the Cause of his Metamorphosis, Vide Ovid* exh. BI 1814
Oil on canvas, 148.5 x 241
Tate
Paris and Madrid only

26
J.M.W. Turner

Palestrina – Composition 1828; exh. RA 1830
Oil on canvas, 140.3 x 248.9
Tate. Bequeathed by C.W. Dyson Perrins 1958

The *Landscape with Jacob, Laban and his Daughters* was probably
the single work by Claude that Turner knew best, and to which
he became the most deeply attached. One of the glories of the 3rd
Earl of Egremont's collection, the picture would have first come
to Turner's attention on his initial visit to Petworth House at
some point in the mid-1790s; his first prolonged stay at the
house took place in the summer of 1809, by which time
Egremont had become one of his most important patrons.

Five years later Turner took the highly unusual step of producing
a full-scale copy (from memory, presumably) of *Jacob, Laban
and his Daughters*, the only obvious difference being the
replacement of Claude's Biblical figures with a cast of characters
from Ovid's *Metamorphoses*. The classical story of the shepherd
Appulus's punishment for crudely attempting to mimic a group
of nymphs had as its central point a lesson about the thoughtless
stupidity of servile imitation – and hence, in the context of
Turner's copy, about the pitfalls of too closely following the
example of the Old Masters. He fashioned this strongly-held
belief into a large-scale canvas in order to attack the policies of
the British Institution, to which he submitted the *Appulia* in
1814 as his entry for its annual landscape painting competition –
a competition designed for young artists, and which rewarded
those who were judged to be most faithful to the past. By
submitting his picture a week after the deadline, Turner made
it clear that he had no desire to compete for the prize, nor any
inclination whatsoever to obey the BI's rules or (above all) its

dictates in matters of artistic taste.[1] Lord Egremont, by the
way, was meant to serve on the jury (though he failed to fulfil
the obligation).

Fourteen years later, during his second stay in Rome, Turner
produced an entirely different sort of homage to the Petworth
Claude and its aristocratic owner, who had by now become
one of the artist's closest friends. In a letter dated 11 August
1828, written on his way to Italy, Turner stated that out of
respect for Lord Egremont's support of living artists, 'it would
give me the greatest pleasure … that my first brush in Rome
… should be to begin for him *con amore* a companion picture
to his beautiful CLAUDE'.[2]

Although the work in question can only have been *Palestrina –
Composition*, this did not in the end become the pendant to
Jacob, Laban and his Daughters, for the simple reason that
Egremont declined to purchase it, opting instead to buy *Jessica*
(no.44) from among Turner's Royal Academy exhibits of 1830.
The Earl's lack of interest in *Palestrina* may have been due in part
to its failure to respect the normal compositional requirements
of a landscape companion-piece, which was expected to
counterbalance, and not to repeat, the arrangement of its
pendant. Had the two works hung side by side, they would have
looked less like companions than as challengers to one another –
and as much as Turner revered this Claude, he had no desire to
come across as second-best. If *Appulia* had shown how well he
understood Claude, the strikingly bright colours and painterly
bravura of *Palestrina* offered a dramatic demonstration of his
creative ability to absorb, revise and radically transform the
example of even the greatest of previous landscape masters.

Unlike the Claude on which it is based, *Palestrina – Composition*
depicts an actual place, an ancient city to the east of Rome that
had been much celebrated by Virgil and Horace. Turner's
hyphenated title prompts us to consider the differences – which
finally are similarities – between an artistic *re-creation* of a
real-world site like Palestrina and the *representation* of nature as
the product of a landscape painter's imagination, whether by
Turner or by implication, Claude. Even Turner's sky contributes
to the lesson. On the left, a jaunty puff of cloud enlivens the deep
azure sky yet does not quite 'explain' the theatrical pattern of
light and shade that falls on the fanciful scene below as it should
in the out-of-doors. To the right thinner, streakier clouds and
recall the clouds in *Landscape with Jacob, Laban and his
Daughters*. Turner's self-styled companion-piece, *Palestrina –
Composition,* puts idealisation in all its variety and potential on
display so that we can appreciate its part in landscape painting's
ability to enchant us – as well as Turner's capacity to meet the
challenge of the past.

24

25

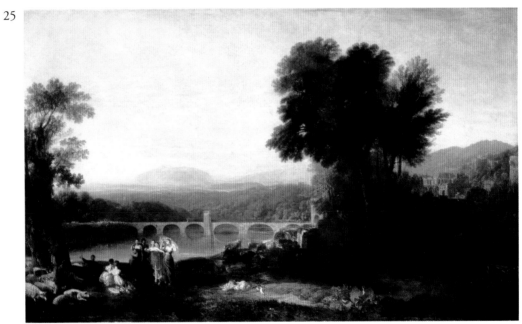

26

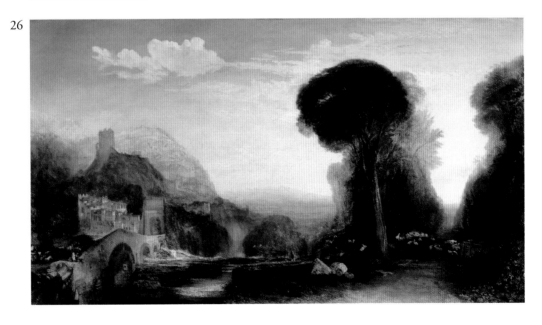

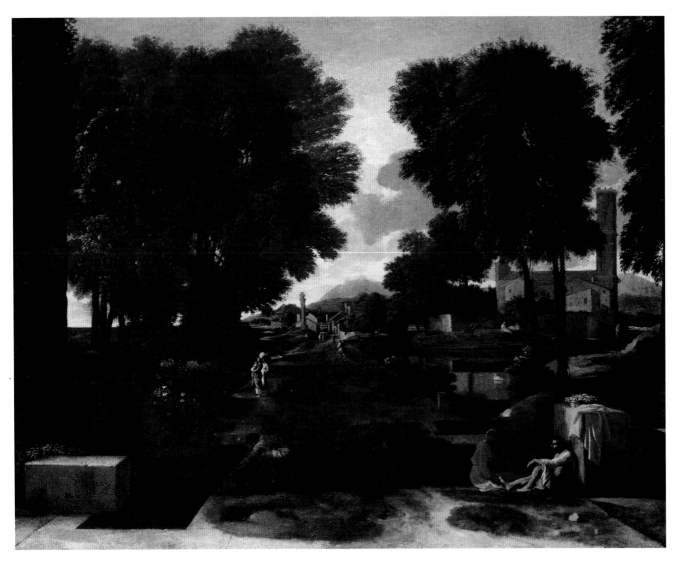

27

27
(After) Nicolas Poussin (1594–1665)
Landscape with a Roman Road late
seventeenth century (?), after original c.1648
Oil on canvas, 79.3 x 100
By Permission of the Trustees of
Dulwich Picture Gallery, London

28
J.M.W. Turner
Châteaux de St. Michael, Bonneville, Savoy exh. RA 1803
Oil on canvas, 91.4 x 121.9
Yale Center for British Art, Paul Mellon Collection

In his 'Backgrounds' lecture in 1811, Turner recalled his impressions of Poussin's *Landscape with a Roman Road* (now known to be the copy of a lost original), which he referred to as an 'Historical Landscape'. A 'slight view' of it, he claimed, was 'sufficient to demand our admiration and enforce respect' for its 'purity of conception uncharg'd with colour or of strained effects'.[1]

Turner probably first saw the picture in 1802, when it was exhibited at Spring Gardens along with the rest of the collection amassed for King Stanislas of Poland (before his forced abdication in 1795) by the dealer Noel Desenfans and his artist-friend Francis Bourgeois. Upon the latter's death in 1811 these paintings became the nucleus of the Dulwich Picture Gallery, where the *Roman Road* quickly became a favourite among artists and visitors. Such was its importance that when the gallery began lending works for study purposes

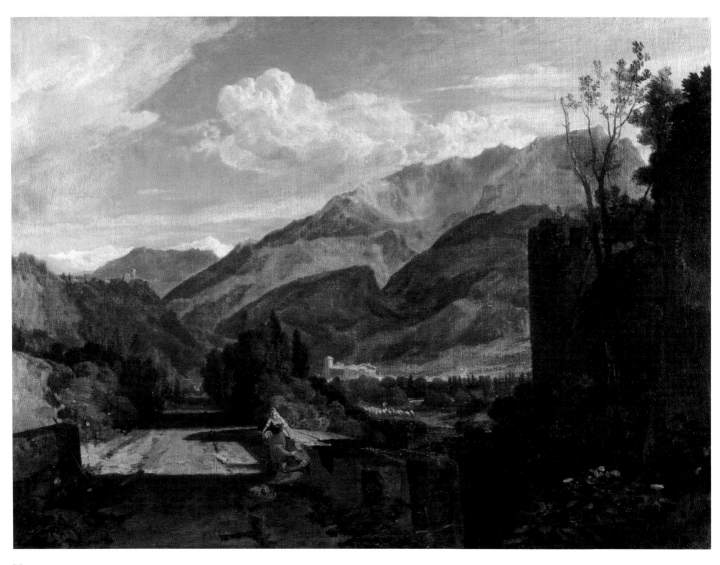

28

to the Royal Academy in 1816, this supposed Poussin was among the first, and the most regularly requested.

Some six months after Desenfans's exhibition, Turner made his first visit to the Continent, arriving near Bonneville in the *Haute-Savoie* in August 1802. Here he made a large number of sketches from nature, which became the basis for two painted views that he showed at the next Royal Academy exhibition (the other *Bonneville* oil, B & J no.46, now belongs to the Dallas Museum of Art). When composing the *Châteaux de St. Michael*, Turner clearly looked to Poussin's well-known picture in order to produce an ordered, classicised image of the rugged scenery of the Alps. But he also devised a number of tactics designed to demonstrate his creative independence, and to animate the rigorously geometric compositional structure of his Old Master model. Although Turner would later praise the *Landscape with a Roman Road*

as a particularly fine example of 'the rules of parallel perspective everywhere regulating and enforcing … propriety' by conducting 'every line' to 'the middle of the picture', the English artist chose to decentralise his own road, leading the eye to the left and then around the prospect, while traversing a range of forms with different textures and tonalities. The severe austerity of Poussin's long, straight avenue has also been softened, by an uneven succession of punctuating shadows cast by walls, bushes and trees. Moreover, by lowering his viewpoint and introducing a permeating golden light (in stark contrast to his model's cool palette), Turner allows his track to dissolve gradually into its mountainous environment; so that while the basic compositional elements recall the *Landscape with a Roman Road*, they do so at a meaningful distance. The final product is a painting that redoes Poussin over again from nature, in what is both an act of homage and an implicit critique.

29
Nicolas Poussin (1594–1665)
Winter, or *The Deluge* 1660-4
Oil on canvas, 118 x 160
Musée du Louvre, Paris

30
J.M.W. Turner
The Deluge exh. Turner's gallery 1805(?)
and RA 1813
Oil on canvas, 142.9 x 235.6
Tate

Of the nineteen works by Nicolas Poussin that were hanging in the Louvre when Turner visited Paris in 1802, it was the *Deluge* – one of a set of landscapes depicting the four seasons – that captured his imagination most of all. But the extensive notes he made about this celebrated picture show that he was anything but cowed by its reputation as an example of the 'truly sublime'.[1] Although Turner praised the *Deluge* for the power of its colouring, he condemned the absurdity of its forms, citing the woman and child in particular as 'unworthy the name of Poussin'.[2] Almost ten years later, in a lecture to the Royal Academy, Turner publicly elaborated on his initial mixed impressions:

> For its colour [the *Deluge*] is admirable. It is singularly impressive, awfully appropriate, just[ly] fitted to every imaginative conjecture of such an event. But … [it is] deficient in every requisite of line, so ably display'd in [Poussin's] other works, [and] inconsistent in his . . . colouring of the figures, for they are positively red, blue

29

and yellow, while the sick and wan sun is not allow'd to shed one ray but tears.[3]

Well before this date, Turner had already set about giving visual expression to his verbal opinions by producing a *tour-de-force* rendering of the same Biblical theme. His own *Deluge*, painted some two years after his return from Paris, is substantially larger than Poussin's, and was clearly intended to make the latter look static and overly theatrical. Whereas the French master's design relies on an ordered grid of horizontals and verticals rendered with tightly controlled brushwork, Turner's composition is dominated by sweeping diagonals which criss-cross back and forth across his canvas in great crashing waves. The effect of unceasing energy is further enhanced by the painterly bravura of his handling, which joins forces with the wild sea and sky as they threaten to overwhelm the storm-swept trees and the struggling specimens of condemned humanity. Thus instead of a narrative image like Poussin's, which asks to be read as the accumulated sum of its various discrete parts – individual human actors and groups, rain, clouds, sun, lightning, sea, land, ark and so forth – Turner presents water, matter, bodies and sky as one unbroken, tumultuous continuum. Lit by the sinister red glow of the setting sun (as if in mute riposte to its 'sick and wan' counterpart in the Poussin), the scene was praised by contemporary critics as a powerful image of apocalyptic chaos and destruction.

Although the *Examiner*'s Robert Hunt took Turner to task for failing to achieve a sufficient 'degree of neatness of execution and drawing,' he hailed the *Deluge* as an 'epic landscape' characterised by 'terror and pathos, the two main sources of the sublime'. Such a work, he went on to say, 'could have been produced only by a mind conversant with Nature's noblest features and a hand obedient to the emotions they produce'.[4] Likewise the *Morning Chronicle* (for 3 May 1813) eulogised Turner's Biblical drama as a 'grand composition…treated with that severity of manner which was demanded by the awfulness of the subject'.

30

31
Titian (c.1490–1576) and workshop
The Virgin and Child in a Landscape with
Tobias and the Angel 1535–40
Oil on panel, 85.2 x 120.3
Her Majesty the Queen

32
J.M.W. Turner
Holy Family exh. RA 1803
Oil on canvas, 102.2 x 141.6
Tate

The *Holy Family* is a rare attempt by Turner at Biblical figurative painting, albeit conceived not for any religious purpose but in self-conscious emulation of the Old Masters. On this occasion his principal model was the Venetian Renaissance artist Titian, whose works had so deeply impressed him on his trip to Paris in 1802 to see the spectacular accumulation of masterpieces that Napoleon's armies had seized from across the length and breadth of Europe. Turner had paid close attention to the array of canonical Italian history paintings assembled at the Louvre, and by submitting his *Holy Family* to the next Royal Academy exhibition publicly signalled his desire to make his mark as an historical artist in the Grand Style.

The richly coloured works of Titian and his fellow Venetians had long been prized by collectors, and had taught British painters a great deal about how to produce visually striking images that commanded the attention

31

of visitors to the annual exhibitions. Indeed one early nineteenth-century writer rather bitterly complained 'that the English School has followed this model rather more than the Roman; but here we find an apology for its error in the caprice and vanity of the public. The artist as well as the actor, is obliged to acknowledge the axiom of "he that lives to please must please to live".'[1]

Turner, however, probably had other, somewhat nobler aims in mind – above all to show that he was capable of expanding his range beyond landscape painting, and of representing the idealised human figure on a large scale. And as it turned out the picture did anything but please. When the *Holy Family* appeared at Somerset House, one reviewer claimed that Turner had 'spoilt a very fine landscape by very bad figures', whilst another simply dismissed it as 'unworthy of his talents'.[2] Henry Fuseli, the Royal Academy's Professor of Painting, was somewhat more sympathetic; although he

would have preferred a higher degree of finish, he was impressed enough with the picture to describe it as 'the embrio, or blot of a great master of colouring'.[3]

That mastery is probably more difficult for us to appreciate now, with the *Holy Family* in a darker state than when it left the artist's easel, though one imagines that Turner's original intentions at this relatively early stage in his career were to give his composition the deep autumnal tones of an Italian Old Master. The particular Titian he had in mind was probably not the work now in The Royal Collection, *The Virgin and Child in a Landscape with Tobias and the Angel* (though he certainly could have known this example), but the *Holy Family and a Shepherd* (c.1510) in the National Gallery, which passed through the London sale-rooms in January 1801. Another allusion may be to the works of Joshua Reynolds, who produced a number of Virgin and Child scenes of the same basic type.

32

33
Claude Gellée,
known as Claude Lorrain (c.1604/5–1682)

Landscape with Moses Saved from the Waters 1639
Oil on canvas, 209 x 138
Museo Nacional del Prado, Madrid

34
J.M.W. Turner

Crossing the Brook exh. RA 1815
Oil on canvas, 193 x 165.1
Tate

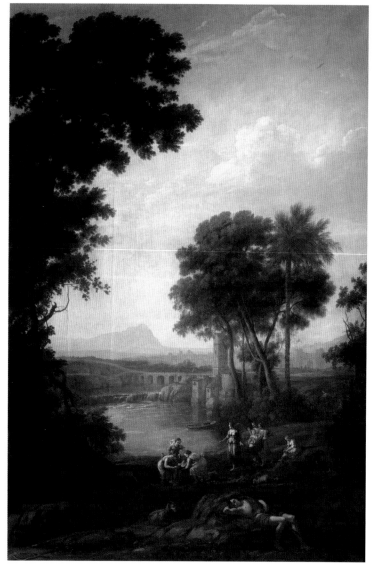

33

Although he could never have seen the original oil, Turner would have known the composition of Claude's *Landscape with Moses Saved from the Waters* through the published engravings of the *Liber Veritatis*, the volume of drawings put together by the seventeenth-century French master as a record of his autograph works. The use of an upright format – something relatively unusual for both artists – coupled with the presence of a multi-arched bridge or aqueduct, suggests that *Crossing the Brook* took *Moses Saved* as its specific model, although Turner almost certainly would also have had in mind Claude's similarly designed *Landscape with Hagar and the Angel* (National Gallery), which then belonged to his arch-enemy the connoisseur George Beaumont. In any event there can be no mistaking the overtly classical character of Turner's monumental prospect of the Tamar river valley in Devon, with its framing trees flanking a central avenue of space that draws the eye past a bridge in the middle distance before culminating in the brightest area of sky just over the horizon. That the same Royal Academy exhibition featured *Dido Building Carthage* (no.94), the closest approximation that Turner had up till then created of a Claudean seaport scene, suggests that he was deliberately soliciting comparisons with the painter he regarded as the greatest of all landscape specialists. Yet the critical responses to both *Dido Building Carthage* and *Crossing the Brook* in 1815 indicate that contemporary viewers were unperturbed by either picture's obvious dependence on Claude; indeed one reviewer even went so far as to claim that

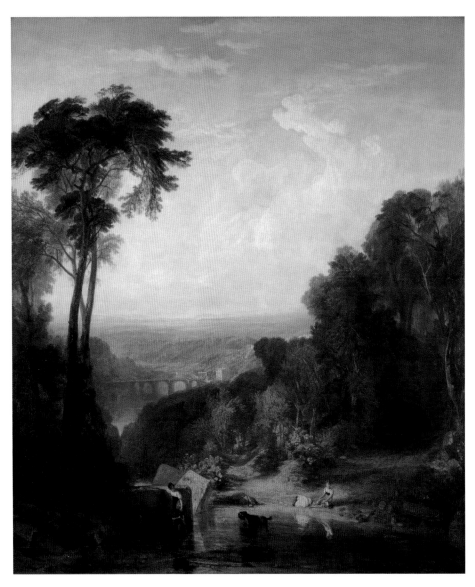

34

he could 'perceive no affinity to any style or school' and that Turner's 'manner and execution are as purely original as the poetic forms which create his composition'.[1]

What such a reaction tells us is either that the standard Claudean formats had by this point become so ubiquitous as effectively to be synonymous with landscape art in general, and/or that the two Turners looked sufficiently different from Claude – in their colouring and handling perhaps above all – to allow them to be viewed as independent productions. A third possibility is that there were at least certain members of the London art audience who preferred to see the operations of artistic genius regulated by a respect for cultural tradition, and that to

them on this occasion (as opposed to many others) Turner seemed to have struck precisely the right balance.

Executed immediately after a prolonged period of experimentation with painting directly from the motif, *Crossing the Brook* also offered an object lesson in how to reconcile the generalising demands of classical art with the specific representational requirements of English nature. Here Turner appeared to be marking out a path for the British School to follow; for according to the aptly-named magazine *The Champion* (of 7 June 1815), *Crossing the Brook* and *Dido Building Carthage* elevated their creator to 'that small but noble groupe [sic], formed of the masters whose day is not so much of to-day, as of "all-time"'.

35
William Hilton (1786–1839)
after Titian (c.1490–1576)
The Death of St. Peter Martyr c.1826
after original of 1530
Oil on canvas, 109.5 x 76
The Collection: Art and Archaeology
in Lincolnshire (Usher Art Gallery)

36
J.M.W. Turner
Venus and Adonis c.1803–4, exh.RA 1849
Oil on canvas, 149.9 x119.4
Stanley Moss, Riverdale, New York

37
Paolo Veronese (1528–1588)
The Finding of Moses c.1570–75
Oil on canvas, 58 x 44.5
Museo Nacional del Prado, Madrid

38
Pier Francesco Mola (1612–1666)
The Vision of St. Bruno c.1660
Oil on canvas, 94 x 70
Musée du Louvre, Paris

35

Before Titian's death, the *St. Peter Martyr* altarpiece was widely regarded as the artist's greatest work; hence all the more reason to regret that it is now known only through copies, following its loss in the fire that ravaged the sacristy of the church of Santi Giovanni e Paolo in 1867. Between 1530 and the year of its destruction, the picture left Venice only once, when along with the other spoils of Napoleon's Italian campaigns it joined the cavalcade of art treasures that were taken to Paris to enrich the Musée Central des Arts in the former Palais du Louvre. Here it became one of the brightest stars in a shining constellation of great masterpieces which Turner, along with hundreds of other British tourists, rushed to see once it became possible to travel to the Continent after the signing of the Treaty of Amiens in March 1802. During the nine days or so that he spent in Paris, Turner took full advantage of the opportunity to study *St. Peter Martyr*, filling three pages of a sketchbook with notes on its effects. The reasons why he devoted so much attention to this particular altarpiece become clear from a lecture he delivered at the Royal Academy several years later, when he asserted that 'The highest honour that landscape has as yet, she received from the hands of Titian … the triumph even of Landscape may be safely said to exist in his divine picture of St. Peter Martyr'.[1] The 'triumph' that Turner had in mind rested first and foremost in Titian's demonstration that landscape could rise above its traditional role as mere setting to become a major actor in the sublime drama of a scene; the results, furthermore, were not just elevated but true – or, as Turner wrote, both 'natural' and 'heroic'.[2] It was precisely this combination of qualities that he was determined to achieve in his own historic landscapes.

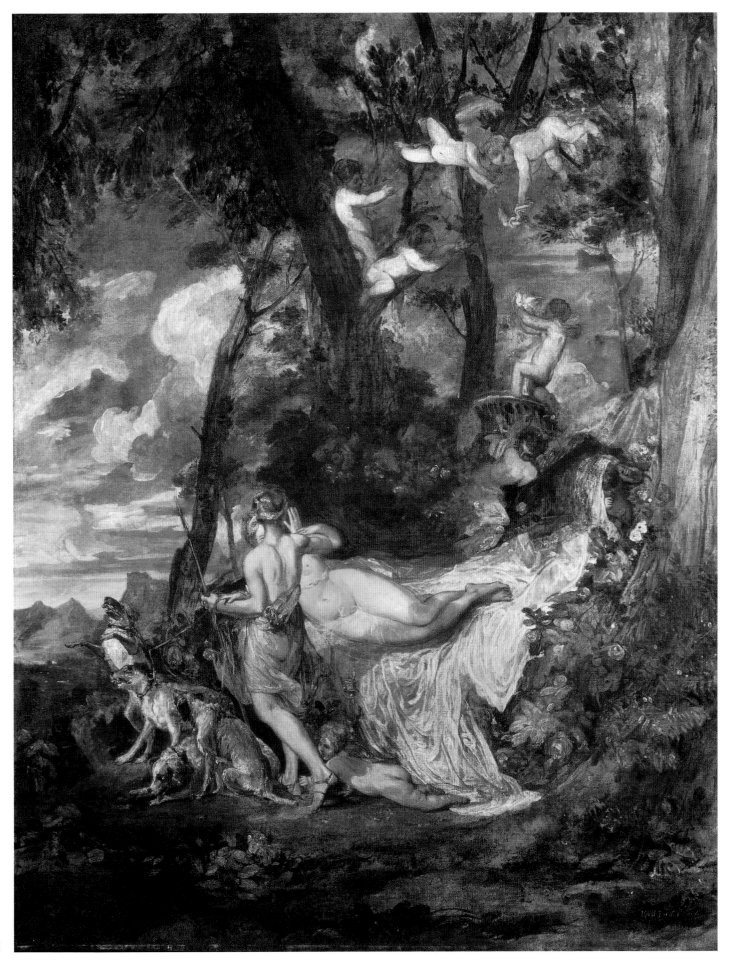

37

While visiting the Louvre, Turner encountered at least one other composition of the same basic type as *St. Peter Martyr* (and almost certainly inspired by it), in the form of Pier Francesco Mola's *Vision of St. Bruno*. Judging from the pencil and chalk study Turner made of this, he seems to have been particularly struck by the triple role that Mola had assigned to his two trees: as a natural feature, as a religious symbol (forming a Cross), and as a formal and narrative link between the ecstatic saint's earthly realm and the heavens above. Later Turner praised the 'beautiful conceptions of pastoral quietude'[3] that he found embodied in *St Bruno* – although he must also have admired the rich Titianesque colouring of Mola's distant mountains and sky.

In Paris Turner was exposed – perhaps for the very first time – to the full range and glory of Venetian Renaissance *colore*.

Five years earlier the British art world had been rocked by the scandal of the 'Venetian secret', when a young woman named Mary Provis and her father had persuaded a number of prominent Royal Academicians to pay ten guineas each for what purported to be the secret recipe for the tints employed by Titian and his contemporaries; and although this was soon revealed to be a hoax (not one in which Turner ever believed, by the way), artists' fascination with Venetian colour persisted unabated. This helps to explain why most of the copies in watercolour that Turner made of the pictures in the Louvre were after works by Giorgione or Titian (though not of the *St. Peter Martyr*, which was known to have been much altered by recent attempts at restoration). Another master colourist who left a deep impression on him at the time was Paolo Veronese; and although Turner never had a chance to see Veronese's

38

Finding of Moses, it is precisely the sort of Venetian historical landscape that he seems to have most profoundly admired.

Upon his return to England, Turner set about trying to digest the lessons he had learned from Veronese, Mola and above all Titian, whose *St. Peter Martyr* he took as the principal model for a large vertical canvas depicting the parting of Venus and Adonis, from Ovid's *Metamorphoses*. The story of Venus's tragic love for the beautiful youth Adonis, whom she tried but failed to prevent from taking part in a hunt that would lead to his death, had often been treated by the Old Masters – most famously, in several versions by Titian and his workshop; Turner would certainly have known the example belonging to John Julius Angerstein (now in the National Gallery), which had arrived in London in 1798 as part of the celebrated Orleans collection. But where Titian portrays Venus from the rear and Adonis frontally, Turner positions us behind the figure of the huntsman, and makes it impossible to see the face of either protagonist. Bodies and landscape thus become the sole conduits of the drama.

Yet despite the originality of this reworking of a familiar iconography, the artist may initially have felt that the results were too derivative to be exposed to public view. The *Venus and Adonis* would only be exhibited at the Royal Academy as late as 1849, by which time it could represent Turner's early work as rooted in an Old Master tradition, and as the foundation for his later, more radically original practice. Recognising the painting's Venetian heritage, one reviewer claimed it was 'proof that [Turner] lived in the light of Giorgione, and was the friend of Titian and Paul Veronese'.[4]

Turner and the North

David Solkin and Philippa Simpson

Turner's sustained response to different aspects of the Northern art tradition was, together with his pursuit of the Grand Style, central to the formation of his artistic identity. Within the academic hierarchy of art, the Italian School stood immeasurably higher than its Dutch and Flemish counterparts, which were criticised for being preoccupied with the straightforward and mechanical description of visible facts, rather than intellectually demanding (and elevating) abstraction. The close attention to detail displayed by Gerrit Dou (1613–1675), David Teniers the Younger (1610–1690; no.50) and other artists of the seventeenth-century 'golden age' of Netherlandish painting, like the interest of its landscape and marine specialists in the peculiarities of weather, light and atmospheric effect, was regarded as both inferior and antithetical to the elevated qualities embodied in the classical tradition. The Flemish-born Jean Antoine Watteau's delicately conceived fantasies of *ancien régime* aristocratic life may appear wholly different again, but they were similarly seen as concerned with the skilful rendering of minute detail, and not with the broad realisation of general truths that would appeal to nobler feelings. Whereas academic theorists associated the Grand Style with high moral significance, permanence, order and clarity, they castigated the Northerners for their preoccupation with the trivial, vulgar and transient specificities of the everyday material world.

David Wilkie
The Blind Fiddler exh. RA
1807
(detail, no.51)

Yet the same 'low' art was not without its influential supporters and admirers. By the early nineteenth century, Britain had seen generations of collectors spend increasingly large sums on Dutch and Flemish landscapes, marines and genre scenes, even at the expense of the more culturally distinguished Italian paintings or, indeed, examples of contemporary British art. The apparent transparency, simplicity and directness of most Netherlandish pictures, their undemanding subject-matter and charm, the sheer virtuosity of their illusionism, even their modest and intimate scale – all these features appealed to buyers who may have respected the Grand Style for its high-mindedness, but found it difficult to like.

During the 1790s such tastes found a new and prestigious source of support in the writings of Uvedale Price and Richard Payne Knight, theorists of the picturesque who used Dutch art as the aesthetic touchstone by which they judged the contemporary landscape garden. Price championed 'variety and intricacy' as qualities of supreme importance in nature and in art, while Knight compared the most picturesque parts of the English countryside with the works of Jacob van Ruisdael, Nicolaes Berchem (c.1620–1683) and Adam Pynacker (c.1620–1673), all Dutch landscapists of high repute.[1] In a broadside attack on academic theory, Knight later went on to argue that painters should depict only what they see, as the seventeenth-century Dutch had done;[2] this must have been one of the aims he had in mind when he commissioned Turner to paint a companion-piece to a famous 'Rembrandt' in his own collection (see nos.41 and 42).

Formulated during the period of the French Wars (1792–1815), the question as to whether the rising British School should

Fig.59
J.M.W. Turner
*Admiral Van Tromp's Barge
at the Entrance of the Texel
1645*, exh. RA 1831
Oil on canvas, 90.2 x 121.9
Sir John Soane's Museum,
London

follow the Italian or the Northern tradition was charged with strong patriotic resonance; and despite the institutional authority of the Academy, the long-standing association of Britishness with empiricism meant that it was the connoisseurs and collectors who won the day, with their arguments for an art based on the close observation of nature. This goes some way toward explaining why so many British painters in this period represented the scenery of the United Kingdom through the filter of seventeenth-century Dutch and Flemish naturalism.

Turner's attention to the Northern tradition needs to be situated within these wider aesthetic debates and market tendencies, as well as in relation to his own artistic ambitions. All three factors – though the last most immediately – underpinned his initial forays into genre painting (that is, the small-scale depiction of everyday life), a type of imagery usually associated with such Continental Old Masters as Rembrandt, Adriaen van Ostade (1610–1685) and Teniers the Younger. The early years of the nineteenth century witnessed a tremendous vogue for the latter in particular, whose works reached record prices in the London sale-rooms. Although often berated for choosing vulgar subject-matter, Teniers was also held up as the prime example of a painter whose sheer technical skill could 'give value to insignificant objects, or even those which seemed offensive';[3] in addition, his scenes were widely applauded for their truthfulness, down to the smallest detail. In 1806 British art critics discovered these same qualities – in a much improved form, it was claimed – in the work of a twenty-year-old Scottish painter named David Wilkie, when he made his Royal Academy debut with a picture called the *Village Politicians*

(no.48). Here one of Wilkie's aims was to make fun of the lower-class interest in 'high' politics – an issue that Turner picked up on in his first exhibited genre painting, *A Country Blacksmith Disputing upon the Price of Iron*, which was hung beside Wilkie's second 'hit' picture, *The Blind Fiddler*, at the Academy a year later (nos.49 and 51). Turner's main goal, however, must have been to try and show that he could outdo the young Scottish prodigy as an interpreter of Teniers. Although reviewers immediately grasped his intentions, the artist must have been disappointed to discover that critical opinion was virtually unanimous in preferring Wilkie's genre scenes to his own; and despite several efforts to promote his case in the succeeding years (for example, no.42), this was one battle that Turner never managed to win.

On the whole he fared much better with his seascapes, where he was generally adjudged to have outshone all contemporary rivals – indeed even, as Sarah Monks observes elsewhere in this volume, to have surpassed 'the BACKHUYSENS and VANDERVELDES of former days'.[4] This competition had begun in earnest in 1800, when the 3rd Duke of Bridgewater had commissioned Turner to paint *Dutch Boats in a Gale* as a pendant to a seascape by Willem van de Velde the Younger (nos.19 and 20), and it continued through to the final decade of his career. Between 1800 and around 1810, and then again from the early 1830s until the mid-1840s, Turner looked to the works of van de Velde as the principal point of reference for his marine imagery. Starting in 1831 with *Admiral Van Tromp's Barge at the Entrance of the Texel* (fig.59), this

branch of his art gained a new thematic dimension with the introduction of references to the history of seventeenth-century Holland, as well as to its art.[5]

He seems to have been particularly fascinated with Admiral Marten Tromp, an exemplary figure of heroic achievement and dogged independence in contemporary British minds – and hence an appropriate alter ego for Turner himself. Yet in respect to the demands of the marketplace, his late van de Velde-like sea-pieces were anything but a declaration of creative independence; for where many of his other, arguably more original works remained unsold, usually there were plenty of buyers for his marines. Not all of these were specifically modelled on van de Velde; on one occasion in 1833 he portrayed the painter Jan van Goyen (1596–1656), *Van Goyen, looking out for a Subject* (fig.60), whilst in 1827 and then again in 1844 he paid tribute to the coastal scenes of Ruisdael, by depicting two views of rough waters off an imaginary 'Port Ruysdael' (nos.69, 70, 98 and 99).

Curiously, Turner (unlike John Constable) never tried to emulate Ruisdael as a painter of landscapes or townscapes, preferring instead – when a Dutch model was called for – to invoke Aelbert Cuyp for this purpose (see nos.46 and 47). In Cuyp's luminosity he found an effect akin to the golden glow of a Claude Lorrain, coupled with a breadth of touch which likewise seemed to lift a defiantly prosaic Northern subject-matter above the realm of the mundane and the particular. But as someone well versed in academic art theory, he was only prepared to claim that among the Dutch and Flemish landscape painters, just 'two, Rembrandt and Rubens, ever dared to raise [nature] above commonality'.[6]

Turner was never deeply enamoured by Rubens, whom he felt was unnatural in his light and colouring (but see no.54); Rembrandt, however, he regarded as one of the true 'greats'.[7] As we have already observed (see pp.106–9), Turner's serious involvement with Rembrandt began in the mid-1790s, and then picked up again after 1806, when he enjoyed his first prolonged opportunity to study *The Mill*, the Dutch master's most celebrated landscape in oils (no.58). But after executing his own version of this composition (fig.35), Turner turned his attentions elsewhere, returning to Rembrandt nearly two decades later, not coincidentally at a time when several British figurative artists had begun working in his style. It was their example, and the golden hues of works like *The Jewish Bride* (fig.39), that led Turner around 1830 to paint a small number of Rembrandtesque subject-pictures (see nos.40 and 44), whose idiosyncratic drawing and high colouring prompted a loud outcry of critical derision. Like other commentators of his generation, Turner valued Rembrandt's colour, chiaroscuro and brushwork as evidence of the artist's unrivalled imaginative powers; and it was what he regarded as the Dutchman's genius that encouraged him to try and liberate his own imaginative faculties, even at the risk of being accused of having turned his back on nature.

Fig.60
J.M.W. Turner
Van Goyen, looking out for a Subject exh. RA 1833
Oil on canvas, 91.8 x 122.9
The Frick Collection, New York

39

40

39
Rembrandt Harmensz.
van Rijn (1606–1669)
Christ and the Woman Taken in Adultery 1644
Oil on panel, 83.8 x 65.4
The National Gallery, London. Bought 1824

40
J.M.W. Turner
Pilate Washing his Hands exh. RA 1830
Oil on canvas, 91.4 x 121.9
Tate

When Rembrandt's *Christ and the Woman Taken in Adultery* appeared on the London art market in 1807, it met with a rapturous critical response. Although the picture had by then been in England for almost forty years, this was the first opportunity most viewers had ever had to examine it at their leisure – prompting the decision to keep it on extended display at Christie's, and then at the house of its new owner, the banker John Julius Angerstein. For the hordes of artists and *cognoscenti* who swarmed around this celebrated Rembrandt, even the most hyperbolic praise failed to do the work full justice. 'All who approached it pulled off their hats' in reverence, claimed the president of the Royal Academy, Benjamin West;[1] while a visitor from France described it as 'the finest thing I ever saw as to the magic of colouring'.[2] In 1824, a year after Angerstein's death, *Christ and the Woman Taken in Adultery* joined thirty-seven other works from his collection to form the core of the National Gallery.

Thus by the time Turner painted *Pilate Washing his Hands*, the Rembrandt had already become one of Britain's best-known Old Masters. Its fame helped to catalyze a minor 'Rembrandt revival' that occurred in English painting in the late 1820s, led by Turner's close friend George Jones (see nos. 78 and 79). But while Jones set out to 'correct' Rembrandt's obvious 'deficiencies' as a figure draughtsman, Turner made no such effort. Indeed as an artist often castigated for his own idiosyncratic portrayal of the human body, he had particular cause to admire Rembrandt as a master who had shown that there was more than mere correctness to the expression of creative genius. More specifically, it was the example of *Christ and the Woman Taken in Adultery* that on this occasion encouraged Turner to use rich colouring and chiaroscuro as a means of communicating the spiritual and

dramatic essence of a Biblical narrative, at the calculated expense of making the action more than a little difficult to read (with Pilate, arms outstretched, almost invisible in the distance). The critical reaction, not surprisingly, was generally less than favourable. The *Literary Gazette* (8 May 1830) condemned the *Pilate* as 'wretched and abortive', and a week later quoted a facetious viewer 'saying, he fancied "a pilot washing his hands was a fine marine subject"'. Three years later, however, a long review of Turner's overall achievement singled out this much maligned picture as a singularly memorable demonstration of the painter's imaginative powers:

> When the miscellaneous crowd … first beheld Turner's painting of 'Pilate Washing his Hands' all experienced the influence of its blaze of light, its gorgeous colouring and magical chiaroscuro. But its grandeur of conception, its passion, expression and pathos, few understood and less appreciated; and many condemned what they could not understand, and looked on the noble effort of genius only as a mere mass of unmeaning colour. In our opinion the grandeur of idea, the power of invention, and the awfully sublime effect on the mind, cannot receive too much praise. … Like Rembrandt, by the mere power of light and shade and harmonious colouring, Turner can rouse the sublimest feelings of our mind … [3]

41
(circle of) Rembrandt Harmensz. van Rijn (1606–1669)

The Holy Family at Night (*The Cradle*) c. 1642–8
Oil on panel, 66.5 x 78
Rijksmuseum, Amsterdam

42
J.M.W. Turner

The Unpaid Bill, or *The Dentist reproving
his Son's Prodigality* exh. RA 1808
Oil on panel, 59.4 x 80
The Schindler Family

In 1807, the connoisseur and writer on the arts Richard Payne Knight invited Turner to paint a companion-piece to a famous masterpiece he owned known simply as *The Cradle*, which had long been regarded as an especially important Rembrandt (though it is now attributed to a close follower). This commission gave Turner an opportunity not only to pit his talents against those of a precursor whom he particularly admired, but also to do so on a relatively public stage, since Payne Knight's was one of London's most accessible private picture galleries.[1] One of its owner's aims, according to the artist Richard Westall (1765–1836), was 'to shew that the moderns [could] stand' with the Old Masters[2] – an ambition that was equally dear to Turner's heart.

The Cradle's high reputation in British artistic circles dated back at least as far as the early 1720s, when Jonathan Richardson had written that:

> All the good properties of a Picture (of this subject) are here in a very high degree, and some as high as one can conceive 'tis possible to raise them … the Expression is exquisite; the Colouring warm, and transparent; a vast number of parts put together with the utmost Harmony … [3]

At that time the painting had been in the possession of the French Royal family, as indeed it remained until 1793, when in the wake of the Revolution it came to London to be sold along with the rest of the Northern pictures which had formerly belonged to the Duc d'Orléans. Shortly after *The Cradle*'s arrival, anxious rumours spread that it had been sold and was to be exported to Russia;[4] so contemporary journalists expressed both wonder and relief when they eventually discovered that

the Rembrandt had been bought by Payne Knight for a thousand guineas, and was therefore to remain in London.

Failing to recognise that the subject was in fact a Holy Family, commentators praised the painting as proof of Rembrandt's 'superior observance, and unequalled accuracy in copying what was observed'.[5] But above all it was his handling of light and shadow that elicited the warmest praise, and upon which Turner focused as he set about fashioning his pendant. In so doing, however, he appears to have had a second point of reference in mind, in the shape of another work in Payne Knight's collection, a picture called *The Alchemist* now believed to be by Gerard Thomas (1663–1720), but which was then attributed to David Teniers the Younger (fig.61). This would then seem to suggest that Turner sought to exploit this commission to support a battle that he had been fighting on another front altogether – not with Rembrandt, but with David Wilkie, who had been widely hailed as Britain's answer to Teniers (see nos.48 and 50).

When *The Unpaid Bill* appeared at the Royal Academy in 1808, it was Turner's rivalry with Wilkie that dominated the critical response. Although the *Examiner*'s Robert Hunt judged the painting 'worthy of its destination as a companion for the cradle-piece of Mr. P. Knight's Rembrandt',[6] while another paper praised the Turner for 'the harmonious distribution of its light and shade',[7] it was widely criticised as a piece of drawing, and for its narrative and formal indistinctness.[8] In what was no doubt an expression of the general consensus, the *Sun* (17 May 1808) said that it was 'sorry to see [Turner] waste his powers in such a work as the present', and 'exhort[ed] him to employ his talents in a higher direction'. Presumably it was only when the picture entered Payne Knight's gallery that Turner's dialogue with Rembrandt came once again to the fore.

Fig.61
Gerard Thomas,
The Alchemist
Oil on canvas,
Dimensions
unknown
Present location
unknown

41
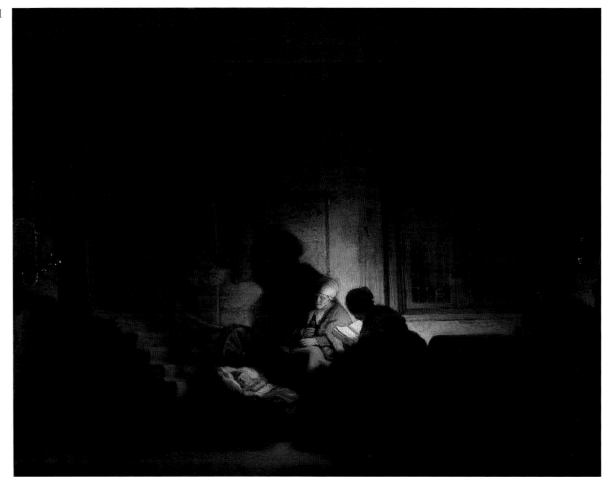

42

43
Rembrandt Harmensz.
van Rijn (1606–1669)
Girl at a Window 1645
Oil on canvas, 81.6 x 66
Dulwich Picture Gallery, London

44
J.M.W. Turner
Jessica exh. RA 1830
Oil on canvas, 122 x 91.5
Tate. Accepted by HM Government in lieu
of tax and allocated to the Tate Gallery 1984.
In situ at Petworth House

45
Gilbert Stuart Newton (1794–1835)
Dutch Girl ('The Window') exh. BI 1829
Oil on mahogany, 37.1 x 27
Tate. Presented by Robert Vernon 1847

43

Of the several compositions by Rembrandt showing a half-length female figure framed by a doorway or window, Turner and his audience would have been most familiar with the example bequeathed to Dulwich College in 1811 by Francis Bourgeois, as part of an important group of Old Masters that became the core collection of Britain's first public art gallery. In 1815 the *Girl at a Window* appeared at the British Institution in Pall Mall, in London's first major exhibition of Dutch and Flemish works, while a year later it made the first of numerous appearances at the Royal Academy schools, where it became a regular teaching aid. Turner would also have been familiar with other Rembrandts of the same basic type, though none is close enough to *Jessica* to be identified as its definitive model.

The colouring of his picture, however, suggests that he may have had other paintings by Rembrandt in mind – notably *The Jewish Bride*, with its passages of brilliant yellow (fig.39;

the picture, now in the Rijksmuseum, was with a London dealer between 1825 and 1836), and the Buscot Park *Portrait of a Man* with long golden hair (see fig.38). This, as Sarah Monks points out in her introductory essay, had featured prominently in another British Institution show of Old Master paintings, which had taken place as recently as 1824. But despite its multiple engagements with Rembrandt, *Jessica*'s artistic lineage passed virtually unnoticed when it appeared at the Royal Academy in 1830. So blinded were the critics by the harsh yellows of Turner's image that they found it difficult to notice anything else.

Whereas the *Girl at a Window* was admired for its 'absolute truth', and 'as purely natural and forcible a head as Rembrandt ever painted',[1] *Jessica* resembled, according to the *Morning Chronicle* (3 May 1830), 'a lady getting out of a large mustard-pot'. 'It looks to me', wrote William Wordsworth, 'as if the painter had indulged in raw liver until he was very

44

45

unwell'; meanwhile *Fraser's Magazine* (vol.2, 1830–1, p.97) proposed a similar metaphor, when it attributed the artist's obsession with yellow to the incurable condition of 'jaundice on the retina'.[2] Amidst this torrent of critical abuse, no one seems to have noticed that Turner was trying to emulate Rembrandt's use of dazzling colour for poetic effect, and in so doing to try and find a purely visual way of conveying the essence of Shakespeare's *Merchant of Venice* – a play that deals with the preciousness of gold, and of a woman, Shylock's daughter Jessica, who desires and who is desired, caught between her father and her lover.

The idea of linking a Rembrandtesque pictorial format of the *Girl at a Window* type with a theme from imaginative literature was not original to Turner. Instead, as Andrew Wilton has perceptively observed, one of his points of departure is likely to have been the illustrated *Annuals* of poetry and prose which several London publishers began to issue in the mid-1820s, the

most famous example being Charles Heath's *The Keepsake*.[3] These Christmas anthologies frequently included engravings of soulful young women, usually depicted at half-length, looking out at the viewer – and it wasn't long before British painters began producing their own independent 'keepsake girls' for display and sale at the annual exhibitions. Turner must have been familiar with several examples of the type, including Gilbert Stuart Newton's *Dutch Girl*, which had been warmly praised at the British Institution in 1829. 'This is manifestly a *fair* specimen of the Nymphs of Holland', stated the *Examiner*, while the *Times* thought it a 'beautiful cabinet picture'.[4]

Despite being based on the same generic Rembrandt source, Turner's *Jessica* was harshly judged to be neither beautiful nor fair. The artist was strongly urged to 'stick to landscape, and tint it from nature's pure tints, not from his own imagination'[5] – advice that he tended to follow less and less consistently as time went on.

46
Aelbert Cuyp (1620–1691)
A Herdsman with Five Cows by a River c.1650–5
Oil on panel, 45.4 x 74
The National Gallery, London. Bought 1871

47
J.M.W. Turner
Abingdon exh. Turner's gallery 1806(?)
Oil on canvas, 101.6 x 130.2
Tate

In a lecture he delivered at the Royal Academy in 1811, Turner reserved some of his most fulsome praise for the works of Aelbert Cuyp – a painter who, he claimed, 'to a judgement so truly qualified, knew where to blend minutiae in all the golden colour of ambient vapour'.[1] It was a commonplace of early nineteenth-century art criticism that the British had been the first people outside the artist's native Holland to appreciate his true greatness; or as the London picture dealer Noel Desenfans observed with some satisfaction in 1802, 'it was reserved to the English nation to have the merit of bringing [Cuyp's abilities] to light, and to give his works the high reputation they are now held in'.[2] Over the previous fifty years, British collectors had avidly pursued Cuyp's light-drenched pastoral scenes; and by the early nineteenth century, when prices were rocketing to unprecedented levels, it was the Dutchman's ability to create

46

'admirable' pictures out of the simplest of materials that had come to be most highly prized.[3]

Like numerous other seventeenth-century Netherlandish painters – David Teniers the Younger (no.50) being another example – Cuyp was also frequently lauded for the unembellished truthfulness of his representations. In 1816, a critic hailed another of his 'landscape with cattle' pictures (in the Dulwich Picture Gallery) for being 'full of that truth of nature just bordering on the artificial, that characterizes this master's best works, and is a proof of the superiority of the true natural tone of colouring over the gaudy exhibition style' of French painters like Claude-Joseph Vernet.[4] Hence by referring to Cuyp – in particular to his treatment of atmospheric effects – Turner managed to satisfy the dictates

of both Old Master art and contemporary English nature. The powerful resonances with past art also invoked the ideal of a golden age, as if to suggest that an Arcadian serenity might still be found on this sunlit stretch of the modern Thames.

The *Abingdon*'s loyalties, however, are not to Cuyp alone. Turner's use of a higher viewpoint, coupled with his construction of a central avenue of space that leads our eye to a brilliant burst of sunshine over the middle of the horizon, shows him drawing on the conventions of classical landscape art, and in particular on the works of Claude. It was by playing different masters – and traditions – off against each other that Turner asserted his independence from the painters who had preceded him, and found a space where he could make his own claims to rendering the 'truth of nature'.

47

48
David Wilkie (1785–1841)
Village Politicians exh. RA 1806
Oil on canvas, 57.2 x 74.9
By kind permission of The Earl of Mansfield
and Mansfield, Scone Palace, Scotland

49
J.M.W. Turner
A Country Blacksmith disputing upon
the Price of Iron, and the Price
Charged to the Butcher for shoeing
his Poney exh. RA 1807
Oil on pine panel, 54.9 x 77.8
Tate

50
David Teniers the Younger (1610–1690)
Two Men Playing Cards in the Kitchen of an Inn c.1635–40
Oil on oak panel, 55.5 x 76.5
The National Gallery, London. Salting Bequest 1910

51
David Wilkie (1785–1841)
The Blind Fiddler exh. RA 1807
Oil on mahogany panel, 57.8 x 79.4
Tate. Presented by Sir George Beaumont Bt 1826

The Royal Academy exhibition of 1806 witnessed the spectacular debut of David Wilkie, a hitherto unknown twenty-year-old Scottish artist, whose *Village Politicians* proved to be the star of the show. Quite unexpectedly, contemporary reviewers went into raptures about this modestly sized genre scene painted in rather dull brownish tints, depicting a group of Scottish peasants in a ramshackle ale-house disputing a point of current affairs that has been raised by the recent delivery of a radical Edinburgh newspaper. Although Wilkie's theme was not entirely without interest, the critical reactions focused mainly on what was judged to be the young painter's remarkably high level of technical accomplishment, as demonstrated by his ability to represent 'common' nature with a degree of truthfulness that appeared to surpass the achievements of any of his predecessors – including the Flemish master David Teniers the Younger, who was widely acknowledged to be Wilkie's principal model.

There were probably several reasons why Turner – who had hitherto done very little in the way of painting everyday life – felt compelled to respond to the *Village Politicians* with a genre scene of his own, and to show this in the following year. First of all, as an established professional who had not long before been the Academy's 'golden boy', he could hardly have been pleased to witness the enthusiastic reception accorded to a new prodigy, ten years younger than himself. At this time in Turner's career, furthermore, he was using the annual exhibitions and his own recently built gallery to stage regular public competitions between himself and a number of canonical Old Masters, including several seventeenth-century Northern painters (notably Cuyp and van de Velde); so it must have been somewhat galling for him to see a contemporary just out of his teens win hands down at much the same game. Last but not least, it was public knowledge that Wilkie enjoyed the support of a group of highly influential collectors and connoisseurs led by the arbiter of taste George Beaumont, who was one of

Turner's most vociferous critics. Having lost out to Lord Mansfield in his attempt to purchase the *Village Politicians* even prior to its appearance at the Academy, Beaumont had immediately agreed to buy Wilkie's next major picture, *The Blind Fiddler*; this composition was already being widely praised in the press as early as the summer of 1806,[1] fully nine months before it went on view at the RA's premises in Somerset House.

Thus as Turner worked in his studio during the run-up to the Academy exhibition of 1807, he would have had in mind to try and outdo not only Wilkie's great 'hit' of the previous year, but another that he'd heard about but probably not yet seen. Not surprisingly, he came to the RA with guns blazing, with not one but two essays in the Netherlandish manner: *Sun Rising through Vapour* (no.103), featuring a Teniers-like group of fishermen in the lower right-hand corner, and *A Country Blacksmith disputing upon the Price of Iron, and the Price Charged to the Butcher for shoeing his Poney*. Anticipating the enormous public interest in a confrontation between one of the most celebrated Academicians and a youthful 'intuitive genius'[2] who had suddenly risen to fame, the hanging committee placed the two Turners and the Wilkie on the same wall of the Great Room, where they could be compared with one another. The brightness of *Sun Rising through Vapour*, or at least so it was later claimed, was designed to overpower *The Blind Fiddler* and all the other works in its immediate vicinity;[3] with *A Country Blacksmith*, however, Turner attacked Wilkie on another front, by offering what he proposed to be a superior reworking of Teniers.

Judging by the picture itself, the grounds for Turner's claim to superiority lay first and foremost in the painterly breadth of his touch, and in his refusal to bow to the connoisseurs' demands for a meticulous attention to the minutiae of nature. In a poem that he inscribed into one of his sketchbooks two years later, Turner privately expressed the opinion that flattery had led Wilkie astray, and had allowed him to be satisfied with a false understanding of Teniers's art.[4] His resentment of the young Scotsman's success may have been fuelled by his failure to convince the public that he was the better artist. Although the *Morning Post* (7 May 1807) wrote that *A Country Blacksmith* was 'admirably composed, delightfully coloured, and possesses all the breadth and attention to general effect so conspicuous in the works of this great Artist', most reviewers felt that Turner's style was too indistinct to produce sufficiently legible narratives of everyday life. In its edition of 27 May, the *Sun* summed up the consensus of critical opinion in the following words:

> It does not appear to us that Mr Turner's genius is properly exercised in works of this nature. In Landscapes and Sea-views he appears to great advantage, but his pencil is much too rough and negligent for familiar scenes of domestic enjoyment. There is a slovenly unfinished character in the whole of this piece, and the Artist, in aiming at a richness of colouring, has produced a gaudy glare.

According to several other commentators, Turner had unconsciously conceded his own shortcomings as a story-teller by burdening his picture with such a lengthy title. This referred to a current political debate about the Pig Iron Duty Bill, and how the costs of Britain's ongoing war with France were impinging upon the lives of its poorest citizens – a theme that linked the day-to-day experience of the common people to the larger events of History in much the same way as Wilkie had done in his *Village Politicians* (without having to use more than a two-word title!). Like his blacksmith and his butcher, Turner was concerned about matters of price, and insisted to John Leicester that he would accept nothing less than the 100 guineas he understood Wilkie would receive for *The Blind Fiddler*. In this respect, if in few others involving his rivalry with Wilkie, Turner got exactly what he wanted.

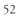
52

53

52
Jean Antoine Watteau (1684–1721)
Gathering near the Fountain of Neptune c.1712
Oil on canvas, 48 x 56
Museo Nacional del Prado, Madrid

53
J.M.W. Turner
What you Will! exh. RA 1822
Oil on canvas, 48.2 x 52
Sterling and Francine Clark Institute, Williamstown,
Massachusetts, USA. Gift of the Manton Art
Foundation in memory of Sir Edwin and Lady Manton

One of the smallest paintings Turner ever showed at the Royal Academy, *What you Will!* met with a mixed response when it appeared at Somerset House in 1822. Although one reviewer called it 'a splendid little piece of colouring', another insisted it was 'not a picture at all, but a mere impertinence'.[1] The *Examiner* agreed, claiming that Turner had submitted 'only a piece of coloured canvas, called What you Will! and to which challenge for a determinate denomination we reply – 'Almost anything but what a picture ought to be!'.[2] At the time no one realised, or so it seems, that 'What you Will!' was Shakespeare's alternative title for *Twelfth Night*, and that the figures in the picture represent characters from the play: Olivia is shown walking with two attendants in the foreground, while Maria, Sir Toby Belch and Sir Andrew Aguecheek hide amidst the sculptures beyond.

In Turner's own mind at least, if not the minds of his original audience, there was a natural link between one of Shakespeare's most light-hearted comedies of love and the playful *fêtes galantes* that were synonymous with the eighteenth-century French painter Jean Antoine Watteau. It was from pictures like Watteau's *Gathering near the Fountain of Neptune* (though not from this specific example) that Turner borrowed the salient features of his own composition: not just its small scale, intricate brushwork and jewel-like colouring, but also the idea of presenting a group of theatrically-costumed figures and emblematic statues in a sylvan park-like setting.[3]

Although the same spirit of frivolity may have been at work in Turner's choice of title, which punningly refers to Watteau's (i.e. 'What you's) name, there can be no doubt of the sincerity of his admiration for the French artist's work. He even went so far as to tell his friend the Reverend William Kingsley, that 'he had learned more from Watteau than from any other painter'.[4] Yet while the Watteauesque character of *What you Will!* didn't pass unnoticed in 1822, critics were unsure about the seriousness of Turner's intentions, the *Repository of Arts* (for 1 June) even going so far as to call the picture 'a whimsical attempt' at the earlier artist's manner. 'Mr Turner', the same reviewer went on to say, 'is a man of too much original power, and capable of producing a corresponding effect, to be indulged in this species of painting.'

If several critics said much the same, this may have been because they regarded Turner and Watteau as entirely antithetical creative personalities. Watteau, wrote William Hazlitt, 'might almost be said to breathe his figures and his flowers on the canvas – so fragile is their texture, so evanescent is his touch'.[5] Turner's art, by contrast, could never have been accused of being 'fragile' or 'evanescent'; instead he was celebrated for the 'power' of his imagination, and the 'corresponding' robustness, even crudeness, of his touch. His attempt to emulate a painter so unlike himself underlines the risks he was prepared to run in order to maximise his range, and thus, in protean fashion, to assume as many different artistic guises as possible.

54
Peter Paul Rubens (1577–1640)

Landscape by Moonlight 1635–40
Oil on panel, 64 x 90
The Samuel Courtauld Trust,
The Courtauld Gallery, London

55
J.M.W. Turner

The Forest of Bere exh. Turner's gallery 1808
Oil on canvas, 89 x 119.5
Tate. Accepted by HM Government in lieu of tax and
allocated to the Tate Gallery 1984. In situ at Petworth House

56
Thomas Gainsborough (1727–1788)

Boy driving cows near a pool 1786
Oil on canvas, 58.4 x 76.2
Tate. Presented by Robert Vernon 1847

Rubens's *Landscape by Moonlight* held a particular significance for early nineteenth-century British artists; not only was it by a prominent Old Master, but it had been one of the highlights of the collection of Joshua Reynolds, the first president of the Royal Academy and a figure who was widely regarded as the founder of the modern British School. In his highly influential *Discourses* to the Academy, Reynolds had spoken of this nocturnal scene as an especially fine example of that 'fulness' of effect 'produced by melting and losing the shadows in a ground still darker than those shadows', even if this meant taking certain liberties with nature. On this occasion 'Rubens has not only diffused more light over the picture than is in nature, but has bestowed on it those warm glowing colours by which his works are so much distinguished'. The painter 'might indeed', Sir Joshua goes on to say, 'have made [the scene] more natural, but it would have been at the expence of what he thought of much greater consequence, – the harmony proceeding from the contrast and variety of colours'.[1] Although one might have thought that Turner would have been prepared to endorse this order of priorities, in his own lectures to the Royal Academy he was considerably less charitable. Rubens, he felt compelled to say, 'could not be happy with the bare simplicity of pastoral scenery or the immutable laws of nature's light and shade', and so he 'threw around his tints like a bunch of flowers', thus sacrificing truth for the sake of sheer colouristic bravura. One wonders whether the *Landscape by Moonlight*, with its relatively sombre and

restricted palette, might have been the exception that proved the rule, and demonstrated what Turner felt that Rubens and Rembrandt, alone among the Dutch and Flemish masters, possessed in common: the laudable capacity to raise nature above her 'commonality'. The same elevating vision, Turner went on to assert, had also informed the works of Thomas Gainsborough,[2] whose landscapes owed so much to the achievements of Rubens.

Retaining Rubens's 'warm glowing colours',[3] together with the tranquil Arcadian spirit by now almost synonymous with Gainsborough, Turner attached these features to the view of a particular place in the Hampshire countryside, shown at a particular time of day; likewise he took pains to differentiate each tree and each animal from the next. The woodcutters and the pollarded trees also make it clear that this image portrays a modern working forest, and not some scene from the classical Golden Age. 'Though it is nothing as a subject', wrote the engraver-cum-critic John Landseer of *The Forest of Bere*, 'it is everything as a picture', thanks to 'the rich and harmonious union of its parts'.[4] The key to achieving that richness and that harmony, and to creating something so significant out of such unprepossessing thematic materials, lay first and foremost in Turner's judicious deployment of his Old Master models. His success at balancing a close attention to observed nature with the aesthetic legacy of not one but two renowned earlier landscape painters may have prompted the 3rd Earl of Egremont to purchase *The Forest of Bere* when he saw it on exhibition at the artist's studio – though the fact that Egremont owned the forest in question can't have done Turner's cause any harm.

56

57
J.M.W. Turner
*Windmill on Hill: Valley and Winding River
in Middle Distance; Sunset Effect* c.1795
Pencil and watercolour on paper, 19 x 27.7
Tate

58
Rembrandt Harmensz. van Rijn (1606–1669)
The Mill 1645–8
Oil on canvas, 87.6 x 105.6
National Gallery of Art, Washington, Widener Collection 1942

59
J.M.W. Turner, engraved by William Say
Windmill and Lock 1811
Etching and mezzotint, 17.8 x 25.9
Tate. Presented by A. Acland Allen through The Art Fund 1925

Rembrandt's *The Mill* was a work of exceptional significance for late eighteenth- and early nineteenth-century British landscape artists. Having been removed from Paris in 1792 together with the other Dutch and Flemish pictures in the famous Orleans collection, the following year it was placed on extended exhibition in London, prior to being sold at auction. The picture was already Rembrandt's most celebrated landscape, and it did not disappoint its English audience: 'the mill aloft and so lonely in the waste – the dashing surge below – the gathering shadows above – and the veracious colouring of the ether – are all matchless', one newspaper critic was moved to write.[1]

Although just eighteen at the time of the first Orleans sale, within two years or so Turner signalled his aspiration to emulate Rembrandt by taking *The Mill* as his compositional model (in reverse) for a watercolour featuring a windmill perched on a hilltop and silhouetted against a golden sunset sky. But this was to be only the first of a sequence of acts of homage that Turner would pay to a Rembrandt he particularly admired. In 1806, the British Institution borrowed *The Mill* for inclusion in the first of its annual 'schools', where artists were able to study it closely and at length. Here Turner's second encounter with the Rembrandt seems to have left an even stronger impression upon him than the first: for by 1810 he had produced and exhibited in his own private gallery the *Grand Junction Canal at Southall Mill* (fig.35) – a large canvas so obviously

based on *The Mill* as to give Turner little opportunity to assert his own presence, apart from his much brighter treatment of the sky. Developed from sketches made while on a walk near Brentford, *Grand Junction Canal* seems to have been the product of 'one of those fortuitous occasions when an artist came upon a subject in nature which reawakened an aesthetic stimulus received from another painter's picture'.[2] That stimulus, as Sarah Monks notes in her introductory essay, encouraged Turner to pursue his ongoing exploration of chiaroscuro as an expressive force in its own right, one that could give an image significance irrespective of its subject-matter.

A year later, in 1811, Turner made precisely this point about Rembrandt's picture in a lecture he delivered to the students of the Royal Academy. Here Turner willingly conceded that the subject of *The Mill* may well have been 'the most objectionable that could be chosen'; but this should only compel us to admire Rembrandt all the more for creating 'that veil of matchless colour, that lucid interval of Morning dawn and dewy light on which the Eye dwells so completely enthrall'd, [that] it seeks not for its liberty, but as it were, thinks it a sacrilege to pierce the mystic shell of colour in search of form'.[3] Just around the time that he spoke these words, Turner made a further public proclamation of his reverence for *The Mill* by including a mezzotint version of his *Grand Canal Junction* in the *Liber Studiorum*, the collection of prints after his own pictures that aimed to demonstrate the full range of possibilities of landscape art. His decision to include one of his most derivative compositions as part of the *Liber* underlines the high value he placed on the landscape painter's ability – as first demonstrated by Rembrandt and then confirmed by himself – to elevate the most humble of nature's materials to the level of pastoral poetry.

57

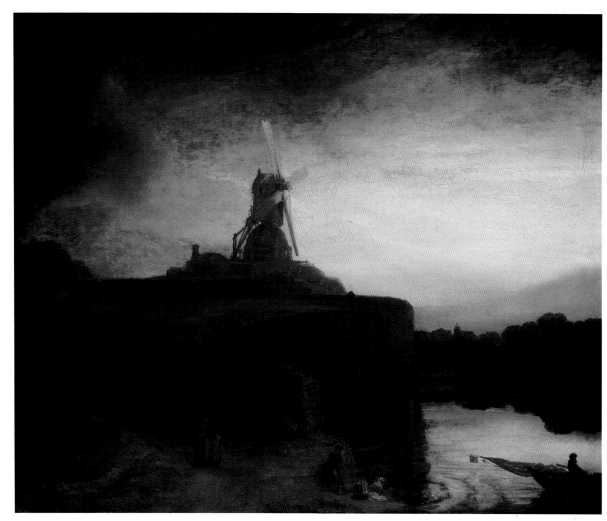

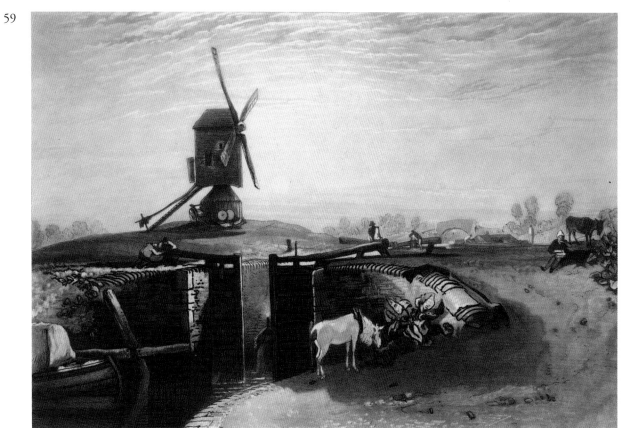

60
Aelbert Cuyp (1620–1691)
The Maas at Dordrecht c.1650
Oil on canvas, 114.9 x 170.2
National Gallery of Art, Washington, D.C.
Not exhibited

61
Augustus Wall Callcott (1779–1844)
Entrance to the Pool of London exh. RA 1816
Oil on canvas, 153 x 221
The Trustees of the Bowood Collection
Not exhibited

62
J.M.W. Turner
Dort, or Dordrecht, the Dort Packet-Boat
from Rotterdam becalmed exh. RA 1818
Oil on canvas, 157.5 x 233
Yale Center for British Art. Paul Mellon Collection
Not exhibited

When *Dort, or Dordrecht, the Dort Packet-Boat from Rotterdam becalmed* went on view at the Royal Academy in 1818, it received a mixed critical response. Several papers were enthusiastic – the *Morning Chronicle* called it 'one of the most magnificent pictures ever exhibited'[1] – but others questioned the truth of Turner's representation. One asked how the sun shining from beyond the horizon could illuminate the front of the scene: 'this picture has been called a miracle in art, but Mr. Turner also represents a miracle in nature'.[2]

This combination of praise and censure points toward the picture's dual origins, in studies done from nature and in previous works of art. During a tour of 1817 through the Low Countries and the Rhineland, Turner had made a number of drawings of Dordrecht (including several of the Groote Kerk, which features prominently in the background of his oil). But if he then used these sketches (and his memory) to give his scene an air of authenticity, Turner made it evident that he also had in mind to throw the gauntlet down to not one but two other artists, a seventeenth-century Dutchman and a contemporary Englishman.

The Dutchman, of course, was Aelbert Cuyp, a native son of Dordrecht and by far the most famous painter of the town and its environs. Long a favourite of British collectors and connoisseurs, Cuyp had been well represented at the loan exhibition of Dutch and Flemish Old Masters held by the British Institution in 1815; here one of the highlights had been *The Maas at Dordrecht*, then in the possession of Abraham

Hume.[3] The notion that this sort of Cuyp would be well worth redoing seems initially to have occurred to Augustus Wall Callcott, who shortly set about putting this idea into practice in his *Entrance to the Pool of London*. This enormous canvas proved to be one of the most popular works at the Royal Academy exhibition in 1816, where contemporary critics found it hard to disentangle Callcott's fidelity to nature from his equally obvious loyalty to Cuyp. 'To say, as has been said, that it [the *Pool of London*] is more like Cuyp than nature, is not true, and to say it is not like both would be so likewise', William Henry Pyne struggled to say in the *Repository of Arts*, before going on to claim that, 'Of this species of style we think this the very best picture we ever saw'.[4] That 'species' was one which seemed to satisfy the demands of naturalism as well as the imperative to respect tradition. Thus while another critic could confidently describe the *Pool of London* as 'perfect nature',[5] a third told his readers that 'those who have not yet seen the exhibition, but have seen the vigorous effects of Cuyp in the British Institution gallery last summer, may form in their mind's eye a pretty correct view of Mr Callcott's picture'.[6]

Especially considering their widely publicised rivalry of a decade's standing, Turner would surely have regarded Callcott's triumph as an irresistible challenge to his own position as Britain's leading landscape painter, and also as the nation's supreme interpreter of Old Master landscape art. So having drawn on Cuyp's golden atmospheric effects earlier on in his career (no.47, for example), with the *Dort* he did so again – only now, by choosing Dordrecht as his subject-matter and engaging far more closely with Cuyp's example, Turner may have aimed to elicit direct comparisons with the Dutch master, and thus to push Callcott out of the picture altogether.

But if these were Turner's aims, they only met with limited success. Although the *Dort* attracted many admirers, at the Royal Academy in 1818 it was compared unfavourably with Callcott's latest effort, a view of the *Mouth of the Tyne* (now lost), mainly on the grounds that Turner's colouring was insufficiently true to nature.[7] Critics also cited the same failing as the reason why the *Dort* fell short of Cuyp's fabled ability to imitate 'with great perfection the purity and brilliancy of light'.[8] In diffusing such dazzling luminescence across the entire expanse of his panoramic view, Turner appeared to have abandoned his great precursor's commitment to naturalism. 'A charming display of *colours*', one reviewer condescendingly remarked, 'we would say of *colouring*, but that we do not think they are appropriate to the scene'; because of the overall brightness of his palette, in other words, Turner's portrayal of a modest Dutch town looked too much 'like the latest glories of Carthage' that the same artist had exhibited to public acclaim at the previous Royal Academy exhibition (fig.70).[9] Harping on much the same point, another critic attacked the 'ideality' of Turner's colouring for being 'quite out of character when the scene . . . is selected from ordinary nature'.[10] Apparently art and nature were not always easy masters to satisfy.

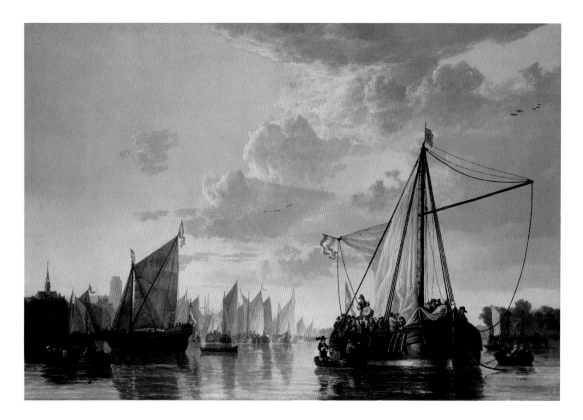

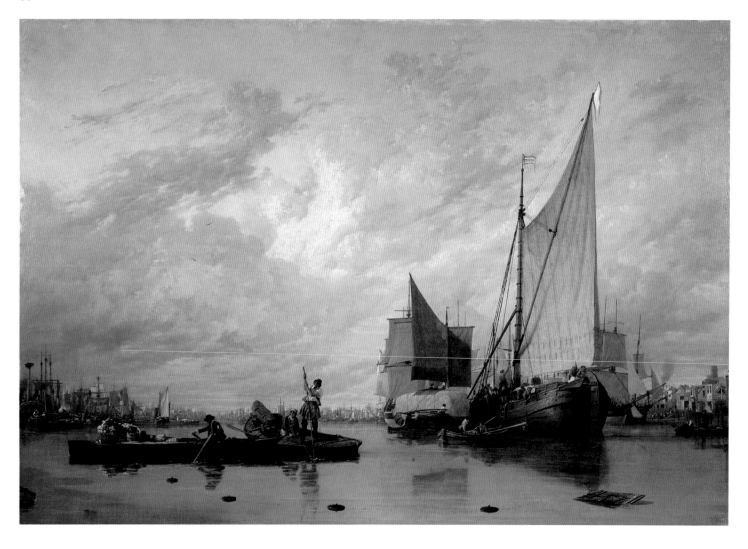

62

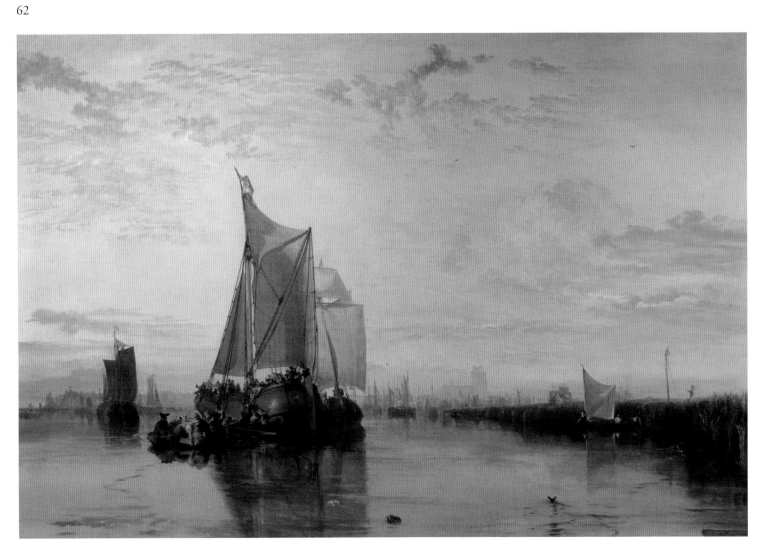

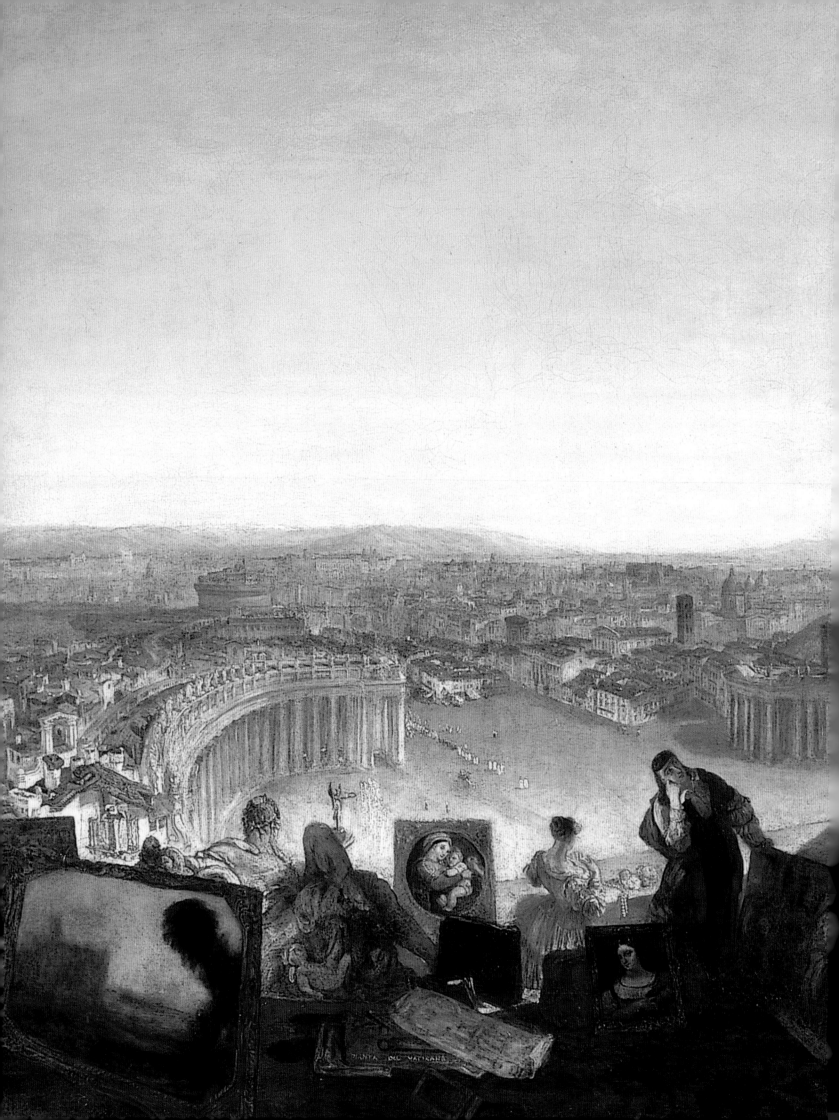

Painters Painted: The Cult of the Artist

Ian Warrell

By the 1810s and 1820s the Paris Salon regularly included painted tributes to a growing pantheon of venerated Old Masters in scenes that illustrated telling anecdotes from their private, as much as their working, lives. Although this trend runs in parallel with the Romantic treatment of history, in literature as well as in painting, its aims were often a thinly disguised attempt to dignify the position of contemporary artists through loaded comparisons with the status and treatment of earlier painters, who had been fêted by popes, or attended at their deathbeds by kings. Such images also allowed scope for their makers to assert a connection with more celebrated figures whose reputations were firmly established, simultaneously reassuring potential patrons of their worthiness.[1]

In Britain scenes of a similar nature had appeared erratically since John Hamilton Mortimer depicted Salvator Rosa in the guise of a bandit in 1776.[2] But in 1820, when Turner embarked on the first of his pictures of artists, there was no real sense of this type of work belonging to a native tradition that existed to be built upon. This unexpected move on his part raises a number of questions: was he consciously tapping into the French genre; what did he hope to achieve through his deployment of this kind of domestic history painting; and what does his choice of artists reveal?

Before his first trip to Italy in 1819 Turner had only a limited acquaintance with modern French painting; but while in

Rome, which had recently re-emerged as the centre of the pan-European art world, he would have had the opportunity to learn about, if not actually to see, recent developments. There were two French artists based in Rome who had already created images of earlier painters: François-Marius Granet (1775–1849) and Jean-Auguste-Dominique Ingres (1780–1867). Although there is no record of the English landscapist meeting either man, the subject and many of the incidental details of Ingres's *Raphael and La Fornarina* from 1814 (fig.62) would reappear in the only picture Turner exhibited after his return to London in February 1820: *Rome, from the Vatican. Raffaelle, accompanied by La Fornarina, preparing his Pictures for the Decoration of the Loggia* (no.63). His choice of theme may be a matter of pure coincidence, derived from shared sources and the widespread tendency among early nineteenth-century artists to identify with Raphael, their most revered precursor. But Turner's habitual pattern of vulture-like assimilation of new possibilities for recognition suggests that the question of whether Ingres was another of his targets should remain open. He could, at the very least, have become aware of the French artist's theme, and registered its potential.

The striking choice of Raphael as the focus for Turner's initial foray into the field of artistic biography only fully makes sense when taken in conjunction with Turner's self-designation as an 'Historical Landscape' painter, a description that seeks to suggest the wider frame of reference and ambition that he brought to his work.[3] Of the artists that one might have expected him to celebrate after his stay in Rome, the foremost candidate has to be Claude Lorrain, whose images had long resonated powerfully for Turner

J.M.W. Turner
Rome, from the Vatican exh.
RA 1820 (detail, no.63)

and were continually brought to mind by the landscapes he encountered in Italy. Curiously, however, he did not create his own personification of Claude in 1820, nor at any later point. He would have known something of Claude's appearance from the eighteenth-century publication of the *Liber Veritatis*,[4] which included an engraved self-portrait, and the same volume would have provided him with narratives about the life and working practices of his role model. Yet since none of these stories inspired him to give them painted form, it has to be assumed that Turner felt the best tribute he could pay was through his own adherence to Claudean prototypes, right up to his final exhibits (no.92); in essence he chose to showcase Claude's art as the defining feature of the seventeenth-century master's life.

Although the picture of Raphael on the loggia of the Vatican was the only exhibited result of Turner's stay in Italy, it seems that at roughly the same time he began work on another large-scale canvas showing the Grand Canal in Venice, framed by the Rialto bridge.[5] Despite deciding not to bring this image to completion, its existence indicates that the impact of Italy had not been entirely confined to the light and the traditions of design in the south; like many of his British peers, Turner may have felt himself more in tune with the rival tradition of Venetian colour. In fact, when asked on his return to England to name which artist he most wished to have been, he instantly replied 'Tintoretto'.[6] This ready affinity with the great exponent of Venetian chiaroscuro, who like Turner was renowned as a self-possessed and truculent character, raises the possibility that the unfinished Venetian picture may have been intended to contain or express some kind of tribute to Tintoretto. Indeed, Turner had studied some of his pictures in the Palazzo dei Camerlenghi, right by the Rialto bridge. On the other hand, it is just as likely that he was thinking of Canaletto, whose prospects of Venice were the benchmark against which all subsequent portrayals were measured, and who later became an incidental feature in Turner's first painted Venetian view (no.67).

Alongside *Bridge of Sighs, Ducal Palace and Custom House, Venice: Canaletti Painting*, Turner's Royal Academy exhibits in 1833 included a work entitled *Van Goyen, Looking out for a Subject* (fig.60), and it is probable that there was an element about these portrayals and stylistic evocations of other artists of what Hugh Honour has identified as 'painted rather than written art criticism'.[7] Why else would Turner juxtapose so glaringly the two artists in the same Academy exhibition? He depicts them both seeking inspiration directly from the settings found most often in their paintings, and, in

Fig.62
Jean-Auguste-Dominique Ingres
Raphael and the Fornarina 1814
Oil on canvas, 66.3 x 55.6
Fogg Art Museum, Cambridge, MA

Canaletto's case, actually at work. Given Turner's own ability to conjure up an encyclopaedic array of cities and landscapes at will, powerfully transformed by his imagination, it is possible that he was actually proposing the limitations of the form of topographical painting pursued by these precursors. Moreover, it is undoubtedly significant that he had generally resisted *plein air* painting himself. If anything, he seems closer to Jan van Goyen's suggested means of identifying a subject through steady assimilation than to Canaletto's literalism.

The *Van Goyen* image appeared at the end of a sequence of nine exhibited canvases that invited comparison with seventeenth-century Dutch marine painting – beginning in 1827 with *Port Ruysdael* (no.70), the depiction of an imaginary site painted in the manner of Jacob van Ruisdael, and obviously named in his honour. That same year saw Turner execute *Rembrandt's Daughter* (fig.37), his second oil – after *Rome and the Vatican* – featuring the portrayal of one of his artist heroes, here shown in the role of a concerned father intercepting a love-letter directed to his (entirely fictional) daughter. Painted at a time when Turner was progressively incorporating into his own work the

rich, dark tonality of Rembrandt's interiors, this canvas (unfortunately now much deteriorated) is, as Sarah Monks notes elsewhere in this volume (p.80), based on the master's composition of *Joseph and Potiphar's Wife*, then in Thomas Lawrence's collection (fig.36). *Rembrandt's Daughter* falls into the broader pattern of behaviour that saw Turner appropriate specific artists, or what he felt to be the essence of their style, in order to reveal something about himself; he also pursued this tactic with Jean Antoine Watteau, who in 1831 he depicted at work in an imagined scene that sought to make a sophisticated point about the French painter's – and his own – use of colour (no.64). Other artists he represented directly or indirectly included van Dyck, Poussin and Titian.[8] As in his commercial endeavours, the range of artists Turner selected was generally in step with, and sometimes a little ahead of, shifts in contemporary taste, so that he featured Giovanni Bellini (c.1430–1516) in one of his later Venetian oils at a time when the National Gallery had yet to acquire any Bellinis for its collection (no.68). The literary or historical source for *The Depositing of John Bellini's Three Pictures in la Chiesa Redentore, Venice* has not been identified, though it is more likely to have been Turner's own invention. Like his contemporaries, he alluded on occasions to apparently genuine historical or biographical sources, claiming a documentary veracity for his pictures, though his reference in 1844 to a supposedly standard work – *The Lives of the Dutch Painters* – for example, has proved

impossible to identify.[9] Further evidence of his attachment to the cult of artistic celebrity comes from the fact that he bid successfully at auction to acquire the palettes of the two earlier masters of the British School – William Hogarth and Joshua Reynolds – as well as a cast of Raphael's skull.[10]

By featuring artists so prominently in his work from the later 1820s onwards, Turner was almost certainly giving visual manifestation to concerns about his mortality, and whether he had achieved enough to merit a place alongside the predecessors he most admired. Indeed, this was the period when he drafted his first will, with its impudent instruction that two of his landscapes should be hung in the National Gallery next to a pair of Claudes (see nos.94 and 103). But his pictures of painters are generally not combative, and indicate that he thought of himself as part of a brotherhood of artists. This was the underlying point behind his moving tribute to David Wilkie, who had died off Gibraltar on his return from the Middle East (fig.63). Deploying a sombre palette, and a prominent use of black, which had come to be especially associated with Wilkie, *Peace – Burial at Sea* was paired with a fiery depiction of Napoleon in captivity on St. Helena.[11] Once again, Turner was making a case for the significance and enduring power of art, above and beyond more temporal events.

Fig.63
J.M.W. Turner
Peace – Burial at Sea exh. RA
1842
Oil on canvas, 87 x 86.7
Tate

63
J.M.W. Turner

Rome, from the Vatican. Raffaelle,
Accompanied by La Fornarina,
Preparing his Pictures for the Decoration
of the Loggia exh. RA 1820
Oil on canvas, 177.2 x 335.3
Tate

Turner's view of Rome, from the second floor of Leo X's loggia in the Vatican, was the first of his paintings to include the portrait of another artist.[1] By virtue of its enormous size, this ambitious picture claimed a prominent position at the Royal Academy exhibition of 1820, which opened just a few weeks after the three hundredth anniversary of the death of Raphael (6 April 1520), who in the early nineteenth century was generally acknowledged as a universal genius, and the foremost artist of the modern era.

In a work conceived in the same spirit as Jean-Auguste-Dominique Ingres's *Raphael and the Fornarina* (fig.62), painted in Rome six or seven years earlier,[2] Turner shows the Renaissance artist caught between the demands of his Art and his Muse, and seemingly choosing the higher calling. Raphael appears to be considering the location for his *The Building of the Ark*.[3] Accompanying him is his mistress, the famously beautiful Margherita Luti, a baker's daughter, or 'La Fornarina', who stands between two easel paintings (the *Portrait of a Woman* and the *Madonna della Sedia*), for which she was believed to have modelled (effectively real and ideal representations). Both were then on display in the prestigious Tribuna gallery in the Uffizi.[4] On the floor lie some plans of the Vatican, not as designed by Raphael when he presided over the construction of the sacred complex, but as it was eventually built, while above these is a sculptural ensemble, incorporating elements of ancient and modern statuary; this may refer to Michelangelo as much as to anecdotes about Raphael's interest in sculpture.[5] Lastly there are two more pictures. At far left is another design for the loggia, *The Expulsion of Adam and Eve from Eden*, which is partially concealed by a large framed classical landscape painting. Despite its resemblance to the works of Claude Lorrain, this picture-within-a-picture has been interpreted as alluding to Raphael's skill as a landscape artist; indeed the inscription 'Casa di Raffaello' confirms the personal connection with its idealised rendering of the house in the grounds of the Villa Borghese in Rome, known as the Casino

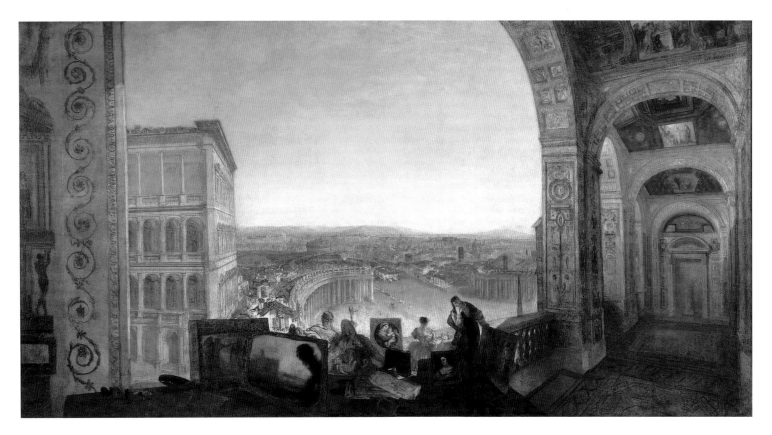

63

Oligiati-Bevilaqua, which Raphael decorated with images of La Fornarina.[6] And, if this framed prospect looks like a Claude, it looks even more like a work by Turner (for example, *The Thames near Windsor*, ?1807, Petworth House), who thus positions himself as the inheritor and improver of the great tradition of Roman art of the sixteenth and seventeenth centuries.

Recent scholarship has made a strong case for Turner's close identification with Raphael, in terms of his personal life as well as his demonstrated achievements and ambitions as both artist and architect. Indeed, when the picture was exhibited in 1820, the catalogue specified his status as Professor of Perspective and a member of the Roman Academy of St Luke, and gave the addresses of his London gallery and his suburban villa in Twickenham, both of which had been shaped by his architectural aspirations. But it also appears Turner was making another more fundamental point in the picture, implicitly contrasting the nature of patronage during Raphael's lifetime and three

hundred years after the master's death. By 1820 few British artists, however successful, could rely on support from the monarchy or the Church. Turner's ability to exploit commercial opportunities meant he was better placed than most, but he continued to find the distinction of royal favour elusive. Having failed to sell the Prince Regent his 1819 Watteau-inspired view *England: Richmond Hill, on the Prince Regent's Birthday* (fig.19), which is the same format as *Rome, from the Vatican*, he would have been encouraged by rumours in the press while he was in Italy that claimed he had received a commission to 'paint the most striking views of Rome from the Prince Regent', together with the prince's interest in obtaining records of Raphael's damaged frescoes.[7] Although it transpires there was no substance to this story, Turner's hopes of receiving royal approval based upon his Italian material can only have been heightened by the news as he arrived back in England of the accession of the Prince as George IV. Ultimately, however, the painting remained unsold, and it was not until 1822 that a royal commission was forthcoming (no.89).

64
J.M.W. Turner
Watteau Study by Fresnoy's Rules exh. RA 1831
Oil on oak panel, 40 x 69.2
Tate

65
Richard Parkes Bonington (1802–1828)
François 1er, Charles Quint and the Duchesse d'Etampes c.1827
Oil on canvas, 35 x 27
Musée du Louvre, Paris

The origins of Turner's *Watteau Study by Fresnoy's Rules* are closely linked with those of *Rome, from the Vatican. Raffaelle, Accompanied by La Fornarina, Preparing his Pictures for the Decoration of the Loggia* (no.63), painted eleven years earlier in 1820.[1] Both images celebrate a named artist, who is represented with some of the works on which his reputation is founded, thereby highlighting the possibility for a painter of achieving immortality through his art. But whereas the huge canvas of 1820 was a very bold public statement on this theme, the 'Study' is deceptively more modest and domestic in appearance. Painted on oak panel, it is closely connected with Turner's visits in the late 1820s to Petworth House, the home of the 3rd Earl of Egremont, where he was accorded his own studio (or 'Study'), to which he was permitted to bring paintings from the wide-ranging collection for closer scrutiny. When he exhibited the *Watteau Study* in 1831 it was paired with another scene, depicting Lord Percy (an ancestor of Lord Egremont) during his time of captivity in the Tower of London in the aftermath of the Gunpowder Plot (5 November 1605); in this the figures are based on portraits by Anthony van Dyck at Petworth.[2] It has been plausibly suggested that the connection between Turner's pictures is that both Watteau and van Dyck took their lead as colourists from Peter Paul Rubens, an artist

Turner seems to have viewed more positively from the mid-1820s onwards.[3] In both works, Turner was competing with the purveyors of the increasingly popular scenes of Romantic history painting, which concentrated on what were intended to be endearing, if somewhat sentimental and apocryphal moments in the lives of historical figures, including writers and artists. His key target in this genre would have been Richard Parkes Bonington (1802–1828), whose reputation had soared after his premature death.[4] But Turner would also have been aware that such images were especially popular in their engraved form in the lavishly produced annuals, such as *The Keepsake*, which reached a far larger and more enduring audience than the Academy's exhibitions; this point is relevant to the prominence of printed images in the *Watteau Study* itself, reflecting their importance in maintaining reputations.

In choosing Watteau as the hero of his scene Turner implied a connection between himself and his French precursor, thus reinforcing the playful point he had already made in *What You Will!* of 1822 (no.53). A further link with his own experience is suggested by the unkempt chaos of the depicted studio, which was based on the informal colour sketches Turner made of some of his contemporaries at work in the Old Library at

Fig.64
Gérard Scotin (1690–c.1755), after Antoine Watteau
Les Plaisirs du Bal 1730
Etching with some engraving, 55.1 x 67.7
The British Museum, London

Fig.65
Gérard Scotin after Jean Antoine Watteau
La Lorgneuse c.1727
Etching with some engraving, 38.9 x 28.8
The British Museum, London

64

Petworth.[5] And there may be a more personal allusion in the way the door is portrayed, recalling the one in the Old Library, which had a special opening panel to allow Turner to check who had knocked before deciding whether or not to admit any would-be visitors.

Inside Watteau's studio the focus falls on the artist himself, positioned as a commanding dark presence at the centre of the image. Intently observing the amorous couple seated in front of him, he adopts a Watteauesque pose (derived from works such as *The Enchanter,* fig.66) as he sketches on a board resting on his knee. In fact the couple's flirtation has already been preserved in the picture known as *La Lorgneuse* (fig.65), shown perched on the easel behind him. Although Turner would have known the original oil, then in the collection of his patron the poet Samuel Rogers, he shows it in reverse, as it had appeared in the *Recueil Julienne*, a volume of prints based on Watteau's designs; it is probably this book that is shown in the foreground. The picture on the far left side is also based on the engraved version (again reversed) of Watteau's *Les Plaisirs du Bal*, (fig.64) one of the most admired works in the Dulwich Picture Gallery since its opening in 1814 . Just as the artist stands between the lovers and their painted selves, Turner seems to create a similar relationship between his inaccurately coloured recreation of *Les Plaisirs du Bal* and the shaft of sunlight on the right – perhaps by way of suggesting in paint, as David Wilkie had done in words,

that the Watteau was to be particularly admired for its airiness.[6] Further strengthening the idea of the artist as a kind of magician, or alchemist (a term often applied to Turner himself in this period), are the jars of colour, brushes and a palette, which line the space closest to the viewer. Indeed, Turner deliberately drew attention to the process of painting by appending to his title in the Academy's catalogue an extract about the effect of colours from a translation of Charles Alphonse du Fresnoy's *De Arte Graphica* (*The Art of Painting*):

> White, when it shines with unstain'd lustre clear
> May bear an object back or bring it near.[6]

Turner illustrates this effect deftly across his image, suggesting in the dust sheet on the left something of the shimmering fabrics with which Watteau was so closely identified. But the issue of white has a personal, valedictory aspect. This stems from the fact that Turner had been repeatedly attacked as a 'White Painter' in the 1810s because of his use of the white grounds that gave his oils a lighter tonality, closer to the appearance of watercolours. In this picture Watteau stands in front of a canvas that has exactly such a white ground, on which appears the preliminary design of part of *Gersaint's Shop-Sign*, one of his best-known paintings.[8] Turner's point appears to be that great art ultimately triumphs over the vagaries of contemporary taste.

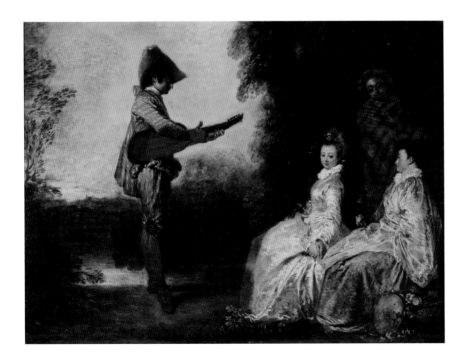

Fig.66
Jean Antoine Watteau
The Enchanter c.1716
Oil on copper, 19 x 26
The National Trust for Scotland

66
Giovanni Antonio Canal, known as Canaletto (1697–1768)

The Bacino di San Marco on Ascension Day c.1733–4
Oil on canvas, 76.8 x 125.4
Her Majesty The Queen

67
J.M.W. Turner

Bridge of Sighs, Ducal Palace and Custom House, Venice: Canaletti painting exh. RA 1833
Oil on mahogany, 51.1 x 81.6
Tate. Presented by Robert Vernon 1847

68
J.M.W. Turner

Depositing of John Bellini's Three Pictures in La Chiesa Redentore, Venice exh. RA 1841
Oil on canvas, 73.6 x 115.5
Private Collection

One of the first two paintings of Venice that Turner exhibited included a playful reference to Canaletto, the most famous delineator of the city.[1] By adding to his topographical title the punning phrase 'Canaletti painting', Turner was both highlighting his inclusion of a portrait of the great Venetian, shown at work in the left-hand foreground of his image, and at the same time audaciously proposing that his own picture, with its focus on the key landmarks of Venice, was an effective substitute for one of the earlier artist's canvases.

By the 1830s Venice and Canaletto were inextricably linked in British minds, so that in 1833, just as Turner started to exhibit views of the city, one writer declared: 'Canaletti's pencil has been so much, and so ably employed in the illustration of [Venice], as to have made every one more or less familiar with its leading beauties'.[2] It was this general familiarity with Canaletto's views, more often in their engraved than painted form, that Turner was relying on in his picture. But even as he paid his respects to his predecessor, there is a sense that Turner did not feel

66

67

constrained by a need to reproduce Canaletto's individual stylistic manner, particularly in his realisation of water, where he limits the number of craft on the Bacino to create shimmering reflections on its glassy surface.[3] For him, Canaletto was essentially a reference point only, not a daunting master that he felt he had to struggle to emulate.

But Turner was undoubtedly aware of the tendency in the British press to compare any depiction of Venice with those of Canaletto, and it was very probably the praise conferred on Venetian scenes by Richard Parkes Bonington and Clarkson Stanfield, who were thought to have surpassed both Francesco Guardi (1712–1793) and Canaletto, that spurred him to undertake his own pictures of the city. It has been suggested that the specific stimulus for this sudden shift in focus may have been Stanfield's view of *Venice from the Dogana* (no.84), which also appeared at the Royal Academy in 1833. At the time the *Morning Chronicle* (6 June 1833) even went so far as to claim that Turner only embarked

on his work once he knew Stanfield's subject, and that he completed it in just a couple of days, though the way the picture is built up makes this extremely unlikely. Nevertheless, the implicit contest was seized on by the critics (even though it was not easy to compare the two works directly, as they were in different galleries), and Turner was widely considered the victor. William Henry Pyne felt the comparison revealed the more 'poetic' nature of Turner's work, which was not simply a 'dry transcript of the scene'.[4] But in Turner's mind this triumph seems to have been rather equivocal. Despite attracting a buyer for the painting, at a time when so many of his canvases were being returned to him unsold after the Academy exhibitions, he is said to have insisted on his standard price of 250 guineas, remarking to a friend that 'Well if they will have such scraps instead of important pictures, they must pay for them'.[5]

Yet typically, on realising the commercial potential of Venetian subjects, Turner subsequently made views of the city a

mainstay of his exhibits, almost annually for the next twelve years. Although echoes of Canaletto's example can be dimly discerned in the earliest of this series, Turner increasingly found his own means of representing Venice, rejecting Canaletto's diligent topographical exactitude in preference for vague and distant prospects of unfamiliar corners, illuminated by a waning twilight. His final tribute to Canaletto took the form of the joyous procession of gondolas and other vessels on the wide Giudecca canal in his *Depositing of John Bellini's Three Pictures in La Chiesa Redentore*, executed after his third and final visit to Venice in 1840. This looks back to the regattas and other festive scenes Canaletto had painted and drawn, including that of the *Sensa*, when the Doge set out to wed the city with the sea in the symbolic act of throwing a ring into the water at the mouth of the Lagoon, an event that inspired one of Turner's unfinished Venetian compositions.[6]

But significantly, despite borrowing the idea of an extravagant ceremonial event from Canaletto, the focus of *Depositing of John Bellini's Three Pictures* actually falls on the much earlier artist Giovanni Bellini (d.1516), whose works were just beginning to receive serious recognition by British *cognoscenti* of Renaissance art. Ignoring the fact that Andrea Palladio's (1508–1580) church of the Redentore had only been completed seventy-five years after Bellini's death, Turner imagined a scene in Renaissance Venice, presumably in the artist's lifetime (though it is by no means clear whether he is present in the crowd) when a group of his devotional pictures were carried in festive triumph on the way to be installed in one of the city's architectural masterpieces.[7] The pictures in the Sacristy then thought to be by Bellini are no longer accepted as his work, and are now attributed to Alvise Vivarini, Francesco Bissolo, Lazzaro Bastiani and Rocco Marconi. Here the main point seems to have been to highlight the widespread celebration of the arts in sixteenth-century Venice, and by implication, their contrasting state of neglect in nineteenth-century London.

68

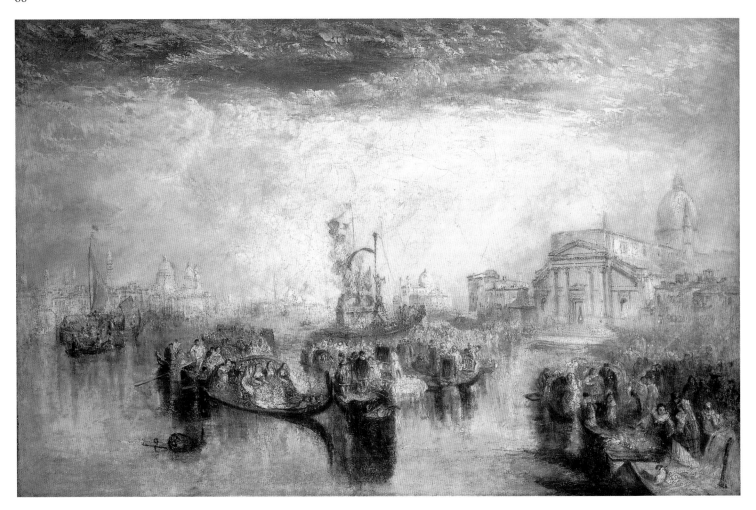

69
Jacob van Ruisdael (1628/9–1682)
Rough Sea at a Jetty c.1652-5
Oil on canvas, 98.5 x 131.4
Kimbell Art Museum, Fort Worth, Texas

70
J.M.W. Turner
Port Ruysdael exh RA 1827
Oil on canvas, 92.1 x 122.6
Yale Center for British Art,
Paul Mellon Collection

Turner referred obliquely to the Dutch seventeenth-century artist Jacob van Ruisdael in the titles of two of his paintings (see also no.99). Rather than including a portrait of Ruisdael at work, as in his 1833 picture of van Goyen (fig.60), he appended the earlier artist's name to an imagined port, seeking to invoke the characteristic subject-matter and style of his predecessor, in preference to biographical anecdote.[1]

Turner's enthusiasm for Ruisdael's pictures dates from at least as early as his first visit to the Louvre in 1802, when he made studious transcriptions of the *Storm on the Dutch Coast* and the celebrated landscape, *Le Coup de Soleil*.[2] In his notes on the first of these, Turner's appreciation of the contrasting play of light and shade was tempered by his reservations about whether Ruisdael had accurately recreated the behaviour of the sea on a lee shore. Nevertheless, the latter artist's portrayal of the frothy, wind-driven waves of a surging tide at a harbour's mouth was one of several maritime subjects by the Dutch master that

69

served as the inspiration for Turner's 1827 exhibit *Port Ruysdael*. He would have had the chance to renew his acquaintance with the Louvre picture when he paused in Paris at the end of a tour of Brittany and the River Loire during the preceding year. But an alternative, or additional source for his own canvas could well have been Ruisdael's *Rough Sea at a Jetty*, which passed through the London art market in June 1826.[3] A further example of this subject type, and perhaps the closest to Turner's own composition, is the *Storm off the Dutch Coast* by Ruisdael now in Manchester City Art Galleries, though the early history of this picture remains unknown, making it impossible to establish whether Turner had definitely seen it.

All of these images adhere to a relatively limited palette, in which the subtly variegated greys used for the sea and sky are relieved only by the warm, earthy tones of sails, or the glimpse of a patch of blue above the clouds. In adapting this formula to his own purposes, Turner absorbed Ruisdael's

habit of enlivening his canvases with passages of white highlights to replicate the spume of the churning waves. The rather flimsy-looking beacon on the left of *Port Ruysdael* also has its origins in Ruisdael's images, but Turner intensifies the viewer's understanding of the climatic conditions by making the structure bend in the prevailing wind, and indicating the struggle of a seagull as it attempts to land on the ladder.

Aware that other artists, such as Bonington and Constable, were encroaching upon the arena of marine and coastal subjects, Turner's exhibits in 1827 emphatically sought to reclaim this territory as his own. This was something that the critic Robert Hunt noted in his review in the *Examiner* (1 July 1827): 'We have Mr Turner this season completely at sea, where he is as much at home as on land, perhaps more so too, in our humble judgement, as the best of the Dutch marine painters.' But despite such praise, *Port Ruysdael* failed to find a buyer until 1844.

70

Competing with
Contemporaries

David Solkin

The late Georgian art world was a fiercely competitive arena, with the heat of battle at its most intense in the public exhibitions that took place at the start of each London social season. From 1769 onwards, and even more emphatically from 1780, when it moved to grandiose rooms in the newly-built Somerset House, the Royal Academy reigned supreme; though in 1806 a serious rival emerged, when the British Institution – a private body of collectors and connoisseurs – began to organise its own annual displays of contemporary art at its fashionable premises in Pall Mall. Turner showed his works at both venues, as well as from 1805 in his own private gallery; but the Academy was his institutional home, and it was here that he made his mightiest efforts to outshine his contemporaries.

A watercolour of the Royal Academy exhibition of 1828 (fig.67), featuring Turner's *Dido Directing the Equipment of the Carthaginian Fleet* (destroyed) hanging in the centre of the north wall of the Great Room at Somerset House, gives us a clear notion of the challenge faced by any painter who wanted his imagery to stand out in this jumbled, kaleidoscopic space. Here portraits – especially full-length portraits, which had to be hung on the 'line' running around the room at the height of the top of the doorways – enjoyed a considerable advantage: their (usual) verticality, simple compositions, strong colours and easily legible poses gave them a visual impact beyond the reach of any other genre, with the possible exception of large-scale history painting, which was typically designed

J.M.W. Turner
*The Angel Standing in
the Sun* exh. RA 1846
(detail, no.81)

around a central figure or action capable of being read at first glance. Landscapes, on the other hand, were almost always horizontal, and they demanded a more leisurely mode of viewing – one that meandered back and forth between different planes and from side to side, registering a variety of different objects, incidents and effects en route.[1] In a space crowded with a noisy multitude of people, and with hundreds of pictures clamouring for attention on the walls, landscape painters had to make the most of their relatively limited resources if they were to succeed in catching the spectator's eye, and to hold it for any considerable length of time.

Among Britain's leading landscape specialists in the late eighteenth century, the most effective exhibition performer was the French-born Philip James de Loutherbourg, who, drawing upon his experience as a Drury Lane scene-painter, had learned how to exploit perspective, light and colour to spectacularly theatrical ends. Although his works were often criticised for being too glaring, and for sacrificing truth to nature in a vainglorious effort to draw attention to themselves, they were great favourites with the public, who enjoyed the artist's mastery of sublime special effects in combination with his ruggedly 'romantic' subject-matter: aside from being a popular purveyor of battle scenes, he was one of the first to paint the Lake and Peak Districts, Snowdonia and the Alps. Turner may not have liked de Loutherbourg's garish colouring, or the hardness of his outlines; but of all the established painters of exhibition landscapes, 'Old Leatherbags', as he was popularly known, was the one to beat.

With this aim in mind, Turner set about developing a similar thematic repertoire, while trying to outdo de Loutherbourg

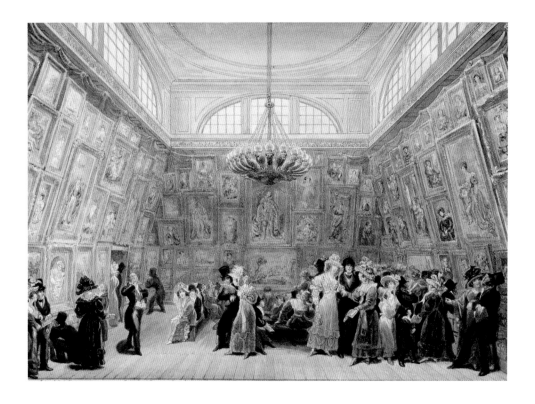

Fig.67
George Scharf
*The Royal Academy
Exhibition of 1828* 1828
Watercolour, 18.4 x 26
Museum of London

for painterly richness and sheer visual drama (see nos.73 and 74). The point of the exercise was not lost on contemporary observers; in 1806 the art critic for the *Sun* compared Turner's *Fall of the Rhine at Schaffhausen* (fig.69) with de Loutherbourg's view of the same site shown eighteen years earlier (fig.68), and like many others he found Turner's portrayal wanting: 'Instead of boldness and grandeur, his picture, in our opinion, is marked by negligence and coarseness, and the prevailing features of the colouring seem to have been produced by *sand* and *chalk*.'[2] The emphatic materiality of the painted surface in Turner's work may have offered a stark contrast to de Loutherbourg's slick finishing – but it was not to everyone's taste. Nor was the enormous picture of the *Battle of Trafalgar* that George IV commissioned as a pendant to the Frenchman's *Glorious First of June* (nos.89 and 88). After suffering a barrage of criticism for its lack of accuracy, within five years both the *Trafalgar* and its companion-piece had been exiled from St. James's Palace to the Naval Hospital at Greenwich, where the de Loutherbourg still continued to be preferred.

However, amongst other things de Loutherbourg taught Turner to appreciate that high colouring could act with the force of a trump card in the public exhibition space. According to the Victorian painter George Dunlop Leslie (1835–1921), 'Artists used to dread having their pictures hung next to [Turner's], saying that it was as bad as being hung by an open window. They caught your eye the instant you entered the room.'[3] Sometimes Turner heightened his colouring during the brief period after all the pictures had been hung on the walls but before the exhibition opened to the public. The most famous instance of his doing so, on what were known as 'varnishing days', took place at the Royal Academy in 1832, when he introduced a red buoy into an almost monochromatic grey seascape, in order to draw attention away from the lurid hues of the painting hanging next to it, John Constable's *Opening of Waterloo Bridge* (nos.72 and 71). This act of one-upmanship may have been taken in revenge for a 'crime' that Constable had committed at the previous year's exhibition, when as a member of the hanging committee he'd reputedly replaced a Turner that had already been given an advantageous position in the Great Room with a painting of his own – to the intense irritation of his fellow academician.[4]

In 1832 Turner also engaged in a more congenial joust with his good friend George Jones (1786–1869), when by private prior arrangement they both exhibited panel pictures of the same Old Testament story, of the three Israelites who miraculously survived being thrown into the fiery furnace. Although Turner painted his composition without having set eyes on Jones's, he must have anticipated that the latter would be a fairly conventional affair, and thus the perfect foil for a demonstration of his own radical originality. He further took the opportunity afforded by *Shadrach, Meshech and Abednego* to embark on a competitive dialogue with the

Fig.68
Philip James de Loutherbourg
The Falls of the Rhine at Schaffhausen
exh. RA 1788
Oil on canvas, 165 x 227
Victoria and Albert Museum, London

Fig.69
J.M.W. Turner
The Fall of the Rhine at Schaffhausen exh. RA 1806
Oil on canvas, 144.7 x 233.7
Museum of Fine Arts, Boston. Bequest of Alice
Marian Curtis and Special Picture Fund

'visionary' artist Francis Danby (1793–1861), whose works he admired for their poetic quality. On this occasion, however, as later with *The Angel Standing in the Sun*, Turner made it clear that his admiration for Danby's powers of imagination did not extend to his younger rival's highly finished and precise manner of delineating forms, which he eschewed in favour of a far looser and more richly textured handling of paint.

In most of Turner's 'friendly contests' with his British contemporaries, much more was at stake than simply who overshadowed whom on the exhibition walls. Almost invariably, it was when other painters tried to rival the Old Masters that he went to greatest lengths to try and assert his own superior powers of emulation. Such was the case in his fierce competition with David Wilkie, over which of the two artists could show a greater understanding of the works of David Teniers the Younger; with Augustus Wall Callcott, over who was the better interpreter of Aelbert Cuyp (see nos.61 and 62); and with Clarkson Stanfield, over Canaletto. Likewise it was Thomas Stothard's (1755–1834) essays in the manner of Jean Antoine Watteau that stimulated Turner's attempts to go out of his usual way to produce his own versions of the Frenchman's signature *fêtes galantes*.

Although Turner emerged triumphant from most of these contests, there were times when critical opinion broadly adjudged him to have lost. Such was the consensus reached concerning his early forays into genre painting, a field that he was strongly urged to cede to the victorious Wilkie. Some twenty years later Turner once again rose to the challenge of a prodigious young talent, but this time he stood on much firmer ground. Unlike Wilkie, the Nottingham-born but Paris-based Richard Parkes Bonington was a landscape painter; and in the French coastal scenes and Venetian views he began exhibiting in London in the mid-1820s, he displayed a dazzling luminosity and opulent palette which had clearly been inspired by the recent work of none other than Turner himself. But it was only after Bonington's studio sale, a year after his sadly premature death in 1828, that the older painter picked up the gauntlet thrown down by his brilliant young follower – first with *Calais Sands*, with its florid hues and vast expanse of space (no.83), and then, a few years later, with the first of his own portrayals of Venice.

Although he never ceased attending to current developments in British landscape painting, during the closing decades of his life Turner's interest in contemporary practice gave way more and more to a preoccupation with his own art, and its place within history. In his will he left instructions that two of his finest pictures were to be bequeathed to the National Gallery, on the specific condition that they were to be hung beside two masterpieces by Claude Lorrain – and therefore to be placed apart from (and by implication above) the rest of the British School. Turner had saved his final, highest trump card for the very end.

71
John Constable (1775–1837)

The Opening of Waterloo Bridge
(*'Whitehall Stairs, June 18ᵗʰ 1817'*) exh. RA 1832
Oil on canvas, 130.8 x 218
Tate. Purchased with assistance from
the National Heritage Memorial Fund,
the Clore Foundation, The Art Fund,
the Friends of the Tate Gallery and others 1987

72
J.M.W. Turner

*Helvoetsluys; — the City of Utrecht, 64,
going to Sea* exh RA 1832
Oil on canvas, 91.4 x 122
Fuji Art Museum, Tokyo

These two works are reunited here for the first time since the Royal Academy exhibition of 1832, when they featured in what is probably the most famous episode of artistic rivalry in the history of British art. After more than a decade of anxious labour, John Constable had finally completed *The Opening of Waterloo Bridge* – one of his largest compositions, and what would turn out to be his sole exhibited picture of a modern London subject – only then to have the misfortune of finding it hanging in one of the secondary galleries in Somerset House directly beside a seascape by Turner, the exhibition landscape artist *par excellence*. Of the two images, Constable's was by far the larger and more luxuriantly coloured, as well as filled with an incomparably greater amount of visual incident; hence it was almost guaranteed, or so at least one would have thought, to make the *Helvoetsluys* look a dull and pale thing by comparison. But if such was Constable's expectation, he had reckoned without Turner's practised capacity to take full advantage of the opportunity to make last-minute adjustments to his

71

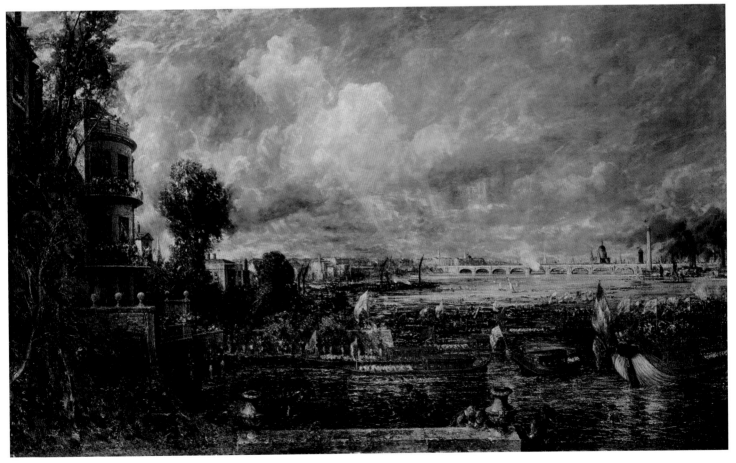

canvases, during the so-called 'varnishing days' just prior to the opening of each annual exhibition.

Here is where Constable's first biographer, Charles Robert Leslie, takes up the story. The *Opening of Waterloo Bridge*, he writes:

> seemed as if painted with liquid gold and silver, and Turner came several times into the room as [Constable] was heightening with vermilion and lake the decorations of the city barges. Turner stood behind him, looking from the *Waterloo* to his own picture, and at last brought his palette from the great room where he was touching another picture. And putting a round daub of red lead, somewhat bigger than a shilling on his grey sea, went away without saying a word. The intensity of the red lead, made more vivid by the coolness of his picture, caused even the vermilion and lake of Constable to look weak.' He

has been here', said Constable, 'and fired a gun' … The great man did not come into the room for a day and a half; and then, in the last moments that were allowed for varnishing, he glazed the scarlet seal he had put on his picture, and shaped it into a buoy.[1]

If Turner meant his buoy to imply that Constable was out of his depth, the same coin-sized 'daub' of red may also have been his way of acknowledging that his old rival's ambitious picture belonged to the tradition of Venetian colourism that had originated at the time of the Renaissance. More recently, this heritage had included the eighteenth-century *vedute* painter Canaletto, whose own Thames views were an obvious point of reference for *Waterloo Bridge*. Turner would wait until the following exhibition before demonstrating how to (re)do a Canaletto (see nos.66 and 67). In 1832 the noise of his 'gun' may only have been heard by the two artists involved; nonetheless Constable was convinced that Turner had shot him out of the water.

72

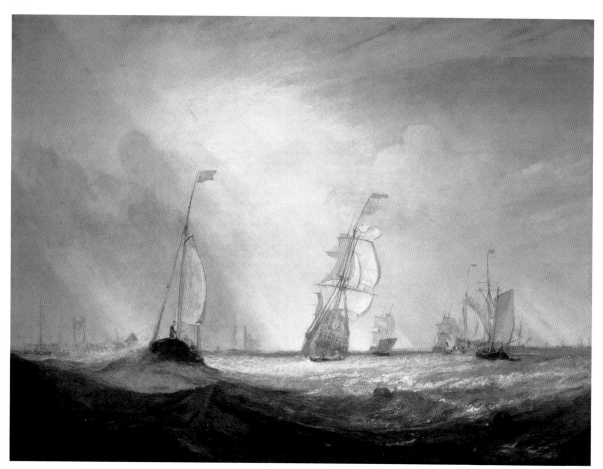

73

73
Philip James de Louterbourg (1740–1812)
A Waterspout in the Mountains of Switzerland exh. RA 1809
Oil on canvas, 106.7 x 157.5
Petworth House, The Egremont Collection. Acquired in lieu of tax by
HM Treasury in 1957 and subsequently transferred to The National Trust

74
J.M.W. Turner
The Fall of an Avalanche in the Grisons exh. Turner's gallery 1810
Oil on canvas, 90.2 x 120
Tate

Turner encountered Philip de Louterbourg's eye-catching
image of an Alpine flood[1] on several occasions in 1809: initially
(surely more than once) at the Royal Academy, and then
shortly afterwards during his first stay with the 3rd Earl of
Egremont at Petworth House, where the picture had recently

joined one of the nation's most important collections of
modern British paintings and sculpture. De Louterbourg had
emigrated from his native France to London in 1771, and since
that time had established himself as a firm favourite with the
capital's exhibition-going public. By the early nineteenth
century his landscapes had become virtually synonymous with
the popular aesthetic of the Sublime, which offered viewers
the vicarious experience of danger, grandeur and horror as
spectacular visual entertainment. Storms and dramatic
mountain scenery were particularly obvious candidates for
such sensationalist treatment, which de Louterbourg knew
how to orchestrate more effectively than anyone else.

Although the artist's success as a landscape showman may
have been due in part to his judicious choice of iconography,
it also owed a great deal to what eighteenth-century critics
called his 'happy stile':[2] the lively draughtsmanship, high
finishing and striking colour contrasts that were a hallmark
of his French training made his pictures stand out at the
annual exhibitions, to the point where they often

74

overpowered any works hanging in the immediate vicinity. It was in this respect that Turner was determined to profit from de Loutherbourg's example – but there were other lessons he had in mind to learn from him as well.

Turner's engagement with de Loutherbourg's art had actually begun as early as c.1792–3, when he had produced a series of watercolours, mainly of imaginary coastal scenes, in the manner of the older man's compositions (see figs.53 and 54). Three years or so later, when he first began to paint in oils, once again it was de Loutherbourg whom he took as a model, doubtless recognising that for sheer technical accomplishment there was no better master available. Around 1810 the two artists became neighbours in Hammersmith, where Turner became such a frequent visitor at the Frenchman's house that his wife refused him entry in fear that he was out to steal her husband's secrets. We cannot be sure what these were – maybe things of a technical or even of an alchemical nature – but the theatrical *éclat* of the *Fall of an Avalanche in the Grisons* suggests that her anxieties may not have been entirely unfounded.

In fact, Turner did not visit the Grisons on his tour of Switzerland in 1802; thus his picture is more likely to have been painted in response to the news of an avalanche that had taken place in this region of the Alps in December 1808, when twenty-five people had been crushed to death in a single cottage.[3] This allusion to an actual event is entirely consistent with that commitment to realism which Turner saw as lacking in the works of so many modern French painters, whose productions he condemned as 'all made *up of Art*'.[4] That he (amongst many others) regarded de Loutherbourg in the same critical light is borne out by the handling of paint in the *Avalanche* scene, which emphatically eschews his senior rival's slick finish and hard outlines in favour of a richly textured surface built up with heavy impastos, leaving the marks of the artist's palette knife as much in evidence as the broad sweeps of his brush. The sublimity of the final product derives in equal measure from the energy invested in the act of painting and from the awesome power of the avalanche it describes.

75
Jean Antoine Watteau (1684–1721)
Fêtes Vénitiennes c.1718
Oil on canvas, 55.9 x 45.7
National Galleries of Scotland, Edinburgh

76
Thomas Stothard (1755–1834)
Sans Souci exh. RA 1817
Oil on panel, 80 x 52
Tate. Bequeathed by Henry Vaughan 1900

77
J.M.W. Turner
Boccaccio relating the Tale of the Bird-Cage exh. RA 1828
Oil on canvas, 121.9 x 89.9
Tate

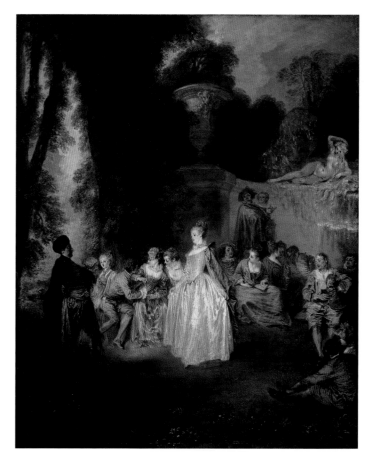

75

Whilst putting the finishing touches to his picture of *Boccaccio relating the Tale of the Bird-Cage*, on one of the varnishing days just prior to the opening of the Royal Academy exhibition of 1828, Turner remarked to his colleague Charles Robert Leslie: 'If I thought [Stothard] liked my pictures as well as I like his, I should be satisfied. He is the Giotto of England.'[1] Either Leslie had misheard, or his memory had failed him: for surely Turner must have said that Stothard was the *Watteau* of England – an opinion for which there was ample justification. One of the most prolific book illustrators of the period, as well as one of the Royal Academy's few exponents of history painting, Stothard played a leading part in the revival of Watteau's *fête galante* imagery that took place in Britain during the immediate aftermath of the Napoleonic Wars. His first major

success in this mode of fanciful pastoral imagery was *Sans Souci*. Although the title may allude to the Arcadian ethos of Frederick the Great's rococo palace of the same name, it was probably more broadly meant to signify 'without a care', as the motto of a leisurely idyll, nostalgically evocative of the lost aristocratic paradise of pre-revolutionary France.

A version of Stothard's picture, together with several of his portrayals of Boccaccio's *Decameron*, belonged to the patron and poet Samuel Rogers, who was also an important collector of Watteau's works; in the mid-1820s, furthermore, Turner and Stothard had collaborated on a luxury edition of Rogers's most famous poem, *Italy* (published 1830). But if Turner conceived of his *Boccaccio* as an act of homage to both

76

77

a fellow-artist he admired and the writer who'd employed them both, the immediate catalyst for this tribute may have been the publication of an engraving of Stothard's 'celebrated Picture called *Sans Souci*' in *The Bijou, or Annual of Literature and the Arts*[2] at the beginning of 1828. This composition and one of Stothard's published illustrations to Boccaccio (from an English edition of 1825) provided Turner with the principal starting-points for his own design, though of course at the same time he must have been mindful of Watteau paintings like the *Fêtes Vénitiennes*. The fact that no story about a birdcage appears in the *Decameron* suggests that Turner's title was chosen for its vaguely poetic aura, the point being not to illustrate Boccaccio's verses, but rather to use them (along with the incongruous silhouette of East

Cowes Castle in the background) to enhance the courtly and pastoral flavour of the Watteau-Stothard tradition.

In 1828 a critic noted that, 'On land, as well as on water, Mr Turner is determined not merely to shine, but to blaze and dazzle. Watteau and Stothard, be quiet! Here is much more than you could match.' But 'With respect of the details in this gaudy experiment', he went on to say, 'the less they are inspected the better for the reputation of the artist'.[3] Although most other reviewers were inclined to agree, here as on other occasions Turner was willing to risk public ire to assert his right to manipulate forms, as well as light and colour, to imprint his own distinctive stamp on another master's (in this case, two other masters') work.

78
J.M.W. Turner
Shadrach, Meshech and Abednego
in the Fiery Furnace exh. RA 1832
Oil on mahogany panel, 91.8 x 70.8
Tate

79
George Jones (1786–1869)
The Burning Fiery Furnace exh. RA 1832
Oil on mahogany panel, 90.2 x 60.8
Tate. Presented by Robert Vernon 1847

80
Francis Danby (1793–1861)
Subject from 'Revelations' exh. RA 1829
Oil on canvas, 61.5 x 77.8
Rosenblum family

81
J.M.W. Turner
The Angel Standing in the Sun exh. RA 1846
Oil on canvas, 78.7 x 78.7
Tate

It was not by happenstance that Turner and his friend George Jones simultaneously decided to illustrate the same Biblical story (*Daniel* III: 26), of the three Israelites who miraculously survived unscathed when the tyrant Nebuchadnezzar threw them into a furnace as punishment for their refusal to worship an idol – nor that both pictures appeared at the same Royal Academy exhibition, in 1832. The story behind this pair of works is best told by Jones himself, in a memoir written some years after Turner's death:

> Another instance of Turner's friendly contests in art arose from his asking me what I intended to paint for the ensuing Exhibition. I told him that I had chosen the delivery of Shadrach, Meshech and Abednego from the Fiery Furnace. 'A good subject, I will paint it also. What size do you propose?' Kitcat. 'Well, upright or lengthway?' Upright. 'Well, I'll paint it so. Have you ordered your panel?' No, I shall order it tomorrow. 'Order two and desire one to be sent to me; and mind, I will never come into your room without inquiring what is on the easel, that I may not see it.' Both pictures were painted and exhibited; our brother Academicians thought that Turner had secretly taken advantage of me and were surprised at our mutual contentment, little suspecting our previous friendly arrangement.[1]

Even if Turner kept his promise not to look at Jones's painting, he must have anticipated that it would conform to certain standard pictorial conventions, above all in its treatment of the human figure, and in its arrangement of forms to produce a legible narrative. But Turner's *Fiery Furnace* does neither of these things. Instead of highlighting the main elements of the story, it focuses our attention on a group of richly dressed oriental women, who seem completely oblivious to the fire enveloping the nominal protagonists beyond. Its flames, moreover, seem to sweep throughout the scene with the force of a whirlwind that threatens to dissolve everything in a storm of red-hot colour. The single critic who essayed a comparison of the two pictures felt that the only thing to be said for Jones's

'*Nebuchadnezzar* … is, that it is not so absurdly treated by him as by his brother academician Mr. Turner, who … has painted the same subject without the slightest display of character or expression, but with his accustomed ignorance of the human form'.[2] Although other papers condemned the work in far stronger terms, the *Library of the Fine Arts* took exception to the general consensus, characterising *Shadrach, Meshech and Abednego* as 'one of those extraordinary flights in which Mr Turner is so fond of indulging, to the astonishment and unfeigned delight of one half of the world of art, and the astonishment and self-conceited supercilious remarks of the other … The figures … flit before us, as they ought to do, in a superhuman manner, but to our mind it is impossible to conceive a finer effect of lurid light than is here portrayed'.[3] But in a move that must even have left Jones completely in the dark, Turner had in mind another recent picture with a similar light effect: for surely it was Francis Danby's (1793–1861) *Subject from 'Revelations'* that provided him with a template for his overall design, and with the prototype for the idol whose outstretched arms command the central upper register of the *Fiery Furnace* scene.

In the mid-1820s Danby had emerged from his native Bristol to become one of the most acclaimed painters at the London exhibitions, with a sequence of extravagantly coloured sunset scenes and sensational Apocalyptic subjects that owed much to the enormously popular John Martin (1789–1854). Whereas the Academy regarded Martin as a vulgar showman, it welcomed the more conventionally trained Danby, whom Turner would later defend as a 'poetical painter'.[4] The illustration to the Book of Revelation[5] which Danby showed in 1829 belonged to a set of four paintings that William Beckford – an important patron of Turner's some thirty years earlier – had commissioned to hang in Lansdown Tower in Bath, the 154-foot-high culmination of his lifelong interest in architectural follies. Beckford and Danby fell out, however, and the paintings were never delivered; soon afterwards, financial woes and personal scandal forced the artist to flee to the Continent, where he and his family at first struggled for their very survival.[6]

In 1831 the Academy helped Danby out with a gift of £50; and a year later, Turner paid private homage to the now penniless exile by adapting the design of the *Subject from 'Revelation'* for use in his *Shadrach, Meshech and Abednego* (probably not by coincidence, the suffering Israelites had likewise been exiled, in their case to Babylon). Like the Israelites, too, Danby eventually returned home. By 1840 he was back in London, where he gradually rebuilt his career; his restoration to respectable society was confirmed in 1845, when Queen Victoria purchased his *Gate of the Harem* (destroyed) from the British Institution. A year later – the events may or may not have been connected – Turner exhibited not one but two paintings based on Danby compositions: *Queen Mab's Cave* (BI 1846; B&J no.420; Tate), which reworked the design of *An Enchanted Island* from 1824 (BI 1825; private collection); and *The Angel Standing in the Sun*.

Now returning for a second time to the *Subject from 'Revelation'*, Turner borrowed the basic idea of Danby's principal figure as well as his Apocalyptic source (from a slightly later point in the same book of the Bible[7]); but in almost every other respect the two pictures could hardly be more different from one another. Neither here nor on any other occasion did Turner make any effort to paint like Danby, choosing instead to recast his fellow artist's rather literal renderings of literary themes into his own far freer, more allusively 'poetical' – and painterly – idiom.

78

79

82

82
Richard Parkes Bonington (1802–1828)
French Coast with Fishermen exh. BI 1826
Oil on canvas, 64.3 x 96.7
Tate. Purchased with assistance from the Heritage Lottery Fund,
The Art Fund and Tate Members 2004

83
J.M.W. Turner
Calais Sands, Low Water, Poissards Collecting Bait exh. RA 1830
Oil on canvas, 73 x 107
Bury Art Gallery, Museum & Archives

Raised in Nottingham, Richard Parkes Bonington moved
to France with his family in 1817, where his father set up a
lace factory in Calais before moving to Paris the following
year. Here Richard met and befriended Eugène Delacroix
(1798–1863), and entered the atelier of the history painter
and portraitist Baron Jean-Antoine Gros (1771–1835), while
also embarking on a series of sketching tours in the
environs of the capital. Although he enjoyed some success
at the Paris Salons of 1822 and 1824, his major career
breakthrough took place in 1826, when he exhibited two
French coastal views (including the picture shown here) at
the British Institution in London. The critical acclaim was
immediate and hugely enthusiastic: '… here are pictures',
wrote the reviewer for the *Literary Gazette*, 'which would
grace the foremost name in landscape art. Sunshine,

83

perspective, vigour, a fine sense of beauty in disposing of the colours …' – Bonington was simply a prodigy.

In speaking of 'the foremost name in landscape art', the writer for the *Gazette* may well have had J.M.W. Turner in mind. Along with his friend Delacroix, Bonington had visited London in 1825, where he paid close attention to Turner's work; he must have been particularly fascinated by the *Harbour of Dieppe* then on view at the Royal Academy (B&J no.231; Frick Collection, New York), both on account of its French subject-matter and its startlingly pale luminosity, so reminiscent of watercolour. The *French Coast with Fishermen* shows Bonington putting into practice the lessons learnt from Turner about light and colour especially, and combining these with a virtuoso freshness of touch that was very much his own.

Four or five years later, after the widely publicised studio sale following Bonington's sadly premature death (from tuberculosis) in 1828, Turner returned the compliment with *Calais Sands, Low Water, Poissards Collecting Bait* – an expansive beach scene unmistakably in the Bonington mode, and executed with a brilliant transparency that recalled the younger artist's work in watercolour as well as oil. A more personal touch is provided by the molten sunset sky, which strikes a note of dramatic intensity that lay outside of Bonington's range. Both artists, however, were admired for their ability to conjure something beautiful and memorable out of the most insignificant landscape themes, and to do so with seeming effortlessness. As the *Morning Chronicle* (3 May 1830) wrote of *Calais Sands*, 'it is literally nothing in labour, but extraordinary in art'.

84
Clarkson Stanfield (1793–1867)
Venice from the Dogana exh. RA 1833
Oil on canvas, 130 x 165.4
The Trustees of the Bowood Collection

85
J.M.W. Turner
Venice from the Porch of the Madonna della Salute exh. RA 1835
Oil on canvas, 91.4 x 122.2
Metropolitan Museum of Art, New York.
Bequest of Cornelius Vanderbilt, 1899

After Richard Parkes Bonington's death in 1828, Clarkson Stanfield made a concerted effort to assume his mantle as the leading British painter of Venetian views. He first visited the city in 1830, and then, drawing on his training as a scene painter for the theatre, went on to mount a spectacular diorama showing Venice from the Bacino di San Marco, which featured in a Drury Lane pantomime the following year. Around the same time Stanfield received a lucrative order from the Earl of Lansdowne for a series of ten Italian landscapes, including three Venetian subjects, to decorate the dining room at Bowood House. The importance of this commission, and of another that came from no less a personage than George IV himself – despite the fact that Stanfield had yet to join the Royal Academy – created a great deal of resentment in established artistic circles; and whether or not Turner shared the same sentiments, he knew a rival when he saw one, and readily rose to the challenge.

Thus it may have been upon learning that Stanfield was going to submit *Venice from the Dogana*, one of the

84

Lansdowne pictures, to the Royal Academy in 1832, that Turner decided to exhibit his first two Venetian oils, a view of the piazza adjoining the Ducal Palace (lost), and the *Bridge of Sighs, Ducal Palace and Custom-House Venice: Canaletti painting* (no.67). As the title's final phrase implies, here Turner was inviting viewers to compare his artistry with Canaletto's, as if perhaps to suggest that Stanfield was of no consequence whatsoever. But contemporary observers were well aware that they were witnessing a contest between the two living British painters; and even though the *Dogana* and the *Bridge of Sighs* were placed in different rooms, critics were quick to make the connection. The victory, all agreed, was entirely Turner's. According to the *Spectator* (11 May 1833), the Stanfield may have been 'cleverly painted, but the comparison with the same subject by Turner is fatal to it. It is to Turner's picture what a mere talent is to genius.'

Two years later, when Turner exhibited his *Venice from the Porch of the Madonna della Salute*, the press was still suggesting that his motivation was to best Stanfield, and to show Lord Lansdowne that he had chosen the wrong artist. These reports, however, were probably incorrect. Although there still may have been some element of rivalry between them, by now the two painters had become friends, and Stanfield had been elected to full membership of the Academy; besides, the dramatic proliferation of Venetian subjects in the various London exhibitions made it evident that this most romantic of Italian cities could support a veritable army of British topographers, never mind just one or two.[1] Throughout his career as a painter of Venice, Turner remained in dialogue with Canaletto (who had also depicted the Grand Canal from the porch of the Salute), and with a burgeoning number of contemporaries like Stanfield, J.D. Harding, William Etty and Augustus Wall Callcott. All of these other artists (including Canaletto) might have produced more meticulously observed portrayals of Venice's buildings, canals, boats, inhabitants and so forth; whereas Turner's views, by contrast, offered more in the way of atmospheric poetry.

85

86

86
Thomas Girtin (1775–1802)
The White House at Chelsea 1800
Watercolour, 29.8 x 51.4
Tate. Bequeathed by Mrs Ada Montefiore, 1933

87
J.M.W. Turner
The Lauerzersee with the Mythens 1848
Pen and watercolour, 36.8 x 54
Victoria and Albert Museum,
London: Henry Vaughan Bequest

Of all the works by the watercolourist Thomas Girtin, who had been the friend and rival of his youth, none more firmly lodged itself in Turner's memory than *The White House at Chelsea*. Never publicly displayed during its creator's lifetime, this work was recognised as Girtin's supreme masterpiece when it appeared in a series of exhibitions of drawings organised by the publishers George and William Bernard Cooke in the early 1820s. The Cookes then commissioned Thomas Lupton to produce a mezzotint reproduction, and paid Turner to correct the trial proofs, before issuing the print in their *Gems of Art* in 1823.

An article in the *European Magazine* for January of that year succinctly explained why the *White House* merited such special regard. For here, according to the anonymous critic, to a greater extent perhaps than in any other of Girtin's watercolours, one could fully appreciate how 'he produced

87

the most powerful and faithful effects of nature by ordinary and simple means' – a result rendered all the more remarkable by the 'apparent ease' with which it had been achieved.[1] At the centre of this performance lies the white house itself, highlighted by the rays of the setting sun and casting its reflection across the broad flat stretch of the River Thames. Not only does this humble building encapsulate the mood of elegiac transience that suffuses the scene as a whole; but since the artist has described its form by leaving this area of the paper virtually unpainted, in the most understated way imaginable the house draws attention to both the economy and the virtuosity of the creative process which has brought this wonderfully expressive panorama into being.

There is a story, almost certainly apocryphal, which tells that 'when a connoisseur, more plain-spoken than polite, declared to the great Turner that in his hackney coach, now at the door, there was a drawing "finer than any of yours", the great Turner, after the first moment of irritation, replied to his visitor, "Well then, if it is finer than any of mine, I can tell you what drawing is in your hackney-coach. It is Tom Girtin's *White House at Chelsea*."'[2]

Entirely mythic this anecdote may be; but there can be no doubt of Turner's lifelong reverence for the composition in question. He wrote its name down on two of his late Swiss sketches, and just a few years prior to his own death in 1851 he incorporated the motif of a white building perched on a calm twilight shore into several watercolour views of the Alps, including *The Lauerzer See, with the Mythens*. Like the Girtin that inspired it, this image champions Turner's seemingly effortless mastery of his chosen medium, as well as his ability to evoke a profoundly reflective mood – in part by reanimating the signature achievement of his long-dead rival and friend.

88
Philip James de Loutherbourg (1740–1812)

The Glorious First of June, 1794 1795
Oil on canvas, 266.5 x 373.5
National Maritime Museum, London.
Greenwich Hospital Collection

89
J.M.W. Turner

The Battle of Trafalgar, 21 October 1805 1823–4
Oil on canvas, 261.5 x 368.5
National Maritime Museum, London.
Greenwich Hospital Collection

Turner's *Battle of Trafalgar* was his only royal commission, painted on order for George IV as a companion-piece to the equally enormous naval battle scene by Philip de Louterbourg that the monarch – then Prince of Wales – had purchased some two decades earlier. Both works were meant to form part of a decorative scheme devised in 1822 for the three major state reception rooms at St James's Palace, on the theme of the great military victories of the Hanoverian dynasty, beginning with George II and ending with Waterloo. From May in 1824 the de Louterbourg and the Turner were displayed in the ante-room (the second room in the sequence), on either side of Thomas Lawrence's portrait of George III.

Lawrence had probably been responsible for arranging the commission, and in the summer of 1825 he had to intercede with the king to ensure that Turner got paid (the final sum was 500 guineas, a hundred less than he'd originally agreed). But other arguably more serious problems proved much harder to resolve. Immediately upon the *Trafalgar*'s

88

installation in the Palace, the picture came under verbal attack from a succession of naval men, who strongly objected to the liberties that Turner had taken with nautical and historical truth; in response to their comments he spent no fewer than eleven days making a whole range of minor modifications, though his refusal to budge on larger issues meant that the controversy stubbornly refused to abate.

De Loutherbourg's *Glorious First of June, 1794* – recording the day when Lord Howe's Channel Fleet captured six French ships and sank another in the North Atlantic – had also been charged with inaccuracy upon its first public showing in 1795; but the volume of negative criticism steadily diminished over time, before being eclipsed almost entirely in 1824 by the barrage of disapproval directed at its new companion-piece. When the two works were shown together, furthermore, it became clear that Turner's *Trafalgar* looked much less like the depiction of a heroic victory, and more like a curiously static image of patriotic sacrifice. It is the billowing sails attached to the *Victory*'s falling mast that dominate the scene, and that

pull our attention downwards to the mass of struggling men, one of whom clutches vainly at a Union flag as he sinks beneath the blood-red waves. Of course Trafalgar – unlike Lord Howe's spectacular victory over the French fleet eleven years earlier – was (on account of Nelson's death) a national tragedy as well as a cause for celebration, but Turner may not have been wise to advertise the fact. Moreover this was not the sort of commission that played to his strengths as an imaginative artist, especially one widely celebrated – or castigated – for the painterly indistinctness of his touch; in modern battle scenes it was the mundane facts that mattered, and that viewers expected to see rendered in meticulous detail. Although Lords Howe and Nelson may have led the British navy to triumph over France, in the battle of the pictures the French-trained de Loutherbourg had no difficulty in overcoming the challenge of his English rival. But the earlier artist's victory proved to be a pyrrhic one: for in 1829, no doubt tired of the continued grumbling at Turner's *Trafalgar*, George IV sent both works to Carlton House before giving them to the Naval Gallery at Greenwich Hospital.

89

Turner Paints Himself into History

Ian Warrell

The late 1820s were overshadowed for Turner by a series of deaths, beginning in 1825 with that of his greatest patron and friend, Walter Fawkes, and culminating with the loss of his father in September 1829. By then in his mid-fifties, Turner had probably already pondered his own demise and what it would mean for his long-term reputation. But this latest bereavement almost immediately prompted him to write his first will, in which he made provision for two of the paintings that he held dearest to be left to the National Gallery. The terms of the will stated that he offered the Gallery *Dido building Carthage* (no.94) and *The Decline of the Carthaginian Empire* (fig.70) 'provided the above two pictures *are deemed worthy* to be and are placed by the side of Claude's "Sea Port" and "Mill"' (no.93 and fig.30).[1] The phrasing of this offer is noteworthy, with its assertiveness tempered by an air of apparent hesitancy and humility. However, no one reading these words at that time could have failed to recognise Turner's presumption in targeting the two Claudes he had specified. The *Seaport with the Embarkation of the Queen of Sheba* (no.93) and the *Landscape with the Marriage of Isaac and Rebecca* (usually then referred to simply as *The Mill*) had been amongst the most expensive landscape paintings ever acquired by any British collector, and were viewed as the standard by which all subsequent attempts in this field could be judged. It is also remarkable that Turner felt confident in proposing such terms at a point when his own reputation was far from assured among his

contemporaries (except as a painter of watercolours). Nevertheless, through this private gesture, he was consciously and fearlessly positioning himself as the only valid challenger to Claude's supremacy as the master of classical landscape art.

In 1829 the National Gallery had only been in existence for five years, and was still housed in John Julius Angerstein's former residence on Pall Mall. It was not until 1836 that the collection moved to the west wing of its present home on Trafalgar Square, which it then shared for thirty years with the Royal Academy. From the outset, the Gallery's range of works spanned representative examples of the most revered Old Masters, as well as the foremost painters of the British School, such as William Hogarth, Joshua Reynolds and Richard Wilson. The only living artist whose works were featured in the core founding collections was David Wilkie, a circumstance that must have rankled Turner's competitive nature (see nos.48–51). Indeed, Wilkie's continuing popularity, not only in the genre subjects with which he had made his name, but also in historical scenes, was probably one spur that drove Turner to try his hand at a number of figurative subjects toward the end of the 1820s, though these exercises were just as often attempts to joust with past masters, like Rembrandt, through those of the present (see nos.78–9).[2]

From 1830 onwards there was also a sense that Turner began to compete more and more with himself.[3] Over the preceding decade, as critical opinion became more hostile to his current work, and frequently stated its preference for his earlier style, few of his major exhibits had sold, and his

J.M.W. Turner
Sun rising through Vapour
exh. RA 1807
(detail, no.103)

Fig.70
J.M.W. Turner
The Decline of the Carthaginian Empire – Rome being determined
on the Overthrow of her Hated Rival, demanded from her such Terms
as might either force her into War, or ruin her by Compliance: The
Enerated Carthaginians, in their Anxiety for Peace, consented to give
up even their Arms and their Children exh. RA 1817
Oil on canvas, 170 x 238.5
Tate

increasingly congested gallery and its adjacent studio were in danger of becoming a monument to wrong-headed ambition, rather than a hub of artistic success. Turner could at least console himself that his earlier pictures continued to attract the esteem of art lovers. This was certainly the case for his masterpiece of 1807, *Sun rising through Vapour* (no.103), which twenty years later he bought against stiff competition at the sale of the deceased Lord de Tabley. Contemplating the justly celebrated painting once again at close quarters led him to try another version of the subject, which he exhibited in 1830:

Fish-Market on the Sands – the Sun rising through a Vapour.[4] Sadly, this canvas was destroyed in 1956, but it is apparent from old reproductions that Turner sought to clothe his youthful achievements in his more mature manner, as if attempting to reconcile for himself a belief in his continuing ability as a painter of quality and originality. Furthermore, this confrontation with his younger self seems to have been an important factor in his decision to rewrite his will in 1831, where he substituted *Sun rising through Vapour* for *The Decline of the Carthaginian Empire* as the second of the pair of pictures he wanted juxtaposed

with the National Gallery's most renowned Claudes. This decision effectively shifted Turner's claims on posthumous fame by commandeering both the classical *and* the northern traditions of seventeenth-century landscape painting, as Kathleen Nicholson explains elsewhere in this volume (see pp.68–9).

Another direct confrontation between Turner and one of his earlier pictures took place in 1838, a year after his *Dutch Boats in a Gale* from 1801 was exhibited at the British Institution alongside the van de Velde that had inspired it (nos.19 and 20). By now well entrenched in its hostility to Turner's art, *Blackwood's Magazine* hailed the van de Velde as the finer picture, and claimed Turner's realisation of water and other detail was damaged by his willingness to sacrifice any sense of naturalism to vainglorious effect.[5] Turner's riposte appeared at the Institution a year later, when he redeployed the central group of boats from his composition of 1801 in a picture entitled *Fishing Boats with Hucksters bargaining for Fish* (fig.43). As if in open defiance of the *Blackwood's* critic, this later painting is even more extreme in the way it is constructed around contrasting light effects, and in its exaggerated handling of the undulating sea, with its startling reflections and wind-whipped surfaces. That Turner had other purposes in mind than his normal concern to produce a work for sale is suggested by the fact he sent the *Hucksters* to the exhibition without bothering to designate a price. Some years later, as Sarah Monks notes (see pp.84–5), he expressed a hope that it could be seen alongside *Dutch Boats in a Gale* and its pendant by van de Velde. Surely it must have been Turner's need to assert his continuing prowess, coupled with a desire to refute the aspersions cast on his youthful masterpiece, that underlay this strange incident. But this was not to be the last time he resumed sparring with an Old Master by reworking one of his own earlier images, for in 1844 he did exactly this with a seascape painted seventeen years previously in tribute to Jacob van Ruisdael (see nos.70, 99).

With the benefit of hindsight, it is clear that the frequency with which Turner made direct reference to earlier painters from the 1820s onwards was an indication of a need to feel confident of his place alongside the canonical Old Masters. Even as he pressed on towards a more modern aesthetic in his choice of subjects, or in his realisation of form and handling of paint, he continued to reassert his faith in the great tradition of European painting, most notably as epitomised by the works of Claude Lorrain. In fact, of the one hundred or so pictures he exhibited between 1820 and 1850, more than a quarter could be said to adhere to the principles of Claudean design. As can plainly be seen from the contemporary works of Samuel Palmer and Francis Danby, Turner was not alone in idolising Claude as a vital touchstone for the modern landscape artist. But the broad trend in European aesthetics was beginning to move in other directions, as may even have been evident to some of those who saw the paintings in emulation of Claude that Turner exhibited at Rome in 1828 (for instance, no.91).

One man whose tastes were informed by the more exacting naturalism of the mid-nineteenth century was Turner's critical champion John Ruskin, who paradoxically tried to defend precisely this aspect of Turner's art. A sense of the divergent tastes of the painter and his most influential exponent can be most readily located in their attitudes to Claude. In the first volume of *Modern Painters* (1843), the book Ruskin wrote to defend and champion Turner, he repeatedly disparaged Claude's works as merely generalised, and therefore neglectful as true landscapes. But, more unsettlingly, he belittled as 'nonsense pictures' those works in which Turner addressed Claude's legacy, and specifically the two great Carthage paintings.[6] Turner may well have fumed about this dismissal of the pictures with which he hoped to secure his posthumous reputation, and indeed it seems the friendship between the two men became cooler after 1845. Before then, however, Ruskin had paid Turner to reprint for him a complete set of the *Liber Studiorum* mezzotints, with somewhat unexpected consequences. For although the critic had little or no liking for the *Liber*'s most Claudean subjects, an ironic by-product of his commission was that it reanimated Turner's own interest in his earlier prints, and especially in the images that Ruskin so reviled. During the mid-1840s Turner reworked ten of the *Liber Studiorum* compositions in a set of canvases similar in size, style and level of finish (including no.96).[7] Eight of these paintings were based on prints that bore the designation 'EP' (most probably Elevated Pastoral), which placed them in the category of landscape that featured Turner's most overt pastiches of Claude. None of this group of oils was exhibited in Turner's lifetime, and so they remained at the wonderfully indeterminate state he seems to have created for works prior to their resolution in the forum of an exhibition. As such they constitute a sustained and transcendently beautiful, private rebuttal of Ruskin's objections, offering a final reaffirmation of the tradition of landscape painting running from Claude directly to Turner himself.

90
Claude Gellée,
known as Claude Lorrain (c.1604/5–1682)
Seaport at Sunset 1639
Oil on canvas, 103 x 135
Musée du Louvre, Paris

91
J.M.W. Turner
Regulus exh. Rome 1828, reworked, exh. BI 1837
Oil on canvas, 89.5 x 123.8
Tate

92
J.M.W. Turner
Mercury sent to Admonish Aeneas exh. RA 1850
Oil on canvas, 90.2 x 120.6
Tate

90

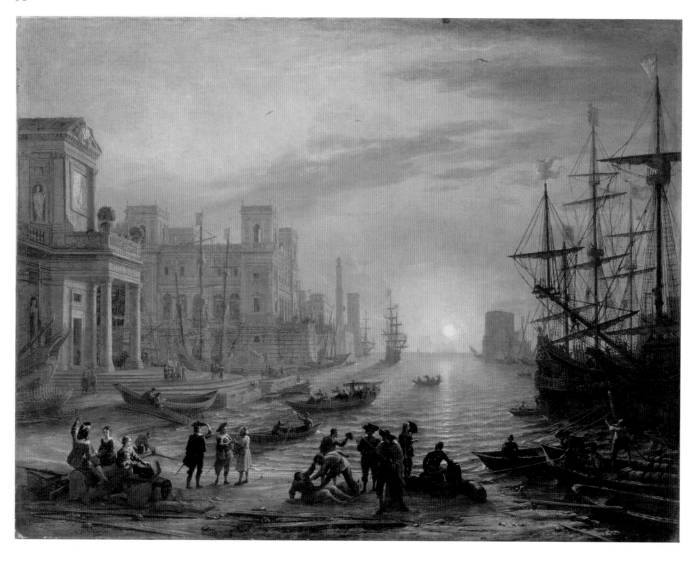

In the course of his travels in Italy and France during the 1820s, Turner seized several opportunities to study the works of Claude Lorrain, for whom his admiration took on new life and intensity as a result. The sketchbooks he used on these journeys include a number of shorthand studies of Claude's compositions, accompanied by written assessments of their colours and of the effects the artist had achieved. In Paris in 1821, for example, Turner made notes on eight of the fifteen Claudes that were then hanging in the Louvre.[1] But more than any other type of landscape by Claude, it was his seaports that continued to have the most enduring relevance to Turner's own work, perhaps in part because this type of picture deliberately focused on the poetry – both visual and by association moral – of contrasting nuances of light. As in his Carthage scenes of the 1810s (see no.94 and fig.70), Turner's subsequent deployments of his precursor's seaport formula indicate an audacious belief that he could add something new and important to one of Claude's signature pictorial inventions.

This was presumably Turner's reasoning in 1828 when he painted *Regulus*, one of three canvases he exhibited during his second stay in Rome in an impromptu one-man show that was intended to address (and to stimulate) the international artistic community's interest in his work.[2] In what was no doubt a ploy deliberately designed as a provocative gesture to his pan-European audience, Turner brazenly borrowed the composition of *Regulus* wholesale from an acclaimed image by Claude (see fig.31), the *Seaport with the Villa Medici* in the Uffizi Gallery in Florence (itself a repetition, in reverse, of a picture Claude had painted a year earlier; no.90 is a later version of the 1637 canvas).[3] This bold act of appropriation proved to be highly controversial. In a letter written from Rome to England in February of 1829, the young Charles Eastlake spoke of the 'general severity' of the 'angry critics' of Turner's exhibition. But Eastlake's loyally patriotic description of the event also reveals something of the show's intended impact, when

91

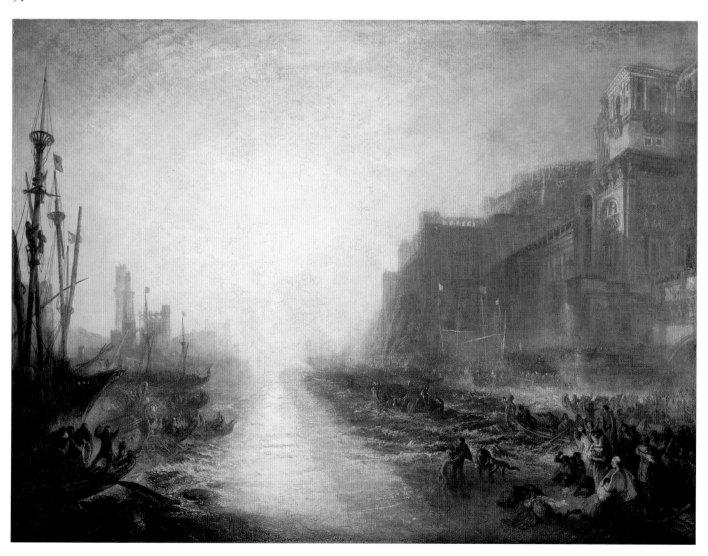

he speaks of how the representatives of different national schools were 'astonished, enraged or delighted … at seeing things with methods so new, so daring and excellences so unequivocal'. Eastlake concluded that many of the artists who attended the event 'were fain to admire what they confessed they dared not imitate'.[4]

With its orderly lines of perspective converging towards the sun, *Regulus* comes much closer to the Claudean model than most of Turner's seaports. The dramatic effect of the glaring sun, possibly a sunrise, is actually heightened in the painting as we see it now, for when Turner subsequently exhibited the canvas in London for the first time, nearly a decade later in 1837, he substantially reworked the image (perhaps to obscure damage to the canvas), smearing white across its surface, then tracing lines to exaggerate the paths of intense sunlight through the air and over the crests of the waves. The overpowering brightness of the revised painting was probably meant to evoke the fate of its eponymous protagonist, Marcus Atilius Regulus (died c.250 BC), a Roman general who suffered the horrible torture of having his eyelids removed by his Carthaginian captors for steadfastly adhering to his patriotic duty (see p.70).

Carthage also provided the setting for Turner's last finished reworkings of the Claudean seaport format: four pictures dealing with the drama of Dido's doomed love for Aeneas that the artist painted after 1845, when, in declining health, he retreated to the seclusion of his riverside home in Chelsea. These works were apparently created through a process in which each image was built up as Turner went repeatedly from canvas to canvas with his charged brush, as if working on a production line (this method resembles his longstanding practice in watercolour). The set of four pictures, of which three now survive, then became his last exhibits at the Royal Academy, appearing there in 1850, eighteen months before his death.[5]

Mercury sent to admonish Aeneas and its three companion-pieces represent a conscious last tribute to Claude – the culmination of a half-century of efforts to assimilate and supplement the seventeenth-century master's example. That ambition assumes its most dramatic visual form in the scene's shimmering iridescent light, as it envelops and dissolves buildings, ships, water and people, an effect achieved through the innumerable small touches of Turner's brush. His decision to exhibit each of the pictures in this final quartet with an extracted fragment from his epic in verse, *The Fallacies of Hope*, points to a deeper and more intangible ambition that he identified with Claude: to imbue landscape painting with the expressive power of great poetry.

Turner's text for this canvas invoked a 'morning mist', made palpable in the heavy impasto in the top half of the image. In the lower left-hand corner Aeneas is visited by Mercury, the messenger of the Gods, who reminds the hero that he must leave Carthage for Italy in order to fulfil his destiny.

92

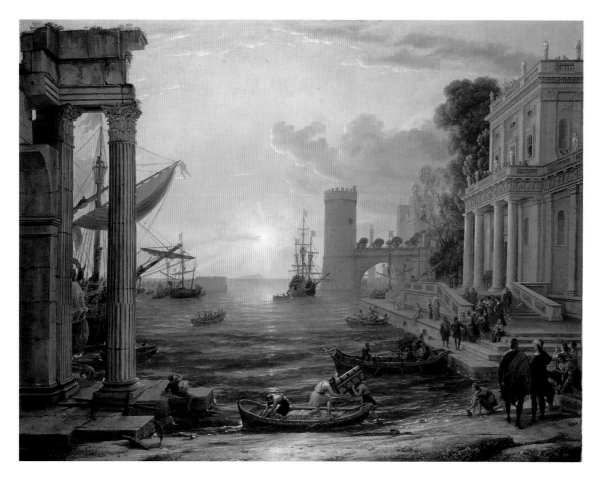

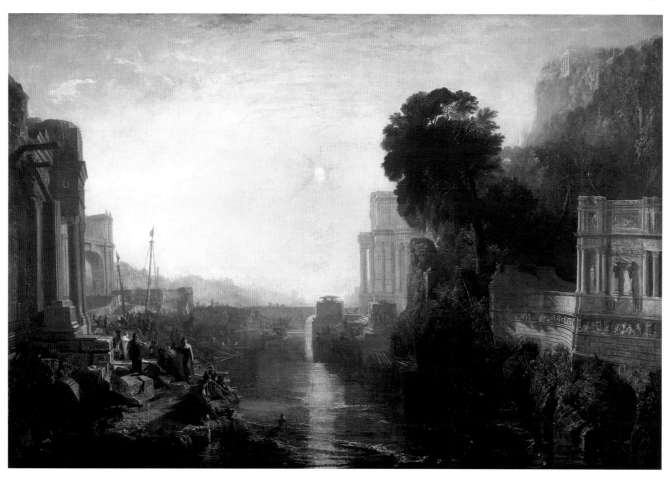

93
Claude Gellée,
known as Claude Lorrain (c.1604/5–1682)

Seaport with the Embarkation of the Queen of Sheba 1648
Oil on canvas, 149.1 x 196.7
The National Gallery, London. Bought 1824

94
J.M.W. Turner

Dido building Carthage; or the Rise
of the Carthaginian Empire exh. RA 1815
Oil on canvas, 155.5 x 230
The National Gallery, London. Turner Bequest, 1856

Turner's devotion to the works of Claude was legendary among his contemporaries, who remembered him as a 'very young' man weeping with envious admiration before one of the earlier artist's *Seaport*s in the collection of John Julius Angerstein.[1] If the story is true, if only in essence, the event referred to must actually have taken place during the first five years of the nineteenth century, when Turner was already in his later twenties, and probably concerns the *Seaport with the Embarkation of Saint Ursula* (1641; also the National Gallery, London). Angerstein, a leading London insurance broker, had acquired this picture in November of 1802. The following spring, however, he made his most exciting and substantial purchase of works by Claude, when he purchased a pair of large paintings shortly after they had been imported from France.[2] Generally known to Turner's generation as 'The Sea Port' and 'The Mill', the subjects depicted were two stories from the Old Testament: the *Embarkation of the Queen of Sheba* and the *Marriage of Isaac and Rebecca* (fig.30). To the astonishment of all, Angerstein paid the vast sum of 8,000 guineas for both; this at a time when Turner was only able to obtain 250 guineas for his largest and most ambitious canvases (this was what he received for the *Bridgewater Sea-piece*, no.20). The seemingly insurmountable gap between the colossal figures paid for Old

Master paintings and what a relatively successful young artist, such as Turner, could achieve must have quickened his resolution to address aspects of his professional work to the taste of this potentially lucrative market, even as his ambition was conjoined with a sincere appreciation of the greatness of Claude's achievement.

By the time he exhibited *Dido building Carthage* in 1815, his understanding of the principles of Claude's art was acute, having been enriched through years of close study of the many original works by the master that had ended up in British collections.[4] Indeed, the critic for the *Times* (6 May 1815) considered that Turner's mind 'must have been saturated with Claude Lorrain', when he set to work on the composition. At the time Turner was presumably aware, as Michael Kitson has noted,[4] that other artists had failed to rise to the challenge of Claude's seaports in the intervening 130-odd years since the French artist's death. Rather than simply adopting the neatly framing architectural structures deployed by Claude for his theatrical presentations of sunrise or sunset, Turner's *Dido* offers a less open, more complex spatial setting, where the human drama is inextricably interwoven with the atmospheric effect. This development from Claude was central to Turner's desire to champion a type of landscape painting in which the background was as significant as its ostensible narrative. The picture is one of several in which he contemplated the meanings of the Virgilian story of Dido and Aeneas, who, as representatives of Carthage and Rome, acted as allegorical surrogates for the clash and evolution of empires that Turner was witnessing in the European conflict with Napoleonic France.[5]

Although the connoisseur George Beaumont told those in his circle that *Dido building Carthage* was a product of 'false taste, not true to nature',[6] it was generally considered a triumph. In the *Champion* (7 May 1815), the work was hailed as one of those 'achievements that raise the achievers to that small but noble group, formed of the masters whose day is not so much of today, as of "all-time"'. Rumours circulated in the following years that Turner had secured its sale for 800 guineas, but the canvas remained with him, and his sense of what he had achieved made him afterwards reluctant to sell it. By 1829, in any case, he planned to leave it to the nation, though this did not spur him to ensure it was well preserved. After *Dido building Carthage* joined the National Gallery collection in the 1850s, areas of the sky had to be repainted to replace damage caused while the picture had hung in Turner's increasingly dilapidated gallery.

95

95
Claude Gellée,
known as Claude Lorrain (c.1604/5–1682)
Pastoral Landscape with the Arch of Titus 1644
Oil on canvas, 102 x 136
Private collection

96
J.M.W. Turner
Landscape: Woman with Tambourine c.1845
Oil on canvas, 88.5 x 118
Tochigi Prefectural Museum of Fine Arts, Japan

97
J.M.W. Turner, engraved by Charles Turner
Woman and Tambourine 1807
Etching and mezzotint, 18.4 x 26.7
Tate. Presented by A. Acland Allen through The Art Fund 1925
Not exhibited

The *Pastoral Landscape with the Arch of Titus* was one of
a host of works by Claude Lorrain that by the end of the
eighteenth century had found a home in Britain, where the
master's ideal scenes, distilled from his studies of Rome and

the Campagna, were eagerly collected by the landed
gentry and aristocracy. To his classically educated viewers,
Claude's imagery conjured up the leisured and harmonious
Golden Age evoked by numerous ancient poets, and by
Virgil in particular. Another significant dimension of
meaning accrued to the *Arch of Titus* in 1772, when it was
engraved by William Woollett and published by John
Boydell under the title of *Roman Edifices in Ruins: The
Allegorical Evening of the Empire*, thus giving the picture
an historical resonance that its seventeenth-century creator
would almost certainly not have intended to convey. By
spreading the fame of the original oil, Woollett's engraving
also made it a particularly familiar example – for a British
audience at least – of the compositional type most
frequently associated with Claude as a painter of landscapes
(as opposed to seaports): this places the spectator in front
of and above an extensive prospect divided into a
succession of horizontal planes, framed by trees and
punctuated by glimpses of classical architecture – here the
Arch of Titus (made to look more ruined than was actually
the case) overlapping the Ponte Nomentana at right, the
remains of an aqueduct silhouetted in the middle distance,
and part of the Colosseum just beyond. These various
elements help direct the eye along a central avenue of space,
culminating in the brightest area of sunlit sky just over the

96

97

horizon; the overall effect aims to convey a sense of perfect order, poised between simple nature on the one hand and highly sophisticated culture on the other.

Inspired perhaps by his first sight of the famous Altieri Claudes (see pp.19, 20 and fig.32), Turner began experimenting with this landscape formula when he was in his mid-twenties (see, for example, fig.28), and from then until the end of his career it assumed an important place in his habitual repertoire. In 1807 he adapted its basic structure for use in his *Woman and Tambourine*, one of the initial batch of mezzotints in his *Liber Studiorum* (in itself an overtly Claudean enterprise; see p.63).[1]

He classified this print under the heading 'E.P.' – probably meaning 'Elevated Pastoral' – the designation he used for those *Liber* landscapes that were most overtly indebted to the works of Claude. The enduring relevance of this type of image-making to Turner only became apparent after his death, with the discovery of a late unfinished canvas that repeated essentially the same composition.[2] In the painted *Woman with Tambourine* everything is enveloped in an all-pervasive golden air, recalling the words Turner had chosen more than thirty years earlier to characterise the best qualities of Claude: 'calm, beautiful and serene …

The golden orient or the amber-coloured ether … harmonious, true and clear, replete with all the aerial qualities of distance, aerial lights, aerial colour … '.[3]

Just as these comments are an edited, pared-down version of what Turner had originally detected in the full range of Claude's art, so his late canvases are distilled versions of his early tributes, offering a personal and more concentrated idea of what he felt was most important to retain from, and to aspire to surpass in, Claude's example. DS & IW

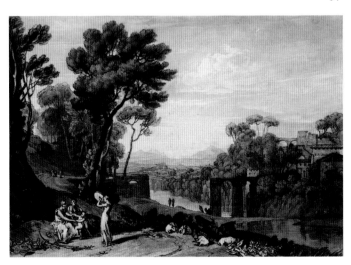

98
Jacob van Ruisdael (1628/9–1682)

Rough Sea c.1670
Oil on canvas, 107 x 125.8
Boston Museum of Fine Arts. William Francis Warden Fund

99
J.M.W. Turner

Fishing Boats bringing a Disabled Ship into Port Ruysdael exh. RA 1844
Oil on canvas, 91.4 x 123.2
Tate

100
J.M.W. Turner

Ostend exh. RA 1844
Oil on canvas, 92.9 x 123.2
Neue Pinakothek, Munich
Not exhibited

101
J.M.W. Turner

Snow Storm – Steam-Boat off a Harbour's Mouth making Signals in Shallow Water, and going by the Lead. The Author was in this Storm on the Night the Ariel left Harwich exh. RA 1842
Oil on canvas, 91.4 x 121.9
Tate

Although Turner was certainly familiar with Jacob van Ruisdael's rural landscapes, in his own work he addressed the Dutch artist exclusively as a painter of the sea and its coasts.[1] The first public expression of this interest had taken the form of *Port Ruysdael*, one of his Royal Academy exhibits in 1827 (no.70). Fourteen years later Turner returned to the same imaginary anchorage, with an image that not for the first time instanced his late habit of taking on another artist at second-hand via one of his own earlier pictures (see pp.208–9). On this occasion that earlier work still remained in his studio (though at long last in the process of being sold) when the second *Port Ruysdael* scene was on Turner's easel – a factor that would have made him acutely aware of the passage of time and of his remarkable divergence from a style that he could perhaps no longer recover.[2] It may be that such anxieties about his own enfeeblement were projected onto the picture, giving rise to the reference in the title to a ghostly-looking 'Disabled Ship' being accompanied into port.[3] Nonetheless, the verve with which Turner continued to paint at this time signifies that he did not consider there to be any real diminution of his talent. If anything, he remained staunchly defiant, justifying the

relatively indistinct character of his recent performances with the comment, 'Yes, atmosphere is my style'.[4]

Both the *Fishing Boats bringing a Disabled Ship into Port Ruysdael* and the related painting of *Ostend* certainly testify to his ability to conjure up, with Prospero-like magnificence, restless, churning seas and rain-laden clouds. There is, admittedly, a comparative slackness in the handling of paint in these two late works, so that the overall impression coheres only as a suggested whole, but is found to be intangible as the eye attempts to seize and animate individual detail. The fact that the ships and the undulating waves are more fully modelled in a third sea-piece that Turner exhibited in 1844 (*Van Tromp, going about to please his Masters, Ships a Sea, getting a good Wetting*, Getty Museum, Los Angeles), indicate that the less resolved appearance of the other pair must have been a conscious decision, pursued in order to demonstrate how a painted canvas, daubed with grey and white colour and spattered highlights, could truly make manifest the sensation of cold, windswept ocean and fresh, breezy skies. Ruskin, certainly, appreciated Turner's aims in these works, noting privately that he had 'some little doubts whether the Ostend be quite worthy of him – but the Port Ruysdael is I think absolute perfection – the best *grey* sea piece ever painted by man!'[5]

Two years previously Turner had shocked visitors to the Royal Academy with what was arguably his most startlingly original, and certainly one of his most defiantly modern, contributions to the seventeenth-century Dutch marine painting tradition. The vestiges of that heritage can still easily be traced in the remarkably succinct composition of *Snow Storm – Steam-Boat off a Harbour's Mouth* – and in its largely monochromatic palette – less reminiscent of Ruisdael, perhaps, than of his contemporary Jan van Goyen, or the cooler tones of Willem van de Velde the Younger; but the supercession of sail by steam is only one sign of Turner's determination to bring that legacy up to date, and to make it his own. The image itself offers a disturbing vision of man-made power caught up in natural forces at their most brutal extreme, with no stable surface on which the eye can rest. What can be seen of the blindly imperilled steam-boat is deliberately obscured through the swirling films of snow and sea spray, which, if we are to believe Turner's lengthy and complicated title, recreate the effects of a storm that he (as the 'Author' of the picture) had actually witnessed himself. However, the given specifics of the boat and its home port – names possibly jumbled in the artist's mind – together with the date of the storm, have frustrated all attempts to pinpoint the exact event he may have been illustrating, raising questions about the reliability of Turner's proposition.

98

99

100

This was clearly a sensitive point, as is plain from the well-known contemporary account of the *Snow Storm* that John Ruskin later reported. On being quizzed by Ruskin's friend the Reverend William Kingsley about the genesis of the painting, Turner is said to have responded to the effect that, 'I did not paint it to be understood, but I wished to show what such a scene was like; I got the sailors to lash me to the mast to observe it; I was lashed for four hours, and I did not expect to escape, but I felt bound to record it if I did.'[6] Though these may not have been the artist's precise words, both this anecdote and the phrasing of his title indicate that Turner wanted to stress the unique nature of the artist's vision of the world, as well as the epic dangers he was required to face in order to pursue his heroic calling.

Yet the idea of being strapped to a ship's mast was not, in fact, unique or original to Turner. As he must surely have been aware, several earlier marine painters were believed to have put themselves at risk in almost exactly the same fashion – the closest and best-known example (fig.71) being the eighteenth-century Frenchman Claude-Joseph Vernet (1714–1789). But given the *Snow Storm*'s closer kinship with seventeenth-century Dutch art, here it may be just as pertinent to recall the behaviour of Ludolf Backhuizen (1631–1708), whose biographers made frequent reference to his habit of taking a boat out to sea to seek out storms 'in order to observe the crash of the Seawater against the coast, and the changes of Air and Water under these conditions'.[7] Precedents such as these underline the fact that Turner positioned *Snow Storm: Steam-Boat off a Harbour's Mouth* in a lineage of Old Master image-making, based on the kind of imaginative transformation of observed experience that he habitually claimed to be at the core of his artistic process. But as in so many of his later pictures, it is in the materiality of paint that Turner defines himself both within and outside the traditions he invokes and sets out to transcend.

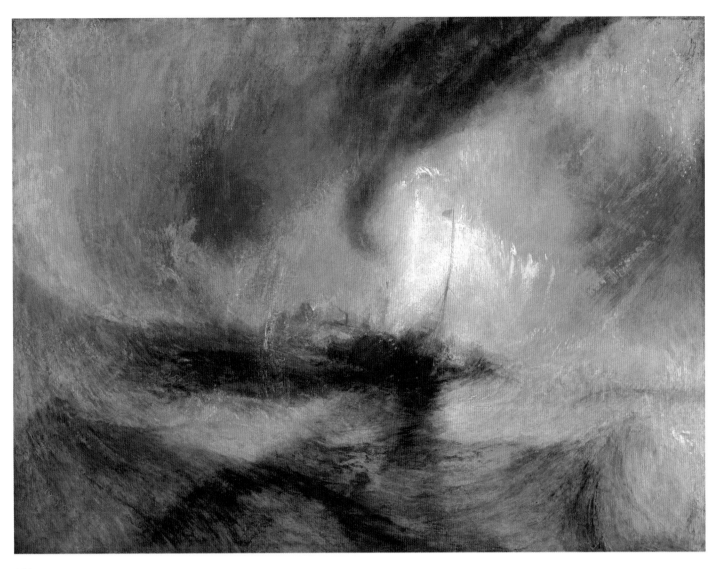

101

Fig.71
Horace Vernet
*Joseph Vernet Attached to a Mast,
Studies the Effects of the Tempest* 1822
Oil on canvas, 275 x 356
Musée Calvet, Avignon

102
Jan van de Cappelle (1624/6-1679)

A Calm 1654
Oil on canvas, 110 x 148.2
The National Museums & Galleries of Wales

103
J.M.W. Turner

Sun rising through Vapour:
Fishermen cleaning and selling Fish exh. RA 1807
Oil on canvas, 134 x 179.5
The National Gallery, London. Turner Bequest, 1856

In 1831 Turner changed the plan he had originally conceived and outlined in his will two years earlier, and for *The Decline of the Carthaginian Empire* (fig.70) substituted *Sun rising through Vapour* as one of the two pictures that he proposed to bequeath to the National Gallery, on the condition that these would be hung between two designated works by Claude (see no.93 and fig.30).[1] This amendment indicates his desire to impress posterity with the widest range of his achievement, and to acknowledge publicly his enormous debt to seventeenth-century Dutch landscape art in a picture that subtly fuses the classical and northern traditions.[2] Presumably Turner's decision was further swayed by the recent acclaim that *Sun rising through Vapour* had attracted when it came to auction in 1827 – for as the picture was carried in to Christie's sale-room the assembled multitude broke into spontaneous applause.[3] Perhaps Turner's head was, indeed, turned by such a warm response, since he then bought the work himself for 490 guineas – paying 140 guineas more than John Leicester had given him only nine years earlier. Cynically, one could deduce that this was a classic example of an artist protecting the value of his stock in a competitive market; such practices continue to occur today. Yet there was clearly something more personal, something of special significance to Turner's own self-esteem as an artist, bound up in his seemingly profligate act of reacquiring an old picture at such a dear price.

Sun rising through Vapour invokes a rich variety of seventeenth-century Dutch and Flemish precedents. The boorish fishermen and the closely observed studies of fish are grounded in the genre scenes and still lifes of David Teniers

the Younger and any number of his Netherlandish contemporaries; similar clusters of boats can be found in the works of Willem van de Velde and Ludolf Backhuizen; while the transforming passage of warm golden light seems particularly indebted to Aelbert Cuyp, or just possibly to the sudden burst of sunshine in Jacob van Ruisdael's *Coup de Soleil* (*Ray of Sunlight*) in the Louvre.[4] However, Turner derived the central idea of a 'Calm', with motionless boats adjacent to the shore, specifically from works by the Amsterdam marine specialist, Jan van de Cappelle. Sale records indicate that many examples of this type of van de Cappelle passed through the London art market just prior to and during the early 1800s.[5] It is known that the picture exhibited here was consigned for sale in 1794, but afterwards returned to the London residence of Lord Dundas, where Turner may very well have seen it.[6]

Together with *A Country Blacksmith disputing upon the Price of Iron* (no.49), *Sun rising through Vapour* was first exhibited in 1807, the year in which Turner entered into open rivalry with David Wilkie, the brilliant young Scottish genre painter who had been hailed as superior to Teniers. But aside from trying to outdo Wilkie, Turner's aim was to take on the entire Dutch tradition – a strategy that Benjamin West, for one, judged as the behaviour of a man 'run wild with conceit'.[7] By 1819, however, when *Sun rising through Vapour* had become one of the centrepieces of John Leicester's famous collection of modern British art, Turner was viewed more patriotically, 'not as the imitator, but the successful competitor of the most celebrated masters in the Dutch, and Flemish Schools'.[8] Such comments, together with the growing admiration for the picture in the later 1820s, surely contributed to Turner's determination to ensure that *Sun rising through Vapour* would join *Dido Building Carthage* in an attempt to secure his reputation as one of the greatest landscape painters of all time.

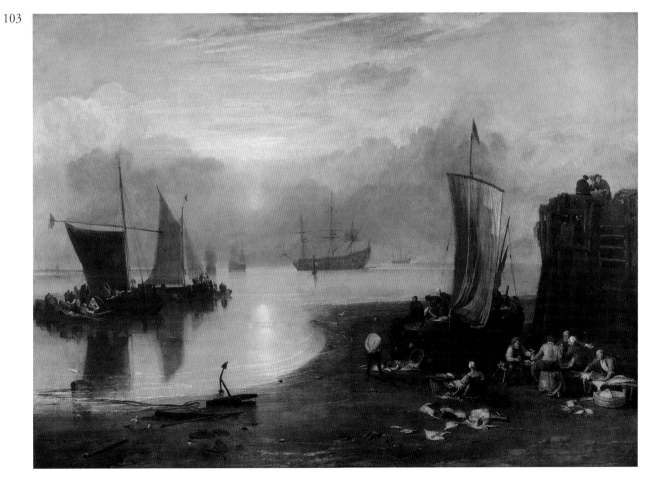

Notes

In addition to references to Butlin and Joll's standard catalogue of Turner's oil paintings (B&J), the following notes and list of exhibited works (p.233) refer to A.J. Finberg's *Inventory of the Turner Bequest* (1909), now at Tate (TB), and watercolours by Turner in other collections, as listed by Andrew Wilton, 1979 (W).

Turner and The Masters

pp.13–27

1 Smiles 2006, p.24.
2 Reynolds, *Discourses*, XII, 1784, p.217.
3 *Ibid.*, VI, 1774, p.113.
4 I am grateful to Eric Shanes, who is currently preparing a monumental biography of Turner, for information about the artist's manner of speaking.
5 Hamerton 1879, p.3.
6 Arthur Murphy, *The Gray's-Inn Journal*, no.iv, 11 November 1752, in *The Works of Arthur Murphy, Esq.*, 7 vols., London 1786, V, p.34.
7 Henry Fielding, *The History of Tom Jones, a Foundling*, 4 vols., London 1749, III, p.133.
8 William Beechey, quoted in William T. Whitley, *Artists and their Friends in England 1700–1799*, 2 vols., Cambridge 1928, I, p.380.
9 Edward Young, *Conjectures on Original Composition. In a letter to the author of Sir Charles Grandison*, 2nd edn., London 1759, pp.11–12.
10 For the most stimulating analyses of the development of attitudes toward literary property in eighteenth-century England, see Mark Rose, *Authors and Owners: The Invention of Copyright*, Cambridge, MA, and London 1993; Benjamin Kaplan, *An Unhurried View of Copyright Republished (and with Contributions from Friends)*, Newark, NJ, 2005 (originally publ. 1967); Alan Macfarlane, *Original Copy: Plagiarism and Originality in Nineteenth-Century England*, Oxford 2007, introduction and chapter I; Laura J. Rosenthal, '(Re)Writing Lear: Literary Property and Dramatic Authorship', in John Brewer and Susan Staves, eds., *Early Modern Conceptions of Property*, London and New York 1995, pp.324–38; and Nick Groom, *The Forger's Shadow: How Forgery Changed the Course of Literature*, London 2002.
11 Young, *Conjectures*, p.17.
12 Reynolds, *Discourses*, XIV, 1788, p.247.
13 Ziff, '"Backgrounds"', p.133.
14 This is what Richard Woodhouse, in a letter to Keats of 21 October 1818, wrote that he had understood the poet to have said; quoted in Walter Jackson Bate, *The Burden of the Past and the English Poet*, Cambridge, MA, and London 1991 (orig. publ. 1970), p.5.

15 William Wordsworth, 'Essay, Supplementary to the Preface', 1815, quoted in Macfarlane, *Original Copy*, p.21.
16 *Arnold's Library of the Fine Arts*, II, 1831, p.366.
17 John Opie, *Lectures to the Royal Academy*, 2nd Lecture, 1806, appendix to *Arnold's Library of the Fine Arts*, IV, 1832, p.32. Turner read and annotated an earlier edition of Opie; see note 24 below.
18 The story of Turner's first reaction to Claude's *Queen of Sheba* (or possibly to one of the other two Claude 'Seaports' then in the Angerstein collection and now in the National Gallery) is told by George Jones, in his 'Recollections of J.M.W. Turner' (published in Gage, *Correspondence*, p.4); while it was Joseph Farington who witnessed and recorded Turner's mixed response in 1799 to either the *Father of Psyche*, or its companion-piece, *Landscape with the Arrival of Aeneas at Pallanteum* (fig.32), which had recently been purchased by William Beckford. See Farington, *Diary*, vol.IV, 8 May 1799, p.1,219.
19 Gage 1987, p.110.
20 Bate, *Burden of the Past*, p.4.
21 *Ibid.*, p.3.
22 J.M.W. Turner, BL Add MS 46151, Q, ff.3v–4r, quoted in Smiles 2006, p.215. Turner's wording closely echoes Edward Young, who on p.17 of his *Conjectures on Original Composition* asks, 'But why are *Originals* so few? not because the writer's harvest is over, the great reapers of antiquity having left nothing to be gleaned after them'. Turner, however, seems to take a more pessimistic stance, by implying that the harvest has indeed ended, even if the odd valuable has inadvertently been left behind.
23 [John Taylor,] *True Briton*, 4 May 1799, reprinted in *Sun*, 13 May 1799; quoted in B & J, p.7.
24 This is one of Turner's marginal annotations in his copy of Opie's *Lectures*, quoted in Venning 1983, p.42.
25 Opie, *Lecture*, II, 1807, in *Arnold's Library*, p.20.
26 Ziff, '"Backgrounds"', p.147.
27 [John Britton,] *British Press*, 6 May 1803, and *True Briton*, 16 May 1803; both quoted in B & J, p.37.
28 Farington, *Diary*, vol.VI, 22 May 1803, p.2,034.
29 For an excellent discussion of the implications of 'manner' as a trope in British art criticism in this period, see Kriz 1997, pp.21–32.
30 *St James's Chronicle*, 11–13 May 1815.
31 Farington, *Diary*, vol.XIII, 5 June 1815, pp.4,637–8.
32 Turner, quoted in Venning 1983, p.44.

33 *Spectator*, 11 February 1837, quoted in B & J, p.173.
34 Ziff, '"Backgrounds"', p.146.
35 Bloom, *Anxiety of Influence*, p.30, xix.
36 Reynolds, *Discourses*, XIV, 1788, p.247.
37 [William Henry Pyne,] *Repository of Arts*, vol.9, 1813, p.25.
38 Bate, *Burden of the Past*, p.4.

Facing up to the Past

pp.29–39

This essay is indebted to Francis Haskell's ground-breaking study, *The Ephemeral Museum: Old Master Paintings and the Rise of the Art Exhibition*, New Haven and London 2000.

1 James Barry, *The Works of James Barry, Esq. Historical Painter*, ed. Dr Edward Fryer, 2 vols., London 1809, II, p.217.
2 William Buchanan, *Memoirs of Painting*, 2 vols., London 1824, I, pp.138–9.
3 *Times*, 23 February 1790.
4 *Public Advertiser*, 2 May 1793.
5 For crowds, see *World*, 14 May 1793; and for profits, see *Morning Chronicle*, 4 April 1793. Throughout the course of the exhibition, works were sold by private contract, but remained on view until the show had closed.
6 See, for example, *Oracle*, 5 April 1794, and *Public Advertiser*, 8 March 1793.
7 Farington, *Diary*, vol.I, 7 March 1794, p.169, and vol.I, 28 February 1794, p.167.
8 *Morning Chronicle*, 26 March 1794.
9 *Oracle*, 7 June 1794. For crowds see, for example, *Morning Chronicle*, 1 May 1794, *Morning Post*, 30 May 1794.
10 See *Morning Post*, 2 May 1794, for a detailed description of the hang.
11 Unidentified newspaper, National Art Library Press Cuttings, vol.III, p.734.
12 D.E. Williams, *The Life and Correspondence of Sir Thomas Lawrence*, London 1831, p.167.
13 For arguments over tickets, see Farington, *Diary*, vol.III, 28 December 1798, p.1,121, and vol.IV, 1 and 3 January 1799, pp.1,123 and 1,126.
14 *Ibid.*, IV, 4 January 1799, p.1,127.

15 James Barry, *A Letter to the Dilettanti Society*, London 1799, appendix, p.229.

16 Farington, *Diary*, vol.III, 3 and 4 January, 25 May, 29 July 1799, pp.1,127–8, 1,228, 1,258.

17 *Ibid.*, vol.IV, 11 January 1799, pp.1,132.

18 For details of low sales in 1799, see Jordana Pomeroy, 'The Orleans Collection: Its Impact on the British Art World' in *Apollo*, 145, February 1997, pp.29–30. On the later sale, see the fully-annotated copy in the British Museum Print Room of Peter Coxe, Burrell and Foster, *Catalogue of the Remaining Part of the Orleans Collection of Italian Paintings*, London, 14 February 1800, which names all the buyers and gives the prices they paid.

19 'T' (William Hazlitt), 'On the Pleasure of Painting', *London Magazine*, 2 December 1820, p.603.

20 Buchanan, *Memoirs*, I, p.8.

21 Rev. William Shepherd, *Paris in 1802 and 1814*, London 1814, pp.1–2.

22 Francis Blagdon, *Paris as it Was and as it Is; or, a Sketch of the French Capital … in a Series of Letters Written by an English Traveller, during the Years 1801–2 to a Friend in London*, 2 vols., London 1803, I, p.149.

23 For example, Sir John Dean Paul, *Journal of a Party of Pleasure to Paris, in the Month of August 1802*, London 1802, 39; Shepherd, *Paris*, p.49; Francis Elizabeth King, *A Tour in France, 1802*, London 1814, p.58; and Henry Fuseli, letter to William Roscoe, 16 November 1802, in David H. Weinglass, ed., *The Collected English Letters of Henry Fuseli*, Millwood, NY, 1982, p.256.

24 Blagdon, *Paris*, pp.148–9.

25 John Carr, *The Stranger in France, or a Tour from Devonshire to Paris*, London 1803, p.109.

26 Henry Redhead Yorke, *France in Eighteen Hundred and Two*, edited and revised by Richard Davey, London 1906, p.157.

27 Dawson Warren, *The Journal of a British Chaplain in Paris during the Peace Negotiations of 1801–2*, ed. A.M. Broadley, London 1913, p.36, entry for 20 November 1802.

28 Blagdon, *Paris*, pp.182–3.

29 *Morning Chronicle*, 3 August 1802.

30 Farington, *Diary*, vol.V, 6 September 1802, p.1,833.

31 Turner, 'Studies in the Louvre' sketchbook, TB LXXII, 41a–2.

32 Referred to as such in *Notice de Plusieurs Précieux Tableaux recueillis a Venise, Florence, Naples, Turin et Bologne, Exposés dans le grand Salon du Musée*, Paris, an XI Thermidor [i.e. 1802–3], p.64.

33 Count Joseph Truchsess, *Proposals for the Establishment of a Public Gallery of Pictures in London, Addressed to the Nobility and Gentry of the British Empire, and Particularly to the Inhabitants of the Metropolis*, London 1802, p.1.

34 Letter from Count Truchsess to Ozias Humphrey, 22 July 1802, in Royal Academy of Arts archive, HU/5/116.

35 Letter from Blake to William Hayley, 23 October 1804, cited in Thomas Wright, *Life of William Blake*, 2003, p.166.

36 *Daily Advertiser, Oracle and True Briton*, 6 May 1806.

37 John Britton, *Catalogue Raisonné of the Pictures Belonging to the Most Honourable Marquis of Stafford, in the Gallery of Cleveland House*, London 1808, first page, unnumbered.

38 Other accessible collections included those owned by Thomas Hope and Simon Clarke. See *The Picture of London*, London 1806–8. Citation from *Times*, 16 August 1806.

39 George Perry, *A Descriptive Catalogue of the Pictures in the Collection of the Marquis of Stafford in London*, London 1807, p.2.

40 *Cabinet of the Arts*, London 1805, book IV, pp.154–5.

41 *Catalogue of the Works of British Artists Placed in the Gallery of the British Institution*, London 1811, p.11.

42 *Morning Chronicle*, 26 June 1806.

43 *Examiner*, 16 September 1810, p.587.

44 *Catalogue of Pictures by Rubens, Rembrandt, Vandyke and Other Artists of the Flemish and Dutch Schools*, London 1815, p.10.

45 Farington, *Diary*, vol.XII, 25 December 1812 and 8 May 1813, pp.4,271 and 4,346.

46 Anon., *Catalogue Raisonée of the Pictures now Exhibiting at Pall Mall*, London 1815–16, citing the British Institution's own *Catalogue of the Works of British Artists Placed in the Gallery of the British Institution*, London 1811, p.9, but meant here as an attack on the Institution's policies.

47 Prince Hoare, *Annals of the Fine Arts*, II, London 1817, p.173.

48 Noel Desenfans, *A Descriptive Catalogue of Some Pictures of the Different Schools … London 1802*, p.2.

49 *Repository of the Arts*, London 1819, p.107.

50 Louis Simond, *Journal of a Tour and Residence in Great Britain, during the Years 1810 and 1811 by a French Traveller*, London 1815, p.156.

51 *Examiner*, 18 September 1831, and *Times*, 4 May 1826.

'Stolen Hints from celebrated Pictures'

pp.41–55

1 This essay is greatly indebted to the work of Jerrold Ziff, John Gage, Michael Kitson, Selby Whittingham and Cecilia Powell, who have all contributed substantially to the identification of which Old Master pictures Turner studied, as well as clarifying what his engagement with tradition meant to his own art. I am also grateful to my colleague David Solkin for his advice and contributions to this essay.

2 Smith apparently used his drawing to highlight the need for better protection for the works in his care; see Stephen Lloyd and Kim Sloan, *The Intimate Portrait: Drawings, Miniatures and Pastels from Ramsay to Lawrence*, Scottish National Portrait Gallery, Edinburgh 2008, p.161.

3 For specific considerations of this issue, see F. Calvo Serraller et.al., *Picasso: Tradition and Avant-Garde*, Museo del Prado, Madrid, 2006; Wilfried Seipel, Barbara Steffen, Christoph Vitali, *Francis Bacon and the Tradition of Art*, Kunsthistorisches Museum, Vienna 2003.

4 Thomas Phillips, *Lectures on the History and Principles of Painting*, London 1833, p.ix. John Henry Fuseli was Professor of Painting at the Royal Academy from 1799 to 1803, and again from 1810 until his death.

5 Turner's copies of details from Michelangelo's *Last Judgement* (based on engravings) are in a private collection. His copies in oils from Gainsborough and Wilson are B & J, nos.43–5. The sketchbook from the late 1780s and early 1790s in the Princeton Art Museum contains copies after de Loutherbourg, while the 'Wilson' sketchbook (c.1796–7) also includes studies from Vernet (TB XXXVII, 104/105; Tate).

6 Farington, *Diary*, vol.III, 12 November 1798, pp.1089–90.

7 See TB CCCLXXIII–CCCLXXV; see 'Monro School' in Joll et al. 2001, pp.189–90.

8 Of the many works realised by Turner from the sketches of other artists, see, for example, *The Siege of Seringapatam* (watercolour, c.1800, Tate); *The Eruption of the Souffrier Mountains in the Island of St Vincent* (1815, University of Liverpool; B & J, no.132); the two paintings of the Temple at Aegina in Greece (1816, private collections; B & J, nos.133–4); and his watercolour depictions of the Holy Land (c.1832–4; Wilton 1979, nos.1236–63) and India (c.1835; Wilton 1979, nos.1291–7).

9 See TB XXXIII I, and the 'Wilson' sketchbook, TB XXXVII, 78/79, 86/87, 92/93, 98/99, 100/101; all Tate.

10 The 'Dolbadan' sketchbook (TB XLVI, Tate) contains (on f.114a) Turner's copies of Poussin's *Landscape with a Man killed by a Snake* (now National Gallery, London) and (on f.118) the *Exposition of Moses* (now Ashmolean Museum, Oxford); both works were then in the possession of the Welsh baronet Sir Watkin Williams-Wynn. Turner's version of Claude's *Landscape with the Arrival of Aeneas before the City of Pallanteum in Latium* (fig.32) is in the 'Studies for Pictures' sketchbook, TB LXIX, 122, Tate.

11 The 'Jason' sketchbook includes various landscape studies made in the spirit of Dughet, as well as a copy of François Vivares's engraving of Dughet's *Landscape with Horseman* (TB LXI, 1, Tate); see *Gaspard Dughet called Gaspar Poussin 1615–75*, Kenwood House, London 1980, p.51, no.42. Another composition, apparently based on Dughet, occurs in the 'Spithead' sketchbook c.1807, TB C, 44, Tate.

12 For these and other drawings formerly in Turner's collection, see David Blayney Brown and Rosalind Mallord Turner, *Turner's Gallery, House and Library*, Tate Britain, London 2001. See TB CCCLXIX for the drawings by Samuel Scott.

13 See Ziff, '"Backgrounds"', pp.135, 138.

14 'France, Savoy, Piedmont' sketchbook, TB LXXIII, 2 (see David Hill, *Turner in the Alps*, London 1992, p.22, repr.); and 'Studies in the Louvre' sketchbook, TB LXXII; both Tate. These books have now been re-catalogued by David Blayney Brown for the Tate's revision of A.J. Finberg's *Complete Inventory of the Turner Bequest* (1909), which will begin to appear on-line in 2009 (see www.tate.org.uk). See also Jean-Pierre Cuzin and Marie-Anne Dupuy, *Copier Créer. De Turner à Picasso: 300 oeuvres inspirées par les maîtres du Louvre*, Musée du Louvre, Paris 1993, pp.80–82.

15 Guillaume Faroult has kindly confirmed that two of the three pictures Turner attributed to Domenichino were correctly identified in the official catalogues as by Guercino in 1802, but that there was a slight element of doubt about the authorship of Guercino's *Mars and Venus* (a work subsequently returned to Modena, where it is now in the Galleria Estense).

16 'So extraordinary a work' was how Farington described the *Transfiguration*, in his *Diary*, vol.V, 6 September 1802, p.1,832.

17 See especially the entry for 'Mola' in Henry Fuseli (ed.), Rev. Matthew Pilkington, *A Dictionary of Painters from the Revival of the Art to the Present Period. A New Edition*, London 1810, p.333.

18 The issue was raised by Ziff, '"Backgrounds"', pp.129 n.18, 145. But see also Kitson 1983 in Warrell 2002, p.179, for an overview of the opinions on why Turner neglected the Louvre Claudes, as well as Faroult and Solkin (pp.87– 95) in the present volume.

19 See Ziff, '"Backgrounds"', p.128, and Venning 1983, p.45.

20 Venning 1982, p.38. Much the same point was made in the late twentieth century by Francis Bacon: 'In a way, one is continually working and thinking and looking at things which don't have any immediate bearing on what one is trying to do, but they seem to come up again … You make a vast well of images within yourself out of which things keep coming'; from an interview with Bacon by Peter Beard (c.1974), quoted in Margarita Cappock, '"The Chemist's Laboratory":

Francis Bacon's Studio', in *Bacon and the Tradition of Art*, Vienna 2003, p.90.

21 Farington, *Diary*, vol.V, 4 October 1802, p.1,900.

22 The model for the image may have been the well-known self-portrait by George Morland, now in the Castle Museum, Nottingham.

23 For Turner's private criticism of Beaumont, see Ziff, '"Backgrounds"', pp.131–2, n.26. For more recent discussions of the sepia study, see Felicity Owen and David Blayney Brown, *Collector of Genius: A Life of Sir George Beaumont*, New Haven, CT, and London 1988, p.166, and Andrew Wilton and Rosalind Mallord Turner, *Painting and Poetry: Turner's 'Verse Book' and his Work of 1804–1812*, Tate Gallery, London 1990, pp.37–40, 132.

24 The only copies he made directly from Claude during this period were of a batch sold at auction on 2 June 1804 (TB XLVII, 19v; see Warrell 2002, pp.56–7).

25 Ziff, '"Backgrounds"', p.133.

26 See Ziff, '"Backgrounds"', p.135, n.36. See also the letter to Thomas Phillips in January 1818, where Turner requests the loan of the engravings of Titian's *St Peter Martyr* and the Pesaro altarpieces, in Gage, *Correspondence*, p.72.

27 On this issue, see Ziff, '"Backgrounds"', pp.126–7, and Venning 1982, p.36.

28 Ziff, '"Backgrounds"', p.146. Francesco Zuccarelli (1702–1788) was a Venetian painter of rococo landscapes who spent more than fifteen years working in England.

29 Turner encountered Watteau's *Enchanted Isle* in the collection of his friend James Holworthy, and surely would have known that the picture had once belonged to Sir Joshua Reynolds. See Margaret Morgan Grasselli and Pierre Rosenberg, *Watteau 1684–1721*, National Gallery of Art, Washington, 1984, pp.393–5, no.60.

30 B & J, no.140, Tate. Turner seems to have sought out further pictures by Watteau while in Paris in 1821; see Whittingham 1985a, pp.12–13. During the same trip he made a Watteauesque sketch of figures dancing close to a windmill (TB CCLVIII, 19, Tate). This has been identified as a variant of *Une Fête Champêtre. Réjouissance de Soldats* by Jean-Baptiste Pater (see Warrell 1999, p.22), but could perhaps relate to an unknown version of Watteau's *Actors at a Fair*; the principal version is at Schloss Charlottenburg, Berlin.

31 Much of the following discussion of what Turner studied in Rome and Florence is indebted to Powell 1987. See also Nicola Moorby, 'An Italian Treasury: Turner's Sketchbooks', in Hamilton 2009, pp.111–17.

32 See Warrell 2003, p.59, for Turner's copy of Veronese's *Family of Darius* (now National Gallery, London); and Warrell 1999, pp.47, 56, for the French pictures Turner studied in connection with Scott's *Life of Napoleon*.

33 Turner's copies from the works of Titian, Tintoretto and Veronese are noted in Warrell 2003, pp.17, 59–61; for Turner's comment on Tintoretto, see the letter to George Jones, in Gage, *Correspondence*, p.138.

34 For the Uffizi Claude, see 'Rome and Florence' sketchbook, TB CXCI, 60; repr. in Warrell 2002, p.116. Turner's other discoveries are discussed and illustrated in Powell 1987, pp.96–9.

35 See Powell 1987, pp.65–71; and 'Remarks (Italy)' sketchbook, TB CXCIII, 80-81; all reproduced in Warrell 2002, pp.108–13.

36 Turner's sketches for the painting are in his 'Tivoli and Rome' sketchbook, TB CLXXIX. These include his study of Alessandro d'Este's bust of Raphael (f.24; repr. Powell 1987, p.62).

37 See Gage 1969, p.101, and Gage 1987, p.60.

38 See Faroult and Solkin, p.88.

39 See Gage 1969, pp.100–01. The picture was listed as no.311 in the Inventory of Turner's House Contents, and no.30 in the 1874 sale, where it fetched £14. See Appendices 1 and 2.

40 Many of the details of these lists, together with an assessment of their significance, were first presented in Gage 1969, pp.243, n.94, and 244, n.101.

41 The name 'Turner' was widespread, making it difficult to assume that it always refers to the artist. However, it seems possible that both J.M.W. Turner and his father sometimes dabbled in buying and selling paintings. See, for example, the sale of a Van Dyck portrait of Charles I at Christie's, 3 February 1810 (17), apparently from the collection of 'Turner Senior', who could have been William Turner Senior.

42 Monro sale, Christie's, 26 June 1833 (77): The subjects were *Christ disputing with the Doctors* and a *Flight into Egypt*. The latter drawing is in a private collection.

43 Roger Quarm, 'Van de Velde, Abraham Storck and Turner's *Admiral Van Tromp's Barge at the Entrance of the Texel, 1645*', *Turner Society News*, vol.108 (March 2008), pp.9-11. Turner probably acquired the Storck at Christie's, 25 April 1831 (lot 66, 'A View in Amsterdam, with Numerous Figures and Boats'; bt Turner). This sale took place just days before the opening of the Academy exhibition, so Turner had presumably encountered the Storck sometime before, studying its key elements closely in order to be able to reproduce them.

44 See Turner's purchases at the Balmanno sale: Sothebys, 4–11 May 1830, lots 143, 190 (after Titian), 258, 553 (Stothard's *Romeo and Juliet*), 895 (Stothard engravings). Noted in Gage 1987, pp.147 and 251 n.89.

45 See Selby Whittingham, *J.M.W. Turner, R.A.*, no.2, December 1993, p.112.

46 See David Hansen, *John Glover and the Colonial Picturesque*, Tasmanian Museum and Art Gallery, Hobart 2003, p.135. In his one-man exhibitions of the 1820s, Glover juxtaposed his own works with those of Claude and Wilson – a practice that Turner may have had in mind when he drafted his first will in 1829. Glover's Claudes were *The Mill on the Tiber* (1650) and *Landscape with Piping Shepherd* (1667; fig.22), which are now in the Nelson-Atkins Museum of Art, Kansas City.

47 The assessors of Turner's estate referred to Wals as 'geoffride of Naples'. The roundel in the Turner Bequest has also been attributed to Agostino Tassi (c.1580–1644); the House Inventory indicates that this was one of a pair (see appendix, nos.359 and 360 'Do'), but its companion-piece can no longer be traced. Nos.357 and 361 in the Inventory are listed as 'Ruysdael' and 'Claude', but there is nothing to indicate what these pictures may have been, or whether the attributions were indeed correct.

48 See A.J. Finberg, *The Life of J.M.W. Turner*, London 1961, rev.ed., p.265. In the 1830s Turner also offered the Academy a triple portrait of its three Italian founding members – Agostino Carlini, Francesco Bartolozzi and Giovanni Battista Cipriani – by John Francis Rigaud (1742–1810); the picture is now in the National Portrait Gallery, London. See Gage 1987, p.32.

49 Indeed, as late as 1888 the National Gallery's Director, Frederick Burton, was actively acquiring copies of pictures by Velázquez and Rembrandt as study tools for those unable to travel to see the originals; see Jonathan Conlin, *The Nation's Mantelpiece: A History of the National Gallery*, London 2006, p.89.

50 *Bacchus and Ariadne*; B & J, no.382, Tate.

51 Lawrence sale: Christie's, 15 May 1830, nos 99 (Correggio) and 116 (Giorgione).

52 During Turner's second visit to Rome, his Scottish colleague Andrew Geddes made a painted copy of this Titian; see Helen Smailes, *Andrew Geddes: 'A Man of Pure Taste'*, National Galleries of Scotland, Edinburgh, 2001, p.69; see also p.118, n.121. Wilkie recalled Turner praising Geddes's copy of a Veronese (Alan Cunningham, *The Life of David Wilkie*, 3 vols, London 1843, vol.II, p.328).

53 See his note of Gerard ter Borch's *The Parental Admonition* (c.1654, Rijksmuseum, Amsterdam) in the 'Holland' sketchbook, TB CCXIV, 81.

54 See 'Dieppe, Rouen, Paris' sketchbook 1821, TB CCLVIII, 19v-20, 32v, 34; all reproduced in Warrell 2002, pp.117–23; see 'Copenhagen to Dresden' sketchbook 1835, TB CCCVII, 6; repr. ibid., pp.158–9. Cecilia Powell notes that at Dresden Turner strayed from the recommendations of his guidebook in recording these works (see Powell 1995, p.55).

55 All of these copies occur in the 'Copenhagen to Dresden' sketchbook, TB CCCVII, 6-7a, and feature four works by Correggio (*Madonna with St Sebastian, Madonna with St George, Madonna with St Francis* and *The Penitent Magdalen Reading*); Raphael's *Sistine Madonna*; Aert de Gelder's *Christ before Pilate*; Govaert Flinck's *David giving Uriah the Letter*; Ruisdael's *Stag Hunt in a Wood with a Marsh*; and Watteau's *Conversation in a Park*. The Flinck was then attributed to Rembrandt. For Turner's sketching in the Dresden gallery, see Powell 1995, pp.53–5, 116–17.

56 Finberg 1961, p.314; see also Ziff, '"Backgrounds"', p.130.

57 See 'Old London Bridge' sketchbook, TB CCV, 44; and 'Vienna up to Venice' sketchbook, TB CCCXI, inside cover).

58 See the 1828 'Rome to Rimini' sketchbook, TB CLXXVIII, 46a; and Ian Warrell, 'Exploring the "dark side". Ruskin and the Problem of Turner's Erotica: A Checklist of Erotic Sketches in the Turner Bequest', *British Art Journal*, vol.IV, no.1 (Spring 2003), pp.5–46.

59 Hilton's version of Titian's *St Peter Marytr* (no.35). John Scarlett Davis made numerous studies in the Louvre in 1830–31 (see those at Tate, including T10574 of Mola's *Vision of St Bruno*). For Cox, see Scott Wilcox, *Sun, Wind and Rain: The Art of David Cox*, Yale Center for British Art, New Haven, CT, 2008, pp.16–32. For Bonington, see Patrick Noon, *Richard Parkes Bonington,* Yale Center for British Art, New Haven, CT, 1991, p.164, and Matt Cambridge, *Richard Parkes Bonington. Young and Romantic*, Castle Museum, Nottingham 2002, pp.64–71. For Constable's copies of the Claudes belonging to Sir George Beaumont, see Graham Reynolds, *The Later Paintings and Drawings of John Constable*, New Haven, CT, and London 1984, pp.127–8; for the same artist's studies from Ruisdael, see Seymour Slive, *Jacob van Ruisdael: Master of Landscape*, Los Angeles County Museum, Los Angeles, CA, 2005, pp.29–35.

60 Letter from J.J. Ruskin to John Ruskin, 21 February 1842, Ruskin Library, Lancaster. Earlier in the letter Ruskin senior had written, 'I saw in Turner's rooms, Geo.Morlands Wilsons, Claudes, portraits in various styles – all by Turner'. Some of these items may indeed have been by Turner, but Ruskin may have been confused by some of the pictures listed here in Appendix 1.

Turner, Claude and the Essence of Landscape

pp.57–71

1 Gérard de Lairesse, *Groot Schilderboek*, 1707, translated by John Frederick Fritsch as *The Art of Painting in All Its Branches*, London 1778, Book VI, on Landscape, p.203. The Fritsch translation first appeared in 1738. Interestingly, a new edition of *The Art of Painting* appeared in English in 1813. De Lairesse (1640–1711) spent his career in Amsterdam painting history and allegorical subjects.

2 *Ibid.*, p.208.

3 William Hazlitt, 'Pictures at Burleigh House', *New Monthly Magazine*, April 1822, in *The Complete Works of William Hazlitt*, ed. P.P. Howe, 21 vols., London and Toronto 1932, X, p.66.

4 Hazlitt, 'On the Picturesque and Ideal. A Fragment', published in *Table Talk*, London 1821, Essay 32; *Complete Works*, VIII, pp.317–21.

5 Ziff, '"Backgrounds"', p.144.

6 In 1824 Richard Payne Knight acquired an album of nature studies by Claude, which he bequeathed to the British Museum upon his death three months later. Ian Warrell detects their influence on a number of Turner's monochrome pen drawings from c.1824, as well as the series of mezzotints known as the *Little Liber*, c.1824–6. See Warrell 2002, p.176, no.57.

7 Ziff, '"Backgrounds"', p.144.

8 Hazlitt, 'On Genius and Common Sense', published in *Table Talk*, London 1821, *Complete Works*, VIII, p.39.

9 Reynolds, *Discourses*, IV, 1771, pp.65–6.

10 Ziff, '"Backgrounds"', p.144.

11 Reynolds, *Discourses*, XIII, 1786, pp.237–8.

12 Lawrence Gowing, 'Nature and the Ideal in the Art of Claude', *Art Quarterly*, vol.37, no.1, 1974, p.91. Gowing goes so far as to claim that 'So far as landscape painting became, in essence, modern painting, it might even be agreed that [Claude] was, in a profound sense, the founder of the art we know.'

13 The work by Claude that prompted this remark was either *The Father of Psyche Sacrificing at the Temple of Apollo* (fig.2) or *Landscape with the Arrival of Aeneas before the City of Pallanteum in Latium* (fig.32), both of which Turner first saw in 1799. See Farington, *Diary*, vol.IV, 8 May 1799, p.1,219, as well as p.19 in this volume.

14 A comprehensive account of Turner's involvement with Claude can be found in Kitson 1983 in Warrell 2002.

15 Claude's *Liber Veritatis* (*Book of Truth*; now in the British Museum) is a book of composition drawings recording the appearance of most of his paintings from 1635–6 onwards, together with the names of their buyers. Its function was to act as a safeguard against forgeries. Two hundred of the drawings in the *Liber* were reproduced in etching and aquatint by Richard Earlom, and published in two volumes by John Boydell in 1777.

16 Six years later Turner reprised the same basic exercise with an even larger Claudean composition showing an English scene, his *Thomson's Aeolian Harp* of 1809 (B & J, no.86; Manchester City Art Galleries).

17 The sun seen head-on is a motif that Turner studied in nature, as had Claude, rather than an effect he necessarily borrowed. He surely also noted the motif's absence in the landscapes of predecessors like John Wootton and Richard Wilson, and the generalised skies that resulted.

18 [William Henry Pyne], *Repository of Arts*, June 1815, quoted in B&J, p.94. Here Pyne is referring to both *Crossing the Brook* (no.34) and *Dido Building Carthage* (no.94).

19 Hazlitt, 'British Institution (1814)', first published in the *Morning Chronicle*, 5 February 1814, *Complete Works*, XVIII, p.14.

20 Gage, *Correspondence*, pp.118, 120.

21 *Ibid.*, p.75.

22 De Lairesse, *Groot Schilderboek*, p.270. The author, a champion of learned painting, encouraged more of the former.

23 The first scholar to make this observation was John Gage, in Gage 1969, p.143.

Turner Goes Dutch

pp.73–85

1 See, for example, Richard Payne Knight's *The Landscape: A Didactic Poem, in Three Books*, 2nd edn., London 1795, discussed and republished in Gavin Budge (ed.), *Aesthetics and the Picturesque, 1795–1840*, 6 vols., Bristol 2001, vol.I.

2 Charles Westmacott, *British Galleries of Painting and Sculpture, Comprising a General, Historical and Critical Catalogue … of Every Work of Fine Art in the Principal Collections*, London 1824, p.199.

3 Farington, *Diary*, vol.IV, 10 November 1799, p.1,301 (quoting James Northcote). Cf. Joshua Reynolds's otherwise perplexing comment that van de Velde was 'the Raphael of Ship painters': ibid., vol.VII, 27 July 1805, p.2,596.

4 ibid., vol.XI, 28 September 1811, p.4,001. See also 9 November 1811, p.4,028.

5 ibid., vol.IV, 18, 25, 26 and 29 April 1801, pp.1,539, 1,541 and 1,543–4. See also 'Turner and the North' in this volume, pp.143–5.

6 *Star*, 4 May 1801, *Porcupine*, 7 May 1801 and *Monthly Mirror*, June 1801, quoted in B & J, p.12.

7 Bridgewater had acquired van de Velde's painting in 1795: see Michael Robinson, *The Paintings of the Willem Van de Veldes*, 2 vols., National Maritime Museum, London 1990, 2, p.829.

8 See Farington, *Diary*, vol.V, 5 May 1802, p.1,175, where a diagram indicates that the hang included Raphael's *The Virgin and Child* (*The Bridgewater Madonna*) c.1508, Titian's *Diana and Actaeon* and *Diana and Callisto* 1556–9, and five of Poussin's *Seven Sacraments* 1644–7, all (apart from the *Diana and Actaeon*) on loan to the National Gallery of Scotland.

9 Thornbury 1877, p-.283.

10 Farington, *Diary*, vol.VIII, 5 May 1807, p.3,038. See also 7 April 1807, p.3,007.

11 [Robert Hunt,] exhibition review, *Examiner*, 4 June 1809; [John Williams,] 'Anthony Pasquin', exhibition review, *Morning Herald*, 4 May 1809; and *Repository of Arts*, I (1809), p.490. See also [John Landseer,] *Review of Publications of Art*, no.2, 1 June 1808, p.167, for a similar encomium to this painting's pictorial power.

12 [Robert Hunt,] *Examiner*, 4 June 1809, p.367.

13 Although see also *The Unpaid Bill, or the Dentist Reproving his Son's Prodigality* (no.42) commissioned by the connoisseur Richard Payne Knight, most likely as a pendant to *The Holy Family at Night* (no.41), then attributed to Rembrandt and also a star item in the Orleans collection sale.

14 Edward Dayes, 'Instructions for Drawing and Coloring Landscapes', in *The Works of Edward Dayes*, London, 1805, p.292, to which Turner was a published subscriber.

15 'Greenwich' sketchbook, c.1808, TB CII, 19.

16 Advertisement in *Times*, 5 October 1797.

17 Ziff, '"Backgrounds"', p.145.

18 *Dort, or Dordrecht, the Dort Packet-Boat from Rotterdam becalmed* (1818, Yale Center for British Art), *Harbour of Dieppe (Changement de Domicile)* and *Cologne, the Arrival of a Packet Boat. Evening* (RA 1825 and 1826, respectively, both Frick Collection, New York). See also Turner's *Orange-Merchant on the Bar, going to Pieces; Brill Church bearing S.E. by S., Masensluys E. by S.* (1819, Tate), which revives both his interest in the work of van de Velde and his own manner of marine painting of ten years earlier.

19 'The Mirror of Fashion', *Morning Chronicle*, 10 October 1822.

20 See *Morning Chronicle*, 19 May 1824, and *Times*, 3 June 1824.

21 *Times*, 11 May 1827, *Morning Post*, 15 June 1827, *New Monthly Magazine*, vol.iii, 1827, pp.379–80, and *Literary Magnet*, vol.3, 1827, p.334.

22 *La Belle Assemblée; or, Bell's Court and Fashionable Magazine*, 1 June 1830. See also *Sun*, 3 May 1830, and *John Bull*, 10 May 1830.

23 *Morning Chronicle*, 3 May 1830, and *Morning Chronicle*, 19 May 1824. See also *Literary Gazette*, 8 May 1830, p.23, and *John Bull*, 10 May 1830.

24 *John Bull*, 10 May 1830.

25 *Ibid.*, and the *Athenaeum*, 5 June 1830, p.347.

26 James Roberts, *Introductory Lessons, with Familiar Examples in Landscape, for the Use of Those who are Desirous of Gaining some Knowledge of the Art of Painting in Watercolours*, London 1809 edn., quoted in Nicholas Eastaugh et al., *Pigment Compendium: A Dictionary of Historical Pigments*, Butterworth-Heinemann, London and Amsterdam 2004, p.285.

27 *The Morning Chronicle*, 19 May 1824. See Getty Provenance Index © Databases (http://www.getty.edu/research/conducting_research/provenance_index/) for details of *The Jewish Bride*'s sale (as *Jephthah and his Daughter*), 3 May 1828, lot 67. The painting had previously been in the collection of London picture dealer John Smith, whose *A Catalogue Raisonné of the Works of the Most Eminent Dutch, Flemish and French Painters*, London 1834–42, vol.VII, p.145, emphasises its 'astonishing freedom and mastery of hand', and 'prodigality of colour and brilliancy of hues'.

28 See John Constable's apt comment of 1832, adapting John Dryden's poem 'Alexander's Feast; or, the Power of Music', that Turner 'is in the clouds / The lovely Jessica by his side / Sat like a blooming Eastern bride', quoted in B & J, p.187.

29 *La Belle Assemblée; or, Bell's Court and Fashionable Magazine*, 1 June 1830, p.272.

30 *Storm on the Dutch Coast* (c.1670, Louvre, Paris), *Rough Sea with Sailing Vessels* (c.1668, Museo Thyssen-Bornemisza, Madrid), *Rough Sea at a Jetty* (c.1660, no.69) and *Rough Sea* (c.1670, no.98). The first of these paintings had been sketched by Turner on his visit to Paris in 1802; the other three had appeared on the London art market and in private collections during the 1820s.

31 'Studies in the Louvre' sketchbook 1802, TB LXXII, 23.

32 *Examiner*, 1 July 1827, p.404.

33 *Ibid.*

34 See David Blayney Brown, *Augustus Wall Callcott*, exhibition catalogue, Tate Gallery, London 1981, pp.41 and 64–5.

35 See Pieter van der Merwe, *The Spectacular Career of Clarkson Stanfield, 1793–1867: Seaman, Scene-Painter, Royal Academician*, exhibition catalogue, Sunderland Museum and Art Gallery 1979, pp.25 and 93–4.

36 Besides *Fishing Boats with Hucksters* discussed here, see the ten exhibited paintings of seventeenth-century Dutch shipping produced by Turner between 1831 and 1844: *Admiral Van Tromp's Barge at the Entrance of the Texel, 1645* (1831, fig.59); *The Prince of Orange, William*

III, embarked from Holland, and landed at Torbay, November 4th, 1688, after a Stormy Passage (1832, Tate, London); Van Tromp's Shallop, at the Entrance of the Scheldt (1832, Wadsworth Atheneum, Hartford, CT); Helvoetsluys:—the City of Utrecht, 64, going to Sea (1833, no.72); Rotterdam Ferry Boat (1833, National Gallery of Art, Washington, DC); Van Goyen, looking out for a Subject (1833, fig.60); Van Tromp returning after the Battle off the Dogger Bank (1833, Tate, London); Van Tromp, going about to please his Masters, Ships a Sea, getting a Good Wetting (1844, J. Paul Getty Museum, Malibu, CA); Ostend (1844, no.100); and Fishing Boats bringing a Disabled Ship into Port Ruysdael (1844, no.99).

37 See 'huckster, n.', The Oxford English Dictionary, 2nd ed. 1989. OED Online (Oxford University Press), 1 October 2008 <http://dictionary.oed.com/cgi/entry/00181778>.

38 Letter to Thomas Griffith, 1 February 1844, reproduced in Gage, Correspondence, pp.195–6.

39 Literary Gazette, 3 June 1837, p.354.

40 See B & J, p.223, for a contemporary account which hints at Turner's use of watercolour paints while producing this work. Under examination, the paint surface indeed shows some signs that watercolour may have been used, but their prominent location together with the painting's protracted conservation history preclude their further analysis. My thanks to Faye Wrubel, Conservator of Paintings at The Art Institute of Chicago for her kind assistance.

'He said he held it very low'
pp.87–95

1 We would also like to express our gratitude to and regard for Vincent Pomarède, a specialist in French landscape painting of the first half of the nineteenth century; also to Frauke Josenhans and Catherine Sterling, who were good enough to share information with us and to pass on their knowledge of the painter Jean-Victor Bertin. Finally, thanks to Professor Michel Baridon for his meticulous scrutiny of our text and for his suggestions.

2 Jacqueline Guillaud, Maurice Guillaud, Andrew Wilton, David Hill, Nicolas Alfrey, Michael Kitson, Turner in France: Watercolours, Paintings, Drawings, Engravings, Sketchbooks, Paris, Centre Culturel du Marais, 1981. Also Warrell 1999.

3 For more on the importance of the Louvre in 1802 to the growth of Britain's Old Master exhibition culture, see Philippa Simpson's essay in this volume, as well as Francis Haskell, The Ephemeral Museum: Old Master Paintings and the Rise of the Art Exhibition, New Haven, CT, and London 2000, pp.46–81.

4 Farington, Diary, vol.V, 4 October 1802, p.1,900.

5 On late eighteenth- and early nineteenth-century British criticism of French art, see Anne Puetz, 'Foreign Exhibitors and the British School at the Royal Academy, 1768–1823', in Solkin 2001, pp.229–41; see also Kriz 1997, pp.33–56. Interestingly enough, there was at least one French critic who shared Turner's view of Marguerite Gérard's Les Regrets (fig.44), stating that 'This landscape is overworked; everything in it is artificial'. See Revue du salon de l'an X ou examen critique de tous les tableaux qui ont été exposés au Musée, Paris 1802, p.31.

6 Farington, Diary, vol.V, 2 September 1802, p.1,822.

7 Gérard and Vincent were invited to dinner by West on 27 September; Guérin's studio was visited by Flaxman on 7 September; see Farington, Diary, vol.V, 7 September 1802, p.1,836, and 27 September 1802, pp.1,878–9.

8 Farington, Diary, vol.V, 2 September 1802, p.1,821.

9 Ziff 1963, p.319.

10 Pierre-Henri de Valenciennes, Éléments de perspective pratique, à l'usage des artistes suivis de réflexions et conseils à un élève sur la peinture, et particulièrement sur la peinture de paysage. Par P.H. Valenciennes, peintre; de la société philotechnique, de celle libre des sciences et arts de Paris, etc. etc. A Paris, chez l'auteur, au Palais national des sciences et arts, Desenne, libraire, au Palais égalité, no.2, Duprat, libraire pour les mathématiques, quai des Augustins, près le Pont-Neuf, no.71, an VIII, A Paris, chez l'auteur, an VIII [1799–1800].

11 Ziff 1963, p.316.

12 Nicholson 1990, p.54.

13 Farington, Diary, vol.III, 9 April 1797, p.818.

14 Ziff 1963, pp.316, 319.

15 Gage 1969, p.152. The majority of the Claudes then on display were of modest dimensions (on average 1 x 1.3 m), with places in the highest tier reserved for larger works, as can clearly be seen from Maria Cosway's etchings of 1802. Some of the Claudes were very small indeed, such as his Campo Vaccino or View of a Port with the Capitol (56 x 72 cm), which suggests they were hung at the lowest level; this is where they and Claude's Anointing of David by Samuel appear in Benjamin Zix's watercolour of the Marriage Procession of Napoleon and Maria-Louisa of Austria Through the Grande Galerie, 1810, Paris, Musée du Louvre, Department of Graphic Arts, deposited by the Manufacture de Sèvres (INV. M§4, 1832, no.25). Another possibility is that Turner felt that there were enough Claudes in England, and that he knew them sufficiently well, to allow him to concentrate his attention on works by other artists on show in the Louvre.

16 Valenciennes, Éléments, pp.376, 383–4.

17 Ibid., p.385: 'Undoubtedly, to make a name in historical landscape means overcoming great difficulties, but they are not insurmountable. Poussin was the proof.'

18 Ibid., p.380.

19 At the close of the Salon, the French state purchased three of the exhibits, Taunay's Act of Bravery being the only landscape. The other two works were Pierre-Narcisse Guérin's Phaedra and Hippolytus (1802; Musée du Louvre, Paris) and Anne-Louis Girodet's Death of Endymion (1793; Musée du Louvre, Paris).

20 Formerly in the collection of Guy de Aldecoa, Paris, the Bertin painting was sold at Christie's, New York, on 21 October 1997, lot 341. Frauke Josenhans and Catherine Sterling have confirmed the possible identification of this Bertin picture with that exhibited in 1802; although the time of day depicted seems to be late afternoon (as opposed to sunset), the long shadows would indicate that the sun is indeed setting.

Education and Emulation
pp.99–121

1 Edward Dayes, The Works of the Late Edward Dayes, London 1805, p.352.

2 Ziff, '"Backgrounds"', p.141.

3 See Farington, Diary, vol.IV, 9 February 1799, p.1,154.

4 Thornbury, Life of Turner, p.71.

3, 4, 5, 6

1 St James's Chronicle, 20 May 1797, p.4.

7, 8, 9

1 Ziff, '"Backgrounds"', p.141.

2 Henry Fuseli, 'Lecture II – Art of the Moderns', 1801, in Wornum, Lectures, p.403.

10, 11, 12, 13

1 Matthew Pilkington, The Gentleman's and Connoisseur's Dictionary of Painters, 2nd edn., London 1798, p.824.

2 See David H. Solkin, 'Richard Wilson's Variations on a Theme by Gaspard Dughet', Burlington Magazine, vol.CXXIII, no.940, July 1981, pp.410-14.

16, 17, 18

1 Anon., review of Royal Academy 1797, in Victoria and Albert Museum Press Cuttings.

2 Farington, Diary, vol.IV, 9 February 1799, p.1,154.

19, 20, 21

1 Thornbury 1877, p.8.

2 Porcupine, 7 May 1801, quoted in B & J, p.12.

3 Farington, Diary, vol.IV, 25 April 1801, p.1,541; vol.IV, 18 April 1801, p.1,539; vol.VI, 1 April 1804, p.2,287.

The Academy and the Grand Style
pp.123–41

1 Reynolds, Discourses, nos.16, 43, 84, 97, passim.

22, 23

1 Matthew Pilkington, A General Dictionary of Painters, London 1824, p.240.

24, 25, 26

1 For additional discussion of this episode, see David Solkin's and Kathleen Nicholson's introductory essays to this volume; and also Nicholson 1980, pp.679–86.

2 Gage, Correspondence, pp.118, 120.

27, 28

1 Ziff, '"Backgrounds"', p.143.

29, 30

1 John Carr, The Stranger in France, or a tour from Devonshire to Paris (London, 1803) p.108.

2 Studies in the Louvre Sketchbook, TB LXXII, 41a-2.

3 Ziff, '"Backgrounds"', p.144.

4 [Robert Hunt,] Examiner, 30 May 1813, p.348.

31, 32

1 John Britton, Catalogue Raisonné of the Pictures Belonging to the Most Honourable Marquis of Stafford, in the Gallery of Cleveland House, London 1808, p.32.

2 British Press, 9 May 1803, and Monthly Magazine, vol.15, February–July 1803, p.439.

3 Farington, Diary, vol.VI, 2 May 1803, p.2,023.

33, 34

1 [William Henry Pyne,] Repository of the Arts, June 1815, quoted in B & J, p.94.

35, 36, 37, 38

1 Ziff, '"Backgrounds"', p.135.

2 Notes from the Studies in the Louvre Sketchbook, TB LXXII, p.28.

3 Ziff, '"Backgrounds"', p.141.

4 Art Union, June 1849, quoted in B & J, p.114.

Turner and the North

pp.143–67

1 Uvedale Price, *An Essay on the Picturesque, as Compared with the Sublime and the Beautiful*, London 1794, p.284; Richard Payne Knight, *The Landscape, a Didactic Poem. In Three Books. Addressed to Uvedale Price, Esq. by R.P. Knight*, London 1794, p.45n.
2 [Richard Payne Knight,] review of *The Life of Sir Joshua Reynolds*, by James Northcote, in *Edinburgh Review*, vol.23, September 1814, p.285.
3 Uvedale Price, *Essays on the Picturesque*, London 1810, p.xiv.
4 [Robert Hunt,] *Examiner*, 4 June 1809, p.367.
5 Tromp had led the Dutch fleet to notable victories over the navies of both Charles I and Cromwell. His final and fatal defeat at the battle of Scheveningen, in July 1653 – popularly believed to have occurred after he refused to lower his flag in British waters – was widely regarded as Old England's second greatest naval triumph after that over the Spanish Armada. We are grateful to Sarah Monks for this information.
6 Ziff, '"Backgrounds"', p.145.
7 For an excellent discussion of Turner's relationship to Rembrandt, see Kitson 1988, pp.2–19.

39, 40
1 Farington, *Diary*, vol.VIII, 10 June 1807, p.3,064.
2 Louis Simond, *Journal of a Tour and Residence in Great Britain, during the Years 1810 and 1811 by a French Traveller*, London 1815, p.157.
3 [William Henry Pyne,] 'British School of Living Painters: J.M.W. Turner, R.A.', *Arnold's Magazine of the Fine Arts*, ns., vol.I, 1833, pp.316–17, quoted in Gage 1987, p.6.

41, 42
1 John Feltham, *The Picture of London*, London 1806 and following years, p.301, identifies Payne Knight's collection as accessible on application.
2 Farington, *Diary*, vol.VIII, 11 February 1808, p.3,220.
3 Jonathan Richardson, Sr. and Jr., *An Account of Some of the Statues, Bas-reliefs, Drawings and Pictures in Italy, &c.*, London 1722, p.21.
4 *Public Advertiser*, 17 April 1793.
5 *Oracle*, 5 April 1793.
6 [Robert Hunt,] *Examiner*, 15 May 1808, p.316.
7 *Public Ledger*, 6 May 1808.
8 See, for example, *Le Beau Monde*, vol.III, Supplement, 1808, p.350.

43, 44, 45
1 Peter George Patmore, *Beauties of the Dulwich Picture Gallery*, London 1824, p.55.
2 All these quotes come from B & J, pp.186–7.
3 Wilton 1989, pp.14–33.
4 *Examiner*, 22 February 1829, p.116; *Times*, 2 March 1829.
5 *La Belle Assemblée; or, Bell's Court and Fashionable Magazine*, 1 June 1830, p.272.

46, 47
1 Ziff, '"Backgrounds"', p.146.
2 Noel Desenfans, *A Descriptive Catalogue of the Different Schools*, London 1802, pp.140–1.
3 [John Landseer,] 'Mr Turner's Gallery', *Review of Publications of Art*, vol.I, 1808, p.163.
4 *Annals of the Fine Arts*, 1816, p.370, quoted in Kriz 1997, p.120.

48, 49, 50, 51
1 See [Francis Ludlow Holt,] *Bell's Weekly Messenger*, 17 August 1806, p.263.
2 *Sun*, 6 May 1806.
3 For a discussion of this confrontation, see David H. Solkin, 'Crowds and Connoisseurs: Looking at Genre Painting at Somerset House', in Solkin 2001, pp.163–4.
4 'Hastings' sketchbook, TB CXI, 65a, as transcribed in Marks 1981, p.347.

52, 53
1 *Gentleman's Magazine*, vol.92, 1822, p.447; *Edinburgh Magazine and Literary Miscellany*, vol.89, 1822, p.782.
2 *Examiner*, no.746, 12 May 1822, p.301.
3 Presumably the blindfolded figure refers to the blindness of love, as well as to the theme of masquerade that runs through *Twelfth Night*. The wrestling cupids allude to love's struggles, while the Three Graces echo the figures of Olivia and her attendants.
4 As reported by John Ruskin in 1856, in Ruskin, *Works*, XXXV, p.601, quoted in B & J, p.138.
5 William Hazlitt, 'The Dulwich Gallery', *London Magazine*, vol.7, January–June 1823, p.16.

54, 55, 56
1 Reynolds, *Discourses*, VIII, 1778, p.161.
2 Ziff, '"Backgrounds"', p.146.
3 John Britton, *The Fine Arts of the English School*, London 1812, p.23.
4 *Review of Publications of Art*, June 1808, quoted in B & J, p.59.

57, 58, 59
1 *Oracle*, 5 April 1794, p.2.
2 B & J, p.73.
3 Ziff, '"Backgrounds"', p.145.

60, 61, 62
1 *Morning Chronicle*, 4 May 1818.
2 *Annals of the Fine Arts*, vol.3, London 1818, p.297.
3 B & J, p.104, wrongly state that *The Maas at Dordrecht* that was lent to the British Institution in 1815 belonged to the Duke of Bridgewater. Butlin and Joll may have confused this picture with Cuyp's *Prince Frederick Henry at Nijmegen* (but called in the early nineteenth century *The Canal at Dort*), which did belong to Bridgewater, and which Turner would also have known.
4 [William Henry Pyne,] *Repository of Arts*, 1 June 1816, p.358.
5 *New Monthly Magazine*, vol.5, London 1816, p.543.
6 *Examiner*, vol.439, 26 May 1816, p.333.
7 See B & J, p.104.
8 Alexander Chalmers, ed., *General Biographical Dictionary*, vol.19, London 1815, p.434.
9 *Literary Gazette*, vol.2, London 1818, p.299.
10 'T', *Champion*, 24 May 1818, quoted in B & J, p.104.

Painters Painted

pp.169–83

1 There is a growing body of research on this phenomenon: see Francis Haskell, *Past and Present in Art and Taste*, New Haven and London 1987, pp.90–115.
2 John Sunderland, 'John Hamilton Mortimer: His Life and Works', *The Walpole Society*, vol.LII, 1986, p.188, no.140.7, fig.251.

3 A point made by Gerald Finley in 'J.M.W. Turner's *Rome from the Vatican*: A Palimpsest of History?', *Zeitschrift für Kunstgeschichte*, vol.49, no.1, 1986, pp.71–2.
4 For a brief discussion of Claude's *Liber* and its function, see Kathleen Nicholson's essay, p.63 above.
5 B & J, no.245; see Warrell 2003, p.18, fig.5.
6 Quoted in Powell 1987, p.70; for Turner's studies from Tintoretto, see Warrell 2003, pp.17, 58–62.
7 Hugh Honour, *Romanticism*, New York and London 1979, p.95.
8 For Turner's portrait of Poussin (Indianapolis Museum of Art), see Warrell 1999, pp.200–2, fig.181; for his use of Titian's *Bacchus and Ariadne* (1840, Tate; B & J, no.382), see Warrell 2003, pp.63–6.
9 B & J, no.410, Getty Museum, Los Angeles.
10 Bought at the sale of John Jackson (Christie's, 16 July 1831, lot 174). Jackson was in Rome at the same time as Turner in 1811–20.
11 *War. The Exile and the Rock Limpet*, Tate, London (B & J, no.400).

63
1 Turner's sketches for the composition are in the 'Tivoli to Rome' sketchbook, TB CLXXIX, ff.13v–21v, 24, 25v–26 and the 'Rome C. Studies' sketchbook, TB CLXXXIX, f.41, both at Tate; note that the larger sketch includes the bust of Raphael at the end of the arcade, which may have been Turner's stimulus for the presence of the Renaissance artist in his painting. The sculpture is absent in the painting itself. For further discussion of this picture see: B & J, no.228; Finley 1986, pp.55–72; Robert E. McVaugh, 'Turner and Rome, Raphael and Fornarina', *Studies in Romanticism*, no.26, Fall 1987, pp.365–98; Powell 1987, pp.110–17; Maurice Davies, *Turner as Professor: The Artist and Linear Perspective*, exh. cat., Tate Gallery, London 1992, pp.85–90; Finley 1999, pp.114–20; Hamilton 2009.
2 Ingres's first version of this composition, dated 1813, was formerly in the museum at Riga.
3 Turner's depiction of Raphael's designs as free-standing works in their own right may owe something to his familiarity with the artist's celebrated tapestry cartoons (in the Royal Collection, and represented by Thornhill's copies at the Royal Academy) and an assumption that similar preparatory works existed for the images in the loggia. Their inclusion as studies is supported by Turner's title, which describes Raphael 'preparing his pictures for the decoration of the loggia', even though the setting is already complete. But Turner may have wanted to create a sense of continuity, implying a way in which the past lives in the present.
4 The *Portrait of a Woman* (Uffizi, Florence) was thought to depict La Fornarina, and is now attributed to Sebastiano del Piombo. The *Madonna della Sedia* is now to be found at the Palazzo Pitti.
5 For more on Turner's representation of sculpture, see the forthcoming article by Ian Warrell.
6 The preparatory sketch on which the image is based has recently been identified by Nicola Moorby as part of the Tate revision of A.J. Finberg's *Inventory of the Turner Bequest*. See 'St Peter's' sketchbook, TB CLXXXVIII, 45v, Tate.
7 *Literary Gazette*, no.148, 20 November 1819, p.747; Hamilton 2009, pp.52–3.

64, 65

1 See the sketches in the 'Tivoli to Rome' sketchbook which underlie both pictures, TB CLXXIX, 25v–26, Tate. For further discussion see B & J, no.340; Finley 1981; Christopher Rowell, Ian Warrell and David Blayney Brown, *Turner at Petworth*, London 2002, pp.74–5; and Patrick Noon, *Constable to Delacroix: British Art and the French Romantics*, exh. cat., Tate, London 2003, p.146, no.74.

2 B & J, no.338, Tate.

3 Whittingham 1985b, p.34. Turner studied Rubens's *Chapeau de Paille* around 1823–4 (TB CCV, f.44), and in 1833 copied his *Portrait of Hélène Fourment in a Fur Wrap* in Vienna (TB CCCXI, inside cover).

4 See Patrick Noon, *Richard Parkes Bonington*, New Haven and London 2008 (no.410).

5 TB CCXLIV, 20, 23, 29, 102, 103. See Rowell, Warrell and Brown 2002, pp.150–9.

6 See Whittingham 1985b, p.34.

7 See the translation by William Mason, a copy of which Turner owned. He may also have known the heavily annotated copy owned by Sir Joshua Reynolds in the Royal Academy Library.

8 For the history of this picture, see Margaret Morgan Grasselli and Pierre Rosenberg, with Nicole Parmentier, *Watteau: 1684–1721*, National Gallery of Art, Washington 1984, no.73. The final Watteauesque image in Turner's picture, on the cupboard at the back, may be a compressed version of *L'Île enchantée* (fig.18). Turner sketched the composition around the time the picture was acquired from the Reynolds sale by his friend James Holworthy (TB CXLI, 26v–27). Another version of Watteau's painting emerged with a Petworth dealer in the 1970s.

66, 67, 68

1 See B & J, no.349; Warrell 2003, pp.18–19, 48, 105–7; Smiles 2006, p.79; Katharine Baetjer, '"Canaletti Painting": On Turner, Canaletto and Venice', *Metropolitan Museum Journal*, vol.42, 2007, pp.163–72; Ian Warrell, 'The Approach of Night: Turner and La Serenissima', in Martin Schwander (ed.), *Venice: From Canaletto and Turner to Monet*, exh. cat. Beyeler Foundation, Basel 2008, pp.56–67.

2 *Arnold's Magazine*, September 1833, p.501.

3 Warrell 2003, p.48.

4 *Ibid.*, p.106.

5 Gage, *Correspondence*, p.5.

6 B & J, no.501, Tate.

7 See Warrell 2003 pp.187–8.

69, 70

1 See B & J, no.251; Bachrach 1994, vol.2; Hamilton 2003, fig.5.

2 'Studies in the Louvre' sketchbook, TB LXXII, 22a, 23 and 81, Tate.

3 Seymour Slive, *Jacob van Ruisdael*, exh. cat., Royal Academy of Arts, London 2005.

Competing with Contemporaries
pp.185–205

1 My discussion of how landscapes were viewed in the public exhibitions relies heavily on Bermingham 2001 in Solkin 2001, esp. pp.140–1.

2 *Sun*, 21 May 1806, quoted in B & J, p.48.

3 George Dunlop Leslie, *The Inner Life of the Royal Academy with an Account of its Schools and Exhibitions Principally in the Reign of Queen Victoria*, London 1914, p.146; quoted in Rosenthal 2001 in Solkin 2001, p.146.

Presumably Leslie's principal source of information was Charles Robert, his father.

4 The Constable painting in question was *Salisbury Cathedral from the Meadows* (exh. RA 1831; National Gallery, London); for a good recent account of this episode, see Rosenthal, *ibid.*, p.149.

71, 72

1 Charles Robert Leslie, *Autobiographical Recollections*, 2 vols., London 1860, I, pp.202–3.

73, 74

1 Traditionally described as the portrayal of an avalanche, and often confused with the *Avalanche in the Alps* shown at the RA in 1804 (Tate, London), the Petworth picture's correct title and identity have only recently been established by Olivier Lefeuvre in *Philippe-Jacques de Loutherbourg (1740–1812): Vie et Oeuvre*, Ph.D. thesis, 4 vols., University of Paris IV-Sorbonne 2008, vol.2, pp.842–4, cat.no.206.

2 *General Evening Post*, 24–27 April 1784; *Gazetteer and New Daily Advertiser*, 27 April 1784. Both quoted in Anne Puetz, 'Foreign Exhibitors and the British School at the Royal Academy, 1768–1823', in Solkin 2001, p.232. My discussion of de Loutherbourg's contemporary reputation is based on Puetz's excellent essay.

3 David Hill, *Turner in the Alps: The Journey through France and Switzerland in 1802*, London 1992, see p.12 for a map of Turner's route.

4 Farington, *Diary*, vol.V, 4 October 1802, p.1,900.

75, 76, 77

1 Leslie, *Autobiographical Recollections*, I, p.130.

2 *The Bijou Annual* for 1828 is advertised, with a complete list of its illustrations, in the *London Literary Gazette* of 24 November 1827, p.768 – though it is not clear whether the *Annual* was available for purchase before the turn of the year.

3 *Literary Gazette*, 17 May 1828, quoted in B & J, p.152.

78, 79, 80, 81

1 George Jones, 'Recollections of J.M.W. Turner', in Gage, *Correspondence*, p.5.

2 *Examiner*, 10 June 1832, quoted in B & J, p.197.

3 *Library of Fine Arts*, June 1832, quoted in *ibid.*, *idem*.

4 John Ruskin, *Works*, ed. Cook and Wedderburn, VII, London 1905, p.443n, quoted in Gage 1987, p.136.

5 *Revelation* X: 5: 'and the angel which I saw stand upon the sea and upon the earth lifted up his hand to heaven'.

6 For information on Danby's complicated personal life, see the *Oxford Dictionary of National Biography* article by Francis Greenacre at www.oxforddnb.com.

7 *Revelation* XIX: 17–18: 'And I saw an angel standing in the sun; and he cried with a loud voice, saying to all the fowls that fly in the midst of heaven, come and gather yourselves together unto the supper of the great God; That ye may eat the flesh of kings, and the flesh of captains and the flesh of mighty men, and the flesh of horses, and of them that sit on them, both free and bond, both small and great.'

84, 85

1 For a fuller discussion of Turner's relationship with Stanfield and other contemporary British painters of Venetian views, see Warrell 2003, pp.101–17

86, 87

1 *European Magazine*, vol.lxxxi, January 1823, p.55.

2 Frederick Wedmore, *Studies in English Art*, London 1876, I, pp.112–13.

Turner Paints Himself into History
pp.207–23

1 Finberg 1961, p.330: my emphasis.

2 As well as those exhibited here, see B & J nos.238, 293, 296–8, 435–6, 444–9 and Wilton 1989. Some of those pictures previously thought to have connections with Petworth House have recently been linked with East Cowes Castle; see Robert Hoozee (ed.), *British Vision: Observation and Imagination in British Art 1750–1950*, Museum voor Schone Kunsten, Ghent, 2007, pp.325–9.

3 See Ian Warrell, 'Dopo Turner ancora Turner. Indagine sulle origini dello stile maturo dell'artista' in Marco Goldin (ed.), *Turner e gli impressionisti. La grande storia del paesaggio moderno in Europa*, Museo di Santa Giulia, Brescia, 2006, pp.53–63.

4 B & J no.335, pp.188–9.

5 B & J, p.13 and 223–4.

6 John Ruskin, *Modern Painters*, London 1843, I, Pt.II, Sec.I, Ch.VII, in Ruskin's *Works*, 1903, vol.III, p.241.

7 For the ten canvases, see B & J, pp.298–9, nos.509–15, 517–19. The present writer has linked no.517 with *Liber* plate 8, *The Castle above the Meadows*, but it could also be a reworking of the design of the unfinished plate (no.90) based on his painting *Narcissus and Echo* (B&J no.53). See also Joll et al. 2001, pp.169–170.

90, 91, 92

1 'Dieppe, Rouen and Paris' sketchbook, TB CCLVIII, 19v–20, 32v, 34, Tate. See Warrell 2002, pp.117–23.

2 See B&J no.294; Nicholson 1990, pp.111–15; Finley 1999, pp.96–8, 211–4. For further discussion of the *Regulus*, its theme, and its relationship to Claude, see Kathleen Nicholson's essay, pp.70–1.

3 H. Diane Russell, *Claude Lorrain 1600–1682*, National Gallery of Art, Washington, D.C., 1982, pp.133–4, no.23. Turner's appropriation here of a celebrated Claude recalls the pointed use he had made of Claude's *Landscape with Jacob, Laban and his Daughters* in 1814, in the forum of the British Institution (see nos.24 and 25).

4 Charles Lock Eastlake quoted in William T. Whitley, *Art in England: 1821–1837*, Cambridge 1930, p.159.

5 B&J nos. 429–32; the second of these (B&J no.430) is presumed to have been destroyed in the later 1920s.

93, 94

1 See 'Memoir' of George Jones in Gage, *Correspondence*, p.4. For Angerstein and his collection, see Egerton 1998, pp.358–65. It may be that Jones was confusing the Angerstein pictures with the 'Altieri' Claudes, which Turner saw at William Beckford's house in May 1799. See Farington, *Diary*, vol.IV, 8 May 1799, p.1219.

2 For details of Angerstein's three *Seaports* by Claude see Humphrey Wine, *National Gallery Catalogues: The Seventeenth-Century French Paintings*, London 2001, pp.50, 64, 82, 94.

3 See B&J no.131, and Egerton 1998, pp.272–81.

4 Kitson 1983 in Warrell 2002, p.181.

5 See Nicholson 1990, pp.103–10; also Kay Dian Kriz, 'Dido versus the Pirates: Turner's Carthaginian Paintings and the Sublimation of Colonial Desire' in Michael Rosenthal, Christiana Payne and Scott Wilcox, eds., *Prospects for the Nation: Recent Essays in British Landscape, 1751–1880*, New Haven, CT, and London 1997, pp.231–60.

6 Farington, *Diary*, vol.XIII, 5 June 1815, pp.4,637–8.

95, 96, 97

1 See Gillian Forrester, *Turner's 'Drawing Book': The Liber Studiorum*, exh. cat. Tate Gallery, London 1995, pp.48–9.

2 See B&J, no.513, and Shanes 2001, pp.169–70.

3 Ziff, "'Backgrounds'", p.144.

98, 99, 100, 101

1 For Turner's copy of the Ruisdael landscape in the Louvre, see TB LXXII, 22v, 81; and for that of the *Stag Hunt in a Wood with a Marsh at Dresden*, see TB CCCVII, 6; both Tate.

2 The two compositions are not only roughly similar, but it is also clear that Turner was still in the process of resolving the descriptive and topographical detail for his three 1844 seascapes as he was beginning to negotiate the sale of the earlier *Port Ruysdael* to Elhanan Bicknell by 27 March 1844 Ruskin reported that Bicknell had just bought six Turners (*The Diaries of John Ruskin*, eds. Joan Evans and John Howard Whitehouse, Oxford 1956, vol.I, p.270). For these see Shanes 2001, pp.24–5.

3 Bachrach 1994, p.61.

4 Ruskin, *Diaries*, loc. cit., I, 29 April 1844, pp.273–4.

5 Letter from Ruskin to B.G. Windus, 10 May 1844, quoted in Selby Whittingham, *J.M.W. Turner, R.A.* no.2, 1993, p.102.

6 See B & J, p.247; note that Rev. William Kingsley stresses that his account is only an approximation, or 'nearly [Turner's own] words'. See also Turner's cryptic reference to the picture on 29 April 1844 in a meeting with John Ruskin, referred to in note 4 above.

7 Quoted in Seymour Slive, *Jacob van Ruisdael: Master of Landscape*, New Haven, CT, and London 2005, p.224.

102, 103

1 See B&J no.69; Egerton 1998, pp.266–71; and Paul Spencer-Longhurst, *The Sun Rising Through Vapour: Turner's Early Seascapes*, Barber Institute, Birmingham 2003, p.37.

2 The origins of *Sun rising through Vapour* can be found in the 'Calais Pier' sketchbook, TB LXXXI, where the sketches for its composition are intermingled with those for the more overtly classical watercolour of the *Lake of Geneva, with Mont Blanc* (Yale Center for British Art, Paul Mellon Collection). Common to both are the precise forms of boats, as well as the underlying structure of a spit of land with a sharply tapering bay. Evolving simultaneously, at exactly the moment when Turner might have seen Angerstein's newly-acquired Claude *Seaport* compositions (including no.93), the studies provide evidence of the ways in which Turner assimilated his Old Master sources.

3 See Egerton 1998, p.269.

4 For Turner's copy of Ruisdael's picture, and his critical assessment of it, see 'Studies in the Louvre' sketchbook, TB LXXII, 22v, 81, Tate.

5 See Getty Provenance database: www.getty.edu/research/conducting_research/provenance_index/

6 Turner subsequently painted a watercolour view of the family's estate at Aske Hall, near Richmond, Yorkshire. See Eric Shanes, *Turner's England 1810–38*, London 1990, p.81, plate 57.

7 Farington, *Diary*, VIII, 7 April 1807, p.3,007.

8 William Carey, *A Descriptive Catalogue of Paintings by British Artists in the Possession of Sir John Fleming Leicester, Bart*, London 1819, p.23. Turner owned a copy of this catalogue.

Appendix 1

Inventory or schedule of pictures and drawings assumed to be by artists other than J.M.W. Turner found in his home, dated 21st June 1854 National Gallery Archive: nos.1–310 are works by Turner now at Tate). Compiled and annotated by Ian Warrell.

Appendix 2

Sale of paintings by other artists from Turner's collection: Christie's 25 July 1874 (amount fetched in brackets). Discussion by John Gage in his 1969 book (p.243 fn.94 and p.244, fn.101). Compiled and annotated by Ian Warrell.

Select Bibliography

B&J: Martin Butlin and Evelyn Joll, *The Paintings of J.M.W. Turner*, 2 vols., New Haven, CT, and London 1977, revised 2nd ed. 1984

Bachrach 1981: A.G.H. Bachrach, 'Turner, Ruisdael and the Dutch', *Turner Studies*, vol.I, no.I, 1981, pp.19–30

Bachrach 1994: Fred G.H. Bachrach, *Turner's Holland*, Tate Gallery, London 1994

Bermingham 2001: Ann Bermingham, 'Landscape-O-Rama: The Exhibition Landscape at Somerset House and the Rise of Popular Landscape Entertainments', in Solkin 2001, pp.127–43

Egerton 1998: Judy Egerton, *National Gallery Catalogues: The British School*, London 1998

Farington, *Diary: The Diary of Joseph Farington*, I–VI, eds. Kenneth Garlick and Angus Macintyre; VII–XVI, ed. Kathryn Cave, index by Evelyn Newby, New Haven, CT, and London 1978–98

Finberg 1909: A.J. Finberg, *A Complete Inventory of the Drawings of the Turner Bequest: With which Are Included the Twenty-three Drawings Bequeathed by Mr Henry Vaughan*, 2 vols., London 1909

Finley 1981: Gerald Finley, '*Ars Longa, Vita Brevis*: the *Watteau Study* and *Lord Percy* by J.M.W. Turner', *Journal of the Warburg and Courtauld Institutes*, vol.44, 1981, pp.241–7

Finley 1999: Gerald Finley, *Angel in the Sun: Turner's Vision of History*, Montreal 1999

Gage 1969: John Gage, *Colour in Turner: Poetry and Truth*, London 1969

Gage 1974: John Gage, 'Turner and Stourhead: the Making of a Classicist?', *Art Quarterly*, vol.37, 1974, pp.59–87

Gage, *Correspondence*: John Gage, ed., *The Collected Correspondence of J.M.W. Turner: With an Early Diary and a Memoir by George Jones*, Oxford 1980

Gage 1987: John Gage, *J.M.W. Turner: 'A Wonderful Range of Mind'*, New Haven, CT, and London 1987

Gowing 1966: Lawrence Gowing, 'Turner and the Use of the Past', *Art and Literature*, vol.9, Summer 1986, pp.82–90

Hamerton 1879: Philip Gilbert Hamerton, *The Life of J.M.W. Turner, R.A.*, London 1879

Hamilton 2009: J. Hamilton, *Turner & Italy*, National Galleries of Scotland 2009

Joll et al. 2001: Evelyn Joll, Martin, Butlin and Luke Hermann(eds.), *The Oxford Companion to J.M.W. Turner*, Oxford 2001

Kitson 1983: Michael Kitson, 'Turner and Claude', *Turner Studies*, vol.2, no.2, Winter 1983, pp. 2–15; reprinted in Warrell 2002, pp.176–84

Kitson 1988: Michael Kitson, 'Turner and Rembrandt', *Turner Studies*, vol.8, no.I, 1988, pp.2–19

Kriz 1997 Kay Dian Kriz, *The Idea of the English Landscape Painter: Genius as Alibi in the Early Nineteenth Century*, New Haven, CT, and London 1997

Marks 1981: Arthur S. Marks, 'Rivalry at the Royal Academy: Wilkie, Turner and Bird', *Studies in Romanticism*, vol.20, 1981, pp.333–62

McCoubrey 1984: John McCoubrey, 'War and Peace in 1842: Turner, Haydon and Wilkie', *Turner Studies*, vol.4, no.2, 1984, pp.2–7

Munsterberg 1983: Marjorie Munsterberg, *The Image of the Artist: J.M.W. Turner, 1800–1819*, unpubl. Ph.D, Columbia University, New York 1983

Nicholson 1980: Kathleen Nicholson, 'Turner's "Appulia in Search of Appullus" and the Dialectics of Landscape Tradition', *Burlington Magazine*, vol.120, 1980, pp.679–86

Nicholson 1990: Kathleen Nicholson, *Turner's Classical Landscapes: Myth and Meaning*, Princeton, NJ, and Oxford 1990

Powell 1987: Cecilia Powell, *Turner in the South: Rome, Naples, Florence*, New Haven, CT, and London 1987

Powell 1995: Cecilia Powell, *Turner in Germany*, exh. cat., Tate Gallery, London 1995

Rawlinson 1906: W.G. Rawlinson, *Turner's 'Liber Studiorum': A Description and a Catalogue*, 2nd ed., London 1906

Reynolds, *Discourses*: Sir Joshua Reynolds, *Discourses on Art*, ed. Robert R. Wark, New Haven, CT, and London 1975

Rosenthal 2001: Michael Rosenthal, 'Turner Fires a Gun', in Solkin 2001, pp.144–55

Ruskin *Works*: E.T. Cook and Alexander Wedderburn, eds., *The Works of John Ruskin*, Library Edition, 39 vols., London 1903–12

Smiles 1990: Sam Smiles, ' "Splashers", "Scrawlers" and "Plasterers": British Landscape Painting and the Language of Criticism, 1800–40', *Turner Studies*, vol.10, no.I, 1990, pp.5–11

Smiles 2006: Sam Smiles, *The Turner Book*, London 2006

Solkin 2001: David H. Solkin, ed., *Art on The Line: The Royal Academy Exhibitions at Somerset House 1780–1836*, New Haven, CT, and London 2001

Thornbury 1877: Walter Thornbury, *The Life of J.M.W. Turner, R.A.*, London 1877

Venning 1982: 'Turner's Annotated Books: Opie's *Lectures on Painting* and Shee's *Elements of Art* (I)', *Turner Studies*, vol.2, no.I, 1982, pp.36–46

Venning 1983: 'Turner's Annotated Books: Opie's *Lectures on Painting* and Shee's *Elements of Art* (II)', *Turner Studies*, vol.2, no.2, 1983, pp.40–9

Warrell 1999: Ian Warrell, *Turner on the Seine*, exh. cat., Tate Gallery, London 1999

Warrell 2002: Ian Warrell, *Turner et le Lorrain*, exh.cat., Nancy 2002

Warrell 2003: Ian Warrell, *Turner and Venice*, exh.cat., Tate, London 2003

Whittingham 1985a: Selby Whittingham, 'What You Will; or Some Notes Regarding the Influence of Watteau on Turner and other British Artists (I)', *Turner Studies*, vol.5, no.I, 1985, pp.2–24

Whittingham 1985b: Selby Whittingham, 'What You Will; or Some Notes Regarding the Influence of Watteau on Turner and other British Artists (2)', *Turner Studies*, vol.5, no.2, 1985, pp.28–48

Wilton 1979: Andrew Wilton, *J.M.W. Turner - His Art and Life*, New York 1979

Wilton 1989: Andrew Wilton, 'The "Keepsake" Convention: *Jessica* and Some Related Pictures', *Turner Studies*, vol.9, no.2, 1989, pp.14–33

Wilton 2006: Andrew Wilton, *Turner as Draughtsman*, Aldershot 2006

Wornum, *Lectures*: Ralph Wornum, ed., *Lectures on Painting, of the Royal Academicians. Barry, Opie and Fuseli*, London 1848

Ziff 1963: Jerrold Ziff, 'Turner and Poussin', *Burlington Magazine*, vol.105, 1963, pp.315–21

Ziff, ' "Backgrounds" ': Jerrold Ziff, ' "Backgrounds: Introduction of Architecture and Landscape": A Lecture by J.M.W. Turner', *Journal of the Warburg and Courtauld Institutes*, vol.26, 1963, pp.124–47

Exhibited Works

Only works exhibited at Tate Britain, London, are listed here. Catalogue plate numbers are given at the end of each entry. Unless stated otherwise, works by Turner from the Tate Collection were accepted by the nation as part of the Turner Bequest 1856.

Richard Parkes Bonington (1802–1828)

French Coast with Fishermen
exh. BI 1826
Oil on canvas, 64.3 x 96.7
Tate. Purchased with assistance from the Heritage Lottery Fund, The Art Fund and Tate Members 2004
82

François 1er, Charles Quint and the Duchesse d'Étampes c.1827
Oil on canvas, 35 x 27
Musée du Louvre, Paris
65

Giovanni Antonio Canal, known as Canaletto (1697–1768)

The Bacino di San Marco on Ascension Day c.1733–4
Oil on canvas, 76.8 x 125.4
Her Majesty The Queen
66

Jan van de Cappelle (1624/6-1679)

A Calm 1654
Oil on canvas, 110 x 148.2
The National Museums & Galleries of Wales
102

Claude Gellée, known as Claude Lorrain (c.1604/5–1682)

Seaport at Sunset 1639
Oil on canvas, 103 x 135
Musée du Louvre, Paris
90

Landscape with Moses Saved from the Waters 1639
Oil on canvas, 209 x 138
Museo Nacional del Prado, Madrid
33

Pastoral Landscape with the Arch of Titus 1644
Oil on canvas, 102 x 136
Private collection
95

Seaport with the Embarkation of the Queen of Sheba 1648
Oil on canvas, 149.1 x 196.7
The National Gallery, London. Bought 1824
93

Landscape with Jacob, Laban and his Daughters 1654
Oil on canvas, 143.5 x 251.5
Petworth House, The Egremont Collection (The National Trust). Acquired in lieu of tax by HM Treasury in 1957 and subsequently transferred to the National Trust
24

John Constable (1775–1837)

The Opening of Waterloo Bridge ('Whitehall Stairs, June 18th 1817')
exh. RA 1832
Oil on canvas, 130.8 x 218
Tate. Purchased with assistance from the National Heritage Memorial Fund, the Clore Foundation, The Art Fund, the Friends of the Tate Gallery and others 1987
71

Aelbert Cuyp (1620–1691)

A Herdsman with Five Cows by a River c.1650–5
Oil on panel, 45.4 x 74
The National Gallery, London. Bought 1871
46

Francis Danby (1793–1861)

Subject from 'Revelations'
exh. RA 1829
Oil on canvas, 61.5 x 77.8
Rosenblum family
80

Thomas Girtin and J.M.W. Turner after John Robert Cozens (1752-1797)

Angera, Lake Maggiore c.1796
Watercolour, 15.6 x 25.5
Tate
D36568, TB CCCLXXVI 9
16

Abraham-Louis-Rodolphe Ducros (1748–1810)

The Stables of the Villa of Maecenas at Tivoli c.1786–7
Watercolour and gouache, 74.9 x 107.9
Stourhead, The Hoare Collection (The National Trust)
5

Gaspard Dughet (1615–1675)

Ideal Landscape c.1658–60
Oil on canvas, 93.6 x 133
Lent by Culture and Sport Glasgow on behalf of Glasgow City Council. Bequeathed by Mrs John Graham-Gilbert, 1877
10

Thomas Gainsborough (1727–1788)

Boy driving cows near a pool 1786
Oil on canvas, 58.4 x 76.2
Tate. Presented by Robert Vernon 1847
56

Thomas Girtin (1775–1802)

Lindisfarne Castle, Holy Island, Northumberland c.1797
Watercolour on rough cartridge paper, 38.1 x 52
Metropolitan Museum of Art, New York, Rogers Fund, 1906
17

The White House at Chelsea 1800
Watercolour, 29.8 x 51.4
Tate. Bequeathed by Mrs Ada Montefiore, 1933
86

William Hilton (1786–1839) after Titian (c.1490–1576)

The Death of St. Peter Martyr c.1826, after original of 1530
Oil on canvas, 109.5 x 76
The Collection: Art and Archaeology in Lincolnshire (Usher Art Gallery)
35

Richard Colt Hoare (1758–1838)

The Lake of Avernus, & Temple on its Banks. The Promontory of Misenum & the Castle of Baiae. Part of the Monte Nuovo 1790
Pen and wash, 37.8 x 53.1
Stourhead, The Hoare Collection (The National Trust)
11

George Jones (1786–1869)

The Burning Fiery Furnace exh. RA 1832
Oil on mahogany panel, 90.2 x 60.8
Tate. Presented by Robert Vernon 1847
79

Philip James de Loutherbourg (1740–1812)

The Glorious First of June, 1794 1795
Oil on canvas, 266.5 x 373.5
National Maritime Museum, London. Greenwich Hospital Collection
88

A Waterspout in the Mountains of Switzerland exh. RA 1809
Oil on canvas, 106.7 x 157.5
Petworth House, The Egremont Collection. Acquired in lieu of tax by HM Treasury in 1957 and subsequently transferred to the National Trust
73

Pier Francesco Mola (1612–1666)

The Vision of St. Bruno c.1660
Oil on canvas, 94 x 70
Musée du Louvre, Paris
38

Gilbert Stuart Newton (1794–1835)

Dutch Girl ('The Window')
exh. BI 1829
Oil on mahogany, 37.1 x 27
Tate. Presented by Robert Vernon 1847
45

Giovanni Battista Piranesi (1720–1778)

Interior View of the Villa of Maecenas at Tivoli 1764
Etching, 47.5 x 62.1
The British Museum, London
3

Nicolas Poussin (1594–1665)

Landscape with a Roman Road late seventeenth century (?), after original c.1648
Oil on canvas, 79.3 x 100
By Permission of the Trustees of Dulwich Picture Gallery, London
27

Winter, or The Deluge 1660–4
Oil on canvas, 118 x 160
Musée du Louvre, Paris
29

Salvator Rosa (1615–1673)

Landscape with Hermit c.1662
Oil on canvas, 75.8 x 75.5
Walker Art Gallery, National Museums, Liverpool
22

Rembrandt Harmensz. van Rijn (1606–1669)

Girl at a Window 1645
Oil on canvas, 81.6 x 66
Dulwich Picture Gallery, London
43

The Holy Family at Night (The Cradle) c.1642–8
Oil on panel, 66.5 x 78
Rijksmuseum, Amsterdam
41

Christ and the Woman Taken in Adultery 1644
Oil on panel, 83.8 x 65.4
The National Gallery, London. Bought 1824
39

The Mill 1645–8
Oil on canvas, 87.6 x 105.6
National Gallery of Art, Washington. Widener Collection 1942
58

Landscape with the Rest on the Flight into Egypt 1647
Oil on panel, 38 x 48
National Gallery of Ireland, Dublin
8

Peter Paul Rubens (1577–1740)
Landscape by Moonlight 1635–40
Oil on panel, 64 x 90
The Samuel Courtauld Trust
The Courtauld Gallery, London
54

Jacob van Ruisdael (1628/9–1682)

Rough Sea at a Jetty c.1652–5
Oil on canvas, 98.5 x 131.4
Kimbell Art Museum, Fort Worth, Texas
69

Rough Sea c.1670
Oil on canvas, 107 x 125.8
Boston Museum of Fine Arts. William Francis Warden Fund
98

Paul Sandby
(1725–1809) after
Pietro Fabris
(fl. c.1740–1784)

Part of Naples, with the
Ruined Tower of St. Vincent
published 1778
Etching and aquatint, 35.3 x 53.8
The British Museum, London
1

Clarkson Stanfield
(1793–1867)

Venice from the Dogana exh. RA
1833
Oil on canvas, 130 x 165.4
The Trustees of the Bowood
Collection
84

Thomas Stothard
(1755–1834)

Sans Souci exh. RA 1817
Oil on panel, 80 x 52
Tate. Bequeathed by Henry
Vaughan 1900
76

David Teniers the
Younger (1610–1690)

Two Men Playing Cards in the
Kitchen of an Inn c.1635–40
Oil on oak panel, 55.5 x 76.5
The National Gallery, London.
Salting Bequest 1910
50

Titian (c.1490–1576)
and workshop

The Virgin and Child in a
Landscape with Tobias and the
Angel 1535–40
Oil on panel, 85.2 x 120.3
Her Majesty the Queen
31

J.M.W. Turner, after
Sandby after Fabris

The Ruined Tower of St. Vincent
c.1792
Bodycolour, pencil and
watercolour, 20.2 x 25.3
Tate
D00005, TB I E
2

J.M.W. Turner

Windmill on Hill: Valley and
Winding River in Middle
Distance; Sunset Effect c.1795
Pencil and watercolour on paper,
19 x 27.7
Tate
D00670, TB XXVII I
57

Moonlight, a Study at Millbank
exh. RA 1797
Oil on panel, 31.5 x 40.5
Tate
N00459; B&J 2
7

Limekiln at Coalbrookdale c.1797
Oil on panel, 28.9 x 40.3
Yale Center for British Art,
Paul Mellon Collection
B&J 22
9

The Transept of Ewenny Priory,
Glamorganshire exh. RA 1797
Watercolour, scraping out and
pencil, 40 x 55.9
National Museum of Wales,
Cardiff
W 227
4

The Interior of Durham Cathedral,
Looking East along the South Aisle
c.1798
Pencil, watercolour and gouache,
75.8 x 58
Tate
D01101, TB XXXVI G
6

Aeneas and the Sibyl,
Lake Avernus c.1798
Oil on canvas, 76.5 x 98.4
Tate
N00463; B&J 34
13

Harlech Castle, from Twgwyn
Ferry, Summer's Evening Twilight
exh. RA 1799
Oil on canvas, 87 x 119.4
Yale Center for British Art, Paul
Mellon Collection
B&J 9
15

Warkworth Castle,
Northumberland – Thunder
Storm Approaching at Sunset
exh. RA 1799
Watercolour, 50.8 x 75
Victoria and Albert Museum,
London. Ellison Gift
W 256 / 742
18

Dolbadern Castle,
North Wales exh. RA 1800
Oil on canvas, 119.4 x 90.2
Royal Academy of Arts, London
B&J 12
23

Dutch Boats in a Gale: Fishermen
Endeavouring to Put their Fish on
Board (the Bridgewater Sea-Piece)
exh. RA 1801
Oil on canvas, 162.5 x 222
Private collection, on loan to
the National Gallery, London
B&J 14
20

Châteaux de St. Michael,
Bonneville, Savoy exh. RA 1803
Oil on canvas, 91.4 x 121.9
Yale Center for British Art,
Paul Mellon Collection
B&J 50
28

Holy Family exh. RA 1803
Oil on canvas, 102.2 x 141.6
Tate
N00473; B&J 49
32

Venus and Adonis c.1803–4,
exh. RA 1849
Oil on canvas, 149.9 x119.4
Stanley Moss, Riverdale, New York
B&J 150
36

The Deluge exh. Turner's gallery
1805(?) and RA 1813
Oil on canvas, 142.9 x 235.6
Tate
N00493; B&J 55
30

Abingdon exh. Turner's gallery
1806(?)
Oil on canvas, 101.6 x 130.2
Tate
N00485; B&J 107
47

A Country Blacksmith disputing
upon the Price of Iron, and the
Price Charged to the Butcher for
shoeing his Poney exh. RA 1807
Oil on pine panel, 54.9 x 77.8
Tate
N00478; B&J 68
49

Woman and Tambourine 1807
Etching and mezzotint,
18.4 x 26.7
Tate. Presented by A. Acland
Allen through The Art Fund 1925
Liber Studiorium plate 3
97

Sun rising through Vapour:
Fishermen cleaning and
selling Fish exh. RA 1807
Oil on canvas, 134 x 179.5
National Gallery, London.
Turner Bequest, 1856
B&J 69
103

The Unpaid Bill, or *The Dentist*
reproving his Son's Prodigality exh.
RA 1808
Oil on panel, 59.4 x 80
The Schindler Family
B&J 81
42

The Forest of Bere exh.
Turner's gallery 1808
Oil on canvas, 89 x 119.5
Tate. Accepted by HM
Government in lieu of tax and
allocated to the Tate Gallery 1984.
In situ at Petworth House
T03875; B&J 77
55

The Fall of an Avalanche in the
Grisons exh. Turner's gallery 1810
Oil on canvas, 90.2 x 120
Tate
N00489; B&J 109
74

Windmill and Lock 1811
Etching and mezzotint, 17.8 x
25.9
Tate. Presented by A. Acland
Allen through The Art Fund 1925
Liber Studiorum plate 27
59

Crossing the Brook exh. RA 1815
Oil on canvas, 193 x 165.1
Tate
N00497; B&J 130
34

Dido building Carthage; or the
Rise of the Carthaginian Empire
exh. RA 1815
Oil on canvas, 155.5 x 230
National Gallery, London.
Turner Bequest, 1856
B&J 131
94

Rome, from the Vatican. Raffaelle,
Accompanied by La Fornarina,
Preparing his Pictures for the
Decoration of the Loggia exh.
RA 1820
Oil on canvas, 177.2 x 335.3
Tate
N00503; B&J 228
63

What you Will! exh. RA 1822
Oil on canvas, 48.2 x 52
Sterling and Francine Clark
Institute, Williamstown,
Massachusetts, USA. Gift of the
Manton Art Foundation in
memory of Sir Edwin and Lady
Manton
B&J 229
53

The Battle of Trafalgar,
21 October 1805 1823–4
Oil on canvas, 261.5 x 368.5
National Maritime Museum,
London. Greenwich Hospital
Collection
B&J 252
89

Port Ruysdael exh. RA 1827
Oil on canvas, 92.1 x 122.6
Yale Center for British Art,
Paul Mellon Collection
B&J 237
70

Boccaccio relating the Tale of
the Bird-Cage exh. RA 1828
Oil on canvas, 121.9 x 89.9
Tate
N00507; B&J 244
77

Palestrina – Composition 1828;
exh. RA 1830
Oil on canvas, 140.3 x 248.9
Tate. Bequeathed by
C.W. Dyson Perrins 1958
N06283; B&J 295
26

Regulus exh. Rome 1828,
reworked, exh. BI 1837
Oil on canvas, 89.5 x 123.8
Tate
N00519; B&J 294
91

Pilate Washing his Hands
exh. RA 1830
Oil on canvas, 91.4 x 121.9
Tate
N00510; B&J 332
40

Jessica exh. RA 1830
Oil on canvas, 122 x 91.5
Tate. Accepted by HM
Government in lieu of tax and
allocated to the Tate Gallery 1984.
In situ at Petworth House
T03887; B&J 333
44

Calais Sands, Low Water, Poissards
Collecting Bait exh. RA 1830
Oil on canvas, 73 x 107
Bury Art Gallery, Museum &
Archives
B&J 334
83

Watteau Study by Fresnoy's Rules
exh. RA 1831
Oil on oak panel, 40 x 69.2
Tate
N00514; B&J 340
64

Helvoetsluys; — the City of Utrecht,
64, going to Sea exh. RA 1832
Oil on canvas, 91.4 x 122
Fuji Art Museum, Tokyo
B&J 345
72

Shadrach, Meshech and
Abednego in the Burning Fiery
Furnace exh. RA 1832
Oil on mahogany panel,
91.8 x 70.8
Tate
N00517; B&J 346
79

Bridge of Sighs, Ducal Palace
and Custom House, Venice:
Canaletti painting exh. RA 1833
Oil on mahogany, 51.1 x 81.6
Tate. Presented by Robert Vernon
1847
N00370; B&J 349
67

The Battle of Trafalgar, — — (see above)

Venice from the Porch of the
Madonna della Salute exh. RA
1835
Oil on canvas, 91.4 x 122.2
Metropolitan Museum of Art,
New York. Bequest of Cornelius
Vanderbilt, 1899
B&J 362
85

Depositing of John Bellini's Three
Pictures in La Chiesa Redentore,
Venice exh. RA 1841
Oil on canvas, 73.6 x 115.5
Private Collection
B&J 393
68

Snow Storm – Steam-Boat off a
Harbour's Mouth making Signals
in Shallow Water, and going by the
Lead. The Author was in this
Storm on the Night the Ariel left
Harwich exh. RA 1842
Oil on canvas, 91.4 x 121.9
Tate
N00530; B&J 398
101

Fishing Boats bringing a
Disabled Ship into Port
Ruysdael exh. RA 1844
Oil on canvas, 91.4 x 123.2
Tate
N00536; B&J 408
99

Landscape: Woman with
Tambourine c.1845
Oil on canvas, 88.5 x 118
Tochigi Prefectural Museum
of Fine Arts, Japan
B&J 513
96

The Angel Standing
in the Sun exh. RA 1846
Oil on canvas, 78.7 x 78.7
Tate
N00550; B&J 425
81

The Lauerzersee with the Mythens
c.1848
Pen and watercolour, 36.8 x 54
Victoria and Albert Museum,
London: Henry Vaughan
Bequest
W 1562
87

Mercury sent to Admonish
Aeneas exh. RA 1850
Oil on canvas, 90.2 x 120.6
Tate
N00553; B&J 429
92

Willem van de Velde
the Younger
(1633–1707)

A Rising Gale c.1672
Oil on canvas, 132.2 x 191.9
Lent by the Toledo Museum of
Art. Purchased with funds from
the Libbey endowment, gift of
Edward Drummond Libbey
19

Paolo Veronese
(1528–1588)

The Finding of Moses c.1570–75
Oil on canvas, 58 x 44.5
Museo Nacional del Prado,
Madrid
37

Jean Antoine Watteau
(1684–1721)

Gathering near the Fountain
of Neptune c.1712
Oil on canvas, 48 x 56
Museo Nacional del Prado,
Madrid
52

Fêtes Vénitiennes c.1718
Oil on canvas, 55.9 x 45.7
National Galleries of Scotland,
Edinburgh
75

David Wilkie
(1785–1841)

Village Politicians exh. RA 1806
Oil on canvas, 57.2 x 74.9
By kind permission of The Earl
of Mansfield and Mansfield,
Scone Palace, Scotland
48

The Blind Fiddler exh. RA 1807
Oil on mahogany panel,
57.8 x 79.4
Tate. Presented by Sir George
Beaumont Bt 1826
51

Richard Wilson
(1713?–1782)

Lake of Nemi, or Speculum
Dianae Probably 1758
Oil on canvas, 75.6 x 97.2
Trustees of the Hoare Family,
on loan to the National Trust,
Stourhead
12

Pembroke Town and Castle
c.1765–6
Oil on canvas, 101.6 x 127
National Museum of Wales,
Cardiff
14

Figure Illustrations

3 B&J 13
12 TB XLVI 118
14 TB LXXII 17
15 TB CXXI B
16 TB XC 38a
17 TB CXLI 26a
19 B&J 140
26 Liber Studiorum (plate 13)
27 TB CCLVIII 32a
28 B&J 47
33 B&J 62
34 B&J 80
35 B&J 101
37 B&J 238
41 B&J 271
43 B&J 372
53 D00392, TB XXIII R
56 B&J 11

Lenders and Credits

Index

Page numbers in *italic type* refer to illustrated details.
Works by Turner are listed under the title of the work.
Works by other artists are listed under the artist's name.

Supporting Tate

Tate relies on a large number of supporters – individuals, foundations, companies and public sector sources – to enable it to deliver its programme of activities, both on and off its gallery sites. This support is essential in order for Tate to acquire works of art for the Collection, run education, outreach and exhibition programmes, care for the Collection in storage and enable art to be displayed, both digitally and physically, inside and outside Tate. Your donation will make a real difference and enable others to enjoy Tate and its Collection both now and in the future. There are a variety of ways in which you can help support Tate and also benefit as a UK or US taxpayer.

Please contact us at:

Development Office
Tate
Millbank
London SW1P 4RG
Tel: 020 7887 8945
Fax: 020 7887 8098

American Patrons of Tate
1285 6th Avenue (35th floor)
New York, NY 10019
USA
Tel: 001 212 882 5675
Fax: 001 212 882 5571

Donations, of whatever size, are gratefully received, either to support particular areas of interest, or to contribute to general activity costs.

Gifts of Shares
We can accept gifts of quoted share and securities. All gifts of shares to Tate are exempt from capital gains tax, and higher rate taxpayers enjoy additional tax efficiencies. For further information please contact the Development Office.

Gift Aid
Through Gift Aid you can increase the value of your donation to Tate as we are able to reclaim the tax on your gift. Gift Aid applies to gifts of any size, whether regular or a one-off gift. Higher rate taxpayers are also able to claim additional personal tax relief. Contact us for further information and to make a Gift Aid Declaration.

Legacies
A legacy to Tate may take the form of a residual share of an estate, a specific cash sum or item of property such as a work of art. Legacies to Tate are free of inheritance tax, and help to secure a strong future for the Collection and galleries. For further information please contact the Development Office.

Offers in lieu of tax
Inheritance Tax can be satisfied by transferring to the Government a work of art of outstanding importance. In this case the amount of tax is reduced, and it can be made a condition of the offer that the work of art is allocated to Tate. Please contact us for details.

Tate Members
Tate Members enjoy unlimited free admission throughout the year to all exhibitions at Tate, as well as a number of other benefits such as exclusive use of our Members' Rooms and a free annual subscription to *Tate Etc*. Whilst enjoying the exclusive privileges of membership, you are also helping secure Tate's position at the very heart of British and modern art. Your support actively contributes to new purchases of important art, ensuring that the Tate's Collection continues to be relevant and comprehensive, as well as funding projects in London, Liverpool and St Ives that increase access and understanding for everyone.

Tate Patrons
Tate Patrons share a strong enthusiasm for art and are committed to giving significant financial support to Tate on an annual basis. The Patrons support the acquisition of works across Tate's broad collecting remit, as well as other areas of Tate activity such as conservation, education and research. The scheme provides a forum for Patrons to share their interest in art and to exchange knowledge and information in an enjoyable environment. United States taxpayers who wish to receive full tax exempt status from the IRS under Section 501 (c) (3) are able to support the Patrons through the American Patrons of Tate. For more information on the scheme please contact the Patrons office.

Corporate Membership
Corporate Membership at Tate Modern, Tate Liverpool and Tate Britain offers companies opportunities for corporate entertaining and the chance for a wide variety of employee benefits. These include special private views, special access to paying exhibitions, out-of-hours visits and tours, invitations to VIP events and talks at members' offices.

Corporate Investment
Tate has developed a range of imaginative partnerships with the corporate sector, ranging from international interpretation and exhibition programmes to local outreach and staff development programmes. We are particularly known for high-profile business to business marketing initiatives and employee benefit packages. Please contact the Corporate Fundraising team for further details.

Charity Details
The Tate Gallery is an exempt charity; the Museums & Galleries Act 1992 added the Tate Gallery to the list of exempt charities defined in the 1960 Charities Act. Tate Members is a registered charity (number 313021). Tate Foundation is a registered charity (number 1085314).

American Patrons of Tate
American Patrons of Tate is an independent charity based in New York that supports the work of Tate in the United Kingdom. It receives full tax exempt status from the IRS under section 501(c)(3) allowing United States taxpayers to receive tax deductions on gifts towards annual membership programmes, exhibitions, scholarship and capital projects. For more information contact the American Patrons of Tate office.

The Broere Charitable
 Foundation
Mr Dan Brooke
Ben and Louisa Brown
Mr and Mrs Charles Brown
Michael Burrell
Mrs Marlene Burston
Canvas Magazine
Mrs Elizabeth Capon
Laurent and Michaela Caraffa
Peter Carew
Mr Francis Carnwath and
 Ms Caroline Wiseman
Veronica Cazarez
Lord and Lady Charles Cecil
John and Christina Chandris
Frank Cohen
Mr and Mrs Paul Collins
Terrence Collis
Mr and Mrs Oliver Colman
Carole and Neville Conrad
Giles and Sonia Coode-Adams
Mr and Mrs Paul Cooke
Cynthia Corbett
Mark and Cathy Corbett
Mr and Mrs Bertrand Coste
James Curtis
Ms Michelle D'Souza
Ms Carolyn Dailey
Mrs Isobel Dalziel
Sir Howard Davies
Sir Simon Day
The de Laszlo Foundation
Ms Isabelle De La Bruyère
Mr Jan De Smedt
Anne Chantal Defay Sheridan
Simon C Dickinson Ltd
James Diner
Mrs Noelle Doumar
Joan Edlis
Mr Steven Edwards
Lord and Lady Egremont
Mrs Maryam Eisler
Amanda Eliasch
John Erle-Drax
Stuart and Margaret Evans
Gerard Faggionato
Dana Farouki
Mrs Heather Farrar
Mrs Margy Fenwick
Mr Bryan Ferry
The Silvie Fleming Collection
Mrs Rosamund Fokschaner
Joscelyn Fox
Eric and Louise Franck
Elizabeth Freeman
Stephen Friedman
Julia Fuller
Mr and Mrs Albert Fuss
Gapper Charitable Trust
Mrs Daniela Gareh
Candida Gertler
Patrick Gibson
Mr David Gill and
 Mr Francis Sultana
Mr Simon Gillespie
Mr Mark Glatman
Mr and Mrs Paul Goswell
Penelope Govett
Mrs Andrew Graham
Gavin Graham
Martyn Gregory
Sir Ronald Grierson
Mrs Kate Grimond
Richard and Odile Grogan
Miss Julie Grossman
Mrs Danielle Hains
Louise Hallett
Dr Lamees Hamdan
Andrea Hamilton Photography
Mrs Sue Hammerson, OBE
Samantha Hampshire
Miss Susan Harris
Richard Hazlewood
Michael and Morven Heller
Mr Iain Henderson Russell
Mrs Alison Henry-Davies
Mr Nigel Mark Hobden
Mr Frank Hodgson
Robert Holden
James Holland-Hibbert
Lady Hollick

Mr Jonathan Horwich
John Huntingford
Miss Eloise Isaac
Mr Haydn John
Mr Michael Johnson
Mr and Mrs Peter Johnson
Mr Chester Jones
Jay Jopling
Tracey Josephs
Mrs Gabrielle Jungels-Winkler
Andrew Kalman
Mr Cyril Karaoglan
Rehmet Kassim Lakha
Dr Martin Kenig
Mr David Ker
Mr and Mrs Simon Keswick
David Killick
Mr and Mrs Paolo Kind
Mr Alex Kirgiannakis
Mr and Mrs James Kirkman
Brian and Lesley Knox
Mrs Caroline Koomen
Diane Kordas
Kowitz Trust
Mr Jimmy Lahoud
Simon Lee
Sally Leeson
Zachary R Leonard
Mr Gerald Levin
Leonard Lewis
Ina Lindemann
Anders and Ulla Ljungh
Mr Gilbert Lloyd
George Loudon
Mrs Siobhan Loughran Mareuse
Mark and Liza Loveday
Thomas Loyd
Ms Daniella Luxembourg
The Mactaggart Third Fund
Ms Colleen Mahon
Mr M J Margulies
Mrs Jonathan Marks
Marsh Christian Trust
Mr Robb McGregor
Dr Rob Melville
Mr Michael Meynell
Mr Alfred Mignano
Victoria Miro
Jan Mol
Mrs Roberta Moore Hobbis
Houston Morris
Mrs William Morrison
Mr Stamatis Moskey
Mr Guy and The Hon Mrs
 Naggar
Richard Nagy
Ms Angela Nikolakopoulou
Mrs Annette Nygren
Michael Nyman
Jacqueline O'Leary
Ms Sheen Ochavez
Julian Opie
Desmond Page
Maureen Paley
Dominic Palfreyman
Michael Palin
Cornelia Pallavicini
Mrs Kathrine Palmer
Stephen and Clare Pardy
Miss Camilla Paul
Yana Peel
Mr Mauro Perucchetti
Eve Pilkington
Lauren Prakke
Oliver Prenn
Susan Prevezer QC
Mr and Mrs Ryan Prince
Valerie Rademacher
Miss Sunny Rahbar
Will Ramsay
Mrs Phyllis Rapp
Mr and Mrs Philip Renaud
The Reuben Foundation
Sir Tim Rice
Lady Ritblat
Mr Bruce Ritchie and
 Mrs Shadi Ritchie
Tim Ritchie
Kimberley and
 Michael Robson-Ortiz
David Rocklin
Frankie Rossi
Mr James Roundell
Mr Alex Sainsbury and
 Ms Elinor Jansz

The Hon Michael Samuel
Mrs Sherine Sawiris
Cherrill and Ian Scheer
Sylvia Scheuer
The Schneer Foundation
Ms Joy Victoria Seppala-Florence
Amir Shariat
Neville Shulman, CBE
Mrs Nan Silberschmidt
Andrew Silewicz
Mr Simon Silver
Ms Julia Simmonds
Mr and Mrs David T Smith
Stella Smith
Tammy Smulders
Louise Spence
Ms Brigitta Spinocchia
Digby Squires Esq
Mr and Mrs Nicholas Stanley
Mr Timothy and
 The Hon Mrs Steel
Charlotte Stevenson
Mrs Tanya Steyn
The Swan Trust
Robert and Patricia Swannell
Mr James Swartz
The Lady Juliet Tadgell
Sir Anthony and Lady Tennant
Christopher and Sally Tennant
Soren S. K. Tholstrup
Mrs Margaret Thornton
Ms Celia Bosch Torres
Emily Tsingou and Henry Bond
TWResearch
Melissa Ulfane
Mrs Dita Vankova
Mrs Cecilia Versteegh
Gisela von Sanden
Mr Christopher V Walker
Stephen and Linda Waterhouse
Offer Waterman
Mr and Mrs Mark Weiss
Jack Wendler
Miss Cheyenne Westphal
Mr Benedict Wilkinson
Mrs Carol Winkler
The Cecilia Wong Trust
Mr Douglas Woolf
Mrs Anna Zaoui
Mr Fabrizio Zappaterra

and those who wish to
remain anonymous

American
Acquisitions
Committee

Cota Cohen Knobloch
Marilyn and Larry Fields
David B Ford
Glenn R Fuhrman (Chair)
Liz Gerring and Kirk Radke
Margot and George Greig
Christine and Andrew Hall
Monica Kalpakian
Massimo Marcucci
Stavros Merjos
Gregory R Miller
Jennifer Moses and Ron Beller
Elisa Nuyten and David Dime
Amy and John Phelan
Cynthia H Polsky
Laura Rapp and Jay Smith
Robert Rennie and Carey Fouks
Michael Sacks
Eric and Erica Schwartz
Andreas Waldburg-Wolfegg
Christine Wilson

and those who wish
to remain anonymous

Latin American
Acquisitions
Committee

Ghazwa Mayassi Abu-Suud
Monica and Robert Aguirre
Tiqui Atencio Demirdjian
 (Chair)
Luis Benshimol
Estrellita and Daniel Brodsky

Carmen Buqueras
Rita Rovelli Caltagirone
Trudy and Paul Cejas
Patricia Phelps de Cisneros
Gerard Cohen
HSH the Prince Pierre
 d'Arenberg
Tania Fares
Eva Firmenich
Angelica Fuentes de Vergara
Anne-Marie and Geoffrey Isaac
Nicole Junkermann
Jack Kirkland
Fatima and Eskander Maleki
Margarita Herdocia and
 Jaime Montealegre
Victoria and Isaac Oberfeld
Catherine and Michel Pastor
Catherine Petitgas
Isabella Prata and Idel Arcuschin
Estefania and Philip Renaud
Frances Reynolds
Erica Roberts
Alin Ryan von Buch
Lilly Scarpetta and
 Roberto Pumarejo
Catherine Shriro
Norma Smith
Susana and Ricardo Steinbruch
Beatriz Quintella and Luiz
 Augusto Teixeira de Freitas
Paula Traboulsi
Juan Carlos Verme
Tania and Arnoldo Wald
Juan Yarur
Anita Zabludowicz
Maria de la Paz Alice
 and Ronald Zurcher

Asia-Pacific
Acquisitions
Committee

Bonnie and R Derek Bandeen
Mr and Mrs John Carrafiell
Mrs Christina Chandris
Pierre TM Chen, Yageo
 Foundation, Taiwan
Mrs Maryam Eisler
Elizabeth Griffith
Mr Yongsoo Huh
Ms Yung Hee Kim
Ms Kai-Yin Lo
Mrs Yana Peel
The Red Mansion Foundation
Sir David Tang (Chair)
Katie de Tilly

International
Council Members

Doris Ammann
Mrs Miel de Botton Aynsley
Gabrielle Bacon
Anne H Bass
Nicolas Berggruen
Mr Pontus Bonnier
Mrs John Bowes
Brian Boylan
Ivor Braka
The Deborah Loeb
 Brice Foundation
Donald L Bryant Jr
Melva Bucksbaum and
 Raymond Learsy
Foundation Cartier pour
 l'art contemporain
Mrs Christina Chandris
Pierre TM Chen, Yageo
 Foundation, Taiwan
Mr and Mrs Borja Coca
Mr and Mrs Attilio Codognato
David and Michelle Coe
Mr Alfonso Cortina de Alcocer
Mr Douglas S Cramer and
 Mr Hubert S Bush III
Gordon and Marilyn Darling
Mr Dimitris Daskalopoulos
Mr and Mrs Michel David-Weill
Julia W Dayton
Ago Demirdjian and
 Tiqui Atencio Demirdjian
Joseph and Marie Donnelly

Mrs Jytte Dresing
Stefan Edlis and Gael Neeson
Carla Emil and Rich Silverstein
Alan Faena
Doris and Donald Fisher
Dr Corinne M Flick
Mr Albert Fuss
Candida and Zak Gertler
Alan Gibbs
Lydia and Manfred Gorvy
Noam and Geraldine Gottesman
Mr Laurence Graff
Ms Esther Grether
Mr Xavier Guerrand-Hermès
Mimi and Peter Haas Fund
Mr Joseph Hackmey
Margrit and Paul Hahnloser
Andy and Christine Hall
Mr Toshio Hara
Ms Ydessa Hendeles
André and Rosalie Hoffmann
Ms Maja Hoffmann (Chair)
Dakis and Lietta Joannou
Sir Elton John and
 Mr David Furnish
HRH Princess Firyal of Jordan
Mr Per and Mrs Lena Josefsson
C Richard and Pamela Kramlich
Pierre and Catherine Lagrange
Baron and Baroness
 Philippe Lambert
Agnès and Edward Lee
Jacqueline and Marc Leland
Mimi and Filiep Libeert
Panos and Sandra Marinopoulos
Mr and Mrs Donald B Marron
Mr Ronald and The Hon
 Mrs McAulay
Mr Guy and The Hon
 Mrs Naggar
Peter Norton
Young-Ju Park
Yana and Stephen Peel
Daniel and Elizabeth Peltz
Catherine and Franck Petitgas
Sydney Picasso
Jean Pigozzi
Ms Miuccia Prada and
 Mr Patrizio Bertelli
Patrizia Sandretto
 Re Rebaudengo and Agostino
 Re Rebaudengo
Mr John Richardson
Lady Ritblat
Barrie and Emmanuel Roman
Dr and Mrs Mortimer Sackler
Mrs Lily Safra
Muriel and Freddy Salem
Ronnie and Vidal Sassoon
Dasha Shenkman
Uli and Rita Sigg
Norah and Norman Stone
Mr John Studzinski
David Teiger
Mr Robert J Tomei
Mr Robert H Tuttle and
 Mrs Maria Hummer-Tuttle
Mr and Mrs Guy Ullens
Paulo A W Vieira
Mr Robert and The Hon
 Mrs Waley-Cohen
Pierre de Weck
Angela Westwater and David
 Meitus
Diana Widmaier Picasso
The Hon Mrs Janet Wolfson
 de Botton
Anita and Poju Zabludowicz